HFINE
1200
0580

FRAMING FILM is a book series dedicated to theoretical and analytical studies in restoration, collection, archival, and exhibition practices, in line with the existing archive of EYE Film Institute. With this series, Amsterdam University Press and EYE aim to support the academic research community, as well as practitioners in archive and restoration. Please see www.aup.nl for more information.

JULIA NOORDEGRAAF, COSETTA G. SABA,
BARBARA LE MAÎTRE, AND VINZENZ HEDIGER (EDS.)

PRESERVING AND EXHIBITING MEDIA ART

Challenges and Perspectives

AMSTERDAM UNIVERSITY PRESS

This project has been funded with support from the European Commission. This publication reflects the views only of the authors, and the Commission cannot be held responsible for any use which may be made of the information contained therein.

This book is published in print and online through the online OAPEN library (www.oapen.org)

OAPEN (Open Access Publishing in European Networks) is a collaborative initiative to develop and implement a sustainable Open Access publication model for academic books in the Humanities and Social Sciences. The OAPEN Library aims to improve the visibility and usability of high quality academic research by aggregating peer reviewed Open Access publications from across Europe.

Cover illustration: Section of the exhibition *Andy Warhol. Other Voices, Other Rooms*, Stedelijk Museum CS Amsterdam, 12 October 2007 - 14 January 2008. Photo: Gert Jan van Rooij. © The Andy Warhol Foundation for the Visual Arts, Inc. c/o Pictoright Amsterdam 2012

Cover design and lay-out: Magenta Ontwerpers, Bussum

ISBN 978 90 8964 291 2
e-ISBN 978 90 4851 383 3
NUR 670

TABLE OF CONTENTS

8 |

ACKNOWLEDGEMENTS

This book has its origins in a three-year collaboration (2007-2010) between the | 9
Università degli studi di Udine, the University of Amsterdam, the Université
Sorbonne Nouvelle-Paris 3, and the Ruhr-Universität Bochum that was spon-
sored by a grant from the Erasmus Lifelong Learning program. With its 36
contributions by 30 authors from 6 European countries, the book provides a
truly international perspective on the challenges of preserving and exhibiting
time-based media art.

For the sake of clarity, the contributions by different authors on the same
topic are grouped in single chapters, with the endnotes and references at the
end of each chapter. Because of its exceptional length, chapter 9 has been
divided into four thematically grouped subsections, with endnotes and refer-
ences at the end of each section. Chapter 9.1.1, written by Philippe Dubois,
was published previously in French in the Fall 2006 edition of *Cinema & Cie.
International Film Studies Journal*. We are grateful to the publisher for allowing
us to reprint the English translation of his text in the present book.

Catherine Davis translated chapters 1, 7.3, 8.2, and 9.4.4 from the Ger-
man. Franck LeGac translated chapters 9.1.1., 9.2.1, 9.2.3, 9.4.1, and 9.4.2
from the French, as well as sections of chapter 5 and the introductions to part
IV and chapter 9. Paul Gummerson translated chapters 4, 7.1, 7.2, 8.1, and the
introduction to part III from the Italian. Alice Colombi translated chapter 6.3
from the Italian. Reto Kramer and Gianandrea Sasso provided feedback on the
technical issues in chapters 7.1, 7.2 and 8.1.

The editors would like to thank Ariane Noël de Tilly, Senta Siewert, and
Alessandro Bordina for their editorial assistance. Caylin Smith has been very
helpful in retrieving the images for the book. We thank Steph Harmon for her
meticulous and graceful editing of the entire manuscript. At Amsterdam Uni-
versity Press we thank Jeroen Sondervan and Chantal Nicolaes for their sup-
port and assistance in the production of the book.

Introduction

Julia Noordegraaf

Since their emergence, time-based media such as film, video, and digital media have been used by artists who experimented with the potential of these media. In the 1920s, visual artists like Marcel Duchamp and Fernand Léger tested the aesthetic possibilities of film – a practice that continues into the 21st century in the oeuvre of artists such as Tacita Dean and Stan Douglas. The introduction of the first portable video recording system in the 1960s inspired artists like Nam June Paik and Andy Warhol to explore its application in sculptures, projection-based works, and multimedia events, initiating a wave in video art that continues to the present day. At the same time at Bell Labs in New Jersey, artists and engineers collaborated on the first experiments with the artistic affordances of computer technology, providing a foundation for the new field of digital art. The resulting artworks, with their basis in rapidly developing technologies that cross over into other domains of culture such as broadcasting and social media, have greatly challenged the traditional infrastructures for exhibiting, describing, collecting, and preserving art.

In this book, we take up the challenges of preserving and exhibiting media art and provide perspectives on how to meet those challenges both in theory and institutional practice. Time-based artworks that rely on media technologies for their creation and exhibition such as slide-based installations, film-, video-, and computer-based artworks, and net art, are prone to rapid obsolescence and thus cause problems for long-term preservation and display. Besides, these works often explore, expose, and explode the conventional use of the medium in question (in mainstream cinema, broadcasting, Web browsing, or social media), complicating their interpretation once the social and cultural practices to which they refer have disappeared. At the same time, the artistic use of new or obsolete technologies and the social and cultural practices related to them can also show us the benefits and shortcom-

ings of time-based media and thus provides a critical perspective on the highly media-saturated world in which we live. Because of their position at the crossroads between art, technology, and popular culture, media artworks serve as barometers, or signs of the times, and as such they deserve to be collected, interpreted, and preserved in ways that do justice to their identity and ensure their long-term accessibility.

Over the past decade, a number of studies were published that focus on the consequences of the introduction of time-based media in the exhibition space, in particular discussing the ways in which these works challenge the existing practices and models of curating (including Bellour, 2000; Beil, 2001; Iles, 2001; Arrhenius, Malm, and Ricupero, 2003; Joselit, 2004; Païni, 2004; Krysa, 2006; Paul, 2008; Graham and Cook, 2010). Additionally, a number of practicing curators and preservationists have studied the challenges of collecting, documenting, preserving, and restoring media artworks – notable examples are heritage institution-based projects such as the International Network for the Conservation of Contemporary Art (INCCA), the Variable Media Network, and the project Documentation and Conservation of the Media Arts Heritage (DOCAM). Notwithstanding the various models for documenting media art and the various publications that discuss the preservation problems via case studies from practice (such as Laurenson 2001 and 2004; Depocas, Jones, and Ippolito, 2003; Altshuler, 2005; Scholte and Wharton, 2011), a more theoretically informed overview and analysis of this practice is still lacking. This book aims to provide such an overview of the state of the art in preserving and exhibiting media art. It does not aim to be exhaustive but focuses on the most important challenges of and possible solutions for preserving and exhibiting time-based arts and provides clear theoretical perspectives on that practice.

Regarding the substantial literature on exhibiting media art, this book focuses mostly on its collection, analysis, documentation, preservation, and restoration. At the same time, the institutional processing of media art cannot be discussed without reference to exhibition issues. The specific nature of media art – as based on experiments with new technologies, often resulting from collaborations with multiple partners, variable and process-based in nature – poses problems for locating the identity of a work. Often the inaugural exhibition is a key moment in defining the work and an important reference point for collection or preservation issues (see Noël de Tilly, 2011). In addition to this, many choices made in the description, documentation, and restoration of media artworks determine their possible later reuse in exhibitions or other access projects. For example, the multi-authored, long-term project *No Ghost Just a Shell* (1999-2002) by artists Pierre Huyghe and Philippe Parreno discussed in chapter 6 was acquired by the Van Abbemuseum in Eindhoven, the Netherlands, as an *exhibition*, rather than as a collection of individual works. The

inaugural exhibition of this project was the first time all contributions were shown together and also signaled the moment this project was identifiable as a work/exhibition that could be collected. It also is the most important reference point for future presentations of the project (see also Van Saaze 2009).

The preservation and exhibition of media art requires an interdisciplinary approach, combining ideas from art history, museum studies, conservation theory, and media and cultural studies. There is increasing consensus on studying media art as part of art history in general, focusing on the similarities of media art with more established fields of art such as minimalism, conceptual art, installation art, and performance art and using the differences to rethink these more established art practices (see Grau, 2007; Shanken, 2009; Graham and Cook, 2010). Most publications discussing the challenges media art poses for existing practices of preservation and exhibition build upon ideas from museum studies and other heritage domains such as archiving or the performing arts (see Laurenson 2006). We build upon these insights with knowledge from the fields of media and cultural studies. As Beryl Graham and Sarah Cook recently argued, besides art history and museum studies, insights from media studies are crucial for understanding the specific nature of media-based artworks (2010: 111). Media artworks often play on the wider cultural role of media, such as the formats of television broadcasting or the sociocultural and economic uses of software and online social media. Understanding the role and function of media in art thus requires knowledge about the nature of time-based media (technical features, narrative, aesthetics, *dispositifs*, and specific sociocultural and economic contexts of production and distribution) and of the relationship between work and viewer (spectatorship, use, participation) as developed in media and cultural studies. By extension, we also generally prefer to use the term *preservation* rather than *conservation* to denote the activities of both keeping (passive preservation) and restoring media artworks; preservation is the accepted term in the field of audiovisual archiving and restoration (see Fossati, 2009), while the term conservation is used mainly in conservation theory (see Muñoz Viñas, 2005: 14-25).

This book focuses on the preservation and exhibition of all forms of time-based art, from film- and video-based works and slide-based installations to works based on computer technology and the Internet, such as software art and net art. While the characteristics and preservation challenges of film- and video-based art have been studied intensively, resulting in various models and protocols, capturing and (re-)exhibiting born-digital art has only recently become an object of concern (Dekker, 2010; Graham and Cook, 2010; Daniels and Reisinger, 2010; Bosma, 2011). Therefore, this book uses a detailed overview and analysis of established methods for preserving and documenting film- and video-based works as a basis for exploring new roads for capturing

the variable and fugitive forms of multi-authored, interactive, and event-oriented computer-based art.

The structure of the book roughly reflects the process of collecting, valuing, documenting, preserving, restoring, and exhibiting media art. Because of its multifaceted and interdisciplinary nature, capturing media artworks requires a theoretical framework that helps to describe the identity of the work and to contextualize it in a way that does justice to its concept, appearance, and experience. Part I provides various historical and theoretical pathways for approaching and contextualizing the book's principal object: media art. It equips the reader with tools for approaching and defining media artworks – a first step when it comes to curating and preserving this type of art. Since media art is a multi-disciplinary field, we focus on those approaches and topics that are most relevant for the preservation and exhibition of these works. The contributions to part I provide the historical, conceptual, and contextual framework needed to describe and capture works of media art.

In the opening chapter, Chris Wahl sketches the history of media art, providing readers with the means to contextualize individual artworks in the history of the field. It combines a discussion of the history of actual works with a reflection on their interrelation with the history of media technologies and practices. In line with contemporary approaches to media art, the chapter focuses on the relation of media art with, on the one hand, art history in general and, on the other, the history of media outside the field of art.

Chapter 2 builds upon chapter 1 in that it extends the chronological history of media art to an archaeological one. Author Wanda Strauven discusses various forms of historiography, from chronological to genealogical and archaeological, and shows how an archaeological approach can include those dimensions of media history – technological fantasies or science fictions, failed inventions, the similarity of certain media features to earlier examples – that are lost in a more technologically determinist history. The chapter builds upon Michel Foucault's conception of genealogy and archaeology and discusses the various contemporary approaches or "schools" of media archaeology. It also includes examples of how media artists engage a media archaeological perspective, demonstrating how this type of historiography may be particularly relevant for studying the history of media art as situated between art, technology, and popular culture.

Dario Marchiori provides a reflection on media aesthetics in chapter 3, equipping readers with the theoretical context needed for describing media artworks in a way that does justice to their concept, formal aesthetic appearance, and the viewer's experience. The chapter discusses the history of aesthetics as a philosophical discipline and explains how the emergence of media art has complicated the debates in this field. Attention is paid to the

double meaning of the term *media*, as the plural of *medium* – indicating the tools for transmission and expression – and as a new signifying whole – such as journalism, radio and television broadcasting, social media, etc. As outlined above, the double nature of this term is a key feature for understanding many media artworks. The chapter ends with a reflection on how media seem to reconcile the opposition between sensation and thought characteristic of traditional aesthetics in a new whole.

In the final chapter of part I, chapter 4, Cosetta Saba discusses the impact of digitization, particularly focusing on the role of the digital archive in the preservation and re-exhibition of media artworks. Many artists rework archival material (such as Fiona Tan's reuse of colonial footage, or Péter Forgács' reuse of amateur film), or use the archive as a metaphor in their work (for instance by creating new archives, like Douglas Gordon of his own work in his video installation *Pretty much every film and video work from about 1992 until now. To be seen on monitors, some with headphones, others run silently, and all simultaneously*, 1992-present). Additionally, the chapter introduces the crucial notion of documentation, both of the artwork's concept and material-technical components as well as the cultural context in which it was conceived and first experienced. Digital archives might provide a solution for capturing the complexity and variability of media artworks as well as their cultural preservation. Yet, as Saba argues, the specific nature of the digital archive, which turns complex objects into a collection of source codes and where the boundaries between objects, metadata, and archival infrastructure become blurred, poses specific challenges to its future reuse: certain aspects of the original appearance and functionality of the work are lost in the process. Therefore, this chapter investigates the epistemological implications of the digital archiving of media art.

The second part of the book focuses on various strategies and practices of actually analyzing, describing, collecting, documenting, and archiving media artworks. In this and subsequent parts of the book, specific approaches, strategies and models are discussed, analyzed, and elucidated with the help of specific case studies. In part II, the focus lies on the analysis, documentation and archiving of media art.

The second part opens with a reflection on methodologies for describing and analyzing media art, aiming to provide the reader with tools for capturing the identity of time-based artworks. Because of their dependency on technologies that face rapid obsolescence, preserving, exhibiting, and re-exhibiting media artworks raises the fundamental question of where exactly to locate a work's identity. In chapter 5, Dario Marchiori provides a critical reflection on the nature of describing and analyzing media art. In addition, he provides readers with a specific, four-step method for describing, analyzing, interpreting, and evaluating media artworks. The application of this method is demon-

strated with the help of Harun Farocki's video installation *Workers Leaving the Factory in 11 Decades* (2006).

After that, chapter 6 focuses on one of the key strategies for preserving and re-exhibiting media artworks: documentation. Without thorough documentation of their creation, exhibition history, and experience, time-based artworks cannot be collected, archived, or re-exhibited. Annet Dekker describes and compares the main documentation models developed for media artworks, analyzing their values and their limits, and, finally, shows how crucial documentation is to capture the ephemeral and variable nature of media artworks. A discussion of a case study, Blast Theory's mixed reality game *Uncle Roy All Around You* (2003), serves to show how the definition and implementation of documentation strategies needs to be adapted to do justice to the works at hand. A discussion of four other cases, the complex project *No Ghost Just a Shell* (Pierre Huyghe, Philippe Parreno, and many others, 1999/2002) by Vivian van Saaze, the audio installation *Mbube* (Roberto Cuoghi, 2005) by Iolanda Ratti, Alfredo Jaar's installation *Infinite Cell* (2004), and the degradable, site-specific installation *e così sia...* (Bruna Esposito, 2000) by Alessandra Barbuto and Laura Barecca, serve to further illustrate and complicate the documentation issues outlined in the first part of the chapter.

Part III focuses on the theory and practice of the preservation and restoration of media art. Chapter 7 discusses the history and specific nature of the technologies used by media artists and outlines the problems these technologies cause for preservation and later reuse. The chapter provides an overview of the artistic use of film (in particular the small gauges mostly used by artists, such as 8mm, 9.5mm and 16mm, discussed by Simone Venturini and Mirco Santi), video (½-inch and ¾-inch tape, discussed by Alessandro Bordina), and computer technology (discussed by Tabea Lurk and Jürgen Enge). Attention is paid to the history of these technologies, their diffusion and use in artistic production, and the underlying system characteristics such as signal supports, playback and recording equipment, hardware and software components and exhibition requirements. In her contribution to this chapter, Gaby Wijers pays specific attention to the obsolescence of playback equipment, a problem that severely complicates the preservation and re-exhibition of media-based art.

This reflection on technological platforms is followed by a chapter that outlines possible solutions to the aforementioned problems. Summarizing and analyzing the various decision-making models, strategies, and protocols developed by European and North American laboratories and institutions devoted to the preservation and exhibition of media art, chapter 8 describes techniques and methodological steps related to the preservation and restoration of film-, video-, and computer-based artworks. In the first section, Alessandro Bordina and Simone Venturini focus on the preservation and

restoration of film- and video-based artworks. They provide a description of the phases and the practices related to the physical, chemical and mechanical treatments of these types of carriers. A technical perspective on these problems is complemented by a reflection on the ethical implications of the strategies, models, and methods discussed here. In the second section of this chapter, Jürgen Enge and Tabea Lurk focus on preservation and restoration procedures for digital components of media artworks. Emulation and virtualization strategies are discussed and analyzed as possible solutions for the preservation of this type of art. Chapter 8 ends with a case study: Julia Noordegraaf interviews Pip Laurenson about the methods and protocols used for preserving and restoring time-based artworks at Tate, one of the world's leading institutes researching, collecting, preserving, and exhibiting time-based arts.

The last part of the book focuses on accessing and reusing media artworks; in it, two chapters discuss various exhibition strategies ranging from exhibitions in museum galleries to festivals and online events. The contributors to chapter 9 discuss different exhibition formats for time-based media and the specific modes of spectatorship related to them. As indicated above, the exhibition of media art has been widely discussed in a number of different publications and exhibitions. Therefore, rather than presenting an overview of the literature, this chapter starts from one particular problem – what remains of cinema and its "black box" model of spectatorship when it enters the "white cube" of the museum (Philippe Dubois, Stéphanie-Emmanuelle Louis, Barbara Le Maître) – and enriches this debate by adding various "lines of flight" that extend these concerns into the realms of video art (Ariane Noël de Tilly, Térésa Faucon), installation art (Teresa Castro, Elena Biserna), new media art (Claudia d'Alonzo, Arie Altena), popular culture (Senta Siewert), and the Internet (Renate Buschmann).

In chapter 10, Sarah Cook zooms in on the challenges posed by curating computer- and Internet-based media artworks, also known as "new media art." These works are often created by multiple authors, are highly interactive, and are variable in space and time. Besides, their Web-based and interactive nature often makes them unfit for display in traditional exhibition spaces. Cook points out that the debate on how to curate new media art has largely taken place in the field of museology, with a focus on the problems these works cause for traditional museum practice. She asks why extra-institutional freelance curators of contemporary art – who generally have more flexibility and thus could possibly be better suited for exhibiting new media art – have so far largely ignored this newest art form. In line with the often collaborative and participatory nature of these works, and the fact that their production space often coincides with their means of distribution, this chapter takes the form of an edited discussion on curating new media art from the CRUMB web-

site.[1] Therewith it also functions as a platform for showcasing the ideas from various leading curators of new media art.

The book ends with an epilogue in which Julia Noordegraaf and Ariane Noël de Tilly discuss the exhibition *Andy Warhol. Other Voices, Other Rooms*, held at the Stedelijk Museum CS in Amsterdam (2007-2008). The discussion of this exhibition serves to summarize the preservation and exhibition challenges outlined in this book and analyzes these challenges from the various theoretical perspectives also provided here. The Warhol exhibition is a relevant case because it brings together many of the different problems and strategies outlined before, demonstrating how these challenges are met in practice.

In the end, the fact that media artworks challenge existing theories and practices also presents new opportunities: it calls for a fresh perspective on institutionally grown ideas and practices, and invites creative solutions and extra-institutional and cross-disciplinary collaborations. The contributions to this book aim to provide current and future theorists, preservationists, and curators of media art with the baggage to embark on this journey and seize the opportunities that come along.

18 |

NOTES

1. CRUMB stands for "curatorial resource for upstart media bliss" and is an online platform founded by Beryl Graham and Sarah Cook in 2000. CRUMB's activities cover a range of practices, but are predominantly based around research, networking, and professional development for curators of new media art. Http://www.crumbweb.org. Last access: 23 July 2012.

REFERENCES

Altshuler, Bruce (ed.). *Collecting the New. Museums and Contemporary Art*. Princeton, NJ and Oxford: Princeton University Press, 2005.

Arrhenius, Sara, Magdalena Malm, and Cristina Ricupero (eds.). *Black Box Illuminated*. Lund: Propexus, 2003.

Beil, Ralf (ed.). *Black Box. Der Schwarzraum in der Kunst*. Catalogue of the eponymous exhibition, Kunstmuseum Bern, 15 June-9 September 2001. Ostfildern-Ruit: Hatje Cantz, 2001.

Bellour, Raymond. "D'un autre cinema." *Trafic* 34 (2000): 5-21.

Bosma, Josephine. *Nettitudes. Let's Talk Net Art*. Rotterdam/Amsterdam: NAi Publishers/Institute of Network Cultures, 2011.

Daniels, Dieter, and Gunther Reisinger (eds.). *Netpioneers 1.0. Contextualizing Early Net-based Art*. Berlin: Sternberg Press, 2010.

Dekker, Annet (ed.). *Archive 2020. Sustainable Archiving of Born-Digital Cultural Content*. Amsterdam: Virtueel Platform, 2010. Available online – http://issuu.com/virtueelplatform/docs/archive2020_def_single_page. Last access: 23 July 2012.

Depocas, Alain, Jon Ippolito, and Caitlin Jones (eds.). *Permanence Through Change. The Variable Media Approach*. Montreal/New York: Daniel Langlois Foundation for Art, Science, and Technology/Solomon R. Guggenheim Museum, 2003.

Fossati, Giovanna. *From Grain to Pixel. The Archiving Life of Film in Transition*. Amsterdam: Amsterdam University Press, 2009.

Graham, Beryl, and Sarah Cook. *Rethinking Curating. Art After New Media*. Cambridge, MA and London: MIT, 2010.

Grau, Oliver (ed.). *Media Art Histories*. Cambridge, MA: MIT, 2007.

Iles, Chrissy. *Into the Light. The Projected Image in American Art, 1964-1977*. Catalogue of the eponymous exhibition, Whitney Museum of American Art, New York, 18 October 2001-6 January 2002. New York: Whitney Museum of American Art, 2001.

Joselit, David. "Inside the Light Cube." *Artforum* 42 (2004) Fall: 154-159.

Krysa, Joasia (ed.). *Curating Immateriality. The Work of the Curator in the Age of Network Systems*. Brooklyn, NY: Autonomedia, 2006.

Laurenson, Pip. "Authenticity, Change and Loss in the Conservation of Time-based Media Installations." *Tate Papers. Tate's Online Research Journal* (Autumn 2006). Http://www.tate.org.uk/download/file/fid/7401. Last access: 23 July 2012.

—. "The Management of Display Equipment in Time-based Media Installations." In *Modern Art, New Museums. Contributions to the Bilbao Congress 13-17 September 2004*, edited by Ashok Roy and Perry Smith: 49-53. London: The International Institute for Conservation of Historic and Artistic Works, 2004.

—. "Developing Strategies for the Conservation of Installations Incorporating Time-Based Media With Reference to Gary Hill's *Between Cinema and a Hard Place*." *Journal of the American Institute for Conservation* 40 (2001) 3: 259-266.

Muñoz vinas, Salvador. *Contemporary Theory of Conservation*. Oxford: Butterworth-Heinemann, 2005.

Noël de Tilly, Ariane. *Scripting Artworks. Studying the Socialization of Editioned Video and Film Installations*. Ph.D. diss., University of Amsterdam, 2011.

Païni, Dominique. "Should We Put an End to Projection?" *October* 110 (Fall 2004): 23-48.

Paul, Christiane (ed.). *New Media in the White Cube and Beyond. Curatorial Models for Digital Art*. Berkeley, CA and London: University of California Press, 2008.

Scholte, Tatja, and Glenn Wharton (eds.). *Inside Installations. Theory and Practice in the Care of Complex Artworks*. Amsterdam: Amsterdam University Press, 2011.

Shanken, Edward A. *Art and Electronic Media*. London: Phaidon Press, 2009.

Van Saaze, Vivian. "Doing Artworks. An Ethnographic Account of the Acquisition and Conservation of *No Ghost Just a Shell*." *Krisis. Journal of Contemporary Philosophy* 1 (2009): 20-33.

HISTORY, ARCHAEOLOGY, AESTHETICS, ARCHIVE: THEORETICAL PATHS

INTRODUCTION

Vinzenz Hediger

What is media art? Providing a working definition of its object is critical to any emerging new field of study, but particularly to the field of media art. The product of practices that often involve rapidly changing technologies and ephemeral performance elements, media art is difficult for critics, curators, and archivists to pin down in terms of the established taxonomies of art history or film and media studies. Laying the groundwork for the following parts of the book, this part offers four different approaches to the methodological, theoretical, and practical challenges involved in developing a taxonomy of media art that is both historically sound and practically useful.

As Chris Wahl shows in his contribution, the term "media art" first appeared about two decades ago and is closely related to the emergence of the Internet. Since then "media art" has been widely used as an umbrella term that covers video art, installation art, and other artistic practices involving film, digital (moving) images, and recorded sound. Offering a brief genealogy, Wahl traces the history of video, installations, and performance art since the 1960s, with a focus on Nam June Paik and the Fluxus movement. He highlights the importance of television and video technology and their impact in the 1960s and 1970s. Wahl maps the field of media art through three main types of artistic practice: "performance and interaction," "installations and projections," and "*dispositif* and deconstruction." He also outlines three sets of thematic constants: "body and voice, language and writing," "ego identity and sexuality," and "surveillance/control."

Acknowledging the methodological challenges posed by the hybrid time-based practices of media art, Wanda Strauven highlights the virtues of media archaeology, an approach that reframes film history and art history to comprehensively account for the intertwined histories of media art, new media, and film. In a series of close readings Strauven shows how media archaeology, as proposed by Siegfried Zielinski, Erkki Huhtamo, Wolfgang Ernst, and Thomas Elsaesser, variously draws on Foucault's conceptual framework of a history of the present to locate current and historical media practices in a network of technologies and discourses. Abandoning film theory's classical question "What is film?" for an inquiry into the "where" and "when" of media practices, media archaeology comes in four varieties focusing, respectively, on the old in the new, the new in the old, recurring topoi, and ruptures and discontinuities. Highlighting the value of the first three approaches, Strauven endorses the fourth as particularly apposite for the rapidly changing field of media art.

Gauging the impact of media art on another established field of inquiry, philosophical aesthetics, Dario Marchiori outlines the contours and pitfalls of what has come to be known as media aesthetics. Differentiating between the concepts of *medium* – a set of techniques of (artistic) expression – and *media* – a network of technologies of communication – Marchiori shows how the emergence of media art tests the limits of the classical conception of the aesthetic as a reflexive experience as first described in the 18th century by Baumgarten, Burke, and Kant. Taking stock of the varied nature of media art, Marchiori abandons an object-specific approach for a more flexible and inclusive understanding of media aesthetics as a set of reflexive practices that account for both the material and experiential complexities of our current media environment.

In her final contribution to part I, Cosetta G. Saba addresses the problem of defining media art from the vantage point of digital preservation and storage. Drawing on some of the key texts from archive theory and media archaeology, Saba discusses the difficulties involved in storing and retrieving time-based media artifacts and artistic practices. Developing the concept of *transcodification*, Saba uses a number of examples to discuss the challenge involved in documenting media artworks that can only be transferred to a digital storage format at the price of a loss of the ephemeral and experiential dimensions of the work. By outlining the difficulties of making non-storable elements of media artworks retrievable after all, Saba contributes another key element to a working definition of media art for the subsequent parts of the book.

Between Art History and Media History: A Brief Introduction to Media Art

Chris Wahl

When the first commercial browser was released by Netscape in 1994, it immediately became clear that the Internet was no longer merely an exchange platform geared towards the needs of scientists and software engineers, but that it had evolved into a genuinely popular medium (Tribe and Jana, 2006: 6). The development of the graphical user interface (GUI) that now marked the intersection between man and machine was especially important in convincing even the last remaining sceptic that the computer was not just a simple calculator, but rather a complex medium of communication and for the remediation of, among other things, newspapers, film, and radio (Bolter and Grusin, 2000). It was in this context that terms such as "new media" and "media art" first appeared and were retrospectively applied to just about every new movement that had emerged in the arts since the 1960s (Daniels, 2011: 61-62). At the same time, exploring the computer's potential as a medium helped further the idea that every kind of art had always been media art, inasmuch as the term "media" can also refer to all sorts of tools, appliances, machines, artificial extensions of the body etc. However, the precise nature of these concepts as well as the differences between them are hardly clear cut. It is nevertheless possible to define "new media art" as a general term for every kind of art that is created with the help of a computer. Furthermore, there are several synonyms and subdivisions: Occasionally, one hears terms such as "multimedia art," "digital art," "computer art," or "interactive art"; then there is also "net art," which is found on the Internet and can be accessed from any personal computer; and finally there is "installation art" that is characterized by its specific location and concrete materiality.

Within this genealogy, "video art" plays a paramount role. This is due on the one hand to its technological basis, namely the transformation of sounds and images into electronic signals, which constitutes something of a thresh-

old that divides the analogue from the digital. It is hardly surprising, then, that some of the pioneers in video art were also pioneers in using the computer for artistic ends. On the other hand, beginning in the late 1960s, the new medium of video became attractive for artists from different realms of expression (music, dance, performance, political agitation, experimental film, etc.), all of which had recently experienced a transformative phase. Against this technical and thematic backdrop, video art ushered in a first stage in the remediation of established media forms, a process that digitization later compounded. But the most significant change wrought by video art lay in the way it challenged and ultimately redefined the traditional concept of art. The fact that galleries and museums nowadays exhibit not just paintings, photographs, and classical sculptures but also electronic and digital installations, speaks to video art's enduring legacy. Thus Boris Groys has rightly observed that the presence of video art in museums marks the beginning of a new era. While previously one could spend as much time as one liked contemplating a painting, the new visual works with their moving images and accompanying sounds unambiguously dictate the amount of time a visitor has to invest to experience the artwork in its entirety (Groys, 2006: 50-57).[1] "Time-based art" has accordingly now become the term of choice for this genre. Of course, everyone is free to resist the dictates of duration. The practice of displaying video art in so-called "loops" is designed to achieve precisely this; people may come and go as they please and begin, interrupt, and resume the viewing anytime they want.[2] Some artists, such as Rodney Graham in *Vexation Island* (1997), develop a playful approach to the established form of the loop by constructing the narrative so that it resembles a never-ending cycle. In this respect, the display of video art in museums ties in with exhibition practices that were previously associated mainly with Early Cinema or with erotic movie theatres whose demise was, ironically, triggered by the mass availability of videotapes. In cases where audiovisual artworks transcended the possibilities of the traditional gallery space, the "black box" had for a long time been the solution of choice (Paul, 2008: 53,75) and in that context, the work on display indeed assumed an air of the secret and forbidden, or even encouraged a retreat to the safety of childhood.

The emergence of new media art in the 1990s triggered a renewed interest in video art, which is evinced by a host of new publications in which the two phenomena are treated separately (sometimes even by the same authors), even though they are in fact closely related. At universities, the time-honoured discipline of art history responded to this renewed interest, and scholars began studying other forms of images, mainly moving ones, as well as types of image production that differed from the classical artist-centred context. As a result there are now new academic disciplines such as "Visual Studies" or "*Bildwis-*

senschaften." But film and media studies, too, can hardly avoid engaging with audiovisual art. Many film historians still insist on a clearly defined boundary between the cinema and the museum, in spite of the fact that video art has long rendered this distinction obsolete. In this introduction, I will focus mainly on the history of video art with the aim of highlighting some basic elements that are specific to media art as a whole.

Just as the Internet in its early years mainly served as a platform for sharing images and photographs with a larger audience (Baumgärtel, 1999: 14), the video camera was initially often used for documenting performances. What quickly emerged in both cases, however, was a focus that subsequently came to dominate (new) media art and perhaps even constitutes a specific characteristic that sets it apart from traditional art, namely the *dispositif*. Media art is highly self-reflexive in that it frequently displays the conditions of its own production and reflects on the "apparatus" in which its production and reception are inextricably tied together. Moreover, it consistently addresses the viewer, and it sees the relationships between artwork, environment, and man, and between the product and its user as its foremost concerns.[3] In this respect, one could, following Nam June Paik, describe media art as a kind of "practical media theory" (Daniels, 2011: 65). Paik is the pivotal figure in any history of media art. It seems as if he experimented with, or at least thought about, practically everything done in the field through to the present day. Baumgärtel (10), for example, sees him as a pioneer of net art because of his "electronic superhighway" project, which he conceived in 1974 for the Rockefeller Foundation, even though it was never actually realized. Legend would have it that the Korean-born Paik was the first artist to purchase one of the lightweight video recorders that had just been introduced by Sony (the TCV-2020) in New York on 4 October 1965, that he made recordings of Pope Paul VI, who was visiting the city, and that he showed them to the public on the same evening in the "Cafe au Go Go" in Greenwich Village.[4] "Lightweight" in this case means 34.7 kilograms which represented something of a quantum leap compared to the huge machines that were then still being used by television stations. Paik had not even opted for the most practical recorder but had instead chosen one with an inbuilt television screen. The Sony CV-2100 would have weighed only 25 kilograms, which, in addition to the fact that the footage has been lost, is why his account has often been questioned. Be that as it may, the legendary nature of this story is what makes it an especially fitting myth of the origin, the zero hour of video art. Françoise Parfait emphasizes that video proved to be an ideal medium for the women's movement insofar as it was new and not mired in tradition, and could thus be an agent in overcoming patriarchal structures in, for example, the film industry (2001: 260).[5] Shigeko Kubota, who was married to Nam June Paik for almost 30 years, is said to have proclaimed: "Video

is Vengeance of Vagina. Video is Victory of Vagina" (Meigh-Andrews, 2006: 8). The video recorder's compactness, its relatively cheap price, and the fact that recordings could be viewed straight away and did not require a complicated development process (like film) meant that it was ideally suited to the purpose of documenting things with great immediacy, similar to what had just emerged in film under the name of "Direct Cinema" or "Cinema Vérité," and to being screened on television, the number one mass medium.

While the political and social upheavals of the 1960s are usually associated with student protests, the peace movement, environmentalism, sexual revolution, feminism, Black Panthers, and the gay and lesbian movement, the sphere of art produced its own Zeitgeist-evoking terms, among them Conceptual Art, Minimal Art, Anti-Art, Land Art, Body Art, Pop Art, and Fluxus. What these labels have in common is that they imply a change in the concept of the artwork, emphasizing its procedural, immaterial or simply everyday character. It is no coincidence that the Fluxus artist Dick Higgins coined the term "Intermedia" in 1996 in order to designate and propagate the increasingly fluid nature of traditional genre distinctions. Fluxus was founded in 1962 in New York by George Maciunas who, like his friend Jonas Mekas, was also born in Lithuania. Mekas himself was an important figure in the experimental film scene, not least because he had founded the magazine *Film Culture* (1954), the Filmmaker's Cooperative (in 1962 together with Emile de Antonio), and the Filmmaker's Cinematheque (1964) from which the Anthology Film Archive emerged in 1970; to this day, it houses the world's largest collection of avant-garde film art. Paik and Maciunas had met in 1961 and Paik subsequently became one of the most important exponents of Fluxus, a multimedia movement aiming to reconcile art and life that can be traced back to both Dadaist concepts and to the teachings of Zen Buddhism. On 11 March 1963, Paik, who had come to Germany as a music student in 1956, opened his exhibition "Exposition of Music – Electronic Television" in the Galerie Parnass in Wuppertal. Displaying the influence of Paik's mentor John Cage, the exhibition included modified pianos and other objects such as twelve television sets, the screens of which Paik modulated with the help of a technique that had been developed over months by electrical engineers. But Paik was not the first artist to engage in this practice of manipulating television images. On 14 September 1963, also at the Galerie Parnass, another Fluxus artist, Wolf Vostell, presented *Sun in Your Head*, a six-minute-long "dé-coll/age"; this newly coined term denoted an aggressive act that consisted of tearing down, smudging, and interrupting established visual structures.

Although this work is now unanimously classified as video art, the artist actually had to use a 16-mm camera to record the lines he had changed as they appeared on the television screen. The first known use of videotape, on

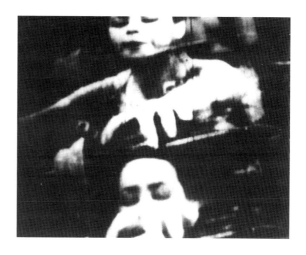

the other hand, must be attributed to an artist whose oeuvre is widely seen as representative for mixing art with the world of consumption, and for the transgression of traditional media boundaries: It was Andy Warhol who, in 1965, used video camera equipment (made by an American manufacturer) to shoot footage of Edie Sedgwick, his Factory Girl, in profile. He then placed her, face-front, next to a huge monitor on which the previously recorded images were playing, and recorded this with a 16-mm camera. The result, which Warhol called *Outer and Inner Space*, made it look as though Edie was talking to herself. Warhol was thus the first artist to mix film and video techniques, and he may have even presented his video footage in public before Paik did (Rush, 2007: 52). But this, again, belongs to the realm of legend. In 1968, videotape finally made its first appearance in the art world. An exhibition at the Museum of Modern Art in New York entitled "The Machine as Seen at the End of the Mechanical Age" featured a primitive video installation by Paik that consisted of footage he had shot of New York's Mayor Lindsay in 1965. In 1969, also in New York, a group exhibition took place entitled "TV as a Creative Medium," which was the first of its kind exclusively devoted to video art (see Fig. 1.2 in color section). It featured, along with Paik, works by other pioneers including Frank Gillette and Ira Schneider.

The first really portable ½ -inch devices (the most prominent being Sony's DV-2400, also known as "Portapak") were introduced in 1967 and immediately triggered a real video boom. At first, they could merely record images but not replay them and, obviously, used open reels; however, they quickly became more powerful and user-friendly. The Japan Standard I, agreed upon in 1969, was intended to guarantee mutual interchangeability between the different brands. When thinking about early video art, it is certainly worth bearing in

mind that most of it was produced for low-contrast black-and-white televisions, because color recordings were still quite expensive. The fact that different systems, many of which have by now disappeared, were competing with one another for many years presents archivists and restorers of video art with the difficulty of having to find and preserve the appropriate hardware.

Also of fundamental importance is the connection between video technology and television technology. The projector and the screen are combined within a closed *dispositif*, as it were, namely the television/monitor (Parfait, 2001: 155). The video image, unlike the film image, consists of two sets of 25 half images that are written continuously in lines, from left to right and from top to bottom. This image can then be immediately controlled, thereby allowing the creation of "closed circuits" and thus an interactive participation in the artwork; another possibility is working with "feedback," that is with an infinite mise-en-abyme.[6] The fact that audio terms appear in this context is certainly no coincidence, given the medium's "fundamental audiovisuality" that Yvonne Spielmann has emphasized: "audio signals govern the way the video looks, and, vice versa, the information contained in the video signals can be broadcast visually and audibly at the same time" (2008: 1) – hence the term "video noise," or "snow," its colloquial equivalent – which refers to the visualization of electronic and electromagnetic noise. Video pioneers Steina and Woody Vasulka famously explored this phenomenon in their work, such as in Woody's *C-Trend* (1975) where one simultaneously sees an image and its sound in the shape of a moving graphic noise (Parfait, 2001: 118). In Steina's *Violin Power* performances (1970-1978), she used the sound she had recorded of her playing the violin to manipulate the visual recording of the performance (Spielmann, 2005: 201). Improvisation, occasionally provocation, and almost scientific experimental designs are recurring themes in media art, as will be discussed in the following section.

PERFORMANCE AND INTERACTION

Many performance artists, such as Robert Rauschenberg in the United States and Günter Brus and Otto Mühl in Austria, began their careers as painters. Brus and Muehl were exponents of what was called the "Wiener Aktionismus" that involved acts of almost masochistic self-mutilation, as documented by the experimental filmmaker Kurt Kren. Two important video artists were to emerge from this movement, VALIE EXPORT and Peter Weibel. While Weibel, in his television performances, attempted to expand the performance space to another medium (see Belting and Weibel, 2005),[7] EXPORT, with whom Weibel frequently collaborated, sought to distance herself from the Actionists by

developing a provocatively feminist style. Happenings, with their hybrid and collage-like nature, relied on a whole array of different media and arts, and sought to actively involve the audience by means of improvisation, as pioneered by Allan Kaprow and Dick Higgins. In Europe, more precisely in Paris, it was apparently Wolf Vostell who organized the first "happening" (Eamon, 2009: 72). Vostell was known not only for covering or burying televisions in concrete, but also for occasionally destroying a TV screen with a rifle (Malsch, 1996: 23).

These beginnings gave way to four basic kinds of video practice: the use of video on stage; the live manipulation of video images by the video jockey; the documentation of performances/spectacles/events; and, the video performance in which the *dispositif* plays a crucial role. Today, using video on stage is a standard theater practice. It is possible to distinguish between two different forms: the live recording, and the screening of pre-produced material (the latter can be traced back to Erwin Piscator in the 1920s, though he used film material (Kaenel, 2007: 93)). Actors on stage may interact with such pre-produced images in fascinating ways, as was demonstrated by Pina Bausch in *Danzon* (1995). One of the pioneers of using live recording on stage was Wolf Vostell who in 1978 staged a Hamlet production where actors where given video cameras that could be controlled on 20 screens (Parfait, 2001: 172). Other artists/collectives working in this tradition include the Canadian Robert Lepage, Frank Castorf at the Berlin Volksbühne, and the Wooster Group in New York. Besides interacting with images, this tradition explores the possibilities of transmitting images from "spaces not visible to the audience" (Kaenel, 2007: 94), and of supplementing the total view of the audience with close-ups. The British director Katie Mitchell has gone furthest in using video on stage. For her production of Virginia Woolf's *The Waves* at the National Theatre in London in 2007, Mitchell, together with video artist Leo Warner, for the first time had an entire film produced live on stage.[8] At any point during the play the audience can choose to either watch the film on the screen above or follow what is happening on stage where actors, musicians, noise makers, and photographers, with the help of several props and working from lots arranged in parallel and consecutive rows, generate shots that are then edited live at a control desk. The technically inferior live recordings are not archived or used again once the performance is over.

Stage events such as Andy Warhol's road show *Exploding. Plastic. Inevitable*, on which he collaborated with Paul Morissey, his right hand, and with the band The Velvet Underground and the singer Nico in 1966-1967, quite consciously translated the performance idea into an audiovisual spectacle of light effects, projections, music/noise and dance (see Fig. 1.3 in color section). Warhol made live recordings of the performance. The real breakthrough, however,

came with the rise of electronic music towards the end of the 1970s, and especially of house music in the 1980s. The term video jockey was initially reserved for the presenters of video clips on MTV; soon, however, it was applied to the "directors" of video installations (some VJs like to think of themselves as filmmakers) whose live performances drew on found film and television footage as well as on pre-produced (occasionally also animated) material, while also interacting with the music and the feedback provided by the audience (Faulkner and D-Fuse, 2006).

The foremost action artist of the 1960s and 1970s in Germany was surely Joseph Beuys, who taught at the Düsseldorf Kunstakademie and whose performances were inspired by an encounter with Paik and Maciunas in 1962. As far as video is concerned, however, it proved to be a particularly popular medium with women artists who used it to showcase and explore public (clichéd) body images as well as their very personal ones. Carolee Schneemann was probably the most well-known American performance artist; on video, the most memorable work, however, was done by Joan Jonas during the 1970s, blending performance, dance and a playful engagement with the camera and its observing function (Spielmann, 2005: 146) in a way that made sense both as a live performance and as a subsequent installation and videotape (London, 1995: 16). One of the great performance artists of all time is surely Marina Abramovic, who for some years now has been engaged in an intense exploration of issues such as "reperformance" (2005, *Seven Easy Pieces* at the Solomon R. Guggenheim Museum in New York) and the documentation of her own performances. Some of her famous early work, which she created together with her long-time partner Ulay, was also partially documented on video, as in *Imponderabilia* (1977), where visitors to an exhibition were welcomed by the two artists in the nude and forced to pass the entrance by squeezing in between their naked bodies. Chris Burden used video to document a more extreme experience when he had an assistant shoot him in the arm in *Shoot* (1971) and Dennis Oppenheim recorded a somewhat less brutal case of self-harming in *Arm Scratch* (1970).

While these artists pursued a more or less documentary approach, there are others, especially in the 1970s, that display a more intense consciousness of the video *dispositif*'s specific potential, such as the possibility of controlling the recording in real time, of continuing the performance in the camera or during postproduction, and relying on close-ups as the ideal camera distance for contemporary screens. As far as women artists go (if one wishes to maintain this classification along gender lines), one may think of the above-mentioned Joan Jonas and her *Vertical Roll* (1972), or of *Raumsehen und Raumhören* (*Seeing Space and Hearing Space*) (1974) by VALIE EXPORT, who in this video seems to occupy different positions in space, accompanied by synthetic sounds of varying intensity, although it is actually a closed-circuit piece that was produced

during the performance. The impression of movement was created with the help of "four video cameras, six monitors and one vision mixer," while the artist in fact occupied the same position throughout the entire performance (Stoschek, 2006: 142). Then there is Ulrike Rosenbach, a master class student under Joseph Beuys, in whose most famous piece *Glauben Sie nicht, daß ich eine Amazone bin* (*Don't Believe I Am an Amazon*) (1975) the late-medieval portrait of Madonna of the Rose Bower and a video image of the artist posing as a female warrior shooting arrows at the painting are superimposed on each other, thus juxtaposing two anachronistic clichés of women.[9] One of the most productive male performance artists and a pioneer of the genre is Bruce Nauman. In *Lip Sync* (1969), a typical Nauman video, one sees a close-up of the artist repeating again and again, for an entire hour, the expression quoted in the title. The dryness of his mouth, the fatigue and tension of his facial muscles, induced by the near endless repetition of the same movement, are palpable, and its almost desperate materiality is further emphasized by the gradually shifting sound track.[10] Another prominent video performer of this period was Vito Acconci who, in his monologues and implicit dialogues, addresses the screen and the imaginary viewer behind it as if interacting with a mirror, while the camera remains perfectly still, as in *Centers* (1971), *Theme Song* (1973), or *Turn-On* (1974). His works thus simultaneously become a staged self-reflection and a critique of television.

The stage and the performative act are also relevant factors in video installations, as can be seen in the works by Tony Oursler, who combines video projections with theatrical props and decors (Rush, 2007: 121, and Haustein, 2003: 96). But even more fundamental to the history of video installation than the theatrical quality of its objects and their presentation is the behavior of the viewer which, in many cases, became inscribed in the art work's functionality and, going by the label of "interactivity," extends into the worlds of cyber space and contemporary game culture. Les Levine in Toronto and Martial Raysse in Paris were among the first to experiment with viewer participation, in 1966 and 1967 respectively (Parfait, 2001: 130). At an epoch-making exhibition in 1969 entitled *TV as a Creative Medium*, Gillette and Schneider, in *Wipe Cycle*, displayed several television sets on which slightly delayed live images of the gallery visitors were shown, occasionally interrupted by TV commercials (London, 1995: 14). For Peter Weibel's *Publikum als Exponat* (*Audience as an Exhibit*) (1969) at the Viennese exhibition *Multi Media 1*, visitors

> were interviewed and filmed with a video camera. These interviews were shown live on televisions in other parts of the gallery. Visitors could also ask to repeat the most recent tape or other tapes on another television so that a visitor could watch himself repeatedly.[11]

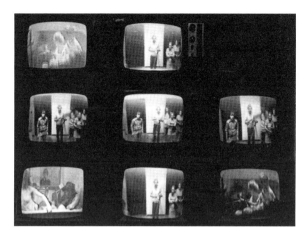

1.4
Frank Gilette and Ira
Schneider, *Wipe Cycle* (1969).
Courtesy Electronic Arts
Intermix (EAI), New York.

34 | In Germany, *Der magische Spiegel* (*The Magic Mirror*) (1970) by Telewissen –
Herbert Schumacher was the first performance in which the subject of recep-
tion was also the object of presentation; in this case, pedestrians in the city of
Darmstadt suddenly and inexplicably saw themselves on a refashioned televi-
sion set.[12] The 1970s saw further developments in this field when Peter Cam-
pus constructed 15 closed-circuit-installations (Rush, 2007: 85), among them
Double Vision (1971) and *Interface* (1972). In the latter installation, the visitor
stands in front of a wall of transparent glass; on it he sees, simultaneously, two
images of himself: one is his inverted mirror image, the other is recorded by a
camera behind the wall and screened onto it by a projector in front of the wall
(Kacunko, 2004: 96). By the end of the 1960s, VALIE EXPORT was also working
on what she explicitly termed "video installations" (Rush, 2007: 95) such as
Autohypnosis (1969/1973).[13] The video installation's interactive aspect, which
is crucial to all these works, neatly captures the fact that they are, to use Nelson
Goodman's concept, allographic versions of an idea or of a concept that can
never be exactly repeated and thus never be copied (Parfait, 2001: 137). Finally,
it is important to distinguish between footage that is screened on a monitor
and footage that is projected into a space or onto a carrier surface. It is also
often the case that real and slightly delayed live material is blended with stock
footage.

INSTALLATIONS AND PROJECTIONS

According to Dieter Daniels, Marcel Odenbach must be called a "pioneer of
the new format of the single-channel-video installation that has now become
common," where only one image source becomes visible (Daniels, 2011: 43).

Dachau (1974) by Beryl Korot on the other hand was, according to Margaret Morse (1991: 163), the first installation to experiment with displaying multi-channel video material on different monitors (four in this case).[14] The simultaneous coexistence of images in video installations can be used dynamically, as in *Win, Place, or Show* (1998) by Stan Douglas: two projection surfaces, tilted against each other, each show one half of a six-minute scene involving two people. The scene is screened as a loop but with varying combinations of the 2x10 camera positions so that it takes two years for a particular combination to repeat itself.[15] Eija-Liisa Ahtila also likes working with several projection surfaces on which different parts of a story are performed. This approach derives, of course, from a filmic device, the split-screen, and may be traced back to the film *Napoléon* (1927) by Abel Gance, which was designed as a triptych. On Ahtila's *If 6 was 9* (1995), Spielmann writes:

> The video work does not remove the splintering of the various perceptions of reality at all; on the contrary, subjective realities become consequently more complex, as processes are shown on the level of visual presentations, which display from very little to nothing in common with the auditively narrated "content" (Spielmann, 2008: 221).

As Mathilde Roman (2008) rightly observes, this type of installation not only defines the amount of time a viewer must spend on the artwork, it also requires him or her to actively engage the surrounding space, as is the case with sculpture.

Although video projectors only started appearing on the market around 1980, the first explorations into the creative possibilities of *film* projections in the form of overlapping images on several screens were carried out in the 1920s by the animation film pioneer Oskar Fischinger. In the 1960s, the name "expanded cinema" was coined to designate such shows, some of which involved further light and musical effects, while other variants were rather more ascetic and austere; the name can be traced back to Stan Vanderbeek and his *Movie-Drome*, a theater for multiple projections that was built in 1963.[16] Other important precursors included Malcolm Le Grice of the London Film Maker's Cooperative (LFMC), founded in 1966, as well as Robert Whitman who did much to modernize theater in New York by incorporating projections in his pieces (Eamon, 2009: 70; Parfait, 2001: 71). Edgar Reitz presented his experiment *VariaVision* at the International Transport Fair in Munich in 1965 (see Fig. 7.5) and described it thus:

> A large, dark, rectangular room. A total of 16 screens float above the viewers' heads, arranged in rows of four, so that every row includes two Cine-

mascope images and two normal-sized colour images. 16 corresponding film projectors sit on a structure of pipes and bridges in the ceiling. (...) A system of 24 groups of loudspeakers projects electronic music from beneath the ceiling. The performance has neither beginning nor end (Reitz, 1983: 33).

By contrast, Michael Snow's *Two Sides to Every Story* (1974) presents a more austere variant: images of a woman are projected on two sides of an aluminium screen hanging from the ceiling; the images were recorded from different angles so that the viewer must walk in circles to understand what is happening (Rush, 2007: 79). This two-sided projection is now also common in video art, as can be seen, for example, in *Rocking Chair* (2003) by David Claerbout. Here, too, a woman is depicted: viewed from the front, one sees her rocking in her chair on the veranda; walking around the image, one now observes her from behind as she pauses and turns, as if she had heard something (Newman, 2009: 97). This kind of arrangement can, in its basic form, be traced back to pre-cinematographic times when the diorama contained daytime and nighttime views in a single image that were made visible by turning the lighting on or off; similarly, the panorama displayed historical events (such as battles) in a closed circuit combining both paintings and objects.

This general interest in the possibilities of spatial arrangements often imperceptibly gives way to a concrete enthusiasm for architectural questions. Aernout Mik (see Hruska, 2009) is a case in point, as is Iñigo Manglano-Ovalle who, for *Le Baiser / The Kiss* (1999), traveled to Mies van der Rohe's Fransworth House in Plano, Illinois, to "paint" on its glass façade (Rush, 2007: 225, 178). Judith Barry likewise uses unusual materials such as glass windows and places such as the cupola of the Financial World Center in New York as projection surfaces for her installations. In some cases, capitalism even creates its own artworks: Times Square is a multimedia installation of which Antonio Muntadas only had to avail himself to make *This is Not an Advertisement* (1985). Since the year 2000, a 60-second-long video work is screened there once every hour as part of *The 59ᵗʰ Minute* project.[17] It was produced with the support of "Creative Time," a non-profit arts organization founded in 1974, which was also responsible for Doug Aitken's outdoor installation *Sleepwalkers* (2007) in which eight different image channels were projected around the Museum of Modern Art every night during one winter month.[18] For the opening ceremony of the 2006 World Cup in Frankfurt, Germany, Atiken's colleague Marie-Jo Lafontaine choreographed significantly larger amounts of light, visual, and audio material (*I Love the World, Skyarena* (2006)).

Such productions ultimately involve two extremes: the monumental/material, or the emphasis on form and the *dispositif* on the one hand, and, on

the other, the dissolution of every kind of audiovisual art into its ungraspable elements light and noise. It is certainly no coincidence that Lafontaine also created huge sculptures from monitors, using 27 for *Les larmes d'acier* (1987). Paik had only used 12 for his 1963 exhibition *Exposition of Music – Electronic Television*; these were arranged individually, while Gillette and Schneider did the exact opposite for what was perhaps the first "video wall" which they called *Wipe Cycle* (1971). In the 1970s, David Hall created works such as *7 TV Pieces* (1971) or – together with Tony Sinden – *101 TV Sets* (1972-1975). But the most famous sculpture in video art was, once again, created by Paik: "His *TV-Buddha* [1974] became so popular that he used this theme again and again in new compositions, rearranging, changing and reinterpreting it" (Haustein, 2003: 99-100). The early video sculptures in particular exuded an air of the "readymade," as if they had been moved from the living room straight into the gallery space where they represented nothing but themselves. This impression is due, of course, to the central and variable role that television occupied for a long time as an "animated" piece of furniture (Acconci, 1991: 128). This is reflected in a contemporary installation, *Küba* (2004) by Kutlug Ataman, where 40 old-fashioned television sets are scattered through a room, and the visitor wanders from one to the next and listens, one at a time, to the stories people tell of their life in the Istanbul shantytown slum of the same name.

In contrast, other artists experimented with the basic elements of cinema, above all Anthony McCall whose *Line Describing a Cone* (1973) has become legendary: A ray of light suddenly enters a dark room filled with mist; within this *dispositif*, it is capable of feigning three-dimensional shapes of every kind, of simulating their emergence and dissolution (see Fig. 1.5 in color section).[19] The special allure of this "ur-form" of every type of projection art derives from the way the audience is invited to participate. The virtual bodies of light and the real bodies of human flesh mutually fertilize and destroy one another. This kind of interaction is physical and confrontational in a way that is difficult to achieve in the ostensibly interactive media constellations of the digital age. These ideas were taken on and continued by Mary Lucier and Lis Rhodes. In *Paris Dawn Burn* (1977), Lucier exposed the light-sensitive parts of her video camera directly to the sun, while Rhodes, in *Light Reading* (1979), used light to "write" on a filmstrip. Finally, Al Robbins, in *Realities 1 to 10 in Electronic Prismings* (1984) designed simple feedback experiments such that the original recording vanished and only pure light remained (London, 1995: 17).

DISPOSITIF AND DECONSTRUCTION

Just as Paik's installation *TV Candle* (1975), where a burning candle was placed into the shell of a television set (Parfait, 2001: 141), had reduced these popular devices to their outer form and exposed them, as it were, as hollow boxes functioning as lanterns, the installation *Ming* (1999) by James Turrell aptly reflects a common concern of contemporary television reception, namely that it encourages a thoroughly passive mode of reception, while simultaneously exploring another, that of the "window to the world". The installation consists of a TV chair in which the viewer is invited to sit, as well as of a wall into which a rectangle is inserted, evoking the shape of a television image that exudes a moving, changing light without broadcasting an actual program (Parfait, 2001: 16). In its critique of television culture, the installation is similar to *Images from the Present Tense 1* (1971) by Douglas Davis who simply turned a television around so that it faced the wall (Parfait, 2001: 19). The ideology of television and its manipulative power were, during the first 20 years of the medium's existence, one of the main motivations behind video art, almost its *raison d'être*. Artists developed different strategies to combat this powerful ideology that assumed the role of both a model and a negative stereotype, such as interrupting and distorting the technical signals, promoting formal and institutional change from the inside, appropriating a broadcast's contents, as well as restaging and rewriting the medium's functions. Some examples of signal distortions were already mentioned above – Vostell's video decollages and the audiovisual experiments and performances by the Vasulkas. Nam June Paik's video work also belongs in this context in that it involved techniques such as distorting the television image by redirecting the flow of electrons with large magnets (Ross, 1986: 170).

In the United States, the late 1960s saw the formation of several groups, both on the East and West Coast, with names such as Videofreex, TVTV (Top Value Television), T.R. Uthco, Video Free America, Optic Nerve, People's Video Theater or Global Village, who availed themselves of the new portable video equipment to produce an alternative television that was itself media critical. They aimed to lift the barrier between sender and viewer, while not completely tearing it down (Boyle, 1991). Like so many initially dynamic counter-cultural movements, this was also absorbed by the establishment; its protagonists either changed fronts or their contents and methods were widely taken on and adapted. To some extent, they can be seen as predecessors of today's Internet pirates; like them, these groups had a penchant for martial rhetoric as evidenced by their war manual *Guerilla Television*, which was published in New York in 1971. Its author, Michael Shamberg, had founded the "Raindance Foundation" in 1969 together with Gilette and Schneider, a sort of counter-

cultural think tank that published one of the first video-art readers (Schneider, 1976). Then there was "Ant Farm," a group of visionary architects who, as concept artists, had bought their first Sony Portapak early on, in 1970, and in 1975 realized the video performance *Media Burn*, a mockumentary in the vein of a television report that broadcasted from a live event in which two men in a car tear through a wall of television sets (Mellencamp, 1988: 200).

Wolf Vostell's *Sun in Your Head* (1963) not only contained deliberately distorted television broadcasts, it also anticipated, by means of montage, the practice that was later to become known as "zapping" (Parfait, 2001: 23); furthermore, by recording this performance, he paved the way for a creative appropriation of television footage. David Hall's *TV Fighter (Cam Era Plane)* (1977) similarly anticipated a phenomenon that was only to develop several years later. Rather than distorting the television image, he superimposes a target on the footage he is filming which is clearly reminiscent of the first-person-shooter games that are popular today. Klaus vom Bruch is also relevant in this context, as "one of the few artist of the 1980s to devote himself exclusively and explicitly to the different formats of video art" (Schmidt, 2006: 167). In 1975 he founded, together with Marcel Odenbach and Ulrike Rosenbach, the Cologne-based Alternativ Television (ATV), where visitors were invited to watch performances and from where illegal broadcasts were transmitted into the neighborhood. In *Das Schleyer-Band I/II* (1977/1978), Vom Bruch created a collage of television material that critically reflected on the news coverage of the kidnapping and murder of Hanns Martin Schleyer, president of the German Federation of Employers, by the terrorist group The Red Army Fraction (RAF). In *Das Duracellband* (1980), Vom Bruch explored television's commercial logic as well as the relationship between weapons and optical instruments and mass media in a way that anticipated related arguments later made by Paul Virilio (1984). Dara Birnbaum, by contrast, dealt critically with the one-dimensional image of women in television, such as in *Technology/Transformation: Wonder Woman* (1976) or *Kiss the Girls: Make Them Cry* (1979). In the early 1980s George Barber became a leading figure of "Scratch,"[20] a movement of video artists that similarly pilfered material from the audiovisual jungle to re-edit it into three- to five-minute-long pieces that were set to the rhythm of a hip-hop sound track. With the publication of *The Greatest Hits of Scratch Video* in 1985,[21] Barber's considerable impact soon extended to the sphere of music video production and television advertising (Hayward: 1990, 134). The omnipresence of advertising was also highlighted in Daniel Pflumm's *Logos auf Schwarz* (1996), a sample of company emblems shown on television. Gabrielle Leidloff's *Moving Visual Object* (1997) by contrast explored what was the perhaps greatest media spectacle of the 20th century since the coronation of Elizabeth II (1953): Princess Diana's funeral.

The enlarged and blurred projection of the small television image renders the live broadcast of this cultural event strange and unfamiliar. By selectively choosing only a few digitized images, Leidloff puts the propagandistic and mythical language of mass media into critical perspective and shows that it has neither an objective nor a representative (Haustein, 2003: 105).

Alexander Lorenz similarly ridicules the informative value of the routine television flow in *Ich lehre euch* (*I Teach You*) (2008) by filtering individual words from the mouths of news anchors, guests in talk shows, game shows, and elsewhere, and rearranging them to produce the prologue of Friedrich Nietzsche's *Thus Spoke Zarathustra*.[22] Christoph Draeger's *Feel Lucky, Punk??!* (1998) on the other hand is something of a hybrid: the artist combines extracts from well-known films such as *Taxi Driver* (1976, Martin Scorsese) or *Pulp Fiction* (1994, Quentin Tarantino) as they were shown on television with imitations of the same sequences, this time performed by lay actors and set against the original soundtrack (Parfait, 2001: 300). "Reenactment" is a useful strategy to revitalize images whose popularity has reduced them to a merely ritual significance and whose original meaning has consequently been lost. The assassination of John F. Kennedy was perhaps the first media event where people could still remember years later exactly when and where they had first seen the television images. It seems safe to assume that every American had watched the Zapruder-film, the amateur footage of the events in the presidential car, at least once – or more likely several times – during the 1970s. This inspired two guerilla groups, Ant Farm and T.R. Uthco in *The Eternal Frame* (1975), to stage a haunting Cinéma-Vérité-style reenactment of the images that had become part of the national memory (Mellencamp, 1988: 214). A more recent example of such large-scale media events, of course, is 9/11. Herman Helle from the Dutch artist collective Hotel Modern produced a four-minute video about the attacks. With juice cartons functioning as skyscrapers and clay dolls as people, the video not only evokes the familiar television footage but also depicts what happened inside the building. The result, entitled *History of the World, Part 11* (2004), works equally well as a video clip because it is set to David Bowie's song *Heroes*.[23]

In *Confess All On Video. Don't Worry, You Will Be in Disguise. Intrigued? Call Gillian* (1994), the artist Gillian Wearing reenacted "TV confessions" made by guests in talk shows, having searched for and found suitable candidates by putting the advertisement quoted in the title in *Time Out*. In *Electronic Diary* (1984-1996), Lynn Hershman simultaneously satisfies and undermines television culture's superficial interest in people's private lives (see Spielmann, 2005: 212) by blending invented and real, relevant and trivial information in a

monologue and confiding it to the camera. Rather than reenacting recognizable television events or formats, an artist may also use the "language" of television. Thus Stan Douglas designed several *TV Spots* (1987) that relied on the typical devices of TV commercials and were later actually broadcast in such a context, yet they contained some deliberate mistakes (Parfait, 2001: 265). Then there are those tapes that focus not on content but on the way viewers behave, as in Richard Serra's *Television Delivers People* (1973), a compilation of catchy phrases conveying unpleasant truths about the popular mass-medium, or in William Wegman's work, who in the 1970s made videos of his Weimaraner dog to show how modes of reception are shaped by conditioning. *Reverse Television* (1984) by Bill Viola, where the viewer observes people watching television, also belongs in this context. The idea of showing not action but reaction goes back to Hitchcock's *Lifeboat* (1944) and has been a part of the canon of filmic language ever since. An explicit focus on the viewer of a performance, however, is also not entirely new; it can be found in *Par desmit minutem vecaks / 10 minutes older* (1978, Herz Frank) as well as in more recent works of video and film art such as *Teatro Amazonas* (1999) by Sharon Lockhart and *Shirin* (2008) by Abbas Kiarostami.

In March 1969, the Boston television station WGBH broadcast a program titled *The Medium is the Medium*. It was the first television show to have been co-created by artists, including, in this case, people such as Nam June Paik, Allan Kaprow, and Peter Campus. In Germany, Gerry Schum developed a similar idea in the late 1960s and founded the "Television Gallery" whose first program "Land Art" was broadcast in April 1969 by ARD, one of Germany's two public broadcasting stations. Other programs included Jan Dibbets' *TV as a Fireplace*; it was here that the idea of marking the end of transmission not with the station logo but instead with the picture of a fireplace or of railroad tracks (in reference to the "phantom rides" of Early Cinema) first took shape (see Fig.1.6 in color section). From 1970 onwards, Schum shifted his efforts towards building a video gallery in which he offered unlimited editions of tapes for sale, a somewhat daring endeavor, since at that time not only "the cultured people working in television did not regard the electronic medium as an independent and artistically self-contained medium worthy of promotion" (Herzogenrath, 2006: 25). One of the tapes produced prior to Schum's suicide in 1973 was Imi Knoebel's *Projektion X* (1972) in which the artist projected an x-shaped light ray onto houses he drove past during a nocturnal car ride through the city of Darmstadt. In 1971, David Hall's ten *TV Interruptions* were broadcast unannounced on Scottish television, thereby deliberately interrupting the usual program (Rees, 2009: 60), while the Belgian television station RTBF broadcast a program titled *Vidéographie* in 1975 (Parfait, 2001: 37). In France, there was Jean-Christoph Averty, an experimental television director responsible for transforming

French television into a true electronic laboratory during the 1960s and 1970s (Parfait, 2001: 33-34), allowing people such as Jean-Luc Godard (together with Anne-Marie Miéville) to explore the creative potential of television. This context was "a specifically French [one], (...) marked by the support of a national institution and the development of new technologies in an experimental direction" (Spielmann, 2008: 173ff). One must also mention institutions such as the Institut National de L'Audiovisuel (INA) where Robert Cahen produced some of his video works. While the broadcasting of art videos on television initially provided these artists with the rare opportunity to get paid for their products (see Daniels, 2011: 44, footnote 10), Chris Burden in 1973 began buying short slots of a few seconds each from a commercial broadcasting station to enable him to exhibit parts of his performance.

The introduction of videotapes in the 1970s paved the way for the creation of a plethora of private film archives; it also meant that viewers could interrupt and repeat screenings of films when watching them in their own homes. In the academic study of both film and art, structuralist-narrative analyses consequently became increasingly popular: the idea for his installation *24 Hour Psycho* (1993), a slowed-down 24-hour version of Hitchcock's film classic *Psycho* (1963), only occurred to the artist, Douglas Gordon, because his home VCR included a slow-motion function. Artists now had a more individualized access to audiovisual media which in turn improved their knowledge of film history and their willingness to use already-existing material in new contexts. According to Christa Blümlinger it was no coincidence that "Appropriation Art became pivotal to art theory in the 1980s" (2009: 15) and that video, according to Frederic Jameson, became the medium of postmodern capitalism (Jameson, 1991). What is specific to this genre is not simply re-employing old material (the found-footage film as something that is "ready-made" is, after all, as old as film history itself) but its creative repurposing by the artist. It is generally held that one of the key films in this context is *Rose Hobart* (1936) by Joseph Cornell. As far as video art is concerned, Peter Roehr's *Filmmontagen I-III* (1965), compiled from American feature films and commercials, is similarly relevant. They begin with the phrase "I change material by repeating it without changing it. The message is: the material's behavior in relation to the number of repetitions," because here, for maybe the first time, the idea of the loop is central to the creative idea. Since then, the video art world has seen an explosion of found-footage works whose material was excised from television programs (as described above) but also from feature films and documentaries. For *Hitchcock Trilogy: Vertigo, Psycho, Torn Curtain* (1987), the artist Rea Tajiri used standard photographs, newsreels and television shows and set them against scores by Bernard Hermann, thus in some sense anticipating the predilection for Alfred Hitchcock's films among artists in the 1990s (Rush,

2007: 173). These included not only the above-mentioned Douglas Gordon but also Christoph Girardet and Matthias Müller who in their *Phoenix Tapes* (1999) presented six thematically arranged sequences from 40 Hitchcock films which they edited from VHS carrier material (Blümlinger, 2009: 108). Raphaël Montañez Ortiz (*The Kiss*, 1984) and Martin Arnold (*Alone. Life Wastes Andy Hardy*, 1998) relied on black-and-white Hollywood films from the 1940s, using a

> scratching process [that] manipulates reversibility and variability in the forward and rewind speeds of the visual movement (by which the film's sound also seems scratched) and becomes a dissecting process revealing sexuality and structures of violence in apparently harmless film scenes (Spielmann, 2008: 181).

Marco Brambilla, by contrast, used explicit porno films for his three-channel installation *Sync* (2005) in which standardized sex shots are thrust onto the viewer in breathtakingly quick succession, thereby raising questions of over-exposure to a certain type of image and of the possibility of stimulation transmitted by audiovisual media (Rush, 2007: 238). Rearranging material from a single film, like in *Rose Hobart*, or from a single filmmaker such as Hitchcock, or, alternatively, collecting similar motifs from several different sources, represent two basic trends of the found-footage film. For *Title Withheld (Shoot)* (1999), the artist Kendell Geers visited video clubs to collect sequences from American films of people shooting (Parfait, 2001: 226), while Christian Marclay in *Telephone* (1995) focused on one particular object (Parfait, 2001: 304). Pierre Huyghe in *Remake* (1995) once again revisited Hitchcock, and specifically his film *Rear Window* (1954), albeit not by reusing it but opting instead for a strategy of imitation.

THEMATIC CONSTANTS

1. Body and Voice, Language and Writing

In Buster Keaton's films inanimate objects and actors were always treated the same. On the one hand this was due to the fact that one could generally not hear the actors speak and that Buster in particular always performed with a still, "objectified" face. On the other hand this promoted an intuitive physical empathy, whereby the outlandish events on screen were directly injected into the viewers' nerve cords. When Steve McQueen in his installation *Deadpan* reenacts a famous gag sequence from Keaton's film *Steamboat Bill, Jr.* (1928, Charles Reisner), in which the wall of a house topples over and falls onto him in

a way that he is spared because the only (window) gap in the wall neatly encloses his body, the artist translates this underlying idea of an immediate physical empathy into the medium of video installation, a medium that, because of its strongly integrative *dispositif*, is especially well suited for addressing all bodily senses through purely audiovisual means. Since the 1990s, extreme time loops have been a remarkably common device of large installations and projections, for example in the works of Bill Viola or Douglas Gordon. This trend in video art can be traced back to the aims underlying the performances of the 1970s, and one could even say that many actors in silent films as well as stuntmen are ultimately nothing other than performance artists. Like the above-mentioned Bruce Nauman and Chris Burdon, Bas Jan Ader was also interested in recording extreme bodily experiences – from falling off a roof to crossing the Atlantic in a 13-foot pocket cruiser which resulted in the artist's premature death – and in communicating intense physical experiences by audiovisual means. The fact that Georgina Starr in her video *Crying* (1993) produced a female remake of Ader's *I'm Too Sad to Tell You* (1970) testifies to his lasting influence on a later generation of artists (Newman, 2009: 104).[24]

The human voice is, on the one hand, an important tool that allows humans to communicate with each other; it is also, by virtue of its specific roughness or graininess (Barthes, 1981), something that endows every human being with an individual and recognizable feature. In this sense, the voice is a body (of sound) in itself,[25] whose effect is often completely at odds with the outward visual impression of a person. This phenomenon is especially obvious in dubbed feature films and forms the subject of Pierre Huyghe's videographical exploration *Dubbing* (1996). But video art's main interest is in the scream as the most extreme way of using one's voice. While screaming on the one hand amounts to a loss of the individual features of a voice, the organ's material power is simultaneously enhanced, thereby turning it into a weapon. For the screaming person, on the other hand, this implies a great deal of physical exertion; it thus provides relief while simultaneously leading to exhaustion. One of the first tapes to explore this motif was aptly titled *Rufen bis zur Erschöpfung* (*Shouting to the Point of Exhaustion*) (Jochen Gerz, 1972). Wojciech Bruszewski, a graduate of the National Film Academy in Lodz and cofounder of the "Workshop of the Film Form," where he experimented with video, in 1975 created the video work *Yyaa* by assembling material from different takes to create a continuous scream on 35 mm. Marina Abramovic, by contrast, screamed continuously and to the point of exhaustion, first by herself in *Freeing the Voice* (1976) and then together with, or against, Ulay, in *AAA-AAA* (1978). Nauman (*Sozio-Anthro*, 1992) and EXPORT (2008, *The Voice as Performance, Act and Body*) in their later work also explored the human voice as a bodily event. According to Haustein (2003: 131), Nauman's video reminds

one, "in its extreme, even invasive presence, of the kind of ritual recitations that can be observed in different 'primeval' cultures from antiquity to the present." Here, Shirin Neshat's *Turbulent* (1998) instantly comes to mind, where a veiled woman, sings not words but vocalizations (according to Newman (2009: 111)), while her body begins to oscillate and seems to enter an archaic state of being. Moreover, Haustein argues (2003: 81) that Shigeko Kubota was one of the first video artists to use "the camera for a serious exploration of the body" in her cycle *Duchampiana* (1972-1978). But the most famous artist to engage with this thematic is certainly Gary Hill who, along with Bill Viola and Tony Oursler as well as Dara Birnbaum and Dan Graham, is among the most influential American video installation artists (Eamon, 2009: 85; Rush, 2007: 118). In his biblical crucifix works *Crux* (1983-1987) or *Crossbow* (1999), the camera becomes a metaphor for the nails on the cross, and the monitors a burden to be borne by modern man. The method employed here of fastening cameras to different parts of the body and thus achieving a splintered mode of perception that pretends that man can see not only with his eyes, had already been tried by EXPORT in *Adjust Dislocations* (1973). Hill also experimented with loops of images of different body parts which he presented on monitors adjusted to their respective size (*Inasmuch As It Is Always Already Taking Place*, 1990). In his "switch piece" *Suspension of Disbelief (for Marine)* (1992) "the sequences of the images of a recumbent male body and a recumbent female one are 'written' both to the right and to the left, one after the other, shifted in time and merged" (Spielmann, 2008: 196). For Hill, the primary medium of reference is indeed

> language, against which he measures the processual possibilities of electronic writing, of combining and transforming elements, and of transcribing of imagery into text and voice (Spielmann, 2008: 192).

This interest in the relationship between language, writing and perception is manifest in works such as *Happenstance (Part One of Many Parts)* (1982-1983) and *Primarily Speaking* (1983), *Ura Aru* (1986) or *Remarks on Color* (1994). The latter is a recording of his daughter reading Wittgenstein aloud; occasionally she makes mistakes because she does not understand the text. The non-comprehension of a foreign language (rather than the non-comprehension of a complex and semantically challenging text) and its resulting transformation into either music or noise are the subject of Anri Sala's *Làkkat* (1994). The title signifies "one whose native tongue is different from the language of the place where he is" in Wolof, one of the official languages in Senegal (Newman, 2009: 115). The video is reminiscent of *Gespräch mit Sarkis / Talking* (1971) by Jochen Gerz who recorded a conversation with Zabunyan Sarkis in which Sarkis spoke

Turkish while Gerz spoke German, so that neither understood what the other was saying. Anticipating Peter Greenaway's film *Pillow Book* (1996), Mona Hatoum, in *Measures of Distance* (1988), relates naked skin (as parchment) to the handwritten text. The artist is seen taking a shower in her London apartment, onto which letters from her mother in Lebanon are superimposed and translated in turn into a voice-over spoken by Hatoum.

2. Ego-Identity and Sexuality

Examining videos from the 1970s, such as those by Vito Acconci in which the artist interacts with the camera as he would with a mirror, Rosalind Krauss, in an influential essay, concluded that video art was imbued with an aesthetics of narcissism (Krauss, 1987). Commenting on Lynda Benglis' tape *Now* (1973) where the artist stages a confrontation with herself in the form of recordings that were made at different times, Parfait (2001: 187) describes it as an expression of the "auto-eroticism of the *dispositif*." It is hardly surprising, then, that according to Raymond Bellour (1988), self-portraits as a genre are much more likely to be realized on video than film. Even Jonas Mekas, the godfather of the lifelong diary film and a decades-long media purist who, on his arrival in New York, began his oeuvre in 1949 with a Bolex, has long made the switch from film to video. In the early 1970s, such different artists as Otto Mühl (Parfait, 2001: 79) or Shigeko Kubota (Rush, 2007: 61) documented their life on video. Jean-Luc Godard portrayed himself in *JLG par JLG – autoportrait de décembre* (1995) and then re-used this footage in *Histoire(s) du cinéma* (1998) together with famous scenes from the history of film and other material from social and cultural history, a concept that resembled that of Chris Marker's *Immemory* (1997). While Sadie Benning in *Girl Power* (1992) introduced a teenage perspective that was less complex but more YouTube-compatible, Rebecca Bournigault in *Missed* (1999), where she filmed herself at the airport at six o'clock in the morning, compared her own presence to an empty space which is marked by the absence of the Other.

Even though Martial Raysse was the first preeminent artist to explore questions of identity with the help of his camera in his installation *Identité, maintenant vous êtes un Martial Raysse* (1967), it was primarily women who took up this theme during the following decade, using their bodies as creative objects to explore the difference between their sense of self and their perception by others, and thus constructing a new assertiveness as female artists but also very generally as human beings. As early as 1969 the club performer Katharina Sieverding, in her tape *Life-Death*, confronted the camera with a "provocative physicality" in a "performance of ambivalent sexuality" (Frieling,

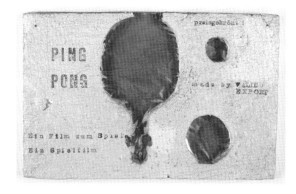

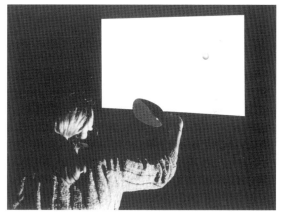

2006: 110). Two years later, Lynn Hershman invented *Roberta Breitmore*, the "first wholly artificial character" (Haustein, 2003: 84). The real female body, by contrast, is the central subject of Friederike Pezold's work. In *Die neue leibhaftige Zeichensprache* (1973-1977) (*The New Incarnate Sign Language*) Pezold, aka Pezoldo, uses close-ups to display her body's sexual characteristics, thus wholly robbing them of their erotic function. In contrast to this dissection of her own body, her installation *Madame Cucumatz* (1975) is a reconstruction of a female body from five monitors that the artist arranges on top of one another. The mirror as a narcissist object of self-contemplation but also of a distorted self-perception is just as present in Joan Jonas' work as the stylistic device of reflection. In *Disturbances* (1974), for example, the image of naked female divers in a lake becomes blurred and merges with the reflecting light on the water's surface. VALIE EXPORT's explorations were more haptic and drastic:

> In her famous *Tapp und Tastkino* (1968), the Expanded Cinema project *Ping Pong, Ein Film zum Spielen* (1968), the first interactive video instal-

lation *Autohypnose* (1973) or in the volume *Stille Sprache* (1973), Export indirectly questioned issues of of gender and sexuality, going so far as to put her own body on display. In *Wann ist der Mensch eine Frau?* [(*When Is Man a Woman?*) 1976, missing] she offers the viewer unlimited use of her body (Haustein, 2003: 82).

While EXPORT always challenged the medium's passive voyeurism by confronting it with an active exploration of the concrete body, the artist Hannah Wilke attempted an internal critique of the televisual image of women. In *Gestures* (1974), Wilke imitates the language of a commercial while simultaneously undermining it by repeating the same movements of her hand in an increasingly violent manner, culminating in an attempt to extinguish her own face (Rush, 2007: 111). Judith Barry in *Kaleidoscope* (1979) or Dara Birnbaum in *P.M. Magazine* (1982) attacked the female stereotypes perpetuated by the mass media, while Joan Braderman, in *Joan Does Dynasty* (1986), drew on the technique of Ulrike Rosenbach's *Glauben Sie nicht, daß ich eine Amazone bin* (1975) and superimposed her own image onto sequences from the popular series. Rosenbach, by contrast, introduced a further form of expression:

> *Tanz für eine Frau* [(*Dance for a Woman*), 1974] is clearly a piece on the issues of self-reflection, mirroring and narcissism, issues which not only video was initially identified with but which were also iconographically associated with a specifically female aesthetic. Not only interrupting but also reinterpreting narcissism can be considered a form of "creative feminism" – and thus it is not surprising that Ulrike Rosenbach founded precisely this "school of creative feminism" in the mid 1970s (Frieling, 2006: 148).

"Creative feminism" also aptly describes the somewhat humorous manner in which Martha Rosler, in *Semiotics of the Kitchen* (1975), presents, and operates within, a *dispositif* that must be described as having a specifically female connotation, at least from the traditional patriarchal perspective that is relevant here: For every letter of the alphabet, she presents a kitchen tool, first appearing humble and subdued, then assuming an aggressive and provocative manner. It seems reasonable to assume that Rosemarie Trockel's *Out of the Kitchen into the Fire* (1993) alludes to the title of Rosler's video. A woman is seen giving birth to an egg in slow motion; the egg is filled with black ink and bursts on the floor. The artist, who uses video as one form of expression among several others

impartially examines the clichéd images of pregnancy, birth, nursing or motherliness. By freeing these subjects from their "dark" negative connotations, she retrieves their legitimate sovereignty that cannot be reduced to emotions or kitsch (Haustein, 2003: 78).

Many tapes by Pipilotti Rist such as *Pickel Porno* (*Pimple Porno*) (1992) not only work as unconventional video clips but also as somewhat satirical variations on stylized sex clips that merge male and female desire. Another parody of the (male) pornographic gaze is Pierrick Sorin's *C'est mignon tout ça* (1993). Marcel Odenbach, on the other hand, asked the beauty queens of Caracas to impress a kiss on the camera lens:

> In his installation *Zu Schön um wahr zu sein* [*Too Beautiful to Be True*] he [then] enlarges the imprint made by their lipsticks, thus separating it from the body. By displaying the mouth in a brutal close-up, he destroys the illusion of perfect beauty. What remains is an image reminiscent of raw human flesh (Haustein, 2003: 88).

A consciousness of the growing familiarity with pornographic images of body parts and especially genitals and how these become detached from their context informs Zoe Leonard's *Ohne Titel* (*Untitled*) (1992). On display at documenta 9, it "show[ed] large close-ups of female genitals between high-ranking works of art history" (Haustein, 2003: 91). A tension between pornography and medical imagery not only informs practically every film used in sex education, but it also constitutes a subject of the feminist critique of science (see Cartwright, 1995). It thus seems apt that Mona Hatoum used the endoscopic camera to make *Corps Étranger* (1994) and *Deep Throat* (1996) (an allusion to the eponymous porn classic (1972, Gerard Damiano)) to juxtapose images of her outside with images of her inside. In Pipilotti Rist's *Mutaflor* (1996), a circular movement epitomizes the way bodily orifices that perform functions of food intake and excretion are re-designated for sexual practices, moving, in one continuous action, into the artist's mouth and out of her anus. Finally, while the voyeurism underlying every porn film was still conceptualized as uniquely male in Lorna Simpson's installation *31* (2002), where 31 monitors display the daily routine of a woman from getting up in the morning to going to bed at night (Rush, 2007: 149), this gaze is now being supplemented by a female one, perhaps indicating the self-confidence of a new generation. Thus in Tracey Moffatt's *Heaven* (1997) as well as in Katarzyna Kozyra's *Men's Bathhouse* (1999) men have replaced women as the object of secret observation.

3. Surveillance/Control

This introduces an additional aspect into our discussion of body images in video art. According to Harun Farocki, one of the first shots of film history, *La sortie des usines Lumière* (1895), is a predecessor of the images produced by contemporary surveillance cameras (Elsaesser, 2004: 238). Since then a number of films have explored the topics of surveillance and voyeurism, among them such prominent films as *Rear Window* (1954) by Alfred Hitchcock, *Peeping Tom* (1960) by Michael Powell, and *Krótki film o milosci / A Short Film About Love* (1988) by Krzysztof Kieslowski, with the telephoto lens of a camera, a film camera, and a pair of binoculars respectively functioning as instruments of surveillance. The *dispositif* at the center of Fritz Lang's *Die 1000 Augen des Doktor Mabuse* (1960), by contrast, is more complex and already marked by television's growing influence; while its depiction in Peter Weir's *The Truman Show* (1998) and in the television show *Big Brother* (since 1999) is the most forceful to date. In Michael Haneke's feature film *Caché* (2005), shot on HD, the technical setup is less complex, though its effect is just as threatening. In a manner reminiscent of David Lynch's *Lost Highway* (1997), a family receives VHS tapes from an anonymous source; these contain material that was recorded in the public by a hidden camera. The film thus alludes to a form of legal surveillance that residents of cities such as London are indeed subject to on a daily basis, and to which Google Earth has recently added a new dimension.[26] In a way, this development presents the ugly counterpart to the incorporation of art into life that was preached during the 1960s.

Nauman's exploration of this issue in *Live-Taped Video Corridor* (1970) remains unsurpassed to this day. Since then, it seems, no artist has been able to match how his installation brilliantly captured the complex relationship between the surveillance machine and its object. Nauman constructed a long corridor and placed a monitor at the far end and a camera at the entrance. The former displays the images recorded by the camera so that the viewer inevitably fails to catch more than the merest glimpse of himself. The closer he draws to the monitor, the smaller his image becomes. Nauman's *Going around the Corner Piece* (1970) was similar in its design. Here, Nauman installed a camera in one corner and a corresponding monitor in the other so that the viewer can never definitively see him or herself on screen. Peter Weibel, taking up this theme in *Beobachtung der Beobachtung: Unbestimmtheit* (*Observation of the Observation: Indeterminateness*) (1973), arranged three cameras and three monitors in a circle so that a person standing in the circle could only see him or herself from behind. The power of the gaze, the impotence of its object as well as the arguable veracity of instant video images were issues that the artist Dan Graham explored in great depth during the 1970s (Eamon, 2009: 83), such

1.8
Bruce Nauman, *Live-Taped Video Corridor* (1970).
Wallboard, video camera, two video monitors, videotape
player, and videotape, dimensions variable, approximately:
(ceiling height) x 384 x 20 inches ([ceiling height] x 975.4
x 50.8 cm). Solomon R. Guggenheim Museum, New York,
Panza Collection, Gift. © 2012 Bruce Nauman / Artists
Rights Society (ARS), New York.

as in his piece *Opposing Mirrors and Video Monitors with Time Delay* (1974). In
the 1980s the critique of the *dispositif* was continued in installations such as
Dieter Froese's *Not a Model for Big Brother's Spy-Cycle* (1987) and Julia Scher's
Security by Julia (1989-1990), but also expanded on through an exploration of
concrete surveillance images. Following in the footsteps of Robert Adrian,
who in his short tape *Surveillance Karlsplatz U-Bahn Station* (1979) exhibited
the surveillance of a station by the Viennese police, the artist Michael Klier in
Der Riese (1983) edited automatically recorded material from public and pri-
vate spaces in several German cities to produce a feature-length "dystopia of
a totalitarian surveillance state" (Kaschadt: 2006, 198). In the 1990s, the pros-
pect of such a dystopia seemed closer than it had before; this led Beat Streuli,
in *Allen Street, New York, 24th, 5* (1994) to opt for something ready-made and
show 45 minutes of the neighborhood mentioned in the title, while Renaud
August-Dormeuil, in *Surveillance du voisin d'en dessous* (1996) exposed the
disappointing and unspectacular nature of images produced in this context
(Parfait, 2001: 277 and 283 respectively). Pipilotti Rist, by contrast, highlights
the degrading effect surveillance can have. In *Closed Circuit* (2000), she placed
cameras in, and monitors in front of, lavatories in a New York gallery so that
visitors were forced to take notice of what they left behind. Disgusting as this
may seem, online pornography platforms contain a host of such amateur vid-
eo material, recorded clandestinely in changing rooms or public showers but
also in public restrooms, exactly as exhibited by Rist. Compared to this, vid-
eos such as *Zoom* by Marcus Kreiss or *Empire 24/7* by Wolfgang Staehle (both

1999) seem rather more innocuous in the way they quote classics of film history. Kreiss zoomed from the terrace of the MoMA in Manhattan onto offices on the other side, in an allusion to Hitchcock's *Rear Window*, while Staehle adapted the concept of Andy Warhol's seven-hour *Empire* (1964). This presence of tradition is also evident in Bruce Nauman's late work, especially in his installation *Mapping the Studio II with color shift, flip flop, & flip/flop (Fat Chance John Cage)* (2001) where the viewer beholds, on several screens, the artist's nocturnal absence in his studio and is instead made aware, especially on the level of sound, of the presence of moths, mice, and his cat (Newman, 2009: 98). Hannes Rickli, in his project *Aggregat Chemnitz: Die Überwachung der Überwachung* (*The Surveillance of Surveillance*, 2008), is interested neither in the general *dispositif* nor in concrete images of surveillance; rather, he had certain surveillance cameras observe each other over a prolonged period of time (Hediger and Rickli, 2008).

Video art, according to contemporary historiographical accounts, emblematically combines all fundamental elements of media art. This hypothesis, formulated at the outset of this essay, informs its preceding sections, which argue that an interest in the conditions governing the artwork's production and existence is a pivotal and thus unifying feature of this very heterogeneous genre. This interest implies a challenge to art's traditional functions, and, if carried to the extreme, it may even lead to their self-dissolution. Thus, for example, Paik – inevitably a protagonist in this context – scrutinized the cinematic *dispositif* in *Zen for Film* (1962-1964) where he ran unexposed film through a projector while performing minimal movements in its light beam. This piece – whether consciously or not – was inspired by Guy Debord's *Hurlements en faveur de Sade* (1952) (Eamon, 2009: 73) and thus inserts itself into a tradition of exploring the limits of representation where, in the audiovisual media, sound tends to survive the end of the image; for this reason Walter Ruttmann's audio film *Weekend* (1930) may also be included in this lineage. Derek Jarman, suffering from AIDS and slowly losing his eyesight, expressed his changing attitude to life with *Blue* (1993), an audio drama with a blue screen, while João César Monteiro staged the fairy tale of Snow White against the background of a black screen in *Branca de Neve* (2000). In *Die Distanz zwischen mir und meinen Verlusten* (*The Distance between Myself and My Losses*) (1983), the video artist Marcel Odenbach covered only a part (albeit a large one) of the material he appropriated with a black plane, thus showing that even a small portion of the original visual information can be sufficient to trigger the recognition of, for example, pornographic contents (Rush, 2007: 137; Parfait, 2001: 257). Mark Wallinger in *Via Dolorosa* (2002) pursued a similar approach when he placed a black square into the center of Franco Zefirelli's TV-mini-series

Jesus of Nazareth (1977) so that the actual images assumed the function of a frame enclosing everything that was not shown (Newman, 2009: 101). In this sense, the objects of media art can function like experimental designs that reduce and contextualize in unexpected ways, thereby deconstructing either themselves or their remediated contents.

| 53

NOTES

1 The audio element presents curators with a significant challenge: they can either decide to provide headphones or else live with the interferences produced by the display of several different objects in the same space.

2 This type of display existed even before the advent of video art, of course. The first apparatus to be invented for the purpose of viewing films, the Kinetoscope, used an infinite loop, and even some pre-cinematographic instruments relied on a circular arrangement of images.

3 Bolter and Gromala (2003: 24) have observed this to be the case in "digital art."

4 Paik also symbolizes a desideratum: historiographies of film and video art to this day focus on Europe and North America, where they were first developed, and only include artists from other continents if they worked in "the West."

5 Parfait also wonders why it did not become a medium of the civil rights movement (2001).

6 For all these reasons, according to Raymond Bellour, Alexandre Astruc's term *caméra stylo* actually applies to video more than film (Bellour, 1991: 421). In 1973, Douglas Davis compared the video camera to a pen with which he wanted to draw (Meigh-Andrews, 2006: 225).

7 Weibel currently serves as director of the Center for Art and Media Karlsruhe (ZKM).

8 "It was like looking at the shoot in a film studio and the final edit simultaneously" (Mitchell, 2008: 90).

9 We also find this technique of blending works of the old masters with contemporary images of the artist in Peter Weibel's *Das Theorem der Identität: Trinität* (1974), in Hermine Freed's *Art Herstory* (1974) as well as in VALIE EXPORT's feature film *Unsichtbare Gegner* (1977). The image of the arrow-shooting woman reappears in Fiona Tan's *Saint Sebastian* (2001).

10 Wojciech Bruszewsksi similarly plays with the (a)synchronicity of image and sound in his *Matchbox* (1975). Cf. Bordwell/Thompson (1994: 679).

11 http://www.peter-weibel.at/index.php?option=com_content&view=article&id=95&catid=5&Itemid=43&lang=de.

12 See http://www02.zkm.de/you/index.php?option=com_content&view=article&id=79%3Ader-magische-spiegel&catid=35%3Awerke&lang=en.

13 In the art scene, the term only became common towards the end of the 1970s (Rebentisch, 2003: 7).

14 The work can be viewed online: http://www.pbs.org/auschwitz/dachau/#.

15 See http://www.medienkunstnetz.de/works/win-place-or-show/.

16 Cf. the legendary book by Gene Youngblood (1970).

17 See also Elena Biserna's discussion of Max Neuhaus' sound installation *Times Square* (1977) in chapter 9 of this volume.

18 See http://www.moma.org/interactives/exhibitions/2007/aitken/.

19 See also Ariane Noël de Tilly's contribution to chapter 9 of this volume.

20 The term "scratch video" was coined by Pat Sweeney in 1985, inspired by a comparison with New York's hip hop scene (Barber, 1990: 116).

21 See http://luxonline.org.uk/artists/george_barber/the_greatest_hits_of_scratch_video.html.

22 See http://www.intervideo-nachwuchspreis.de/index.php/2009-08-26-14-09-48/36-animation-grafik/63-ich-lehre-euch-alexander-lorenz.html.

23 See http://www.hotelmodern.nl/flash_en/x_cinema/cinema.html.

24 *I'm Too Sad to Tell You* can be watched at http://www.basjanader.com/.

25 Garry Hill attempted to visualize it in *Soundings* (1979) and also in *Meditations* (1986).

26 Dietmar Kammerer (2008) brilliantly studies surveillance images in general, making special reference to the extreme example of London.

REFERENCES

Acconci, Vito. "Television, Furniture, and Sculpture. The Room with the American View." In *Illuminating Video. An Essential Guide to Video Art*, edited by Dough Hall and Sally Jo Fifer, 125-134. New York: Aperture, 1991.

Barber, George. "Scratch and After. Edit Suite Technology and the Determination of Style in Video Art." In *Culture Technology & Creativity in the Late Twentieth Century*, edited by Philip Hayward, 111-124. London: John Libbey 1990.

Barthes, Roland. *Le grain de la voix. Entretiens 1962-1980.* Paris, 1981.

Baumgärtel, Tilman. *net.art. Materialien zur Netzkunst.* Nuremberg: Verlag für moderne Kunst 1999.

Bellour, Raymond. "Video Writing." In *Illuminating Video. An essential Guide to Video Art*, edited by Dough Hall and Sally Jo Fifer, 421-443. New York: Aperture, 1991.

—. "Autoportraits." *Communications* 48 (1988), 327-387.

Belting, Hans, and Peter Weibel. "Les "Télé-actions." http://multitudes.samizdat.net/Peter-Weibel-Les-Tele-actions, 2005.

Blümlinger, Christa. *Kino aus zweiter Hand. Zur Ästhetik materieller Aneignung im Film und in der Medienkunst.* Berlin: Vorwerk 8, 2009.

Bolter, Jay David, and Richard Grusin. *Remediation. Understanding New Media.* Cambridge, MA and London: MIT Press, 2000.

—, and Diane Gromala. *Windows and Mirrors. Interaction Design, Digital Art, and the Myth of Transparency.* Cambridge, MA and London: MIT Press, 2003.

Bordwell, David, and Kristin Thompson. *Film History. An Introduction.* New York: McGraw-Hill, 1994.

Boyle, Deirdre. "A Brief History of American Documentary Video." In *Illuminating Video. An Essential Guide to Video Art,* edited by Dough Hall and Sally Jo Fifer, 51-69. New York: Aperture, 1991.

Cartwright, Lisa. *Screening the Body. Tracing Medicine's Visual Culture.* Minneapolis: University of Minnesota Press, 1995.

Daniels, Dieter. "Was war die Medienkunst? Ein Resümee und ein Ausblick." In *Was waren Medien?,* edited by Claus Pias, 57-80. Zurich: diaphanes, 2011.

Eamon, Christopher. "An Art of Temporality." In *Film and Video Art,* edited by Stuart Comer, 66-85. London: Tate, 2009.

Elsaesser, Thomas (ed.). *Harun Farocki. Working on the Sightlines.* Amsterdam: Amsterdam University Press, 2004.

Faulkner, Michael, and D-Fuse (eds.). *Audio-visual art + VJ culture.* London: Laurence King Publishing, 2006.

Frieling, Rudolf. "Life-Death." In *40jahrevideokunst.de. Digitales Erbe. Videokunst in Deutschland von 1963 bis heute,* edited by Rudolf Frieling and Wulf Herzogenrath, 110-115. Ostfildern: Hatje Cantz, 2006.

Groys, Boris. "Vom Bild zur Bilddatei – und zurück." In *40jahrevideokunst.de. Digitales Erbe. Videokunst in Deutschland von 1963 bis heute,* edited by Rudolf Frieling and Wulf Herzogenrath, 50-57. Ostfildern: Hatje Cantz, 2006.

Haustein, Lydia. *Videokunst.* Munich: Verlag C. H. Beck, 2003.

Hayward, Philip. "Industrial Light and Magic. Style, Technology and Special Effects in the Music Video and Music Television." In *Culture, Technology & Creativity in the Late Twentieth Century,* edited by Philip Hayward, 125-147. London: John Libbey, 1990.

Hediger, Vinzenz, and Hannes Rickli. "Infrastruktur beobachten. Über Gebrauchsfilm und Videokunst. Vinzenz Hediger im Gespräch mit Hannes Rickli." In *Quer Feld Über. Zur Topologie von Kunst,* edited by Volkmar Billig and Matthias Korn, 112-140. Nuremberg: Verlag für moderne Kunst Nürnberg, 2008.

Herzogenrath, Wulf. "Videokunst und die Institutionen. Die ersten 15 Jahre." In *40jahrevideokunst.de. Digitales Erbe. Videokunst in Deutschland von 1963 bis heute,* edited by Rudolf Frieling and Wulf Herzogenrath, 20-33. Ostfildern: Hatje Cantz, 2006.

Hruska, Libby (ed.). *Aernout Mik.* Catalogue of the eponymous exhibition, Museum of Modern Art, New York, 6 May-27 July 2009. New York: Museum of Modern Art, 2009.

Jameson, Frederic. *Postmodernism, or, The Cultural Logic of Late Capitalism.* London: Verso, 1991.

Kacunko, Slavko. *Closed Circuit Videoinstallationen. Ein Leitfaden zur Geschichte und Theorie der Medienkunst mit Bausteinen eines Künstlerlexikons.* Berlin: Logos, 2004.

Kaenel, Silvie von. "Was vermag Video auf dem Theater? Stefan Pucher – Matthias Hartmann – Frank Castorf." In *Theater im Kasten*, edited by Andreas Kotte, 91-160. Zurich: Chronos, 2007.

Kammerer, Dietmar. *Bilder der Überwachung.* Frankfurt: Suhrkamp, 2008.

Kaschadt, Katrin. "Der Riese." In *40jahrevideokunst.de. Digitales Erbe. Videokunst in Deutschland von 1963 bis heute*, edited by Rudolf Frieling and Wulf Herzogenrath, 20-33. Ostfildern: Hatje Cantz, 2006.

Krauss, Rosalind. "Video. The Aesthetics of Narcissism." In *Video Culture*, edited by John Hanradt. Rochester, NY: Gibbs Smith, 1987.

London, Barbara. *Video Spaces. Eight Installations.* New York: The Museum of Modern Art, 1995.

Malsch, Friedemann. "Video und Kunst – ein historischer Abriß." In *Künstler-Videos. Entwickung und Bedeutung. Die Sammlung der Videobänder des Kunsthauses Zürich*, edited by Ursula Perucchi-Petri, 17-42. Ostfildern: Hatje Cantz, 1996.

Meigh-Andrews, Chris. *A History of Video Art. The Development of Form and Function.* Oxford and New York: Berg, 2006.

Mellencamp, Patricia. "Video and the Counterculture." In *Global Television*, edited by Cynthia Schneider and Brian Wallis, 199-223. New York/Cambridge, MA: Wedge Press/MIT Press, 1988.

Mitchell, Katie. *The Director's Craft. A Handbook for the Theatre.* New York: Routledge, 2008.

Morse, Margaret. "Video Installation Art. The Body, the Image, and the Space-in-Between." In *Illuminating Video. An Essential Guide to Video Art*, edited by Dough Hall and Sally Jo Fifer, 153-167. New York: Aperture, 1991.

Newman, Michael. "Moving Image in the Gallery since the 1990s." In *Film and Video Art*, edited by Stuart Comer, 86-121. London: Tate, 2009.

Parfait, Françoise. *Vidéo. Un art contemporain.* Paris: Éditions du Regard 2001.

Paul, Christiane. *New Media in the White Cube and Beyond. Curatorial Models for Digital Art.* Berkeley: University of California Press, 2008.

Rebentisch, Juliane. *Ästhetik der Installation.* Frankfurt: Suhrkamp, 2003.

Rees, A.L. "Movements in Art 1941-79." In *Film and Video Art*, edited by Stuart Corner, 46-65. London: Tate, 2009.

Reitz, Edgar. *Liebe zum Kino. Utopien und Gedanken zum Autorenfilm, 1962-1983.* Cologne: Köln 78, 1983.

Roman, Mathilde. "L'art vidéo et la scène. 'Relation in space'." In *Qu'est-ce que l'art vidéo aujourd'hui?*, edited by Stéphanie Moisdon, 16-23. Boulogne: Beaux Arts Éditions, 2008.

Ross, David. "Truth or Consequences. American Television and Video Art." In: *Video Culture. A Critical Investigation*, edited by John Hanhardt, 169-170. Rochester: Studies Workshop Press, 1986.

Rush, Michael. *Video Art.* London: Thames & Hudson, 2007 (2003).

Schmidt, Sabine Maria. "Das Schleyer-Band I/II." In *40jahrevideokunst.de. Digitales Erbe. Videokunst in Deutschland von 1963 bis heute*, edited by Rudolf Frieling and Wulf Herzogenrath, 162-167. Ostfildern: Hatje Cantz, 2006.

Schneider, Ira (ed.). *Video Art. An Anthology*. New York: Harcourt Brace Jovanovich, 1976.

Spielmann, Yvonne. *Video. The Reflexive Medium*. Translated from the original German, with a slightly expanded introduction for the English edition, by Anja Welle and Stan Jones. Cambridge, MA: MIT Press, 2008.

—. *Video. Das reflexive Medium.* Frankfurt: Suhrkamp, 2005.

Stoschek, Jeannette. "Raumsehen und Raumhören." In *40jahrevideokunst.de. Digitales Erbe. Videokunst in Deutschland von 1963 bis heute*, edited by Rudolf Frieling and Wulf Herzogenrath, 140-145. Ostfildern: Hatje Cantz, 2006.

Tribe, Mark, and Reena Jana. *New Media Art*. Cologne: Taschen, 2006.

Virilio, Paul. *Guerre et cinéma I. Logistique de la perception*. Paris: Éditions de l'étoile 1984.

Youngblood, Gene, *Expanded Cinema*. New York: Dutton, 1970.

Media Archaeology: Where Film History, Media Art, and New Media (Can) Meet[1]

Wanda Strauven

INTRODUCTION: MADMAN OR BUSINESSMAN?

For a long time, talking to oneself on the street or in any other public place was considered abnormal, deviant from the expected social norm. Singing on your own was okay, but talking on your own, without having any interlocutor, was simply weird. When taken unawares by a fellow citizen in such an odd situation, a possible and often-spontaneous reaction (which I have indeed caught myself in several times) was to quickly shift from talking to singing, as if to imply: don't worry, I was not talking to myself, I was just singing. Today people talk, or even shout, to themselves all the time on the street – while walking, cycling, or driving their car – often making great gestures to accompany their words. It has become an accepted social behavior because of the existence (and our knowledge of the existence) of the hands-free mobile phone. We know that these people who seem to be talking or shouting to themselves might have an (invisible, distant) interlocutor.

In a memorial piece on 9/11 written a year after the tragic attacks on the WTC Towers in Manhattan, Thomas Elsaesser narrates how this specific change in (acceptance of) human behavior blurs the distinction between a crazy vagabond and a busy entrepreneur. When he encounters two such men on Rembrandt Square in Amsterdam – both gesturing and talking to themselves, the former out of despair, the latter in the midst of a conference call – Elsaesser comes to the conclusion that the businessman's phone with its hands-free device has made the behavior of the homeless man normal. In other words, new media do have an impact on our notion of (social) "normality" (2003: 120).

This striking – and, in Elsaesser's own words, "comical and even heartless" – comparison made me think, in a somewhat twisted way, of Michel Fou-

cault's archaeology of knowledge as first explored in his PhD dissertation on the history of madness, *Madness and Civilization. A History of Insanity in the Age of Reason* (1965, originally published in French in 1961). Instead of asking who is normal/abnormal as in the "comical" scene above, Foucault tries to capture madness as an object of knowledge through time, or rather how madness, as an object of knowledge, is constituted differently in different times, in order to understand the conditions of (and reasons for) exclusion of mad people.

If mad people were sent away with the ship of fools in the Middle Ages, it was because they were regarded as dangerous for society; madness was believed to be contagious, comparable to leprosy. During the Renaissance, however, the fools were accepted again in society because they were seen as privileged beings in that they were (too) close to God. The 17th century is the period of the "Great Confinement," when the insane were considered unreasonable and were locked away and institutionalized. In the 18th century, fools were, because of their lack of reason, considered to be animals and were therefore treated as such. With the rise of Romanticism, the fascination for mad people returned, this time not because of their proximity to God, but because of their closeness to nature and their rebellion against society and civilization; the fool was regarded as a hero. Finally, in the 19th century, society considered fools to be mentally ill people who needed to be cured, which led to the modern (and still reigning) episteme.

As José Barchilon observes in the introduction to *Madness and Civilization*: "Rather than to review historically the concept of madness, [Foucault] has chosen to recreate, mostly from original documents, mental illness, folly, and unreason as they must have existed in their time, place, and proper social perspective. In a sense, he has tried to re-create the negative part of the concept, that which has disappeared under the retroactive influence of present-day ideas and the passage of time" (Foucault, 1988: v). In other words, in order to constitute "madness" as an object of knowledge, one should not only ask the question "what is madness?" but also "when is madness?"; that is, study "madness" in its historical context, in its radically different discursive formations that succeed one another through time. This is the beginning of Foucault's intellectual excavation of the human sciences, which he explores further in *The Order of Things: An Archaeology of the Human Sciences* (1970, originally published in French in 1961), followed by *The Archaeology of Knowledge* (1972, originally published in French in 1969).

NEW FILM HISTORY'S TRIPLE AGENDA

Like "madness" as an object of knowledge changes over time, so do the media. Exemplary in this respect is the history of cinema. During the 20th century, each decennium seems to have "produced" its own form or definition of cinema. As we know, the cinema around 1900 differed radically from the cinema in the 1950s or the cinema of today, not only on a textual level (what kind of films are we watching), but also on the levels of the basic apparatus (different cameras used to produce the films) and the *dispositif* or viewing situation (from the fairground to the drive-in, from the multiplexes to our mobile phone). Thus, in order to define the cinema, we should not only ask the Bazinian question ("what is cinema?"), but also the temporal/historical one ("when is cinema?"). As Elsaesser observes, we should try to "identify the conditions of possibility of cinema ... alongside its ontology," since the cinema is still to be invented, or rather: it is reinvented all the time (2004: 103).

Recently, Malte Hagener has added the locative question ("where is cinema?"), pointing out the apparent impossibility to grasp the cinema of today as an object of knowledge and therefore to locate it, not only metaphorically but also very physically. Cinema has become too instable, too fluid, and too malleable. Its locations are multiple: Internet, DVDs, WiFi, mobile phone, gallery spaces, museums, arcades, YouTube, etc. Hagener observes: "Cinema is in fact ubiquitous, it is everywhere and nowhere at the same time" (2008: 16). Cinema's ubiquity is linked by Hagener to the Deleuzian concept of immanence, to the idea that our perception and our thinking have become cinematic, that the cinema is part of us. Elsaesser, who is not quoted by Hagener in this respect, conceives of this cinematic ubiquity as a return to ontology, or ontologization of the cinema, a project that aims to define cinema no longer in its medium specificity, but as an experience, as a "particular way of being-in-the-world" (Unpublished paper). Ideally, this should lead to the combination of the *what*, the *when*, and the *where*.

Already in the 1980s these three questions were addressed, albeit separately, by the Early Cinema movement set in motion by the 1978 FIAF conference, which took place in Brighton, UK.[2] Part of this legendary conference was the symposium "Cinema 1900-1906" which was prepared by an archival project known as the Brighton Project, which consisted in looking afresh at all surviving examples of pre-1906 cinema (preserved in some fifteen FIAF archives and surpassing the amount of 550 films). This screening, which literally opened the eyes of a new generation of film scholars (among whom Tom Gunning, Charles Musser, and André Gaudreault), signaled the beginning of the New Film History. Whereas this moment is often defined as the "historical turn" of cinema studies, I would like to highlight the triple agenda of these early cin-

ema scholars that, to a certain extent, reflects the three questions discussed above and that has become essential for the emergence of media archaeology: attention for the otherness of the early cinema ("what"), discovery of the multiple origins of early cinema ("when"), and the study of its contextual material ("where").

The Brighton Project led to the discovery of early cinema as an "other" cinema, that is, *not* as an immature form of narrative cinema, or as a preparation of classical cinema, but as a cinema with its own intrinsic values or tropes, such as frontality, acknowledgement of the camera's presence, overlapping editing or repetition of the key action, etc. From the desire (or necessity) to mark the distinction between early cinema and narrative cinema, a terminological debate emerged with, for instance, Noël Burch opposing the "primitive mode of representation" to the "institutional mode of representation" and André Gaudreault and Tom Gunning proposing the opposition between the "system of monstrative attractions" and the "system of narrative integration" (Burch, 1984; Gaudreault and Gunning, 1989).

Important to stress here is that the ontological agenda of early cinema scholars implies a rupture (or epistemic break) between early cinema and narrative cinema. At the same time this means a questioning of the rupture between "pre-cinema" (pre-1895) and "cinema" (post-1895) as canonized by traditional film history, since for many reasons early cinema belongs to what is called pre-cinema rather than to cinema. In other words, the "what" question inevitably has consequences for the "when" question: when does early cinema start and when does it end? Along with issues of periodization, there is also the "historical doubt about the origins of cinema" (Hagener, 2008: 16) and the discovery of so many forgotten pioneers which led to the dismantlement of the myth of the "firsts." The 19th century proved to be very fertile for film historians and film archaeologists alike.[3] More recently, as we will see below, this search into time or academic time traveling has been pushed into "deep time" by someone like Siegfried Zielinski.

With the Brighton Project kicking off New Film History, the otherness of early cinema was initially studied from a formal or aesthetical point of view. Very rapidly, however, this early cinema movement shifted from textual analysis to a (quantitative) non-text approach. As Ian Christie observed: "... crucially, what began as a movement to study these [pre-1906] films empirically – to look at them as archaeological objects – soon became an exploration of their context – of production, circulation and reception – and thus necessarily a study of what *no longer existed* – namely the vast bulk of these film texts and their places and modes of screening" (2006: 66). This contextual strand of New Film History should be seen in relation to the movement of New Historicism, which developed in the 1980s in the field of literary studies and which was grounded

in contextual analysis and the study of non-literary texts. Likewise, the aim of New Film History became the study of non-filmic texts, of contextual material, of socio-economical data, etc. (Allen and Gomery, 1985; Maltby, 2006). A new discipline emerged: *cinema history*, that is, the history of cinema as institution, as exhibition practice, as social space (as opposed to *film history*, which is, generally speaking, a history of masters and masterpieces).

Even if originally not limited to early cinema studies, New Film History soon became more or less synonymous with it (Elsaesser, 1986). Today it is still a valuable and applicable model not only for the study of early cinema but also for other periods in film history and not only for film but also for other forms of media (see Strauven 2006). Furthermore, it inspired (early) film scholars to question the dominance of the visual in film studies, and explore untouched or underexplored domains, such as the sound(s) of early cinema (see among others: Altman, 2004; Lastra, 2000; Wedel, 2004) and the sense of touch in relation to early and pre-cinematic screen practices (see among others: Strauven, 2011; Wedel. 2009). New Film History's relevance lies precisely in its (pioneering) media-archaeological approaches, which range from questioning what is taken for granted or accepted as "truth" to digging up forgotten pioneers, unimportant films and other neglected material or dimensions. Most significant, undoubtedly, has been New Film History's contribution to historical methodology, by challenging or even severely criticizing the methods of traditional historiography such as chronology, genealogy, and especially teleology. Or, more generally, it profoundly changed the attitude of the (media) historian, who should always study the past with genuine wonder: this is the principle of media archaeology as a "hermeneutics of astonishment," as Elsaesser, paraphrasing Gunning, has phrased it (2004: 113).

MEDIA ARCHAEOLOGIES, OR THE THREE BRANCHES OF MEDIA ARCHAEOLOGY

The main question remains, however, whether media archaeology is indeed (merely) a methodology. Interestingly enough, the various practitioners of the field – those who call themselves media archaeologists – do not agree upon what to call media archaeology: is it an approach, a model, a project, an exercise, a perspective, or a discipline? Is media archaeology a subdiscipline in media studies (to be distinguished from media archaeology as subdiscipline in archaeology) or is it rather a "nomadic enterprise," as Jussi Parikka has defined it, and therefore a "traveling concept" (following Mieke Bal), which crosses various disciplines (Hertz and Parikka, 2010: 5)? According to Parikka, media archaeology should be seen as a hybrid discipline, which results in interdisciplinary work. Can media archaeology then still be defined as a school

with its proper set of tools, methods, etc.? As we will see below, there are different methodological schools. But even beyond (or next to) the methodological issue there is the very basic tension between practice and theory: whereas some media archaeologists like Siegfried Zielinski consider it as a very practical activity (comparable with the fieldwork of "real" archaeologists), for others like Thomas Elsaesser, it is rather a metaphor or a conceptual model.

Before discussing these various differences in methodology, it is important to point out that media archaeology made its way into at least three distinct fields (within the larger field of media studies), which I propose here to call the three "branches" of media archaeology: 1) film history/media history, 2) media art, and 3) new media theory. These three branches are historically grown layers, successive phases that continue to coexist over time.[4] For a proper "archaeology" of media archaeology, one could evoke several attempts of alternative historiographies undertaken in the first half of the 20th century (for instance by Walter Benjamin in his unfinished *Arcades Project* and by Dolf Sternberger in his *Panorama of the Nineteenth Century*) (Huhtamo and Parikka, 2011: 6-7). My overview aims at mapping the nascent field and will therefore be limited to the last three decades, since the emergence of media archaeology until its (still ongoing) development as a self-proclaimed discipline, with its own set of problems, body of methods, etc.

In the 1980s, media archaeology emerged, as already sketched above, as part of cinema studies, more specifically *early* cinema studies. Even if, in those years, the early cinema movement did not consciously embrace (or promote) a media-archaeological approach, it is worthy to remember that Thomas Elsaesser, who also coined the term "New Film History," used the term "Media Archaeology" in the title of his introduction to *Early Cinema: Space Frame Narrative*. This volume, published in 1990, wanted to reflect on the legacy of the 1978 FIAF conference and stressed the importance of a "systematic account of early cinema" as precondition for a "cultural archaeology of the new medium" (Elsaesser, 1990: 1). Other pioneering publications to be mentioned here are Jacques Perriault's *Mémoires de l'ombre et du son: Une archéologie de l'audiovisuel* (1981) and Laurent Mannoni's *Le grand art de la lumière et de l'ombre: Archéologie du cinéma* (1994).[5]

Since the 1990s, the first branch of media archaeology developed in broader terms as media history. On the one hand, this development led to excavations of hidden, forgotten, and imaginary media, as for instance in Bruce Sterling's Dead Media Project founded in 1996 and the symposium "An Archaeology of Imaginary Media" organized by Eric Kluitenberg at De Balie, Amsterdam, in February 2004. On the other hand, media archaeology became synonymous with (historical) reading against the grain, a tendency that is most obvious in Zielinski's anarchic form of archaeology or "anarchaeology" which wants

"to escape monopolisation by the predominant media discourse" (1999: 9). Such an enterprise, still somewhat implicit in Zielinski's *Audiovisions: Cinema and Television as Entr'actes in History* (1999, originally published in German in 1989), resulted in the extraordinary time-traveling *Deep Time of the Media. Towards an Archaeology of Hearing and Seeing by Technical Means* (2006, originally published in German in 2002), wherein he discovers the unknown or little studied work of other against-the-grain media thinkers, such as Empedocles (6th-5th centuries BC), Giovan Battista della Porta (16th century), Athanasius Kircher (17th century), Johann Wilhelm Ritter (late 18th century), Cesare Lombroso (19th century), and Aleksej Kapitanovich Gatev (20th century), to name just some key figures of *Deep Time*.

Zielinski's work permits one to make a bridge between the first and the second branch of media archaeology in that his historical quest seems to be driven by his admiration for radical contemporary media artists, "those among the avant-garde of electronics in whose heads and hands the new techniques do not become independent ends in themselves, but are constantly irritated and reflected upon: artists like Valie Export, David Larcher, Nam June Paik, Steina and Woody Vasulka, or Peter Weibel" (1999: 22). Yet it has been especially the Finnish scholar Erkki Huhtamo who put on the map the second branch of media archaeology, turning his attention to a slightly different group of media artists. In his essay "Resurrecting the Technological Past. An Introduction to the Archeology of Media Art," Huhtamo discusses the artworks of Paul De Marinis, Ken Feingold, Lynn Hershman, Perry Hoberman, Michael Naimark, Catherine Richards, and Jill Scott, among others, as examples of a media-archaeological practice consisting in "incorporat[ing] explicit references to old analogue and mechanical machines" (1995). According to Huhtamo this media-archaeological tendency in the arts world has become manifest since the 1990s, but it was already announced during the 1980s by the work of media artists such as Jeffrey Shaw and Toshio Iwai. There are various ways in which media-archaeologically inclined artists (or "artist-archaeologists") engage with the technological past, ranging from explicit remakes of old apparatuses to more subtle displacements or hybrid constructions of past and present. As example of the latter, Huhtamo cites, for instance, Paul DeMarinis's *The Edison Effect* (1989-1993) that brings together three different ages of sound technologies (mechanical, electronic, and digital), combining an Edison phonograph with vinyl discs and laser beams. To illustrate the more straightforward strategy of the remake, Huhtamo mentions Catherine Richards's interactive installation *The Virtual Body* (1993) which can be classified as a "peep-show machine" (Huhtamo, 1995). Another nice example of an explicit remake that comes to mind in this context is Julien Maire's high-tech update of the old-fashioned (and obsolete) slide projector, which he construct-

ed for the installation *Demi-Pas* (*Half Step*, 2002). Typical of Maire's work is the creation of highly original (and technically complex) prototypes by which he engages not only with technology's past but also with its future(s). This artistic time traveling often takes the form of a performance that partly reveals, partly mystifies the operation of the prototypes to an audience of "astonished" museum visitors – a new art form that Edwin Carels has proposed to call "cinema of contraptions" (2012).

If artist-archaeologists seem to share the common goal of "resurrecting the technological past" (which is also, at least partly, shared by scholars who are media-archaeologically inclined), this does not necessarily mean, as Huhtamo points out, that their work explicitly evokes the "old tech," but instead it might use "a contemporary technology as both the terrain and the tool for media archaeological excavation" (Huhtamo, 1995). Such a strategy of (historical) displacement becomes even clearer – as Garnet Hertz and Jussi Parikka discuss in their *CTheory* interview on the "archaeologies of media art" – in the more recent strand of media-archaeological art that "relates to hardware hacking, circuit bending and literally opening up media technologies to reveal the complex wirings through which the time-critical processes of contemporary culture function" (2010: 8). Especially interesting in this respect is the electronic do-it-yourself (DIY) practice of circuit bending, which consists in dismantling, unwiring, and rewiring electronic devices (from battery-powered children's toys to MP3 players) in order to create new (musical) instruments. Such a DIY movement not only relates to historical practices of reuse, in particular the Cubist collage and the Dadaist ready-made, but also and especially counters the high-tech industry of Silicon Valley (with its planned obsolescence) (Hertz and Parikka, 2012). Furthermore, it points to a fundamental difference between scholarly and artistic work, which Hertz and Parikka discuss in terms of layers: while the textual medium is still rather limited to linearity (and therefore narrativity), the artistic (DIY) approach allows more directly for an excavation into multiple layers, turning media archaeology into a real activity, something that "needs to be executed, not constructed as a narrative" (2010: 8).

The idea of media archaeology as a concrete activity, as a material engagement with (technological) devices or apparatuses, is key to understanding how this originally historical enterprise has become attractive to new media studies. Since the beginning of the 21st century, we see that several scholars have started to adopt media archaeology as a method for a (literal, physical) excavation into contemporary media. What is at stake in these projects is not only the questioning of the newness of new media, but also and especially the "exploration of the potentialities of media," or more generally the "dis- and replacement of the concept of media" (Hertz and Parikka, 2010: 6). This

third branch of media archaeology is expanding itself in different new fields of analysis, such as software studies (Fuller, 2008), (digital) media ecology, which includes studies on issues such as "materialist energies" (Fuller, 2005), digital waste (Sterne, 207), and computer viruses (Parikka, 2007); and – last but not least – Wolfgang Ernst's take on media archaeology called "operative diagrammatics," which promotes a non-representational approach, using the (Peircian) diagram as its epistemological tool. By opposing the notion of mapping to the "media-archaeological idea of the diagram," Ernst clearly favors the latter as it is "conceptual rather than visual, topological rather than geographical, non-narrative (data-based) rather than narrative, connective rather than spatial, concerned with code (software) rather than images, numbers rather than sensual perception"; and, therefore, he proposes to "redeem the notion of 'mapping' from the cartographic metaphor and instead remathematize it" (2005: 6).

In an interview with Geert Lovink, Ernst explains the mathematical dimension of media archaeology in relation to the archival numerability: "Media archaeology describes the non-discursive practices specified in the elements of the techno-cultural archive. Media archaeology is confronted with Cartesian objects, which are mathematizable things, and let us not forget that Alan Turing conceived the computer in 1937 basically as a machine paper (the most classical archival carrier)" (Lovink, 2003). Ernst's approach is a good example of material(ist) media archaeology, which focuses on the operative level of the media, that is, the processuality. Rather than a historical project, "operative diagrammatics" is about "creating such situations where you get into contact with media in [their] radical operability and temporality" (Parikka, 2009). According to Parikka, such a take on media archaeology is "a-historical, even unhistorical perhaps" (2009). However, in a previous phase of his career, Ernst carried out a truly Foucauldian project, "an archaeology of the technological conditions of the sayable and thinkable in culture," which did not exclude excavation into ancient Greece and its rhetorical techniques (Lovink, 2003; Ernst, 2000). As we will see below, Ernst can be counted among the most Foucauldian media archaeologists.

RETHINKING TEMPORALITIES

As diverse as these three branches of media archaeology might seem, their agendas share at least four important aspects. Firstly, there is the crucial relation between history and theory. The historical dimension is also present in the third branch, most explicitly when the newness of new media is questioned and more subtly when their potentialities are at stake. In media archaeological

terms, history is the study not only of the past, but also of the (potential) present and the possible futures. A second common ground of the three branches is the vital connection between research and art, between researchers and artists. While this interrelation is most obvious in the second branch, it should be remembered that at the very origins of New Film History there was the (re)discovery of early cinema by avant-garde filmmakers such as Ken Jacobs, Stan Brakhage, and Noël Burch, and documentary film editor Dai Vaughan. For the new media branch, media archaeology seems to have become essential to methods of design, which is the area *par excellence* where research and art meet. Here we should mention again Garnet Hertz, who is a faculty member of the Media Design Program at the Art Center College of Design in Pasadena, California and who is developing a theory of DIY. A third aspect I would like to briefly underline is the central role played by the archive, ranging from the FIAF film archives (Brighton project) to the archives as "cybernetic entities" in

the digital age, as defined by Wolfgang Ernst (Lovink, 2003).[6] Lastly, and most importantly, what the three branches of media archaeology have in common is a rethinking of temporalities. This brings me back, finally, to the methodological issue upon which I touched in the first part of this chapter. Since the way these temporalities are rethought differs, often to a great extent, from school to school.

Indeed, media archaeology, rather than being one school, consists of various schools, not only in terms of (trans)national borders,[7] but also and especially in terms of methodology. To simplify the rather complex picture of a discipline that is still in formation, I identify four dominant approaches for the media-archaeological project of rethinking temporalities; it concerns four different, sometimes opposite approaches adopted by key figures of the field, which consist in seeking: 1) the old in the new; 2) the new in the old; 3) recurring *topoi*; or 4) ruptures and discontinuities. In the remainder of this chapter, I will briefly discuss these four approaches, by highlighting, where possible and relevant, the connection with Foucault's work, in particular his "archaeology of knowledge." As we know, Foucault himself did not include the (audiovisual) media in his archaeological approach. One could say that media archaeology starts where Foucault's analyses end. But then, as Friedrich Kittler reminds us, "writing itself, before it ends up in the libraries, is a communication medium, the technology of which the archaeologist simply forgot" (1999: 5). Therefore, Kittler's technologically determined media history could be considered anti-Foucauldian, even if Kittler is also often seen as the spiritual father of media archaeology, precisely for this very same reason. Kittler's influence can especially be felt in media-archaeological studies that stress the materiality of the media, and somehow crosses the four approaches that I will now discuss separately.

1. The Old in the New: From Obsolescence to Remediation

The first approach of seeking the old in the new is directly inherited from Marshall McLuhan and his law of obsolescence, according to which old media become the content of newer media and, thus, lose their initial novelty and effectiveness, without being eliminated, however. As famously formulated in *Understanding Media*: "the 'content' of any medium is always another medium. The content of writing is speech, just as the written word is the content of print, and print is the content of the telegraph" (McLuhan, 1964: 23-24). This quote also appears in Jay David Bolter and Richard Grusin's study on remediation that, not accidentally, carries the subtitle *Understanding New Media* (2000: 45). Although not overtly promoted as a media-archaeological concept, the principle of remediation is often taken for granted in recent media historical research and therefore needs to be addressed here. According to Bolter and Grusin's own definition, the notion refers to the "formal logic by which new media refashion prior media forms" (2000: 273) – television remediated film that remediated photography that remediated painting, and so on.

In their opening chapter, Bolter and Grusin proclaim being indebted to Foucault, more particularly for their notion of genealogy, as they are "looking for historical affiliations or resonances and not for origins" (2000: 21, note 1). Foucault's genealogy is a Nietzschean genealogy, which should be clearly distinguished from the traditional genealogy or study of family trees, generally adopted by (classical) historiographers who are in search of the origin of things.[8] Foucault's genealogy is not concerned with the pure origin, but with multiple origins and contingencies. It is complimentary to his archaeological project in that it tries to understand or grasp the contingencies that made happen the shift from one way of thinking to another, from one episteme to the next.[9]

Despite their openly acknowledged Foucauldian inspiration, one might have reservations about Bolter and Grusin's method, as it inevitably implies a historical linearity, resulting in an equally inevitable media convergence. According to Zielinski, this is indeed not the appropriate way to do media history: "In [this] perspective, history is the promise of continuity and a celebration of the continual march of progress in the name of humankind. Everything has already been around, only in a less elaborate form; one needs only to look" (2006: 3). Zielinski does not explicitly refer to Bolter and Grusin's work, but he makes his point clear by stating that Michelangelo's ceiling paintings in the Sistine Chapel have nothing to do with today's VR applications and CAVEs.

2. The New in the Old: Anarchaeology or Variantology

To the approach of seeking the old in the new, Zielinski opposes his "anarchic" form of media archaeology which he provocatively (or ironically?) calls *anarchaeology*. Zielinksi seeks (or rather hits upon) the new ("something new") in the old. (2006: 3) He literally digs into the "deep time" of media, going all the way back, as seen above, to the 6th and 5th centuries BC to the life and work of Empedocles. The notion of "deep time," borrowed from the vulcanist James Hutton, refers to geological time and its measurement by analyzing strata of different rock formations. What is crucial for Zielinski's conception of media archaeology is that these strata do not form perfect horizontal layers one on top of the other, but instead present intrusions, changes of direction, etc.[10]

Zielinski's media-archaeological approach is inspired by the science of paleontology, which teaches us that the "notion of continuous progress from lower to higher, from simple to complex, must be abandoned, together with all the images, metaphors and iconography that have been – and still are – used to describe progress" (2006: 5). The study of our geological past tells us that there were moments when "a considerable *reduction* of diversity occurred" (2006: 5-6; italics added); thus, instead of a continuous increasing of complexity, the evolution of nature (including humankind) sometimes takes a step back. This is also true for our media history: according to Zielinski, the "history of media is not the product of a predictable and necessary advance from primitive to complex apparatus," which means that the "current state of the art does not necessarily represent the best possible state" (2006: 7).

The anarchic approach adopted by Zielinski does not only consist in reversing the McLuhanian thinking but also, more generally, in countering the "monopolisation by the predominant media discourse" (cf. supra). In his essay "Media Archaeology," published ten years earlier in *CTheory*, Zielinski already emphasized that he did not try to "homogenize or universalize the historic development of the media" but instead to think and write it "hetero-logically" (1996). In the same essay, Zielinski also stated that media archaeology needs to be seen as a "form of activity", in the Wittgensteinian sense of *Tätigkeit* ("philosophy is not a doctrine it is an activity"). This confirms the above-quoted remark that media archaeology "needs to be executed, not constructed as a narrative." Here it is interesting to note that Zielinski is not only reading old original manuscripts, but also going to the sites (as a true archaeologist), following the footsteps of his heroes (2006: 37-38) .

Zielinski's history can best be described as a study of singularities, which tries to capture the event "in the exact specificity of its occurrence," as Foucault prescribes it in his *Archaeology of Knowledge*: "we must grasp the statement [*l'énoncé*] in the exact specificity of its occurrence; determine its conditions of

existence, fix at least its limits, establish its correlations with other statements that may be connected with it, and show what other forms of statement it excludes" (2007: 30-31). Zielinski's ultimate goal is to collect or put together a large "body of individual anarchaeological studies" which would constitute a "variantology of the media," a media history as a labyrinth consisting of innumerable individual variations (2006: 7).

3. Recurring *Topoi:* The Eternal Cycle of the Déjà Vu

The third dominant approach of media archaeology is the cyclical view proposed and practiced by Erkki Huhtamo. This method is inspired by the work of the literary scholar Ernst Robert Curtius, who in his *Europäische Literatur und lateinische Mittelalter* (1948) tried to explain the internal life of literary traditions by means of the concept *topos*. Deriving from the Greek word for place, a *topos* is a (literary) convention or commonplace. Media archaeology, then, becomes in Huhtamo's words the "way of studying the typical and commonplace in media history – the phenomena that (re)appear and disappear and reappear over and over again and somehow transcend specific historical context" (1996: 300). The result of such an approach is media history as a succession (or eternal return) of media clichés or commonplace views concerning (new) media, technology and their uses. Unlike Curtius who explains the (re) appearance of certain *topoi* by having recourse to Jungian archetypes, Huhtamo stresses that these commonplaces are "always cultural, and thus ideological, constructs." And he adds: "In the era of commercial and industrial media culture it is increasingly important to note that *topoi* can be consciously activated, and ideologically and commercially exploited" (1996: 301). In other words, the (media) industry with its advertisement strategies and other means of communication also plays an important role in this cyclical mechanism, insofar as it can bring to the surface old dreams of annulling time and space as well as old anxieties about the (supernatural) power of media technologies.

This return of both optimistic and pessimistic commonplaces is at the core of Huhtamo's media-archaeological project, which looks back into the past from the perspective of the present and wants to explain what Tom Gunning described some years earlier as "an uncanny sense of *déjà vu*" (1991: 185). Approaching the end of the 20th century, Gunning registers a same kind of mixture of anxiety and optimism around new technologies as Freud observed at the end of the previous century, when the telephone was bridging the distance between family members or friends who were separated from one another by other technologies of modernity, such as the railway or ocean liners. Besides this ambivalent effect of technology, the idea of returning *topos* can also be

MEDIA ARCHAEOLOGY: WHERE FILM HISTORY, MEDIA ART, AND NEW MEDIA (CAN) MEET

applied to more aesthetical or stylistic issues. Here we can think of Gunning's own concept of cinema of attractions, which was dominant in the early days of cinema and then went underground to reappear in a mitigated form in the "Spielberg-Lucas-Coppola cinema of effects" (Gunning, 1990: 61).

Typical media motifs that can be examined following Huhtamo's approach are, for instance, the visceral impact of special effects (from the phantasmagoria to digital 3D), the family as unit for media consumption (from the stereoscope to the television), the courting and therefore distracted spectator (from the kaleidoscope to the *cinématographe*), and so on. While investigating recurring *topoi*, Huhtamo excavates not only neglected and forgotten media, but also, in a somehow Foucauldian vein, the discourses in which these media emerge. Yet Huhtamo is not aiming at a Foucauldian study of discursive formations. His concept of "discursive objects" is closer to the notion of imaginary media, that is, media that did not really exist but were fantasized about in (written or drawn) discourses. A good example of such a discursive object is the observiscope, a fantasy device of the 1910s based on the technologies of the magic lantern, the phonograph, and the telephone, among other things, and destined to return as *topos* at the end of the century in the form of the webcam, video chatting and conferencing, etc.[11]

In Huhtamo's own words, his media-archaeological approach "emphasizes cyclical rather than chronological development, recurrence rather than unique innovation" (1996: 303). However, even if not chronological, such a cyclical view inevitably leads to a linear reconstitution of (media) history, implying not only returns but also "obscure continuities," in a similar fashion as does the history of ideas to which Foucault precisely opposes his "archaeology of knowledge" (Foucault, 2007: 154). By the way, Huhtamo is fully aware of his anti-Foucauldian penchant when he states that his approach is "actually closer to the field characterized by Foucault somewhat *contemptuously* as the history of ideas" (1996: 302; emphasis added).

4. Ruptures and Discontinuities: Foucault's Legacy

In his (new) film history as media archaeology, Elsaesser has been quite sceptical about the cyclical view, more specifically about the return of the "cinema of attractions". He warns us against making "too easy an analogy between 'early' and 'postclassical' cinema" since it might "sacrifice historical distinctions in favor of polemical intent"; for instance, by overemphasizing the attraction principle of contemporary feature films in terms of a return to the origins, one might forget about the important role played by television's commercial breaks in the development of (post-classical) narrative cinema (2004: 101).

A media-archaeological approach means, according to Elsaesser, that we constantly revise our "historiographic premises, by taking in the discontinuities, the so-called dead-ends, and by taking seriously the possibility of the astonishing otherness of the past" (2005: 20). This is the general idea behind a "hermeneutics of astonishment" discussed above; a way of interpreting the past while being astonished by its otherness, instead of looking at it with some preformed present-day ideas. Furthermore, *the* past does not exist; it is always a construction, a selection among many pasts that actually existed or might have existed. Or, as Elsaesser puts it: "History as archaeology ... knows and acknowledges that only a presumption of discontinuity (in Foucault's terms, the positing of epistemic breaks) and of fragmentation (the rhetorical figure of the synecdoche or the *pars pro toto*) can give the present access to the past, which is always no more than a past (among many actual or possible ones)" (2004: 103). Likewise, Ernst refers to Foucault's archaeology of knowledge and his notion of rupture or epistemic break: "The archaeology of knowledge, as we have learned from Foucault, deals with discontinuities, gaps and absences, silence and ruptures, in opposition to historical discourse, which privileges the notion of continuity in order to re-affirm the possibility of subjectivity" (Lovink, 2003).

Whereas Elsaesser's media archaeology can be considered a very general critique of film history as linear development, "either in form of a chronological-organic model (e.g. childhood-maturity-decline and renewal), a chronological-teleological model (the move to 'greater and greater realism'), or the alternating swings of the pendulum between (outdoor) realism and (studio-produced) fantasy" (2004: 80), Ernst sees media archaeology as "a critique of media history in the narrative mode" (Lovink, 2003). According to Ernst, media historians should stop telling (media) stories – but he immediately confesses that he, himself, sometimes slips back into it. Possible alternatives to this narrativization of (media) history could be databases, collages, websites (such as Thomas Weynants's *Early Visual Media*), or image libraries (such as Aby Warburg's *Mnemosyne*). Maybe, after all, the artist-archaeologists are the (only) ones who can really dismantle the linear and narrative modes of media history?

IN THE FOOTSTEPS OF THE MEDIA ARTIST...

Not only does the artistic approach facilitate a multilayered excavation into time and space more easily than scholarly writing; generally speaking, the media artist also operates in direct, physical contact with the medium or, even better, with its materiality. Therefore, the media artist can dig into the

technological past as well as in the potentialities of old and new media more straightforwardly than a (traditional) media historian. The media artist then becomes an example that the new media historian, or media archaeologist, might wish to follow, even if his/her academic toolbox and framework do not "allow" him/her to do so.

In a certain sense, media artists are (already) free enough to "describe the interplay of relations within [the Foucauldian statement] and outside it" as a proper archaeology of knowledge requires (Foucault, 2007: 32). They are free from academic boundaries, disciplinary conventions, and methodological restrictions. The various media-archaeological approaches discussed above in opposition to one another (seeking the old in the new vs. finding the new in the old, studying recurring *topoi* vs. emphasizing discontinuities) can freely be combined in one and the same artwork, or body of artworks.

Media artists, finally, operate more easily (or more spontaneously) in the "real" world to make their fellow citizens aware or even critical about media uses in daily life. A nice example to conclude with is Daniel Jolliffe's mobile sculpture *One Free Minute*, which consists of a huge yellow scone on wheels with a red phonograph horn mounted on top of it. The sculpture contains a cell phone to which people can make calls that are broadcast from the horn: calls are limited to one minute, one free minute of "anonymous public speech."[12] As a popular counterpart, we might think of the UK comedian Dom Joly who in the 1990s disrupted various public places (restaurants, libraries, silent train compartments, art galleries, etc.) by making loud calls with his ridiculously giant mobile phone, a sketch that bluntly "underscor[ed] the incongruity of the private conversation publicly performed" (Hemment, 2005: 33). What both "performances" have in common is that they make very visible the mobile phone or its apparatus, which according to my opening anecdote tends to disappear from our visual field. But, like my opening anecdote, it is all about questioning the impact of new media technologies on our social behavior by recreating such situations in which this impact can be amplified and therefore criticized. It is media history in practice.

NOTES

1 I would like to thank Thomas Elsaesser for his constructive feedback on an early version of this text.

2 FIAF stands for *Fédération Internationale des Archives du Film* (International Federation of Film Archives).

3 Film archaeologists should be distinguished from media archaeologists in that they are mostly interested in devices classifiable as "pre-cinematic" and may be less driven by a Foucauldian notion of archaeology. A good example of a film archaeologist is Laurent Mannoni who, in the early 1990s, published an "archaeology of cinema" based on extensive archival research (cf. infra). One can also think of the collector Werner Nekes and his archaeological film series *Media Magica* (1986-1996).

4 In his blog *Cartographies of Media Archaeology*, Jussi Parikka quite similarly identifies the existence of various historical layers. However, he adds a first layer consisting of the work of Walter Benjamin and more generally early 20th century German media theory. Thereafter he lists three layers since the 1980s which differ slightly from my three branches: 1) new historicism and cinema studies; 2) imaginary media research, variantology, and excavations of hidden and forgotten media; and 3) media theory (2010).

5 In their introduction to *Media Archaeology: Approaches, Applications, and Implications*, Erkki Huhtamo and Jussi Parikka also refer to C.W. Ceram's *Archaeology of the Cinema* (1965) which they consider as a counter-example: despite the title of his book, Ceram adopts a rather traditional historical approach which is positivistic in scope (2011: 4).

6 See also chapter 4 in this book.

7 Besides the Finnish scholars Erkki Huhtamo and Jussi Parikka (both working outside Finland, in the US and the UK, respectively), there is a strong presence of German scholars who can very schematically be divided between the "Berlin School of Media Studies" and the "Amsterdam School of Media Archaeology" (founded by Thomas Elsaesser and adhered to by scholars of various nationalities, among whom myself). With the risk of generalizing, the Berlin School is marked by a Kittlerian legacy of materialist media studies, whereas the Amsterdam School is driven by early cinema studies. For the Dutch context, one should also add the Imaginary Media project undertaken outside the strict academic institution by Eric Kluitenberg. In the US, media archaeology is also being practiced and taught at various universities by new media scholars such as Alexander Galloway (NYU) and Wendy Hui Kyong Chun (Brown University).

8 A good example of this old-school practice is the genealogy of cinema, where different 19th-century families such as persistence of vision, photography and projection, are brought together to "give birth" to the first Lumière show of moving images.

9 It is beyond the scope of this chapter to give a full account of Foucault's genealogical period, which started with *Discipline and Punish* (1975, translated in 1977) and continued with *The History of Sexuality* (1976, translated in 1977). Since the 1970s, Foucault focused his work on the position of the subject and the complex power relations at work in society. However, archaeology and genealogy should not be seen as two separate and incompatible methods; they are rather two sides of the same coin. Or, as Foucault put it: "Genealogy defined the target and aim of the work. Archaeology indicates the field in order to do genealogy" (1983).

10 From the perspective of art history, Georges Didi-Huberman (2000) comes to similar conclusions by considering the image an anachronism, a (temporal) instance where past and present are intermingled. In such an anachronistic, non-linear conception of time, the notion of *montage* is fundamental – as Didi-Huberman further develops in his more recent writings and his reading of, for instance, Harun Farocki's work (2010).

11 For more details on the observiscope, see Huhtamo's caption of the 1911 *Life* illustration "We'll All Be Happy Then" (1996: 296).

12 I would like to thank Tina Bastajian for pointing out this artwork to me. For more information about its live and site-specific versions, see http://www.danieljolliffe.ca/ofm/ofm.htm#.

REFERENCES

Allen, Robert and Douglas Gomery. *Film History. Theory and Practice*. New York: Knopf, 1985.

Altman, Rick. *Silent Film Sound*. New York: Columbia University Press, 2004.

Bolter, Jay David, and Richard Grusin. *Remediation. Understanding New Media*. Cambridge, MA: MIT Press, 2000.

Burch, Noël. "Un mode de représentation primitif?" *Iris* 2 (1984) 1: 113-23.

Carels, Edwin. "The Productivity of the Prototype. On Julien Maire's *Cinema of Contraptions*." In *Bastard or Playmate? Adapting Theatre, Mutating Media and Contemporary Performing Arts*, edited by Robrecht Vanderbeeken, Boris De Backere, and Christel Stalpaert, 178-195. Amsterdam: Amsterdam University Press, 2012.

Christie, Ian. "'Just the Facts, Ma'am?' A Short History of Ambivalence Towards Empiricism in Cinema Studies." *Tijdschrift voor Mediageschiedenis* 9 (2006) 2: 65-73.

Didi-Huberman, Georges. *Remontages du temps subi. L'oeil de l'histoire, 2*. Paris: Minuit, 2010.

—. *Devant le temps. Histoire de l'art et anachronisme des images*. Paris: Minuit, 2000.

Elsaesser, Thomas. "Between Knowing and Believing. The Cinematic Dispositif after Cinema." Unpublished paper.

—. "Early Film History and Multi-Media. An Archaeology of Possible Futures?" In *New Media, Old Media*, edited by Wendy Hui Kyong Chun and Thomas Keenan, 13-25. New York: Routledge, 2005.

—. "The New Film History as Media Archaeology." *CiNéMAS* 14 (2004) 2-3: 75-117.

—. "'Where Were You When…?'; or, 'I Phone, Therefore I Am'." *PMLA* 118 (2003) 1: 120-122.

—. "Early Cinema. From Linear History to Mass Media Archaeology." In *Early Cinema. Space Frame Narrative*, edited by Thomas Elsaesser, 1-8. London: BFI Publishing, 1990.

—. "The New Film History." *Sight and Sound* 55 (1986) 4: 246-251.

Ernst, Wolfgang. "Beyond the Archive. Bit Mapping." Published on *Media Art Net*, 2005. Http://www.medienkunstnetz.de/themes/mapping_and_text/beyond-the-archive/print/. Last access: 25 September 2012.

—. *M.edium F.oucault. Weimarer Vorlesungen über Archive, Archäologie, Monumente und Medien*. Weimar: Verlag & Datenbank für Geisteswissenschaften, 2000.

Foucault, Michel. *Archaeology of Knowledge*. London: Routledge, 2007.

—. *Madness and Civilization. A History of Insanity in the Age of Reason*. New York: Random, 1988.

—. "Foucault Replies to Questions from the Audience at Berkeley's History Department." Transcribed by Arianna Bove. Published on *Generation Online*, 1983. Http://www.generation-online.org/p/fpfoucault4.htm. Last access: 25 September 2012.

Fuller, Matthew (ed.). *Software Studies. A Lexicon*. Cambridge, MA: MIT Press, 2008.

—. *Media Ecologies. Materialist Energies in Art and Technoculture*. Cambridge, MA: MIT Press, 2005.

Gaudreault, André, and Tom Gunning. "Le cinéma des premiers temps. Un défi à l'histoire du cinéma?" In *Histoire du cinéma. Nouvelles approches*, edited by Jacques Aumont, André Gaudreault, and Michel Marie, 49-63. Paris: Sorbonne: 1989. English translation: "Early Cinema as a Challenge to Film History." In *The Cinema of Attractions Reloaded*, edited by Wanda Strauven, 365-380. Amsterdam: Amsterdam University Press, 2006.

Gunning, Tom. "Heard over the Phone. *The Lonely Villa* and the de Lorde Tradition of the Terrors of Technology." *Screen* 32 (Summer 1991): 184-196.

—. "The Cinema of Attractions. Early Film, Its Spectator and the Avant-Garde." In *Early Cinema. Space Frame Narrative*, edited by Thomas Elsaesser, 56-62. London: BFI Publishing, 1990.

Hagener, Malte. "Where is Cinema (Today)? The Cinema in the Age of Media Immanence." *Cinéma & Cie* 11 (2008): 15-22.

Hemment, Drew. "The Mobile Effect." *Convergence. The International Journal of Research into New Media Technologies* 11 (2005) Summer: 32-40.

Hertz, Garnet and Jussi Parikka. "CTheory Interview. Archaeologies of Media Art."

CTheory (2010): http://www.ctheory.net/articles.aspx?id=631. Last access: 25 September 2012.

—. "Zombie Media. Circuit Bending Media Archaeology into an Art Method." *Leonardo* 45 (2012) 5: 424-430.

Huhtamo, Erkki. "From Kaleidoscomaniac to Cybernerd. Towards an Archaeology of the Media." In *Electronic Culture. Technology and Visual Representation*, edited by Timothy Druckrey, 296-303, 425-427. New York: Aperture, 1996.

—. "Resurrecting the Technological Past. An Introduction to the Archeology of Media Art." *InterCommunication* 14 (1995): http://www.ntticc.or.jp/pub/ic_mag/ic014/huhtamo/huhtamo_e.html. Last access: 25 September 2012.

—, and Jussi Parikka. "Introduction. An Archaeology of Media Archaeology." In *Media Archaeology. Approaches, Applications, and Implications*, edited by Erkki Huhtamo and Jussi Parikka, 1-21. Berkeley: University of California Press, 2011.

Kittler, Friedrich. *Gramophone, Film, Typewriter*. Stanford: Stanford University Press, 1999.

Lastra, James. *Sound Technology and American Cinema*. New York: Columbia University Press, 2000.

Lovink, Geert. "Archive Rumblings. Interview with Wolfgang Ernst." Published on *Nettime.org*, 27 February 2003. Http://www.nettime.org/Lists-Archives/nettime-l-0302/msg00132.html. Last access: 25 September 2012.

Maltby, Richard. "On the Prospect of Writing Cinema History from Below." *Tijdschrift voor Mediageschiedenis* 9.2 (2006): 74-96.

McLuhan, Marshall. *Understanding Media. The Extensions of Man*. New York: The American Library, Times Mirror, 1964.

Parikka, Jussi. "Fellowship – and Reading Foucault." Blogpost on *Cartographies of Media Archaeology. Jussi Parikka's Media Archaeology Focused Ideas, Notes and Short Draft Writings*, 17 August 2010. Http://mediacartographies.blogspot.com/2010/08/fellowship-and-thoughts-inspired-by.html. Last access: 25 September 2012.

—. "Professor Ernst's Take on Media Archaeology." Blogpost on *Cartographies of Media Archaeology. Jussi Parikka's Media Archaeology Focused Ideas, Notes and Short Draft Writings*, 22 November 2009. Http://mediacartographies.blogspot.com/2009/11/professor-ernsts-take-on-media.html. Last access: 25 September 2012.

—. *Digital Contagions. A Media Archaeology of Computer Viruses*. New York: Peter Lang, 2007.

Sterne, Jonathan. "Out with the Trash. On the Future of New Media." In *Residual Media*, edited by Charles R. Acland, 16-31. Minneapolis: University of Minnesota Press, 2007.

Strauven, Wanda. "The Observer's Dilemma. To Touch or Not to Touch." In *Media Archaeology. Approaches, Applications, and Implications*, edited by Erkki Huhtamo and Jussi Parikka, 148-163. Berkeley: University of California Press, 2011.

— (ed.). *The Cinema of Attractions Reloaded*. Amsterdam: Amsterdam University Press, 2006.

Wedel, Michael. "Towards an Archaeology of the Early German Music Film." In *Le son en perspective. Nouvelles recherches / New Perspectives in Sound Studies*, edited by Dominique Nasta and Didier Huvelle, 115-133. Brussels: P.I.E.- Peter Lang, 2004.

—. "Sculpting With Light. Early Film Style, Stereoscopic Vision and the Idea of a 'Plastic Art in Motion'." In *Film 1900. Technology, Perception, Culture*, edited by Annemone Ligensa and Klaus Kreimeier, 201-223. London: John Libbey, 2009.

Zielinski, Siegfried. *Deep Time of the Media. Towards an Archaeology of Hearing and Seeing by Technical Means*. Cambridge, MA: MIT, 2006.

—. *Audiovisions*. Amsterdam: Amsterdam University Press, 1999.

—. "Media Archaeology." *CTheory* (1996) – http://www.ctheory.net/articles. aspx?id=42.

CHAPTER 3

Media Aesthetics

Dario Marchiori

AN INTRODUCTION TO AESTHETICS: THINKING THROUGH SENSATIONS

Aesthetics as a philosophical discipline arose in the middle of the 18th century, when art came to be defined as an autonomous field of rules, social practices, and institutions (like museums). For that historical reason, aesthetics is not just "art theory," as it articulates both more general and more particular issues, for instance: perception through the senses, the definition of beauty, judgment of taste, the truth content of an artwork and its relationship to (physical, psychological, economic etc.) reality, the questions of originality and newness; eventually, the definition and the very possibility of "art" itself, which becomes a serious matter in the course of the 20th century. Such different perspectives involve changing considerations about the very role of aesthetics itself, until its apparent diffraction in many art theories. Here, I will consider aesthetics as a reflexive activity more than a closed "discipline," and I will follow the particular path of its encounter with the contemporary questioning of the "media." Media aesthetics is the activity of thinking about our experience of contemporary art, questioning the borders between the notion of "medium" (a means for expression) and "media" (a means for communication), and between art techniques and cultural means.

Alexander Gottlieb Baumgarten, a German philosopher in the age of Enlightenment, was the first to use the Latin word *Æsthetica* to indicate a new philosophical discipline to which he dedicated a fundamental, yet unfinished, work (1735 and 1750). He considered aesthetics a sort of "sister" of traditional (originally Aristotelian) logic that, to him, was unable to approach knowledge through the senses. He gave a complex, three-fold definition of aesthetics: generally speaking, "the science of knowledge through sensations" (*scientia cognitionis sensitivæ*); in a more specific way, "the theory of arts" (*theoria liberalium*

artium); and, finally, "the capacity to think beautifully" (*ars pulchre cogitandi*). Perception, the arts, and beauty were to Baumgarten the main concerns for aesthetic studies, while afterwards – apart from Kant – sensations were to be less considered: in the 19th century, aesthetics became to be considered as *philosophy of art*, that is, a branch of philosophy considering art as its content of thought and beauty as its capital issue. While Kant's aesthetics followed Baumgarten's primacy of sensation, Schlegel and Schiller would prefer to speak of *Kunstlehre* ("art doctrine"), rather than of "aesthetics"; also Hegel, the foremost author of modern aesthetics, would try to displace the idea of aesthetics and to give it a more speculative dimension. But Hegel would also admit that the word aesthetics "indicates the science of sensations" (1975).

Aesthetics contains sensation in its very etymology, going back to the ancient Greek *aisthànesthai*, "to perceive." Reinventing the classic cataloging of arts according to the senses – in particular sight vs. hearing – Baumgarten built up a bridge linking philosophical thought to the senses, trying to find an answer to the traditional philosophical dualism between thought (rationalism) and sensation (empiricism). Here, I will understand aesthetics as *a theoretical inquiry into sensations and thoughts that arise within art experience*, be they linked to art forms and contents, or to a larger context: anthropologic, psychological, socio-economic, and so on. Coming back to *aisthesis*'s perceptive dimension,[1] aesthetic thought responds to strong emotional stimuli, trying to rationalize them and to make generalizations about their issues.

At the core of our reflection upon media aesthetics I will place the study of the dialectical links between art theories and human perception, intended as a historical, changing whole. This way, aesthetics becomes a tool to understand dialectically the connection between the particular and the general, between the individual and the society, between the art field and the world; in a similar way, the aesthetic discourse, when applied to media, starts from considering the very relation between singular artistic "mediums" and social media as a whole. "Media aesthetics" as such, as an unmediated link, conveys the ideological drive to abolish any difference between mediums (old, as well as new ones); on the other side, media aesthetics still remains a particular application of aesthetical thought to mediums and to media, not the only horizon of contemporary aesthetics.

AESTHETICS' MODERNITY

Aesthetics has no original essence, only its history defines its concept, which is deeply connected to the origins of modern art and to the secularization of religious production of images, sounds, objects, and environments. Historical

awareness, need for auto-determination, and rupture within its autonomous tradition are at stake in modern art, whose emergence was linked to aesthetics as a mean to define a new field of practices. Trying to define modern art's independence from classical art, *historicism* is complementary to aesthetics' research for the common aspects of artistic experience. On the other side, complementary to the modern notion of history, aesthetics is also linked to the question of expressing a judgment (of taste, of value, of truth). Kant established that horizon through his conception of aesthetics as judgment of taste. Influenced by Edmund Burke's stress on sensitive perception as vehicle for a shared apprehension of beauty, Kant concludes with the contemplative nature of the judgment of taste: aesthetic pleasure is famously a "disinterested" one, which is both subjective *and* universal (Kant, 1911). Aesthetics does not necessarily judge about particular artworks, but it thinks about and fixes up the criteria for judgment – that is aesthetics' *normative* dimension, which is neither aprioristic or disciplinary, but a necessary complement to the modern stress upon historicity.

The question of judgment also informs a scission between two complementary approaches to art reflection: aesthetics and modern *criticism*. Whereas aesthetics reflects upon more general questions, like perception, experience and art itself, criticism is concerned with particular works of art, or artists. Unlike criticism, the main concern of aesthetics is not judgment and promotion of works of art; but, because of that link between aesthetics and criticism, we cannot conceive a completely non-evaluative aesthetics, which may be simply "nonsense."[2] In postmodern times, while a dismissal of both "aesthetics" and "art" as hermeneutic categories has brought into a crisis the definition of criteria for judgment, nothing demonstrates the necessity to give up the very idea of judgment. Responsive to contemporary dismissal of judgment, Godard's video installation *Vrai/Faux Passeport,*[3] is mainly an anachronistic affirmation of the necessity of critical choice, structured as it is upon an oppositional compilation of film excerpts judged as *bonus* or *malus*. Literalizing the commercial terminology associated with the DVD, which equates the Latin term "bonus" with merchandising and economic "good," Godard again provides these words with their reflexive connotations. He opposes the postmodern ideology of the disappearance of criticism; meanwhile, the very absence of assumed criteria for judgment within the piece seems to signal to the viewer the necessity to rethink them in a subjective way.

As modern philosophical thought in general, modern aesthetics has developed another major concern, which is *reflexivity*, or the drive to reflect upon itself.[4] Aesthetics tries to perceive and debate its own process of thought, and to comment on it: it may conclude with the impossibility of this attempt, like in Husserl's phenomenology, nevertheless it wonders about it. In art's

practice, *modernism* has placed speculative and historical awareness at the very heart of the artwork, so that the artists themselves reflexively inscribe aesthetic concerns into the artwork and within its margins (manifestos, critical writings etc.). Romanticism, then modernism worked through aesthetics, criticism and historicism to introduce reflexivity in art practice. According to Jacques Rancière, we should even replace the very category of modernity with his notion of the "aesthetic organization of arts" (*régime esthétique des arts*): in a Foucauldian perspective, it is the constellation of principles informing the field of experiences and practices that makes history (see Foucault, 2002).

Throughout the 20th century, aesthetics focused on the question of art, to define what art could or should be. Avant-garde solutions aimed to answer in a militant way, trying to displace the frontiers of art, or to make them "explode" into real life (see Poggioli, 1986, and Bürger, 1984): American post-WWII neo-avant-gardism has tried, according to Harold Rosenberg, to prolong and reinvent that practice, beginning with Action Painting (1972). On the other side, the theory of modernism, elaborated by Clement Greenberg and both institutionalized and criticized by the "postmodernist" journal *October*, defined it as a formalist attempt to preserve art's borders, through questioning the specificity of the medium.[5] In the 1950s, these two paths of modernity – avant-garde and modernism – established a new frame of reference, one that posited the interaction between arts and the displacement of art itself. "Neo-avant-gardes" are a paradoxical reactivation of radical modern thought, in which newness depends from looking back to "historical" avant-gardes, ideologically displacing them in a new context, North America, as the new center of artistic elaboration (see Guilbaut, 1983).

Postmodernism, while conceptualizing modernist theories, tried to introduce an avant-garde dismissal of modernism, covering its own ideological purposes through anti-ideological, anti-avant-garde statements. Rejecting modernist and avant-garde radical issues, the postmodern age is the period of canonization of modernity as an all-embracing ("totalitarian") socio-political theory. While modernism is a historical theorization of an artistic reflexive tendency, postmodernism is mostly cultural and theoretical,[6] it is a social theory of art. Both concur to canonize modern art and to unconsciously prepare something different, a more "neutral," descriptive, purely immanent category in art history that will be called contemporary art, which works like a sort of "present continuous" situated at the same time within and without history, and going beyond, or denying judgment. Abolishing the distance between art and society, and the autonomy of aesthetic sphere, in this approach, aesthetics goes back to Baumgarten's or Kant's science of sensations. Media determinates art and society, so that it seems to be paradoxical to speak about authors, genres, movements anymore: literal postmodernism should recog-

nize contemporary "de-defined" art in Mr. Nobody's street art, that amazes the kids in the streets, not within the white cube of a museum or even in the multi-centered net art, that are yet submitted to traditional artistic institutions, public and authorship. If art dissolves in everyday life, it becomes totally immanent, changing aesthetic reflection into cultural studies: that question of the "death of art" accompanies the developing of modern aesthetics, since Hegel to Adorno, while developing in aggressive conflagrations between art and society as in avant-garde thought or in Kracauer's (1995) and Benjamin's (1979) reflections upon the "aestheticization" of everyday life, and the decline of art experience in mass practices, like movies. From this point of view, contemporary technology-driven art practices realize the long path of reification in modern art and thought.

Questioning medium specificity on the one hand and intermedial conflagration of the field of art on the other are the two poles of modernism. That apparent paradox is at stake, for instance, in Michael Snow's all-encompassing work: attentive to the specificity of every medium he uses, he is able to make ideas circulate from one medium to another, creating fluxes of thought which are among the most accurate, intelligent and ironic contemporary practices. The postmodernist version of media art, as opposed to the supposed modernist "enclosure" within the medium, selects and restores one of those modernist poles in order to create its own tradition, the history of media aesthetics as an anti-modernist technological convergence of arts. So, modernist dialectical heterogeneity between "mediums" is rejected to celebrate the integrative path of "media" to join a sort of neo-classical homogeneity. At the same time, postmodernism reshapes the contemporary art field: the very hypothesis of an aesthetics of media is born from a discursive field that opposes modernist and postmodernist arguments, the exploration of a single medium's properties and the hybridizing reinvention of different media in a new whole. The reflection on – and celebration of – technology was to be the core of this change, from Marshall McLuhan onwards.[7] The conditions for the possibility of thinking about "media" had to be linked to a new faith in the "extension" of human body and senses: as McLuhan would put it, a new "global village" is born, one in which media strongly determine the subject's conditions of existence as much as they constitute liberating processes.

"MEDIUMS" VERSUS MEDIA

Before analyzing the interactions between aesthetic tradition and the reflection upon media, we ought to introduce the very question of "medium" itself. A *medium* is an intermediary, a tool for transmission and expression. In the

artistic tradition, it identifies the material or technique used by the artist (oil, pastel, marble, lithography, video, etc.), which can also structure the main genres or singular arts (painting, sculpture, film, music, etc.). The term *media* indicates the collusion of different communication and information tools in a new signifying whole. At first, it was intended that media were devoted to widespread fruition: they were mass media like journalism, cinema, radio, and television. Mainly thanks to McLuhan's propositions, "media" came to define the whole system of intermediation tools artificially constructed by men. At present, the term knows both a multimedia extension and a technology-driven restriction: in dominant discourse, it identifies the integrated circulation of data between different technologies, as the computer does when we consider it as a multi-media "platform." Media are deeply linked to modern technologies of mass communication, like radio, television, and the Internet.[8] In modern times, the search for rapid means of transportation after the Industrial Revolution has radically changed our perception of the world (Schivelbusch, 1979); art itself participates in a reinvention of life structured around the need for mediation and circulation of people, merchandise and data (see Kern, 1983, and Crary, 1990). Journalism and information tools (newspapers, TV, the Internet) as mass media are ways of mediating and transmitting contents between people, and they belong to modern circulation processes. Modernity has promoted the transparency of the medium (for different purposes: economic circulation, quick communication of messages), while modernism has tried to make the public aware of the *artistic* medium, through the artist's reflection on the materiality of his/her expressive work.

The first and foremost theoretician of "media" has been Marshall McLuhan. Starting with *The Gutenberg Galaxy* (1962), McLuhan considered electronic media as the major modern revolution. In his view the contemporary world is structured as a "global village": technological tools are a whole that informs the entire society and even the psychology of the individual, through a "visual homogenizing of experience." To McLuhan, the introduction of movable type was the great transformation from a composed sensorial experience to the dominance of vision. More generally, McLuhan will consider that the human body and mind are both "amputated" and "extended" by media (1964). Media shape our environment and our perception, becoming more important than the content they convey, which may also be another, older medium: that is the meaning of McLuhan's famous formula "the medium is the message."

An operative distinction will be maintained here between "mediums" as the plural anglicized form of "medium," and "media" as a new signifying whole (also employed as a singular noun).[9] The dialectics between mediums and media in contemporary aesthetics realizes the "double character" of art according to Adorno, that is, the "immanence" of its participation in

modern, capitalist, bourgeois society on one hand, and the "autarchy" of the artwork (1999: 310), its monad-like self-closeness as a separate field, on the other. At the same time, while the unmediated affirmation of media aesthetics as a homogeneous field of practices is establishing a new art paradigm, it simultaneously abolishes internal differences, and simply skips the dialectics between art and technology. Also, we encounter another founding split in the very definition of media aesthetics: we can consider it as a way of thinking about media *art*, or we can question the sensations linked to contemporary media and multimedia as *technologies* (TV, computer, mobile, the Internet, GPS navigator, iPod, etc.), as well as the place for subjective perception within the structural effects of media-integrated systems. This way, we again encounter the opposition between art and the world, between artistic devices and socio-economic reality, which has been fundamental throughout the modern age. This very opposition is one of the main issues for media art aesthetics.

On the other hand, we can also wonder about the possibility of reconciliation between art and the world, a sort of return back, in contemporary age, to a pre-modern idea of art as technical skill organized like a "craft." Among the modern mediums there were some that already operated following industrial methods, such as photography, film, and television. Their inclusion in the art field influenced and reconfigured art itself, eventually shaping new media technology's domination of traditional art forms and replicating media's hold on everyday life. For the most part, contemporary artists are more concerned with the articulation and shifting between different mediums than with the expression through single mediums. Media become their primary tools: *media is the medium*. Media art manages transformations, passages, compositions, and blurs between mediums as its materials, and it encourages us to wonder about the status and effects of these new *significant and sensitive circulations through media*. Circulations can be dialectical, polarized, crashing, mystical, fluid, and so on: the *processes* at stake within the artwork and between it and the art world, or the society, will be the main vehicle for expression, meaning and interpretation, and the real issue at stake in the artist's work.

The split between artistic mediums and media recalls the polarity within aesthetics itself between *social* and *artistic* "truth": *media aesthetics* reconsiders this opposition in a new, more conciliated way, which tends to reactivate reflections upon technique as an ontological (neo-Heideggerian) or anthropologic (as in Bernard Stiegler's studies about the permanent link between mankind and techniques) horizon. That may be media aesthetics' main ideological danger, too: in order to be true aesthetics, media aesthetics has to reflect upon the various forms of interactions between singular mediums and to define new media configurations as such; at the same time, media aesthetics has to reflect critically upon its own ideological implications, as

the reflexive dimension remains consubstantial to aesthetics. Up until now, despite many attempts, media studies and aesthetics still remain two separate fields, communicating along ideological, predetermined paths (this seems to be slightly different in North American thought, where synthesis is more advanced, although the consequences are scarcely investigated). The challenge for contemporary media aesthetics is to make those two different traditions converge, while testing its own legitimacy.

During the debates in the 1960s and 1970s on the liberating potential of video and television, the utopian challenge was one of appropriating technology as a tool for sharing. Media were to be intermediaries that should enable more intensive communication. That was one of those possible convergences of media and aesthetics, reactivated in the 1990s by the Internet's social impact on our contemporary world. Media as extended interaction among people, communication as the creation of local/global/"glocal" communities: this avant-garde utopia put the autonomy of the art world in crisis, trying to dissolve it in a revolutionary everyday practice. But, as happened to every artistic avant-garde movement, another possible issue was there, under the social utopia: the simple transformation of the art world, of its concept and its economic structures. In the contemporary age of media, the modern tradition of art is exposed to the risk of being determined by technological progress and to lose its relative autonomy from social and economic totality while dismissing the very idea of utopia as an old-fashioned modern issue. *Media art* is the very place for this paradox: reification of the artwork and demand for artistic status are both contained in its very label.

According to postmodern aesthetics, the media-driven world becomes more and more virtual, mainly through digital media: true or not, this statement brings new ideological issues. But we all know the material and economic dimension of digital data storage, when we lose or break a DVD, a hard disk, or a laptop. New media are not virtual ones, they are material tools embedded in our contemporary, late-capitalist economy: fragile, more and more difficult to repair or to modify, subject to technological (economic) rules, etc. They are intended to make reality virtual, to make the support fragile by pushing it toward an aesthetics of immateriality. It is an old story: media support tends to efface itself, favoring its functions: pragmatic, economic, fictional, aesthetic. Media transparence and the immediacy of communication are economic and ideological drives of the modern age, but even in the contemporary "flexible" media world, reality itself still opposes its materiality. Abstract control systems, video surveillance, or long-distance video-directed bombs are media that seem to replace reality with simulacra. However, despite Jean Baudrillard's theorizations, simulacra cannot abolish reality, as we ought to admit when "facing the extreme," such as contemporary wars and their physi-

cal consequences – human and environmental victims; they may only seek to alter our perception of it through virtualization of the information, through the "anesthetic aesthetic" of the virtual. Critical media art often reworks and/or deconstructs the very idea of an immediacy of pure simulacra, embedding geopolitical data in their material configurations and in their perceptive and sensorial effects.

To summarize, McLuhan studied the converging, superimposing and hybridizing transformations that make mediums interact in a media-driven progress: mass media became simply "the media." Adorno and Horkheimer (2002), while considering mass media too unilaterally, as a totalitarian whole, were right in recognizing the new *Kulturindustrie* power: cultural industry, while changing its characters and its power, still defines our very horizon, and art itself as a relatively autonomous field of practice has been integrated in the large "global village" of media and in the extended and integrated "society of the spectacle" (Debord, 2004). Will aesthetics itself, as a discrete field of thought, still be possible in a world that has changed, reducing artworks to other objects, abolishing every separateness of the art field, just exploiting the exotic appeal of its uniqueness or exceptionality to make money out of it: in a word, the reification of art? Is aesthetics without art still possible? Studying aesthetics' perceptual issues from the perspective of immanence in the media world may be the only way to find art's relevance and urgency within the contemporary world. Or, we may rather discover the importance of its *inactuality*. The importance of phenomenological aesthetics in our times,[10] often linked to a socio-political reading of the artwork, seems to be symptomatic of a renewal of an aesthetic discourse centering on audience perception.

DEFINING MEDIA ART

The monolithic notion of "media" has to be revised in a more complex articulation between different mediums and a critical study of new media configurations. Due to its hybrid nature, media aesthetics should not be considered a coherent field. As long as the question of understanding artistic phenomena is at stake, the terminology we use or invent can help to positively describe new configurations. Inventing terms for media aesthetics applied to contemporary art allows for an immanent perspective on media art, from the very gesture of describing to more theoretical conclusions. Let us consider some examples of useful terms to understand media displacements, evolutions, and transformations.

Remediation is the historical process of transposition of one medium's contents and forms into another medium, as for instance the reinvention of

other mediums' content by digital media, or the television "remediating" film, theater, literature or radio (see Bolter and Grusin, 2000). *Intermediality* can be defined as the dialogue and circulation between mediums, either within the artwork (in multimedia artworks) or between artworks (like in Mauricio Kagel's practice, adapting similar questions and contents to music, theater, radio, film, and video) (see Higgens, 1967). Intermediality explores the space and time "in between," following what Raymond Bellour has defined, in visual terms, "the in-between-images" ("*l'entre-images*") (2002). *Inframediality* can be employed to define the invention spreading at the boundary between mediums, or within the folds of the singular medium:[11] not the back-and-forth between mediums (as with intermediality), but the figures and processes materialized through their collapsing, as with the paradoxical use of theatrical space in Méliès's films, which transcend into magic thanks to the film-specific art of stop motion, or, considering performance's original drive towards immediacy, by using several mediums and collapsing them in a unique experience, as in Warhol's *EPI*, or *Exploding Plastic Inevitable* performances (1966-1967). Video art happened to be particularly able to throw different and heterogeneous layers into a whole, which can be simply a mirror of mixed media practices, or an attempt to make them collapse in an ecstatic new whole, as in Aldo Tambellini's TV performances of the 1960s. As for *multimedia*, it indicates the synesthetic or reflexive effects of overlapping media, developing the idea of *mixed media* practice into a more homogeneous way.[12] While mixing and *media hybridization* both allow the constitution of a new complex whole, *transmediality* identifies the differential drive before and beyond the artwork rather than focusing on the result. A new configuration can emerge by applying certain elements of a medium's tradition in new ways; this can reinvent a medium's meaning and sometimes even its very name. That can be produced with or without a qualitative change: *extended* media defines the latter option (e.g. the passage from simple video monitor to the very idea of installation), while *expanded* media refers to the first one (e.g. the multi-projectors experimental film screening).[13]

Giving a name to phenomena can lead one to question the very status of art, its very possibility: since Marcel Duchamp, there is a strong tradition in contemporary art of artists working in that direction. Nelson Goodman's question "When is art?" (1978)[14] participates in the displacement of aesthetics' main concern toward the *institutional* question (see Dickie, 1974), which became more and more crucial in what began to be called the "art world" (Danto, 1964) of the 1960s and 1970s.[15] In the 1960s, a decade articulated between self-referential autonomy and expanded practices of art, the neo-avant-gardes tried to reinvent or go beyond the art field. Their art considered its institutional definition, defying and reworking its borders – for instance,

raising questions about the "white cube" (O'Doherty, 1999) of museum space. Avant-garde and neo-avant-garde attempts to go beyond art are followed in contemporary art by an ulterior movement: to reinvent art practice through new media, or new interactions between old media. For instance, film projection in most gallery exhibitions transforms itself in digital video projections within a luminous space: a totally different apparatus and way of reception, yet maintaining the principle of projection. Actualizing the avant-garde project, Nicolas Bourriaud's "relational aesthetics" (2002) goes beyond the art field, analyzing aesthetics from the perspective of social theory and practice. Nevertheless, most of the time and despite its statements, media art mirrors the media world while legitimizing itself as a cultural object through the use of the "art" label, thereby instituting a new, homogeneous environment: while often denied by theoreticians, media art is still considered art, which allows the artist to make a living out of it.

The hypothesis of media aesthetics arises when work made within dif- ferent and relatively separate mediums blurs into unique signifying and perceptional circulation (a process that digital media accelerate). For instance, when theater goes beyond the fourth-wall rule and invades the spectator's space, like in Living Theater's or Odin Teatret's practice. Since the 1950s the happening, then performance and installation radically changed the channels of perception, so that every work of art starts to define its own devices: the media disposition and organization (the "apparatus" or, in French, *dispositif*) itself may become the main cue within the artwork. Installations as a tool for participatory art, opened the art field to contemporary immersive, interactive, behavior-driven media practice.[16] Medium specificity or media hybridizing become processes that go beyond the exposition of the work on artwork's materiality, as well as the fact that they are no longer limited to the technological interaction of devices. So, reflexivity was displaced in favor of conceptualizing the organizational and material processes of the artwork, and the institutional questioning of the limits of an artwork itself.

A new configuration, a pluralist stream of artistic inventions, are at stake in 1960s modernism, whose field of practices opposes the exacerbated enclosure within medium specificity to the synergetic conflagration of different mediums (what we called *expanded media*). In both cases, modernist *hypermediality* is an attempt to go through and beyond the medium, in order to reach perceptional overload and to let art explode into life for radical transformation: art faces its own "de-definition." Within this field of tensions, the drive for immediacy, to go beyond the very notion of a medium, turns out to be a very modernist one, complementary to the exploration of medium's specificities, and equally reflexive. Postmodernism, as an avant-garde ideology, has appropriated this *anti-medial* tension in a militant way, creating and dismissing a

frozen notion of "modernism" as medium-enclosed art. In such a context, video seems to have been the main actor to define, and interpret, what we call "media" art. The transfers from one medium to another and the links between them, as well as its ambiguous relationship to television as a mass medium *and* a mass media gave video a very particular place, radicalizing the similar ambiguity we could have found in cinema. While video allowed the permanence and economic negotiability of ephemeral events such as performances, it was also very important to sustain what has become the main form of the contemporary artwork: the installation.

FROM ART AESTHETICS TO MEDIA AESTHETICS: CONTEMPORARY PATHS

After Duchamp, almost everything could become an artwork (De Duve, 1989), a process that could not work without requiring new justifications. Of late, new rules are in effect: for instance, it is increasingly recommended that an artwork blur its own boundaries. At the same time, we must also recognize that blurring genres or techniques is a very old practice in the field of art, not a privilege of postmodern times; even the avant-garde advocated going beyond art's limits and to implicate life. Contemporary art seems capable of integrating every possible element of contemporary life within an artwork or its process, thereby reconciling the opposition between sensation and thought in a new aesthetic whole. Moreover, contemporary art tries to go beyond the very idea of the artwork: participative strategies try to open up the experience to interaction, seeming to give to the viewer the power to modify the artwork through his/her attitudes. Media aesthetics can encourage us to wonder about how the disappearance of the artist and of the artwork may also imply the end of art as defined by modernity. We may be returning to a reframing of artmaking as a craft.

The contemporary media artist is mostly determined by socio-economic strategies of transmitting data and goods, but his/her very existence as an artist has survived the postmodern attacks against the art world, and s/he is even positioned as the main agent of the art industry. As Andy Warhol understood very quickly, an artist's name has become a trademark in contemporary art world: what fills museums is the very name of heroes such as Michelangelo or Matisse, Picasso or Monet. On one hand, big museums seem to have become multinational industries that use their media (artworks, networks, interactive websites, scholarships, and other financial aids, advertisements and merchandising) to create sellable *art worlds*; on the other, small museums proliferate or survive, linked to "local" issues, although many are deserted. Exceptions to this polarized trend are even more noticeable as "resistant" sites, trying to pre-

serve and to share traditions, the necessity of which is reinforced by their dismissal in present times. But when we consider general trends, thinking about big museums themselves as "media" that organize cultural fluctuations, we see an economic organization that is split between the dense material existence (or passive resistance) of traditional art objects and the lighter materiality of the new technologies employed to circulate them. The museum space is reinvented and reshaped by these economic tendencies, and tries to derive some energetic tension and passage from them.

Passages (Krauss, 1977), hybridizing, differentiating practices (as described in a theoretical way by Deleuze and Guattari's (2004) notions of "rhizome" and "deterritorialization") have become the new rule of contemporary art, rendering obsolete the ancient terminology even in order to simply describe an artwork. The very question of how to define an "artwork" has been at stake in a radical art practice from Duchamp up until conceptual and imaginary artworks; today, this question seems to be answered by emphasizing the processual nature of art, or its globally networked character (for instance, net art[17]). Art consists of dematerialized flows of information, and is often simultaneously embedded in social life and linked to the art market and the surviving, relocating "art world." But media aesthetics should avoid falling into the trap of defining the artwork in ways that make it seem "custom-tailored" for academic theory. It is not by chance that postmodernism is first of all a theoretical approach, as I said earlier in this chapter. Against an abstract, "virtual" characterization of the media artwork, the notions that we have recalled or introduced here are simply the new media material tools, reconfiguring art's discursive field.

Media aesthetics is thus to be understood as *a theoretical reflection on thoughts and sensations linked to the articulations between mediums and to media as a whole.* Such a definition is both a challenge and a promise. Often, it is also an ideological hypothesis, one that is bounded in technological faith. The typical overview of media aesthetics generally has to choose between a historical survey of different media (music, dance, theater, painting, sculpture, film, video, etc.) and a very partial panorama of art history trying to find precursors of multimedia practices, starting with Wagner's *Gesamtkunstwerk* and culminating in happenings, *Fluxus*, performance, installation, and the like. Media hybridization and interactivity that create "open" artworks[18] are the main ideological values needed in order to draw up a progressive story, something that should be understood as a new discipline's attempt to discover its own tradition and to embed itself in the history of aesthetics.

When taken in as a real theoretical proposition, the "contemporary" paradigm, in opposition to the "modern," conveys the idea of a "co-presence of heterogeneous temporalities"[19] in a new configuration, as already expressed by Ernst Bloch's definition: "*Gleichzeitigkeit des Ungleichzeitigen*" (the "con-

temporaneity of the non-contemporaneous," which referred to the – dangerous and violent – coexistence of civilization and barbaric tensions in 1930s Germany). Every technological practice seems to be redoubled by an attempt to use it artistically, and/or to enlarge its uses to make people participate more freely in it. If contemporary art is no longer concerned with subordination, signification, and composition, but rather with "differentiation and coordination,"[20] media art, as a possible object of media aesthetics, seems to present a new constellation in which heterogeneous media are functioning together smoothly. Net art, determined as it is by the technological use of digital technologies and the Internet, seems to achieve exactly this sort of synthesis. It allows interaction between different media, while at the same time it reduces all of them to a homogenous digital matter: the computer platform and the World Wide Web. On the other hand, contemporary art may also propose new forms and configurations rather than new apparatuses, working through the medium to achieve new (and sometimes very old) configurations: think, for instance, of Mark Lewis' latest video explorations that rediscover simple Lumière-like "views" and multilayered "magic" works inspired by Méliès. Just as with many other contemporary artists, his work is somewhat split between medium-specific art and multimedia installations.[21] As if film, the least "artistic" medium in modernity (as perceived within the field of art, at least), were still a specific apparatus, one that resists definitive appropriation within the museum's spatiality and temporality. Removed from the black box and placed within the white cube, it becomes something different, something subject to another circulation of time and space, like in home multimedia platforms (see Philippe Dubois' contribution to chapter 9 in this book). Media aesthetics must consider different degrees of specificity between artworks and mediums/media in order to understand the artworks' logic.

The main task for an aesthetics of media should be to consider and study medium, media, multimedia, intermedia, and the like as primary elements in artistic practice and/or in the contemporary perception of our cultural environment (media culture, a re-elaboration of the notion of "visual culture" (Mirzoeff, 2002)). It should encourage us to think, raise questions and try to respond to the (utopian or desperate? happy or terrifying?) hypothesis about the collusion between art and media, or between media and the world. Media aesthetics is a paradoxical conjunction of heterogeneous fields that the contemporary age tries to explore and understand. How could the double bind between aesthetics and art survive the presumed, newly proclaimed "death of art" in the media world? Art is probably not dead, but aesthetics seems to return to its origins, to "sensations" and a more general "perceptional" wondering, linked to sociological, scientific, and technological studies. This situation has to be explored, understood, and critically reinvented by contem-

porary media aesthetics, starting from immanent analysis but articulating it with aesthetic and art tradition.

Contemporary media art shapes heterogeneous co-presence. But why should we consider contemporary artists who are "still" working within singular mediums as not "current"? Our art field is split between media-driven immanence and anachronistic work within singular mediums. Some great artists articulate both aspects, enclosing more general, social concerns about our media-driven world in medium specificity. But the very idea of "contemporary" art permits one to put forward the idea of a pluralist (a dimension which was already polemically present in postmodernism) as well as differential/oppositional way of thinking about the art field. Painters or sculptors still exist, and they may be also good ones. Contemporary aesthetics cannot limit itself to new technologies only; it has to maintain its freedom to think about all art objects, non-art, and perhaps even the disappearance of art, which was at stake from the very beginning in Hegel's aesthetics. Aesthetics remains above all a speculative activity, which is initially separate from praxis and marked by this very separation. As Adorno would have put it, the "proper" art field should be separated from society, but this very separation is haunted by the nostalgia of reconciliation within a new, utopian world. Art's survival as an autonomous field of practices is deeply linked to that fundamental critical position in relation to reality (which is not simply the exhibition of a political idea that the artist assumes to be shared by his/her audience). As the historical process of "modern interpenetration" (*moderne Verfransung*) invested the arts[22], contemporary media aesthetics should reconsider that process in a context in which media circulation has become the main material for artistic work, creating new perceptional and artistic qualities. On that basis, aesthetic thinking is always questioning contemporary media, be they artistic or not; eventually, the reconsideration of the ancient question of *aisthesis* establishes a new starting point for media art aesthetics as a diffracted set of practices.

NOTES

1 A symptom of the actuality of this issue is Jacques Rancière's recent book (2011).

2 Theodor Adorno: "The idea of a value-free aesthetics is nonsense" (1999: 262).

3 Made for his 2006 exhibition *Voyage(s) en utopie* at the Pompidou Center in Paris.

4 According to Jürgen Habermas (1987), it was Hegel who introduced philosophical reflexivity, so founding modern thought.

5 See Clement Greenberg's possibly most famous essay, "Modernist Painting" (1995; originally written in 1960).

6 The very structure of Fredric Jameson's *Postmodernism, or The Cultural Logic of Late Capitalism* (1991) seems to be symptomatic of that issue: the first and the second chapters, which are the more general ones, are devoted respectively to culture and theory, while the study of each particular art form's postmodern condition comes logically later.

7 In doing so, the North American debate on media joins the European cultural reflection on technique from the first half of the 20th century; see, for instance, Maldonado (1979). However, while European thought has to be understood within a debate where nature and culture, and mankind and technology, opposed each other, in the 1960s, a new technological faith came together with a more pragmatist account of technological transformations.

8 For Lev Manovich, whom I will not follow here, such a change leads to the replacement of the very notion of "medium" with a more recent word: "software" (2001).

9 It is the choice made by, among others, Rosalind Krauss (2000).

10 See the decisive little book by Daniel Birnbaum (2005).

11 For this notion, it is useful to rethink Bellour's medium-centered notion of "infra-image" (2002), originating through the unfolding of the images, for instance in Thierry Kuntzel's videos.

12 Bob Goldstein seems to have invented the notion to promote an artistic event in Southampton (1966).

13 A seminal work on media aesthetics is Youngblood (1970). One should remember that Youngblood introduced the important notion of "expanded cinema" not only to speak about multiple projections but to reflect upon the human condition in the new technological environment described by McLuhan, starting from the "metamorphosis in human perception" introduced by the movies, and following its multiple expansions and the changes of human perception.

14 While Goodman answers with a theory of artwork as an object that "functions symbolically," I assume his reflection is a symptomatic one, questioning art's borders to refute the institutional solution.

15 Danto distanced himself from Dickie's arguments, arguing his own intention was to understand the conditions of possibility of an artwork, while Dickie searched for reasons for its actuality.

16 For an account of this approach in contemporary digital art, see Aziosmanoff (2010).

17 See the presentation made by Vuk Cosic at the conference *Net Art Per Se* (Trieste, 21-22 May 1996). According to Cosic, this particular art practice ended in 1998 (conference at the Banff Centre for the Arts). See also Weibel and Gerbel (1995).

18 The paradigm of the "open artwork" was established by Umberto Eco (1989). See also Klotz (1960).

19 Rancière (2000: 37), while speaking about the modern "esthetic régime of arts," a label that I consider even more adapted to contemporary situation of arts.

20 As proposed by Vancheri (2009).

21 http://www.marklewisstudio.com/.

22 See the 1967 essay "The Art and The Arts" in Adorno (2003).

REFERENCES

Adorno, Theodor. *Can One Live after Auschwitz? A Philosophical Reader*. Edited by Rolf Tiedemann. Stanford: Stanford University Press, 2003.

—. *Aesthetic Theory*. Edited by Gretel Adorno and Rolf Tiedemann. London and New York: Continuum, 1999.

—, and Max Horkheimer. "The Culture Industry. Enlightenment as Mass Deception." In *Dialectic of Enlightenment*. Stanford: Stanford University Press, 2002.

Aziosmanoff, Florent. *Living Art. L'art numérique*. Paris: CNRS, 2010.

Baumgarten, Alfred Gottlieb. *Meditationes philosophicæ de nonnullis ad poema pertinentibus*, 1735.

—. *Æsthetica*, 1750.

Bellour, Raymond. *L'Entre-Images. Photo. Cinéma. Vidéo*. Paris: La Différence, 2002.

—. *L'Entre-Images 2. Mots, Images*. Paris: P.O.L., 1999.

Benjamin, Walter. "The Work of Art in the Age of Mechanical Reproduction." In *Film Theory and Criticism*, edited by Gerald Mast and Marshall Cohen, 848-870. Oxford: Oxford University Press, 1979.

Birnbaum, Daniel. *Chronology*. New York: Lukas & Sternberg, 2005.

Bolter, Jay David, and Richard Grusin. *Remediation. Understanding New Media*. Cambridge, MA: MIT Press, 2000.

Bourriaud, Nicolas. *Relational Aesthetics*. Dijon: les presses du réel, 2002.

Bürger, Peter. *Theory of the Avant-Garde*. Minneapolis: University of Minnesota Press, 1984.

Crary, Jonathan. *Techniques of the Observer. On Vision and Modernity in the 19th century*. Cambridge, MA: MIT Press, 1990.

Danto, Arthur C. "The Art World." *The Journal of Philosophy* 61 (1964) 19: 571-584.

Debord, Guy. *The Society of the Spectacle*. London: Rebel Press, 2004.

De Duve, Thierry. *Au nom de l'art. pour une archéologie de la modernité*. Paris: Minuit, 1989.

Deleuze, Gilles, and Félix Guattari. *The Anti-Oedypus*. London and New York: Continuum, 2004.

Dickie, George. *Art and the Aesthetic. An Institutional Analysis*. Ithaca: Cornell University Press, 1974.

Eco, Umberto. *The Open Work*. Translated from the 4th Italian edition, 1976. Cambridge, MA: Harvard University Press, 1989.

Foucault, Michel. *The Archaeology of Knowledge*. 2nd, revised edition. New York and London: Routledge, 2002.

Goodman, Nelson. *Ways of Worldmaking*. Indianapolis: Hackett, 1978.

Greenberg, Clement. *The Collected Essays and Criticism IV. Modernism with a Vengeance (1957-1969)*, Chicago: Chicago University Press, 1995.

Guilbaut, Serge. *How New York Stole the Idea of Modern Art*. Chicago: University of Chicago Press, 1983.

Habermas, Jürgen. *The Philosophical Discourse of Modernity. Twelve Lectures*. Cambridge: Polity, 1987.

Hegel, Georg Wilhelm Friedrich. *Aesthetics. Lectures on Fine Art*. Compiled by Heinrich Gustav Hotho, 2 vols. Oxford: Clarendon Press, 1975.

Higgins, Dick. "Statement on Intermedia.". In *Dé-coll/age*, number 6, edited by Wolf Vostell. Frankfurt and New York: Typos Verlag and Something Else Press, 1967.

Jameson, Fredric. *Postmodernism, or The Cultural Logic of Late Capitalism*. Durham, NC: Duke University Press, 1991.

Kant, Immanuel. *Kant's Critique of Aesthetic Judgement*. Translated by James Creed Meredith. Oxford: The Clarendon Press, 1911.

Kern, Stephen. *The Culture of Space and Time. 1880-1918*, London: Weidenfeld & Nicolson, 1983.

Klotz, Volker. *Geschlossene und offene Form im Drama*. Munich: Hanser, 1960.

Kracauer, Siegfried. *The Mass Ornament*. Cambridge, MA: Harvard University Press, 1995.

Krauss, Rosalind. *A Voyage to the North Sea. Art in the Age of Post-Medium Condition*. New York: Thames & Hudson, 2000.

—. *Passages in Modern Sculpture*. Cambridge, MA: MIT Press, 1977.

Maldonado, Tomás. *Tecnica e cultura. Il dibattito tedesco fra Bismarck e Weimar*. Milan: Feltrinelli, 1979.

Manovich, Lev. "Post-media Aesthetics." In *(Dis)locations*, edited by Zentrum für Kunst und Medientechnologie (ZKM). DVD-Rom. Ostfildern: Hatje Cantz, 2001. Also available at http://www.manovich.net.

McLuhan, Marshall. *Understanding Media. The Extensions of Men*. New York: McGraw Hill, 1964.

—. *The Gutenberg Galaxy. The Making of Typographic Man*. Toronto: University of Toronto Press, 1962.

—, and Quentin Fiore. *The Medium Is the Massage. An Inventory of Effects*. London: Penguin Books, 1967.

Mirzoeff, Nicholas (ed.). *The Visual Culture Reader*. London and New York: Routledge, 2002.

O'Doherty, Brian. *Inside the White Cube. The Ideology of the Gallery Space*. Berkeley, CA: University of California Press, 1999.

Poggioli, Renato. *The Theory of the Avant-Garde*. Cambridge, MA: Harvard University Press, 1968.

Rancière, Jacques. *Aisthesis. Scènes du régime esthétique des arts*. Paris: Galilée, 2011.

—. *Le partage du sensible*. Paris: La fabrique, 2000.

Rosenberg, Harold. *The De-definition of Art. Action Art to Pop to Earthworks*. New York: Horizon Press, 1972.

Schivelbusch, Wolfgang. *The Railway Journey*. New York: Urizen, 1979.

Vancheri, Luc. *Cinémas contemporains. Du film à l'installation*. Lyon: Aléas, 2009.

Weibel, Peter, and Karl Gerbel. *Welcome in the Net World*. Proceedings of @rs electronica 1995 in Linz, Austria. Vienna and New York: Springer Verlag, 1995.

Youngblood, Gene. *Expanded Cinema*. New York: Dutton, 1970.

Media Art and the Digital Archive[1]

Cosetta G. Saba

This chapter aims to introduce an epistemological reflection on the concept of "digital archiving" applied to media art. If the latter appears for many reasons to constitute something "transient and un-archivable" (Ernst, 2004 and 2010), it is because it presents itself ontologically in an exponentially complex form. In other words, the aim is to underline the problems (theoretical and methodological) that media art poses to digital archiving. In order to keep media artworks accessible to contemporary and future users, their inclusion in digital archives is desirable. Digital archives can support the fundamental function of the *cultural conservation* of these works – understood as a process that not only documents and preserves the technological and material dimensions of these complex works, but also the cultural contexts in which they emerged and were seen. However, this is by no means a neutral process – as will become clear, the digital archiving of complex media artworks has a profound influence on their appearance and interpretation. Therefore, this chapter carefully investigates the epistemological implications of the digital archiving of media art.

First it is important to remember that, with respect to media art, the audiovisual component is one of the possible elements but not necessarily always the most important. Media artworks often take the form of complex installations, combining audiovisual components with sculptures, objects, and photographic components, amongst others. How is it possible to "archive," for example, works such as the complex, sculptural installations *Human Being* (2009) by Pascale Marthine Tayou and *Experimentet* (2009) by Nathalie Djurberg,[2] or the "dissipative"[3] sculptures of *Cetacea* (2005; 2010) from the DRAWING RESTRAINT 9 series by Matthew Barney?

Notwithstanding the complexity of many media artworks it is possible to establish a hierarchy between the elements that make up complex installations. If the audiovisual dimension is prominent, it can show itself according to a variety of typological modes such as: (multi)media installation with video, multichannel video installation, single-channel video installation, projective video installation, moving image installation, film installation, video sculpture, time-based installation, and interactive installation.[4]

What should be the procedure for the digital archiving of a film installation such as *Disappearance at Sea* (*Cinemascope*), 1996, by Tacita Dean, of the multichannel installation *The Lightning Testimonies* (2007) by Amar Kanwar,[5] or of the *CREMASTER Cycle* (2002-2003)[6] exhibition by Matthew Barney? How can we use the benefits of digital archiving for the future preservation and accessibility of these works without severely compromising their appearance and meaning?

Creating a digital archive of media artworks potentially entails a reduction of the works' complexity. It is necessary to examine the complexity of media art and understand how the problems that arise in the digital archiving of such works can be resolved. From the viewpoint of information technology, digital archiving is the development of a "digital library," an expression that corresponds to an intrinsically multidisciplinary complex notion,[7] which defines a system of constitution, order, management, and long-term preservation of "rich digital content" according to "specialized functionality" targeted at "user communities."

Developing a digital library involves a digital library system (software architecture concerning the specific functions required by a specific type of digital library) and a digital library management system (software infrastructure that produces and administrates a digital library system made up of all the functions considered fundamental for digital libraries and that provides for the integration of additional software in relation to specialized or advanced functions).[8] Here, the definition of digital library will be limited to the archiving process and aimed at stressing a methodology that, allowing for the convergence of interdisciplinary skills, is able to reproduce the semantics of a complex application domain such as that of media art. This starts from the "conversion" procedures ("translation" and "transformation") of non-digital artwork into digital objects (or "information objects"). This conversion can only represent the complexity of the artwork in the form of a documentary trace.

The method of such an archiving practice is related to the notion of digital library, which is in its own way an "abstract system that consists of both physical and virtual components."[9] It has to refer to the organization of contents[10] (or, more precisely, the repository of contents, ontologies, classi-

fication schemes, and so on), by creating parameters of functional configuration (formats, user profile and document/data model etc.). The *contents* are built through the conversion process of physical objects (also in the case of graphic, photographic, or cinematographic documentary traces of conceptual artworks) into digital objects that, as mentioned before, transform these analogue originals into *documents* kept in the archive. The documentary character induced by the digitalization process must be able to translate the inherent complexity of media artworks.

WAYS OF ARCHIVING: RELATIONS BETWEEN "ARCHIVE" AND "CONTEMPORARY ART"

Over the course of the 20th century, visual artworks acquired an ever-increasing formal complexity. From the first decade of the 21st century onwards, this formal complexity can be seen in the works of a great variety of artists such as Pierre Huyghe, Philippe Parreno, Rirkrit Tiravanija, Tacita Dean, Nathalie Djurberg, and Félix Gonzales-Torres. The oeuvre of these artists is characterized by a recurring mode that presents itself as a "path" (Bourriaud, 1998 and 2009; Birnbaum 2005), where the works of art are only points of immanence in transit, that are also repeated and are subject to variations.

Overall, media art presents a prevalent typology of artworks that require new and effective documentation, preservation, and dissemination methods (with the relevant accessibility levels), which are able to make up a system that can manage the contemporary art scene from the preservation and archiving viewpoint. This scene must be documented, preserved, maintained, and made accessible in a digital archive that preserves contemporary materials and actually works as "archaeology of the future" according to Fredric Jameson's definition (1991), starting from the ability to historicize the concrete examples of contemporary art.

Media artworks belong to a project (or "chain" of projects) and tend to be serial and variable instead of unique and stable. From this follows that media art proves to be "archivable" only from a documentary standpoint, given its multidimensionality and material, conceptual and progressive complexity (compare chapter 6.1). However, the present methods of documentation related to the digital archive show structural limitations. Hal Foster pointed out that, on one hand, interfaces are still screens ("windows"), icons, and texts, whilst on the other hand in this kind of archiving, it is essential to "transform a wide range of *mediums* into various systems of *image-texts*" (Foster, 2002). Because technological media are devices of the cultural industry that contain recording and storing systems, communication systems (with their own ways

of production and reception or consumption), "languages," and expressive techniques, it follows that a proper digital archiving of these media requires the capturing of the specific form of experience (Casetti, 2008: 29-30) (of the relationship between the artwork and the audience) related to the medium in question.

In many ways, the digital archiving of complex media artworks entails consecutive "translations" and progressive "dispersions" of data, but not only that. It also involves a complex integrated system of documentation, semantic indexation, preservation, restoration, and cultural dissemination practices, as well as an epistemological check of applications and information technology, which are subject to programmed obsolescence. In fact, information technology itself requires cyclical monitoring programs, constant maintenance and continuous software upgrading, to ward off the ever-present risk of "everything returning to plastic and silicon again" (Ferraris, 2007).

The processes that take place in media artworks during their translation into digital archival material (as will become clear, also in relation to the practices related to digital conservation), transform them into peculiar digital *contents* to safeguard at an ethical and cultural level, not only at a financial and legal level. Such processes give the action of "archiving" a double meaning. The first is the *construction of information objects*, which are *digital documents* of the media artworks, the second is their public *dissemination* and *accessibility.* In that sense, the digital archive can be an ideal platform for the "cultural conservation" of media artworks described above as a process that not only documents and preserves the technological and material dimensions of these complex works, but also the cultural contexts in which they emerged and were seen. But this is not a neutral "cultural epistemological" process (Foster, 2002: 71-72). In fact, in both its literal and metaphorical definition, the normative and selective administrative function of the archive continues to define itself in the "power" dimension, which is not simply an "operational power" (Foucault, 1972). The archive is a "social place" before being a "physical space"; it is a historically determined institutional space, responsible for the selection and the construction-conservation of documents (Derrida, 1995; Ricoeur, 2000). In a metaphorical sense, the archive is a "collective memory," complete with an institutionalized method for the recording of testimonies designed for the construction of the documents to archive. It pertains to the selection of what, within a specific historical context and with regards to historiographic sources, can be made archivable and what cannot. The modal condition of the possibility of archiving is thus created by the "discourse" (the operating system of values and connections between data) underlying the archive, a discourse that, by indicating what is or is not archivable, selects and organizes the documents – institutionalizes them, as it were. This discourse is carried

out "silently" (Ernst 2004) and therefore not directly observable, but neverthe-less it actively constructs and records the documents within the archive itself.

In that sense, as Wolfgang Ernst says, this "silence" is "power at work, unnoticed by narrative discourse." According to Ernst: "This power is analo-gous to the power of media, which depends on the fact that media hide and dissimulate their technological apparatus through their content, which is an effect of their interface" (Ernst 2004: 48). A "silence" of this kind becomes traceable in the documentary testimonies of "historiographies," in their intent of truth, in the "archived memories" which instead take a form of nar-rative (Ricoeur, 2000). In this way this silence also becomes traceable in the digital dimension, in the software infrastructure with regards to the intercon-necting system of contents and, if it is web based, in the http protocols. As Ernst explains "The real 'archive' in the Internet (in the sense of *arché*) is its system of technological protocols" (Ernst 2010: 87). In such a view, the aggre-gated Internet database progressively shows the literal and metaphorical dimensions of the archive.

In the artistic environment, the diffractions of the cultural transforma-tion produced by the application-diffusion of information technology and the relative "discourse formations" highlight in many different ways, as it were, its "symbolic form." (Panofsky, 1927; Cassirer, 1923) Not so much (or, not only) with respect to artistic practices that conform to the information technology platform or that are digitally isomorphic (as with net art and software art), but rather in relation to a way of thinking – a principle of continuous *transcoding* that moves materials, technological platforms, expressive systems, and signs through a network of connections that are revealed by deeply transformative practices. This results in the final abandonment of the idea of originality in artistic work, since every digitalization process gradually undermines the presence of the source. What was already encoded is encoded again, and every (re-)encoding dissolves the notion of authenticity, that starting with Roman-ticism was inherited by aesthetics that introduced the idealistic notion of uniqueness, originality and thus "artistic character" as a quality belonging to the non-repeatability of the work. With digitalization, every "generation" of data is only a moment in a chain that has no beginning or end. This seems to be the operational principle of most contemporary art. As Nicolas Bourriaud pointed out: "[...] In these works, every element used is valued for its ability to modify the form of another. One could cite countless examples of these *trans-format* practices, all of which attest to the fact that invention modes of passage from one regime of expression to another is indeed a major concern of the art of the 2000s" (Bourriaud, 2009: 135). These transformative practices make use of "temporary displays" within which, in many remarkable ways, the "notion" of archive acts (Derrida, 1995).

In 2004, Hal Foster pointed out the repositioned centrality of the "archive" in the art of the 1990s, defining it as "an archival impulse," with particular attention on the art works by Tacita Dean, Sam Durant, Thomas Hirschhorn and Pierre Huyghe, Philippe Parreno, Douglas Gordon, Stan Douglas, Liam Gillick, and Mark Dion (Foster, 2004). It is in fact a trend towards the metaphorical dimension of the archive, that develops its memorial and "immemorable" dimension (Ricoeur's paradox of oblivion as immemorable resource) in the context of concrete artworks. This way, on the one hand it is possible to branch out towards the latent layers of oblivion and the subtle and silent forms of what Ricoeur calls "archival oblivion, that is archived oblivion" (Ricoeur, 2000, see also Agamben 2007) that inspired Christian Boltanski, Fabio Mauri, and Péter Forgács in different ways. On the other hand, the focus moves from the immediate normative-bureaucratic function of the archive deconstructed in the works of Michael Fehr, Andrea Fraser, Susan Hiller, and Sophie Calle, to the function that defines the archive as part of a complex enunciative and creative strategy, as in the projects of the Atlas Group/Waalid Raad, Thomas Hirschhorn, and Hans Peter Feldmann. In addition, artists such as Fiona Tan act upon single "archives of images" or "image archives" (see Noordegraaf, 2008 and 2009 and Elsaesser, 2009), in the same way that Ken Jacobs and Yervant Gianikian and Angela Ricci Lucchi previously did. Others, such as Gustav Deutsch, Matthias Müller, Christoph Girardet, and Martin Arnold make use of that database of 20th-century images that is cinema, through procedures of re-programming or post-production (see Bourriaud, 2002), as it already happened with Joseph Cornell (*Rose Hobart*, 1936-1939), Gianfranco Baruchello, and Alberto Grifi (*La Verifica incerta. Disperse Exclamatory Phase*, 1964-1965).

The modes of translation of the matter and the concepts from one form to another, from one work to another, involve the archive as a "device" (Foucault, 1972) and as a "display." The complexity of this kind of practices was affected by the use of technologies, not only by information technology.

TECHNOLOGICAL WORKS AND INSTALLATIONS

The pervasive centrality of technology in contemporary art (in devices, strategies of composition, texture, exhibition modes, and media reception) is evident from a semiotic, social, financial and an aesthetic viewpoint. It has its peculiar expression in media art practices (from multimedia installations to live media, from net art to rich media). Since the 1990s, the challenges posed by media art have become ever more present in museums and international research projects in complex ways (see Saba, forthcoming). This is also tes-

tified by the proliferation of terms,[11] the multiplicity of definitions, and the multiplication of research that, in spite of its diversity, nevertheless seems to understand only the phenomenological aspects of the dynamic intersection between the media components that from time to time characterize the devices through which media art expresses itself (whose distinctive features are site, space, time, temporary/variability, and audience interaction).

As previously mentioned, in a wide variety of contexts in terms of environment and theme (Venice Biennale, Kassel documenta, Berlin Biennale für zeitgenössischen Kunst, Tate Triennial and so on) the format of the installation includes not only devices, different expressive practices and objects, but disparate disciplines as well. Pierre Huyghe's project *Note d'intention* is exemplary in such a sense, as is that of the architect François Roche on the "architecture of incompleteness," that Huyghe also elaborated on, in *Casting* (1995) and *Les Incivils* (1995). Something which is still definable as a "work" appoints a dynamic set of actions that involve different disciplines (cinema, music, architecture, but also anthropology, sociology, philosophy, medicine, etc.) and refers to other works and other texts, objects, concepts, bodies, events "that pass through different formats" (Bourriaud, 2009; Baker, 2004). Such disciplinary environments find a semantic amalgam, which transforms the installation work into an "event" whose constituent character is the "plural immanence" (Parfait, 1997: 36), where, notwithstanding the "allographic" variability, active "autographic" elements remain (Genette, 1994), and whose distinctive traits are constructed, as it is said, from site, space, time and the spectator's involvement.

The expressive components utilized in the installation develop a mutual capacity of transformation. Within the installation each expressive component presents a strong interrelational power and becomes able to modify the form of another component. In a way, "inter-linguistic" (or rather inter-semiotic) works exist, without necessarily producing a constituent interfusion (intermediality), since its components belong to an expressive series (photography, cinema, video, sculpture, etc.) and autonomous and different 'linguistics' (distinctive traits of artistic practices in the first decade of the 21st century). So, to define the work outlined by the installation action (authorial gesture), it is necessary to recognize and map the system of interrelations produced through the installed system's assumed configuration. It is to understand which relations activate themselves through the configuration of heterogeneous material components, conceptual aspects, various medial platforms and which autographic and allographic characters unfold themselves there. All these elements make up, in a process, the "text" and the "context" of media artworks together within a given exhibition circumstance that is often site specific.[12] And not just that. The project as a whole comprises the intrinsic arrangement of contemporary

artistic practices that end up being inclusive, with respect to the "work" and its "trans-textual" structure (and therefore also including contextual material such as interviews, conversations, photographic documents, etc.) (Genette, 1982).

Hence, in order to proceed to the digital archiving of these works it is necessary to prepare a set of documentary practices which, within an information technology dimension, allow for the construction of digital "contents" through which any given work can be processed. The documentation prefigures itself not only as methodology for the digital archiving of the metadata and the contents of media artworks (construction of the set of documents which make up the technological base of the whole work), but can be interpreted as a finalized act in the "physical" preservation even in the function of restaging and re-enactment practices (often subject to processes of recreation, see chapter 9.4.3). Within digital archiving, the whole work can exist only through documentation, which enables both conservation and access to the documentation of a media artwork, in all its components.

THE ENTRY OF ARTWORKS INTO THE "ARCHIVE": CONSTRUCTING DOCUMENTS

Because of the complexity and the rapid obsolescence of devices, an artwork based on media technology – be it digital or analogue – risks being lost. Therefore, in the absence of a shared protocol, it has become necessary to define a model of documentation that structures its descriptions, the cataloguing criteria, the management of textual variants, the organization of contextual information, data indexing, and so on, and that encompasses various typological series: video installation (single channel and multichannel), complex installations with video, live media, sound art, and also live networking, interactive pieces and net art and software art. With respect to complex installation forms, one can distinguish works in which the audiovisual component is present and at times prevalent (for example, in the multichannel installation *Women without Men*[13] by Shrin Neshat), from those in which it is not (as in the forementioned sculptural installation *Human Being* (2009) by Pascale Marthine Tayou). In the latter case, the digital techniques and preservation strategies must take into account the fact that the audiovisual component is only one of the constituent elements. Furthermore, the video component is present in various formats and not necessarily in line with the evolution of technology; in fact, it can deliberately be used in obsolete formats. Frequently, media artworks are systematically produced and installed with obsolete technology, as a response to what Rosalind Krauss has termed the post-media condition (Krauss, 2000; see also Baker 2002). Equally often, works produced with

now-obsolete technology are reinstalled with the use of current technological apparatuses (compare chapter 7.4). Contemporary media art is therefore characterized by the coexistence of numerous different formats and devices.

On one hand in the present historical-cultural context, digital technology finally makes it possible to disseminate the complete contents of libraries and museums (e.g., the European digital library, Europeana[14]), on the other hand, it presents certain difficulties with respect to archiving. First, there is the problem of "hyper-production," the proliferation of documents and the uncertainty that derives from this (it is not clear how the documentary function develops, what a document is, or how the selection and ordering of the sources develops). Second, there is the issue of the fragility and instability of the documents due to the obsolescence of devices and formats and the consequent economic sustainability for the care and management of the contents of digital libraries.

In the field of media art, such criticism seems to bring about a methodological divide between the progressive updates of information technology and the various subsequent applications in a series of procedural models that are unrelated to each other. This aspect is translated in the limited interoperability between archival databases, and can influence the future accessibility of the documents. The important results of international research (carried out by, amongst others, the PrestoCenter Foundation) do not seem to be able to adequately respond to the complexity of the practices of archiving and preservation required by media artworks in capacity of their documentary accessibility at any of the following levels:

– the construction of document contents;
– the interoperability of the procedure of the work's preservation through documentation practices;
– entry of the works to the archive through their documentary equipment;
– interoperability between various archival databases.

Regarding the documentation of media artworks, despite the recent increase in international networks between museums and research institutions to test and share the procedural models mainly concerning video art (*Media Matters*, Netherlands Media Art Institute) and the complex multi-media installation (*Inside Installations: Preservation and Presentation of Installation Art,* CULTURE 2000 / 2004-2007), the problem remains as to which methodology to adopt for time-based works and for performance and interactive works, and also for the complex installations in all their various typologies, not to mention for urban and architectural works in media art.

Regarding contemporary art's modes of existence, what can and must be archived in a digital library of complex works, according to which criteria, and in what order, still remains to be defined. How can we archive textual and contextual components in one aggregated complex of data and metadata so as to take into account the variability of the installations and their "plural immanences"? Which tools and methods do we need? In what way and according to which methods does the archive make the activity of documentation and conservation interdependent? How can technological assets of media artworks be recorded and how can their "transmission" be traced? How and according to which methodologies can the complex documentary aggregate of media artworks be made accessible and immediately usable?

These questions emphasize a dimension that can be seen as a function of the traditional archive: the transformation of a "work" into a "document." However, regarding the "digital library" and "digital preservation," further problems come to the fore: in fact, the documentary convergence in a digital archive of works that come from different media introduces a fundamental distinction – mainly regarding the work's audiovisual and interactive dimension – between "static or stable media formats" and "dynamic media formats." In the first example, it concerns a typology of files that translates artworks that are "closed" and "finished" at a display level into documents such as photographs, films, and video or audiovisual components of installations. In the second example, it concerns works that intrinsically consist of dynamic and variable "open" forms such as in the case of software art, where the composition process is continuously put in movement.[15] From a conceptual point of view, these "works" translated into "documents" in the archive will respectively function as "static documents" and "dynamic documents."

A web-based media artwork is itself also already a "digital object" that already operates on the basis of an archive, temporarily making up fragments of the archive; it is made from and is indiscernible from the same archive. In the case of these "born digital" works, their incorporation in the archive coincides with their documentation. Furthermore, the software used will be an intrinsic part of the data. In that sense, as Ernst describes, "When both data and procedures are located in one and the same operative field, the classical documentary difference between data and meta-data (as libraries, where books and signatures are considered as two different data sets) implodes" (Ernst, 2004: 51). In such cases the notions of "artifact," "product," "object," and "document" seem to disintegrate and, with them, the traditional concept of the "archive." On the one hand, regarding the information technology archiving system, it has become possible to keep the data, metadata, and enriched data separate – even through the employment of dedicated grid networks in which distinct layers coexist (one for the transmitting of data, the other for

communicating metadata). On the other hand, regarding the archived work, a documentary difference between data and metadata persists at a system of relations level (semiotic, philological, etc.) and relates to the cultural definition of the work as a document. The fact that the archiving procedure operates within the same information technology operative field in which data is placed opens up the possibility to research new modalities of relation (for example, regarding the visual component, or the research on the ontology of the images in movement, etc.)

In fact, the relational complexity of the media artwork has two major effects. First, these artworks cannot be digitally managed through the application of the traditional cataloguing device of the archive – that is, standard classifiers for homogenous typologies – without causing considerable loss of information. They cannot be digitally archived according to a simple typological distinction (such as video performance/performance art, installation art; net art; etc.) without this causing, at a historical and cultural level, a loss of the relational "meaning" or, rather, their interdisciplinary nature, within the field of contemporary art. Second, these works cannot be documented and digitally conserved when generic practices and procedures are applied – such as documentation, preservation, restoration, migration, and emulation – without this causing a reduction in complexity, or rather a loss of meaning.

The necessity to redefine the concept of "archiving" is clear when it comes to ensuring the continued accessibility of media art, as well as its conservation. As argued above, the digital archiving of media art will have a clear impact on cultural institutions and the art system as a whole. This is because in the environment of museums and exhibition centers, as Foster explains: "More and more the mnemonic function of the museum is given over to the electronic archive, which might be accessed anywhere, while the visual experience is given over not only to the exhibition – that is, as an image to be circulated in the media in the service of brand equity and cultural capital. This image may be the primary form of art today" (Foster 2002: 95).

The documentation and dissemination of our media-based artistic heritage requires a clear methodology. As with physical conservation, the work's complex installation configuration requires, at an archiving level, that the technological platform must be documented too. It follows that at a management level, it is the information technology that documents and preserves, "protects," and opens on to the interpretation of the documentary traces of the complex work. Hence, there is both a practical and theoretical necessity of settling some basic issues that concern the "dematerialization" of media artworks caused by digital technology.

THE "PROTOCOL" DEFINITION: THE CASE OF VIDEO ART

The digital archiving of media artworks requires finding a model that is able to manage the dematerialization process in the right way (in an ethical, philological, semiotic, and technological sense). However, the dematerialization produced by information technology does not have to be interpreted as "negation of materiality," but may be rethought as a new form of "relational materiality," not stabilized in a device (paper, film, etc.) but active in the flow of information (always becoming) which manifests itself (on the surface) according to transitory occurrences. In digital archiving practices the audiovisual component, be it analogue or digital, goes through a transformation, or *transcodification*. As a document, the audiovisual component cannot be revealed in its own medium (this is at least Wolfgang Ernst's argument, see 2004: 51).

Inasmuch as the practices of documentation and preservation refer to the origins of video art, the large migration of video artists' entire collections in the last decade[16] and the research relating to the processes of digitization (specifically highlighted in the FP7-ICT program 2007-2010) have made it clear that the digitization process produces a real transformation for at least two reasons. First, the conversion algorithms (and eventually the restoring algorithms), not to mention the compression algorithms, modify the digitized analogue audiovisual artwork according to the system and digital environment of the destination without establishing a correlation with the analogical environment that was the starting point. The latter can only be produced by the method, indexing, and construction of the documentary apparatus used in preservation (see chapter 6 of this book). Second, the receptive modality produces a strong transformation of the digitized work. This happens because, beyond the interface, it is based on complex database architecture. Furthermore, the works or the constituents of the analogical video work must be able to be "visualized" in the right way on displays that are variable both in dimensional and medial terms, as well as in terms of visual quality and expressive style.

Given such conditions, it follows that, in the absence of an internationally shared protocol, and in the presence of a high rate of obsolescence of digital technology, it would be an error to proceed in digitization by simply copying or migrating files into new formats. The evolution of the devices together with the immediate access to information and its "miniaturization" involve some codification standards, and all codification is a type of structuring that excludes the characteristics that are not "performable" in and by means of that model – it results in a progressive incapacity to transfer the information technology contents. In addition to the loss of data that might be caused by the types of compression, the same remediation system is involved in the loss of information. It is possible to minimize such losses by storing all contextual

information and metadata of the original documents.

Besides, if the history of a document's transmission is not maintained with respect to the various "traditions," it only takes one migration to produce a loss of information. After the digital transcodification in the following migration, route information can be lost at various moments in time, and this puts the integrity of the data at risk. At the very least, the information on what is corrupted from the original device is lost. For example, chemical analysis of the magnetic playback device is rarely carried out, which is compensated for by the procedure of photographic documentation. Therefore, the mold that might have attacked the device is no longer recognizable after digitization. As a consequence, the character of some of the deteriorations present in the digitized signal might no longer be detectable.

The original materials must definitely be preserved; the preserved digital copies, as far as possible, cannot be left out of consideration in the lifecycle of the original analogical work, especially since in the future it will be possible to extract "hidden" information that in the current state of information technology is not yet recognizable. And that is in relation to the double strategy involved in working for preservation purposes: on the one hand, it is necessary to maintain the work's documentary integrity; on the other hand, it's needed to act in the interests of its permanence using currently available technology, but it is desirable to proceed even in view of the technology that will exist in the future (see chapters 8.1 and 8.3).

The absence of shared protocols presents two types of risk, the one technological and the other cultural. From a technical viewpoint, the absence of shared standards creates problems in accessing documents (a historical example of such technological obsolescence are digital archives recorded on digital audio tape, DAT). More generally, it is not taken into account that the "migration" procedures require the transferring and copying onto new formats and devices, whilst the digital instruments necessary for reading are still supported. From a cultural point of view, the history of the transmission of the "document" can get lost. It is therefore necessary to adopt defined and shared criteria for the preservation of contextual information (to be understood as information "external" to the signal) and the metadata (to be understood as information that can be automatically extracted from the signal).

But this is not all. Also regarding the born-digital work, there is a problem of the method of archiving ("representation") and "preservation" ("codification"). It is, in fact, defined by the contents, the device and the format on which it was recorded. The trinomial of "data," "device," and "format," becomes inseparable in the work, and in its visual manifestation, giving these works a specific type of "scriptural" materiality that should be preserved.

The strategies of preservation, established and tested in some major

research projects (such as Inside Installations, DOCAM, Media Matters, and Aktive Archive), adopt the criterion of "variability" without testing and evaluating the procedures (both concerning migration and emulation practices). This criterion is governed by a re-interpretive logic that aims at the reproduction of the work's conceptual dimensions, regardless of "material" circumstances, using new "materials," new devices and new forms of visualization.

The "variability" criteria is intrinsically derived from digital-born media art. This can be deduced from two American influential theoretical guidelines, amongst others, which were defined in the research project Capturing Unstable Media (2003) and the important conference Preserving the Immaterial: A Conference on Variable Media (1998). "Instability" and "variability," although not corresponding ideas, are based upon the same concept: the immaterial "separation" that is produced between the depth of data and the surface (interface) that emerges when the work is being displayed.

As argued before, it is necessary to begin a reflection around the process of "dematerialization" informed by information technology: instead of theorizing a supposed "negation of materiality" it should focus on understanding what opens up "new forms of materiality" (Jiménez, 2002) or rather to begin a "rethinking of the multiplicity inherent in the material." The media artwork's translation and transfer into a digital form for documentary purposes, especially when it concerns audiovisual components, does not produce something immaterial, but assumes another type of materiality with different properties, rewritten from information technology codes (a "materiality" that occupies a physical space in the memory of the hard disk).

This alternative reflection allows for the double problem to be properly managed; the problem which arises when preservation work is being done. On one hand it is necessary to maintain the work's documentary integrity; on the other it is necessary to work towards its digital permanence (through checking, refreshing, and migration) utilizing currently available technology (see chapter 8.1). It follows that first, the criteria implied by the definitions of "variable media" (Depocas, Ippolito, and Jones, 2003) and "intermediate formats" (Bourriaud, 2009) do not seem in any way to resolve the problem of treatment (philological, historic documentary, aesthetic, see Brandi, 2005 [1963]) of inscription (recording) and "writing" of the work both at an ontological level (physical, chemical, electronic, and information technology inscription) and a functional (or socio-semiotic) level. Second, the concept of "original" defines a quality referred to as being "compatible," and "not equivalent," to the "original" version; also with respect to the media origin, this is concerned with the "integrity" of the work and with the conservation of the artist's intention, as well as the aesthetic and cultural history, which requires keeping the "history" of the transmission of the work to be documented.

All these aspects concern the redefinition of the new *material*, and not just *documentary*, status of the works themselves – or rather of their digital "translation" or "metamorphosis" for archiving preservation purposes. It is known that the system of "remediation" implied by the activity of archiving and digital conservation, or rather the current practices of migration and emulation, involves the risk of losing the textual aesthetic quality that can be minimized by way of the memorization of all the contextual data and metadata of the work or original document.

In particular regarding the audiovisual components of media art (or by extension any audiovisual work), the task of the protocols is to make the work's diasystem layers (Segre, 1979)[17] evident and sharable to guarantee cultural history, migration and emulation practices, as well as technical standards. In that sense, the presently widespread paradigm that removes the concept of the "unique original" must be rethought with a greater philological sensibility (even in a digital environment where, from a technical point of view, the distinction between "original" and "copy" has lost its meaning), just as one of the functions of the archive is to preserve the documentary *integrity* of the work. It must be taken into account the fact that remediation, variability, and migration are strategies able to guarantee not only the documentary but also the factual "permanence" of the complex work. In fact, as previously mentioned, the documentation – the constructive action of the media artwork's archiving – even has an effect on museum preservation and presentation. According to this line of thinking, the digital archive not only relates to the construction of the documentary dimension of media artworks, but also predetermines its strategy for preservation.

CONCLUSION: TRANSCODIFICATION

All the forms of media art subject to digital transcodification can maintain meaningful signs and the experiential glow of the original production context. For audiovisual works, such signs can and must be preserved by means of migration and/or emulation processes that adopt philological criteria, so that the work's material traces, expressive strategies, linguistic modalities, and perceptive modes can be restored in the form of digital documents or, more precisely, by means of an integrated set of digital documents. For all the typological cases in which contemporary media art presents itself, at a level of documentary archiving, the work ("*ergon*") must be preserved through digital remediation and also what surrounds and culturally "frames" it (its "*par-ergon*") or, rather, the interpretive and interactive modes, the strategies of use and the perceptive forms.

Regarding the present "preservation scenarios," in facing the risks associated with the different modes of failure and loss of information at a procedural and/or technological level, it is necessary to take into account, in a consistent, modular and interrelated way, the digitization process that puts the different formats of the works together as a whole workflow, with their *parerga* to document, preserve and archive. The preservation of the memory of the artwork's media origin, and therewith of the linguistic-expressive specificity of these media, concerns the concepts of digital archiving at different, but interrelated, levels. These are located at the moments of creating an integrated documentation and of conservation (such as migration and emulation). They are crucial functions of the digital archive, inasmuch as they relate to the construction of the document and must account for the verifiability of the sources, the authenticity of the data and the validation of metadata. It is necessary to know how to act in a preemptive way, prefiguring future developments in information technology with the aim of guaranteeing the integrity of data and metadata for the longest possible period. One must be aware of the totality or wholeness of the work, of its *integrity* and "material coextensivity" in order to be able to recreate the expressive complexity of media art on the basis of the documents that make up the digital archive.

From this point of view, in the context of the contemporary art system, where there is a progressive transformation of the digital library concept and continuous updating of the actions of digital preservation, it becomes more urgent than ever to develop a method and an ethic of the convergence of media artworks on information technology platforms, also for the purposes of an effective interoperability within the archive (and between different archives).

NOTES

1 Thanks to Sergio Canazza for his critical comments and suggestions regarding the area of information technology.

2 Both shown at the 53rd International Art Exhibition Venice Biennale, directed by Daniel Birnbaum.

3 See Prigogine and Stengers (1979).

4 See http://glossary.inside-installations.org. Last access: 11 May 2010.

5 Presented at documenta 12, at the Neue Galerie: http://amarkanwar.com/. Last access: 11 May 2010.

6 After the first exhibition at Ludwig Museum in Cologne (6 June 2002-1 September 2002), the second followed at the Musée d'Art Moderne de la Ville de Paris (10 October 2002-January 2003), and the third exhibition followed at the Solomon R. Gugghenheim Museum, New York (21 February 2003-4 June 2003). See Dusi and Saba (2012).

7 "Digital libraries represent the meeting point of many disciplines and fields, including data management, information retrieval, library sciences, document management, information systems, the web, image processing, artificial intelligence, human-computer interaction, and digital curation. This multidisciplinary nature has led to a variety of definitions as to what a digital library is, each one influenced by the perspective of the primary discipline of their proposer(s)" – http://www.dlib.org/dlib/march07/castelli/03castelli.html. Last access: 11 May 2010.

8 DELOS Network of Excellence on Digital Libraries website http://www.delos.info; the digital library Reference Model website http://www.delos.info/Reference Model. Last access: 11 May 2010.

9 Ibid., see note 7.

10 "The *content* concept encompasses the data and information that the digital Library handles and makes available to its users. It is composed of a set of information objects organized in collections. Content is an umbrella concept used to aggregate all forms of information objects that a digital library collects, manages, and delivers, and includes primary objects, annotations, and metadata. For example, metadata have a central role in the handling and use of information objects, as they provide information critical to its syntactic, semantic, and contextual interpretation" http://www.dlib.org/dlib/march07/castelli/03castelli.html. Last accessed: 11 May 2010.

11 See *DOCAM Terminology* http://archives.docam.ca/en/?cat=15. Last access: 11 May 2010.

12 These are the key components of installation works that must be described according to their relational, textual, and contextual devices – that is, according to a certain and determined communicative situation – and they must be recorded

not only with traditional photo and video documentation practices, but also with methods that consistently complement each specific technique (for example, documentation of space, video, sound, light, interaction with visitors/interactors, etc.) using specific devices such as 3D relief, laser scan for the systemic "mold" of data relevant to space, or virtual reality photography. See *Inside Installations: Preservation and Presentation of Installation Art*, CULTURE 2000/2004-2007.

13 The multichannel video installation *Women without Men* (exhibited in the Room of Caryatids at the Royal Palace of Milan in 2011) is structured through "episodes" (single-channel video installations): *Mahdokht* (2004), *Zarin* (2005), *Munis* (2008), *Faezeh* (2008), and *Farokh Legha* (2008). The artwork has a film version, the 2009 feature film *Women without Men*, based on the novel with the same title (of 1989), by the Iranian writer Shahrnush Parsipur.

14 http://www.europeana.eu.

15 See the NESTOR Network of Expertise in Long-term STOrage of Digital Resources – A Digital Preservation Initiative for Germany, http://www.langzeitarchivierung. de/Subsites/nestor/DE/Home/home_node.html. Last access: 20 July 2012.

16 See the projects *art/tapes/22 Collezione ASAC La Biennale di Venezia*, University of Udine, 2004-2007; *40yearsvideoart.de*, *Video Art in Germany from 1963 to the Present*, K21 Kunstsammlung, Dusseldorf 2005; *Rewind Artists' Video in the 70s & 80s*, University of Dundee and the Scottish Screen Archive, 2005.

17 See also the chapter "Testo," in *Enciclopedia*, vol. 14, 280. Turin: Einaudi, 1981.

REFERENCES

AA.VV. *Universal Archive. The Condition of the Document and the Modern Photographic Utopia*. Barcelona: MACBA, 2008.

Agamben, Giorgio. *In quel che resta di Auschwitz. L'archivio e il testimone*. Turin: Bollati Boringhieri, 2007.

Baker, George. "An Interview with Pierre Huyghe." *October* 110 (2004): 80-106.

Birnbaum, Daniel. *Chronology*. Berlin and New York: Sternberg Press, 2005.

Bolter, Jay David, and Richarch Grusin. *Remediation. Understanding New Media*. Cambridge, MA: MIT Press, 1999.

Bourriaud, Nicolas. *The Radicant*. New York: Lucas & Sternberg, 2009.

—. *Post Production. La culture comme scènario. Comment l'art reprogramme le monde contemporain*. Dijon: Les presses du réel, 2002.

—. *Esthétique relationelle*. Dijon: Les presses du réel, 1998.

Brandi, Cesare. *Theory of Restoration*. Translated by Cynthia Rockwell. Florence: Nardini Editore, 2005.

Canazza, Sergio. "I dintorni delle memorie sonore: un modello ipermediale per il trattamento dell'informazione documentale delle opere di musica elettroacustica."

In *Ri-mediazione dei documenti sonori*, edited by Sergio Canazza and Mauro Casa-
dei Turroni Monti, 95-123. Udine: Forum, 2006.

Casetti, Francesco. "Esperienza filmica e ri-locazione del cinema." *Fata Morgana* 4
(2008): 23-40.

Cassirer, Ernst *Philosophie der symbolischen Formen, I, Die Sprache*, Oxford: Bruno Cas-
sirer, 1923.

Connatry, Jane, and Josephine Canyon. *Ghosting. The Role of the Archive within Contem-
porary Artist's Film and Video*. Bristol: Picture This, 2006.

De Baere, Bart. "Potentiality and Public Space. Archives as a metaphor and example
for a political culture." In *Interarchive. Archivarische Praktiken und Handlung-
sräume im Zeitgenössischen Kunstfeld/Archival Practices and Sites in the Contempo-
rary Art Field*, edited by Beatrice von Bismarck, Hans Peter Feldmann, and Hans
Ulrich Obrist, 105-112. Lüneburg and Cologne: Verlag der Buchhandlung Walther
König, 2002.

De Certeau, Michel. *L'Écriture de l'histoire*. Paris: Gallimard, 1975.

Deleuze, Gilles. *Qu'est-ce qu'un dispositif?* Paris: Éditions du Seuil, 1989.

Depocas Alain, Jon Ippolito, and Caitlin Jones. *Permanence Through Change. The
Variable Media Approach/La permanence par le changement. L'approche des médias
variable*. New York: Guggenheim Museum Publications / Montreal: The Daniel
Langois Foundation for Art, Science and Technology, 2003. Available online – a
http://variablemedia.net/e/preserving/html/var_pub_index.html. Last access: 20
July 2012.

Derrida, Jacques. *Archive Fever. A Freudian Impression*. Translated by Eric Prenowitz.
Chicago: University of Chicago Press, 1995.

Didi-Huberman, Georges. *Quand les images prennent position. L'oeil de l'histoire*, 1,
Paris: Éditions de Minuit, 2009.

Dusi, Nicola and Cosetta G. Saba (eds.) *Matthew Barney. Polimorfismo, multimodalità,
neobarocco*. Milan: Silvana Editoriale, Cinisello Balsamo, 2012.

Elsaesser, Thomas. "Fiona Tan: place after place." In *Fiona Tan – Disorient. Dutch Pavi-
lion, La Biennale di Venezia*, edited by S. Bos, 2.20-2.33. Heidelberg: Kehrer, 2009.

Ernst, Wolfgang. "Underway to the Dual System. Classical Archives and/or Digital
Memory." In *Netpioneers 1.0. Contextualizing Early Net-based Art,* edited by Dieter
Daniels and Gunther Reisinger, 81-99. Berlin: Sternberg Press, 2010.

—. "The Archive as Metaphor. From Archival Space to Archival Time." In *Open 7. (No)
Memory. Storing and recalling in contemporary art and culture*, edited by Jorinde
Seijdel and Liesbeth Melis, 46-52. Rotterdam: NAi Publishers, 2004.

Ferraris, Maurizio. *Sans Papier. Ontologia dell'attualità*. Rome: Castelvecchi, 2007.

—. *Documentalità. Perché è necessario lasciar tracce*. Bari: Laterza, 2009.

Foster, Hal. "An Archival Impulse." *October* 110 (2004): 3-22.

—. "Archives of Modern Art." *October* 99 (2002): 81-95.

Foucault, Michel. *The Archaeology of Knowledge and the Discourse on Language*. Translated by A.M. Sheridan Smith. New York: Pantheon Books, 1972.

Genette, Gérard. *L'Œuvre de l'art. Immanence et trascendance*. Paris: Éditions Seuil, 1994.

—. *Palimpsestes. La litérature du second degré*. Paris: Éditions du Seuil, 1982.

Jameson, Fredric. *Postmodernism, or, The Cultural Logic of Late Capitalism*. Durham, NC: Duke University Press, 1991.

Jiménez, José. *Teoría del Arte*. Madrid: Editorial Tecnos, 2002.

Krauss, Rosalind. *A Voyage on the North Sea. Art in the Age of the Post-Medium Condition*. London: Thames & Hudson, 2000.

Merewether, Charles, ed. *The Archive*, Cambridge, MA: MIT Press, 2006.

Noordegraaf, Julia. "Displacing the Colonial Archive. How Fiona Tan Shows Us 'Things We Don't Know We Know'." In *Mind the Screen. Media Concepts According to Thomas Elsaesser*, edited by Jaap Kooijman, Patricia Pisters, and Wanda Strauven, 322-333. Amsterdam: Amsterdam University Press, 2008.

—. "Facing Forward with Found Footage: Displacing Colonial Footage in Mother Dao and the Work of Fiona Tan." In *Technologies of Memory in the Arts*, edited by Liedeke Plate and Anneke Smelik, 172-187. Basingstoke: Palgrave Macmillan 2009: 172-187.

Panofsky, Erwin. "Die Perspektive als symbolische Form." *Vorträge der Bibliothek Warburg 1924-1925*. Leipzig and Berlin: Teubner, 1927.

Parfait, Françoise. "L'installation en collection." In *Collection Nouveaux médias – Installations. La collection du Centre Pompidou*, edited by Collectif Centre Pompidou, 33-36. Paris: Éditions du Centre Pompidou, 2006.

Prigogine, Ilya, and Isabelle Stengers. *La Nouvelle alliance. Métamorphose de la science*. Paris: Gallimard, 1979.

Ricoeur, Paul. *Das Rätsel der Vergangenheit. Erinnern – Vergessen – Verzeichen*. Göttingen: Wallstein, 1998.

—. *La Mémoire, l'histoire, l'oubli*. Paris: Éditions de Seuil, 2000.

Saba, Cosetta G. (ed.). *On Media Art. A Rewarding Anthology*. Triest: Errata Corrige, 2012.

Segre, Cesare. *Semiotica filologica. Testo e modelli culturali*. Turin: Einaudi, 1979.

Spieker, Sven. *The Big Archive – Art form Bureaucracy.* Cambridge, MA: MIT Press, 2008.

PART II

ANALYSIS, DOCUMENTATION, ARCHIVING

INTRODUCTION

Julia Noordegraaf

After having discussed various historical and theoretical approaches to understanding the complexities of media art in part one, the second part of this book focuses in more detail on analyzing, documenting, and archiving media art. Before being able to identify appropriate strategies for preserving and restoring film-, video-, or computer-based artworks – the topic of part three – or determining suitable exhibition modes – discussed in part four – it is necessary to first capture the exact nature and appearance of the original work.

Whereas the conservation, restoration, and exhibition of classical artworks like painting and sculpture generally primarily raises material problems (investigating the types of materials used, determining the best lighting conditions, etc.), the preservation and exhibition of contemporary time-based media artworks also raises the more fundamental question of exactly where to locate the work. For example, if an artist uses television consoles from the 1970s in an installation, like Miquel-Ángel Cárdenas in *25 Caramboles* (1979/80), can one replace them with contemporary flat screen monitors in a contemporary exhibition (see Van Saaze/NIMK, 2003)? In other words, before being able to decide on preservation and exhibition strategies, a conservator or curator needs to reflect on which material or conceptual components are most relevant for doing justice to the work.

Chapter 5 provides a reflection on the process of describing and analyzing media art, and aims to provide the reader with concrete tools for capturing the identity of media artworks. The analysis of media artworks is aimed at develop-

ing a rational argument which tries to reflect upon the works' configurations and sharable meanings. This is crucial in the practices of conservation and exhibition, both highly dialogical processes involving conservators, curators, the artist(s), and specialists (such as programmers, technicians, laboratory staff, etc.). The analysis of artworks is aimed at describing and interpreting the coherence between their material organization and conceptual layers, as well as linking them to the larger cultural and social contexts in which they appear. This chapter provides a clear road map for analyzing media artworks by distinguishing four moments of analysis: description, analysis, interpretation, and judgment. This four-step analysis is demonstrated with the help of an analysis of Harun Farocki's video installation *Workers Leaving the Factory in 11 Decades* (2006).

Chapter 6 focuses on one of the key elements in the preservation and reexhibition of media artworks: documentation. Because of their reliance on technologies that are subject to rapid obsolescence, as well as their often process-based, performative, and/or interactive nature, media artworks rely for their survival on documentation of their creation, exhibition, appearance, functionality, and experience. As argued in the first section of chapter 6, performative works like *Uncle Roy All Around You* (2003) by Blast Theory can only be recreated when the documentation created by the artists is taken into consideration. The artist interview, demonstrated in section three with reference to the audio-installation *Mbube* (2005) by Roberto Cuoghi, is a strategy for obtaining information on the creation process where documentation is lacking. Sometimes documentation is the only thing that is left of a work, as in the case of the ephemeral work *e così sia...* (2000) by Bruna Esposito discussed in section four, where the video documentation comes to stand in for the lost original. Finally, Van Saaze's ethnographic study of the acquisition by the Van Abbemuseum of *No Ghost Just a Shell* (1999/2002) by Pierre Huyghe and Philippe Parreno in section two of this chapter shows how the specific limitations of a museum's content management system can impact the way an artwork is defined, demonstrating the need to consider documentation in the wider, institutional context of describing, analyzing, and archiving media artworks.

REFERENCE

Van Saaze, Vivian, and Netherlands Media Art Institute, Montevideo/TBA. "Reader
– Of Reinstallation and Preservation of *25 Caramboles and Variations: Birthday
Present for a 25-Year Old* (1979/80), Miguel-Ángel Cárdenas, Collection Stedelijk
Museum Amsterdam." Report on this case study in the research project *404
Object Not Found: What remains of Media Art?* and the exhibition *Thirty Years Dutch
Video Art,* 11 January-8 March 2003. Amsterdam: Netherlands Media Art Institute
and Montevideo/TBA. Available online – http://nimk.nl/_files/Files/cardenas_rap-
port_nimk_en.pdf. Last access: 12 July 2012.

CHAPTER 5

The Analysis of the Artwork

Dario Marchiori

While the Greek etymology of analysis means "dis-solution," analysis as a thinking practice (which has been theorized since the ancient times, initially in the realm of geometry[1]) involves the related idea of a "breaking up"[2]: the first experience of it may be considered that of a child breaking a toy to understand its internal structure, and the way it works. Modern thought has reinforced this "decompositional" conception of analysis, which "found its classic statement in the work of Kant at the end of the eighteenth century" and "set the methodological agenda for philosophical approaches and debates in the (late) modern period (nineteenth and twentieth centuries)." (Beaney, 2012)[3] Hegel asserted the importance of analysis within the movement of thinking itself:

> Analysis of an idea, as it used to be carried out, did anyhow consist in nothing else than doing away with its character of familiarity. To break up an idea into its ultimate elements means returning upon its moments, which at least do not have the form of the idea as picked up, but are the immediate property of the self. Doubtless this analysis only arrives at thoughts which are themselves known elements, fixed inert determinations. But what is thus broken up into parts, this unreal entity, is itself an essential moment; for just because the concrete fact is self-divided, and turns into unreality, it is something self-moving, self-active (Hegel, 1910: 30).

As Hegel does here, philosophy often links analysis to synthesis (mainly by opposing them, see Hügli and Lübke, 2005): deconstructive and reconstructive processes are two moments within the process of thinking, as René Descartes' *Discourse on the Method* (1637) clearly stated. But art is not philosophy, and the analysis of the artwork has to reject philosophical drives to abstractness (as

stated by Descartes: "analysis shows the true way by means of which the thing in question was discovered methodically and as it where a priori" (in Cottingham, Stoothof, and Murdoch, 1985: 110)). Contemporary artwork's analysis has a more particular aim: to understand the way the artwork works, which in its broader sense implicates also the specific way of thinking it is able to create. It is important to notice, together with Hegel, the importance for analysis to move from (*aufheben*) what we already know (*Bekanntsein*); but also the need to recognize the dynamic dimension proper to every "idea" or, we will say, of every artwork.[4]

The understanding of the artwork is a multifolded process, starting from the direct experiencing of it, and its relationship to our sociocultural "horizon of expectations" (Hans-Robert Jauss, 1982). The artwork's configurations and structures will last within memory, both nourishing new experiences in life and informing the reception of other artworks. Being processes, psychological perception and mental cognition develop in time, so that memorial structures (formal memory), their displacements or shifts (migrating memory), as well as dialogue and intellectual debate are at stake during the whole comprehension of the artwork. While all contemporary art may be understood in relation to the "media world," analyzing media art is a practice intended to understand a specific kind of artwork, the media artwork, that is, the most common form of art of our times. Media artworks will here be understood as works of art involving links, overlaps, and transformations between and beyond different mediums, giving particular attention to the most recent ones.

Analysis tries to reach a better understanding of the artwork through a rational (explicative and falsifiable) argumentation,[5] which tries to reflect upon its general configuration and its shared or sharable meanings. Experience and memory become now a less important element, while the attempt to embrace the entire work through methodic instruments becomes the main issue. Although the field of art is not considered a "scientific" domain, analysis bets the artwork to be a rational process, which organizes its form and content, solving some problems and bringing about new ones. Analysis finds out the artwork's material organization and its internal work, be it a conscious or an unconscious process. Analysis restricts the part of the institutional producer and that of the singular receptor, and focalizes onto the work itself as a disposition and interaction between different (homogeneous or heterogeneous) material elements that link them to a larger cultural and social context to be interpreted.

Ideally, analysis gives the same importance to every element of the artwork while trying to find an interpretative path. At the same time, the reading of the artwork cannot be independent from the interpretation we give to it, and the questioning of that relation is the motive behind analysis. The first

step in analyzing an artwork is an adherence to the artwork: being close to it justifies the necessity of a respectful descriptive basis, while the interpretative act is concerned with the matter of the artwork. On the other side, analysis cannot be a pure objectivist explanation. It inevitably contains what Martin Heidegger defined as a "violent" moment: the effort, through interpretation, to grab an unsaid secret from the artwork (Heidegger, 1962).

We may also consider, more generally, that the analyst has to trace its own path within the artwork, inscribing the unavoidable necessity of a subjective drive, and of the analyst's desire (as Jacques Lacan proposed in his reinvention of psychoanalysis, see his 1964 article "Du 'Trieb' de Freud et du désir du psychanalyste" (in Lacan, 1966)) and pleasure/bliss (as Roland Barthes did in his post-semiotic activity[6]). Nevertheless, everything in analysis is geared towards an objective consideration of the artwork: to discover shared questions and to link together internal (to the particular artwork) and external contents. Proceeding from a scientific drive, the analysis of the artwork participates in an ideal of shareable rationality, belonging to the long tradition of the Enlightenment project and to immanent, inductive methods in post-Galilean science; along this path, the place of the observer, his/her desire, and subjectivity have assumed an increasingly important place in the analytical process, sometimes shaking analysis' basis and legitimacy. That is the contemporary tension between objective and subjective drives within an analytical process.

As we will see throughout this chapter, the analysis of an artwork develops through four distinct, although interconnected, moments: description, analysis, interpretation, and judgment. All of them are consubstantial to the analytical process, even if to different extents. Their order is going from the more objective to the more subjective, so that interpretation and judgment are more debatable steps in the analytical process. We could simplify the main questions advanced within analytical moments as follows: what? (description), how? (analysis), why? (interpretation), what for? (judgment). The first three steps may be somewhat compared to the three levels of signification within an artwork, as proposed by Erwin Panofsky (1972):

1. Primary, or natural subject matter: it corresponds to simple denotation, factual recognition of elements, like figures and motifs in painting (pre-iconological level);
2. Secondary, or conventional subject matter: linked to cultural codes, it allows the viewer to recognize connotative meanings such as, for instance, symbols or allegories (iconography);
3. Tertiary, or intrinsic meaning: giving a whole interpretation, it explains the way an artwork is made according to its social and historical context (iconology).

Within the analytical process, we may consider the simple level of recognizing figures and forms as developing through description; then we try to understand the structure and functions within the artwork, reorganizing its matter according to some great axes, already opening to interpretation (the conventional subject matter already implicates an interpretative act in Panofsky's system); finally, we consider cultural significations according the particular forms and processes of the artwork (corresponding, in a way, to Panofsky's "tertiary" meaning).[7] Panofsky's iconology is adapted to understand a particular moment in the history of painting and to link it to cultural history, while media aesthetics has to follow its own characteristics and to wonder about its contemporaneousness to the artworks it is trying to understand. Nevertheless, both models share the search for precise, rational criteria and for in-depth discursive explorations of the artwork. To Panofsky, the three levels of meaning are meant to be autonomous from the artist's expressive intentions, transcribing non-subjective issues and aiming for "objective" explanations. Analysis, too, tries to reach an objective status through logical (inductive/ deductive/abductive) arguments, but it is more and more open to the analyst's subjectivity and to interpretative pluralism. As we will see, my proposition about "judgment" as a necessary foundational moment within analysis will try to synthesize those issues.

Let us now begin our path through artwork's analysis. Each section will be followed by examples of description, analysis, interpretation, and judgment, respectively, conducted by "le Silo," a group of French scholars studying the interactions between arts; they chose to study Harun Farocki's video installation *Workers Leaving the Factory in 11 Decades* (2006) (see Fig. 5.1 in color section).[8]

1. DESCRIPTION

Describing is a process of translation,[9] mainly into verbal mediums: it involves the passage from media artwork's own semiotic characteristics into words, that is, from "secondary modeling systems" into the primary one, natural language (Lotman, 1977).[10] Description combines meaningful concentration and faithfulness, in order to give a simple and homogeneous recollection (mental image) of an object, person, event, activity, or process (or parts of them). Within our discourse, its function is to prepare the analytic gesture, without considering other possible aims like preserving, cataloguing or archiving the artwork. Ideally, description does not explicate, it is a simple account: that means to represent the artwork's form and content to a public interested in understanding it better and more deeply through analysis. But description

maintains a relative "opacity" to interpretation: while inevitably selective, it aims to be "meaningless" and, like Panofsky said elsewhere, it shall be considered something like a "stupid" operation. But "stupid" comes from the Latin word *stupor*: description is a constant oscillation between trying to fully transcribe the artwork, to reveal its details and internal links, and to respond to the initial astonishment it may (or may not) have given to us. Description itself has a heuristic value, for instance, when trying to discover aspects of the artwork that a first contact could have left unobserved, or that seem to be unconscious (which could be used for "symptomatic readings," as we will see). Description means both a representation of the artwork and a patient spread of its details, to which the same attention and relevance are owed. The result is a first step towards going beyond what Hegel called *Bekanntsein*.

Description is a process of mediation, because it translates from one medium to another and from one language (or type of language) to another. Moreover, description is both reduction and addition, if compared to the media artwork. It reduces, because it transfers several elements, heterogeneous languages and mediums into one, generally written and homogeneous discourse; moreover, it gives often more relief to the artwork's topic, proposing a sort of summary of it. On the other side, it adds to the text a detailed attention to its elements, similarities, and configurations, in order to support the paradoxical "discovery of what is there," which is proper to analytical work. Describing may also be, in that sense, a much more "extended" operation than the original artwork: for instance, the detailed description of every element of a movie could take several weeks, and fill several thousands of pages.

Description involves closeness to the artwork, ideally, as if we were describing each particular element of it. Usually, according to speech organization and writing's characteristics, analysis develops itself in a linear way, following the temporal order of the artwork's reception, be it promoted by the medium (like in movies, dramas, symphonies), by the artwork's internal structure (e.g., historical paintings, old multimedia apparatuses like religious temples), or by our own "reading" of it (when analyzing multimedia apparatuses, like installations, interactive artworks, and even exhibition spaces like museums). Schemas may help to give some structural precision and fast visualizations, but they are already linked to a further step in analysis, the explicative reorganization of the matter revealing its structure, functions, and (per-)formative principles.

An artwork may be described as organized matter (even in conceptual and imaginary art, some materiality always remains) presented as a piece of art and organizing different elements, ideas, formal characters, and functions. In contemporary art, the contextual elements have become more and more important, reaching a sort of constitutive character "within" the artwork.

Questioning the active involvement and the role of the artist (or, more generally, the artwork's production), the status of the public (visitors, spectators, listeners, and so on), and introducing into the artwork process what Gérard Genette (1997) defined as "paratexts" (like manifestos, statements, social events around the artwork), contemporary art reinvents the status and borders of the artwork and redefines the rules of analysis. Description involves compromising between all these different actors and to consider also, beyond the "plot" and the formal structure, their intermediations, circulations and interactions. Media artwork proceeds from a specific aesthetical approach that needs specific language to be described. Its very apperception is often processional, and the description we make is linked, but not limited, to our experience of it (one which may also modify the artwork itself, like in interactive art).

The main criteria for the description of media artwork may be summarized as follows:

a. immanence and adherence to the object (literalness);
b. language adequacy (pertinence of translation);
c. dynamic adequacy (pertinence of variation);
d. meaningful concentration and extension (summarizing, skipping, condensation; attention to details, intensification of perception, precision);
e. recognition of unsaid, implicit and repressed elements (retracing traces).

An Example of Description by "le Silo"

On the floor, twelve monitors of the same size show moving images. They are lined up and form a barrier of light emerging from the obscurity in which the installation is most often bathed. Across a distance of a few meters, a bench is available for those who want to sit to watch the images. A film sequence has been assigned to each monitor. For the sound sequences (six in all), headsets allow visitors to listen to the soundtrack.

From left to right, monitors display film sequences that cover the history of moving images from their inception to the contemporary period.[11] The first two monitors, devoted to the first decade of cinema, show two early films, one by the Lumière brothers (1895), the other by Gabriel Veyre (1899). Each monitor then singles out a different decade, represented by a selected sequence. This temporal journey has specific formal implications: it makes it possible to perceive evolutions, transformations, constants. The passage from black and white to color, the gradual arrival of sound, the diversity in the types of

images, documentary or fictional, or even coming from advertising – Farocki's sampling from this huge ensemble of images offered by cinema includes both minor images (commercial, or banal images) and more canonical ones.

What do these images show? A commonplace setting more or less easily identifiable: the gates of the factory, their immediate surroundings, crossed by the workers differently depending on the period and the type of images. A fixed set, a common stage which crowds come to cross and qualify: fleeing bodies (the Lumière brothers), enslaved bodies (Fritz Lang), imprisoned bodies (Slatan Dudow), fighting bodies (D.W. Griffith); or singular faces piercing through a logic of masses, that of Chaplin in *Modern Times*, that of Monica Vitti as the "witness" of *Red Desert*, that of the female worker at the Wonder factory refusing to go back to work after the strike. "Leaving the factory" is the motif these images endlessly replay in the formal brilliance of the sequence, a kind of crystalline unity for the history of cinema – from both the standpoints of meaning and form, as we will see. Short, long, condensed, figurative, literal, documentary, fictional, heavily edited, or lightly edited, these sequences literally show the critical power of cutting.

2. ANALYSIS

The second phase is that of "analysis," strictly speaking. The analyst tries to understand the structure of the artwork, to make explicit the functions of its components, to explain its operational processes. Coming from the scientific field, the notion of "analysis" also implicates following a method, ensuring internal coherence. Analysis's methodical principles may be discussed, corrected and reinvented through an analyst's argumentation, but s/he has to be aware of its methodical assumptions, and to avow them as far as possible. You may also try to question the very basis of the analysis, discussing its criteria, but the operational moment – applying principles following a coherent strategy – has to be maintained. To be sure, a media art analyst should be attentive, sensible, and responsive to the interactions between different mediums, to the constitutional differences in terminology, and the way different elements interact (or not) in the whole structure and experience of the media artwork. Such an activity demands many different capabilities, both specific to single mediums and articulating in interplay.

The following schema gives an overview of some methods that may inform the analysis of the artwork:

a. methodical analysis (following a specific analytical method: iconological,[12] structuralist,[13] formalist,[14] Marxist (Marx and Engels, 2006), sociological,[15] semiotic,[16] psychoanalytic,[17] etc.);

b. homothetic analysis (to follow the method that seems the most pertinent to analyze a specific artwork: for instance, Marxist analysis for Marxist artworks, non-psychoanalytic methods for Classical Greek tragedy);

c. combined, crossing, dialectical analysis (practicing two or more methods);

d. immanent analysis (to refuse or deny any existing methods in order to stay close to the artwork's material to find internal analytical truths).

Since Descartes, analysis is linked to the drive for simplification, for reduction. The Latin translation[18] for the Greek word analysis was *resolutio*, which stresses the importance of "solution", actualized by the cognitivist "problem-solving" model.[19] While description tries to "break up" each particular element and to ignore teleological and interpretative a priori, the properly analytical moment introduces a drive for classification, aimed to understand the structure, principles, and rules of the way an artwork "works." That means according to the specific way the artwork displays itself, linking its preparation to its reception: this way, analysis tries to represent the media artwork according to its apparatus and to the process it involves, not only dealing with it as a physical object.

William Kentridge's recent exhibition in Paris[20] was a major example of media dialectical integration, which aims to establish a form of consistency between different mediums while preserving a deep knowledge of each of them. Kentridge's work, beginning with painting and theater went on connecting together drawing, animation, film, and video in a particular environment experienced in time. Within that exhibition, each room set a particular environment and way of reception in time and space: in the first room, three artworks were reshaped in three contiguous spaces, articulating video projection, music and mechanical puppet theater in a theater-like setting with a seated audience: a fragmented, dialectical "total artwork" to achieve a *Trauerarbeit* for the bloody 20th century; the second room linked eight projections on the four walls (3+1+3+1 "screens") of the piece's perambulatory space, generating various possible positions, for example, consecutive lecture, side-by-side analysis of two or three projections, and mirrorlike study of opposite-sided projections; the third room offered a simpler apparatus using a rotating zoetrope-like anamorphic display of turning projection. To Kentridge, art expresses the "impermanence and improvisionality of the world": in a similar way, such aesthetics create impermanent apparatuses, varying the relational connections for the visitor, and offering him/her different mediums linked to different epochs (from drawing to opera, from eighteenth-century visual toys

to digital projections, and so on), that interact in a "contemporary" cultural reshaping. Analysis has to find out regularities and irregularities within the perceptive whole, and to give an order to its going back and forth between different scales of understanding it. Media artwork creates a circulation between homogeneous or heterogeneous elements.

An Example of Analysis by "le Silo"

For *Workers Leaving the Factory in 11 Decades*, Harun Farocki did some research for one year. He thoroughly tracked down the cinematographic theme of workers leaving the factory. His project involved three decisive moments: inquiry, cutting/sampling, and montage. His montage work includes, on the one hand, the analogical association of individual figures through excerpts and, on the other hand, the material assembly [*montage* in French, translator's note] of the installation in the exhibition room. Through which process does the analysis of twelve preexisting moving images compose a synthesis with its own logic and syntax, conveying a meta-sense both new and implicit in each of the constituent parts? The question determines one of the possible angles in the analysis of the work.

Each moment in the production of the work refers to a distinct gesture. The first step in its production was the moment of documentation and historical inquiry. Through the history of cinema and moving images, Farocki set out to look for formal, stylistic, or ideological traces of one of the founding motifs of cinema. The second moment was that of the selection of excerpts and their sampling. This purely analytical gesture allowed him to distinguish between the similarities and the differences in the various excerpts. Finally, editing the excerpts within a new entity constituted the third moment in the work. Farocki put in place a demonstrative system at once paradigmatic and syntagmatic: paradigmatic because of the expressive variety of a single figure; syntagmatic due to the logic of chronological progression and technical improvement accomplished by cinema and perceptible in the succession of excerpts. On the one hand, the installation thus compresses time thanks to the narrative of a few episodes in the history of a specific cinematographic figure; on the other hand it infinitely stretches and prolongs the time of the repetition of the same figure. In short, Farocki proposes a new temporality, that of anachronistic viewing, both microscopic and macroscopic, between (the contents of) each individual image and (those of) the totality of images featured in the installation. The different durations of the excerpts make each screen vibrate with its own rhythm, adding to this double temporality and reinforcing the irregularity of the rhythm of the whole.

The core of Farocki's work is located at the very place of this articulation, at the intersection of a reflection on history and story, the local and the general, analysis and synthesis, the production of new meanings and the reproduction of old ones. The focal point in his process is the camera. From the Lumière camera to contemporary surveillance cameras, Farocki emphasizes a type of look deprived of subjectivity and consciousness. Behind the figure of the workers leaving the factory, the artist makes an inventory of the cameras filming them. Full-face, from behind, or in their midst, cameras confront workers in movement, let them move away or follow them. They fix them from afar or cling to their movements. Cameras then pass before or behind the boundary separating the factory from the street, placed at this intermediate space of the gates. They occupy the borderline, a virtual dividing line which points to a qualitative shift, the passage from one scale of values to another, rather than it separating two entities of a similar nature. The camera thus plays the part of a transformer. Situated in the space "between," it negotiates the change from the time of production to the time of leisure, and from the body of the anonymous crowd to characters.

3. INTERPRETATION

Having understood the structure and functioning of the artwork, the question of its interpretation comes to the foreground. For sure, interpretation is at work since the very beginning of the analytic path, and informs the single words and concepts we use, and the order of discourse itself. The very idea of understanding the artwork as an organized whole involves a complex play of evidence, assumptions and codifications: no "pure" description or analysis can be done, because that process simply cannot exist without our presuppositions, our desires, even our alienation, hidden behind technical, "objective" language. But description and analysis, as we have defined them, are also efforts to stay beyond interpretation, to resist to the temptation of imposing a meaning, to suspend the explanatory drive. The analytical process is a back-and-forth process linking distinct moments of the comprehension of the artwork in a coherent whole.

Interpretation is a very ancient practice we find in ancient Greece, one which finds in Hermeneutics its own discipline: the Greek god Hermes was the "messenger," the go-between different worlds, mostly divine and human ones. But he also was the god of commerce and trickery: interpretation has to do with truth and falsity, with communicative ambiguities and making sense out of them. Hermeneutical theory is historically linked to the public organization of meaning, that is, to power and ideology, mostly related to sacred

texts, like in Jewish and Christian biblical exegesis. A great separation informs two main interpretative strategies, searching for – if we use medieval categories – literal or spiritual (e.g., metaphorical, allegorical, unspoken) meanings: such an opposition was represented since the beginnings of Christianity by the Antiochene and Alexandrine schools, the latter centered on the recognition of allegories, the former not willing to transcend literal meanings. Medieval theology has formalized the interpretation of the Scriptures according to these two main senses,[21] unfolding the spiritual one in a "threefold division." This gives four levels of meaning in the text: literal (or historical) sense on one hand, and allegorical, tropological (moral), and anagogical senses on the other hand.[22]

Let us consider, for instance, Aldo Tambellini's black-and-white piece *Black* using 1,000 slides, 16mm film, TV managers, and 30 children. This is his contribution to the early "video art" TV broadcasting produced by David Oppenheim, *The Medium Is the Medium* (1969). In order to reflect upon the "social concept" of Blackness and to show (Black) power, he made a series of works both using different mediums and mixed media, as in this case. Our interpretation of the broadcasted piece may be literal, close to the formal matter, to the interplay between and beyond mediums, to the articulation of figuration and abstraction, and of stillness and movement; but we may also be making meaning out of its philosophical and ideological implications, the research of Black's beauty as a means to express Black people's issues; the use of negative images of the children to make a sort of Hegelian "negation of negation," to move beyond representation but also against the idea of Black people as the opposite of "civilization"; the insistence on circular motifs as a mean to express the reference to the vision (the eye), and to link cosmic images to almost documentary ones; the use of visual pulsation as an energetic drive mixing video and film potentialities; the use of mixed voices of Black children to express the pluralistic openness and dynamism of an emerging subject in history, fighting for freedom and self-determination.

Modern hermeneutics as a study of interpretation deployed itself as the attempt to explain an artwork's hidden significations.[23] Laicization of hermeneutical practices extended religious exegesis into philology, trying to find out the original text from different versions of it (i.e. its "tradition"). In occidental traditions, the written text remains the main object of interpretation, but it progressively enlarged into a larger "semiotic" frame, involving every possible search for meaning within communicative contexts. A new polarization arose in modern hermeneutics between "objectivist" and "subjectivist" interpretations, the former considering the autonomous existence of a text according to the author's intentions, the latter involving the reader as the main actor of interpretation. This opposition between drive for "meaning" and drive for "sig-

nificance" was formalized, for instance by Eric Donald Hirsch, Jr., defending the second option against the dominant formalism of New Criticism's "close reading" of the text. Such an opposition seems to reproduce that between two different fields, involving specialized jobs: critics, and academic research. The contemporary cultural field partially blurs such a separation: artworks themselves often propose their own explanations, and interpretative practices articulate increasingly subjective and objective drives. Interpretation is no longer seen as an intellectual, abstract operation, while senses, especially in the case of media environments, play a more important role; they just shall root themselves in objective configurations and develop through argumentative discourse to remain within analysis's expanded frame. In a period of modernist "freezing" of modernity as an historical ideology, Susan Sontag (1966) stressed such a need for sensual lectures of art (an "erotics of art"). While acting like a reaction against dogmatic and univocal theories, this criticism goes beyond the need for restoring the subjective dimension of critical writing, but it is also important for analytical purposes. In our "postmodern" times we have the opposite problem: a sort of dictatorship of the emotional, a new Superego dogma created by contemporary capitalism that Slavoj Žižek repeatedly formalized as the "injunction to enjoy."

Philosophers like Wilhelm Dilthey, Martin Heidegger, and Hans-Georg Gadamer mostly represent contemporary hermeneutics as an enlarged practice of interpretation. They established the notion of the "Hermeneutic circle" as a back-and-forth process between explicit and implicit meaning, linked by Heidegger to the personal experience of the interpreter. So, hermeneutics shapes a new place for the visitor, spectator, and analyst him-/herself: Gadamer's idea of art as a "representation for" someone opens the way to contemporary forms of "relationality" (Bourriaud, 2002). The social and political impact of a media artwork tends to go beyond the limits of the art field and to involve "real" life, often while using "virtual" technologies such as digital platforms to achieve it. Such a theory of media involvement in everyday life as an "extension" of the human field finds its origins in Marshall McLuhan's "communicative" – more than simply "communicational" – utopia, intended to abolish the distinction between artistic mediums and socio-political media: technologies become the main operators to create "communities." Having involved into the media artwork, the process of interpretation displaces itself from simply decoding and making sense from a formal configuration, and wonders about the social implications, relational questions, and temporal (Birnbaum, 2007) evolutions of the artwork.

As I mentioned, the artwork itself may contain interpretative drives, inscribed in its form: self-referent criticism and statements about art, all that which is generally called "reflexivity," a main modernist exigency. A radicalized form of this analysis within the media artwork is the reconsideration of

artworks within the same medium or through appropriation and recoding (Foster, 1985), such as in "visual studies" – a way of thinking about cinema using cinema's own means and material as is done in the film *Visual Essays: Origins of Film* (Al Razutis, 1973-1984), or through video, as in the video project *Histoire(s) du cinema* (Jean-Luc Godard, 1988-1998) (see Brenez, 1998: 313-335). Or we may consider Piero Bargellini's 16mm film *Trasferimento di modulazione* (1969) as another example of reinventing the transfer within the medium. Bargellini shoots the 16mm projection of a pornographic film, reworking the image during development, to let the image show the "latent image" hidden within representation, in the matter of the support. An author may also come back to his own work, as Michael Snow did in the digital "condensation" of his own seminal 16mm film *Wavelength* (1967), which for him has to be seen only as a film screening (see Fig. 5.2 in color section). He took his own film and fragmented it in three parts of the same length, superimposing the three pictures and soundtracks and obtaining a digital work lasting one-third of the original one: the result, the DVD *WVLNT: Wavelength For Those Who Haven't The Time* (2003), is also a theoretical statement about digital video, by a multimedia artist whose work articulates the specificities of particular mediums (painting, drawing, collage, sculpture, installation, music, photography, film, video...).

To conclude, we can summarize the methods for the interpretation of the artwork into the following typology:

a. holistic methods: interpreting the entire artwork in the most exhaustive way;
b. fetishistic methods: to concentrate on details that dazzle the analyst or her/his desire, and considering them as revelators for the whole and/or the only relevant ones to give an interpretation;
c. dialectic methods: to articulate the particular and the general reflecting upon the meaning of different levels of interpretation, in order to find and go beyond interpretative contradictions.

On the other side, as for the relation between the artwork and its contextual elements:

a. circular paradigm: interpretation as a practice centered on the reciprocal, sometimes tautological, relationships between the artwork and its context, (for instance, the Hermeneutic circle, or the "mirror theories" in Marxist hermeneutics);
b. symptomatic paradigm: to concentrate on details as traces of the artwork's "truth," of the artist's subconscious or unconscious, of a collective *Kunstwollen*. This is a mainly negative and fragmentary paradigm that tries to find out a general meaning from the inverted reading of particular aspects of it;

c. deconstructive paradigm: considering the artwork as having no exteriority ("there is no outside to the text" (Derrida, 1976)): the opposition text/context itself becomes no more pertinent to the analyst.

An Example of Interpretation by "le Silo"

Less than a minute elapses between the opening and the closing of the doors, which is enough time to see about a hundred workers pass by, in the first film screened in front of a paying audience at a demonstration of the Lumière cinematograph in December 1895. The motif of exiting from the factory and this inaugural shot by the Lumière brothers first appeared in Farocki's work in a documentary essay (*Arbeiter verlassen die Fabrik*, 1995), which was released in the context of the commemoration of the centenary of cinema. The undertaking was interpreted as announcing the movement triggered by the third Industrial Revolution, with factories gradually emptied of their workers,[24] as well as a genealogy of video surveillance in the workplace. The installation materialized eleven years later in the exhibition *Kino wie noch nie* presented in Vienna and curated by Farocki and Antje Ehmann. The film and the installation share a number of images, but understanding the latter as a mere transposition of the film into an exhibition space would be a mistake. First of all because in 1995 Farocki subjected the excerpts to slow motion, freeze frames, and repetitions, whereas in 2006 he simply exhibited them side by side, at a regular speed (due to the different durations of the excerpts, random montages are presented to the visitors). Besides, the director's commentary disappeared in the installation and the experience of images changed as a consequence.

The alignment of the twelve monitors makes similarities and differences between excerpts visible, inviting one to observe a permanence of forms worthy of Warburg's plates. The recurrence of images of metal gates, walls, and doors reinforces the parallel between the factory and the prison.[25] From a formal standpoint, the barrier of monitors reproduces the line of workers and stands in the way of the visitor's movement. One has to walk around it, just as the Lumières' workers exited the factory and the frame through the sides. The exhibition starts with their anonymous bodies in 1895, in a factory where photographic equipment was produced. By contrast, the work ends with the image of two stars playing the parts of workers, one an icon of modern cinema (Deneuve), the other an icon of the contemporary pop scene (Björk). In *Dancer in the Dark*, the character played by Björk gradually loses her sight, possibly the allegory of a working class gone blind and of a crisis of cinema.

The installation becomes a reflection on cinema and its history. The progression over decades allows one to observe the evolution of technique, from

black and white to color, from film to digital, from silent to sound, one turning point being Griffith's editing in shot/reverse shot (in fact Griffith did appear in another installation by Farocki, presented in the same 2006 exhibition in Vienna). While the gesture of laying out the monitors on the floor evokes Jackson Pollock, their assembly is reminiscent of Douglas Gordon's and Nam June Paik's piles of television sets. Lower than the spectator and freed of any commentary, the film sequences may not suggest the end of cinema, but rather its exit from a conventional habitat, the theater and its darkness, in order to move into art spaces.

4. JUDGMENT

At first sight, the act of judgment may seem to be an external one, when we think of analysis as an objective and shareable practice.[26] Analysis as a "scientific" practice is founded on the repression of personal judgment of value or taste, as well as any form of normative a priori. But such a denial should not be taken for granted, for four reasons at least. First, an artwork always takes position within a context: its interpretation leads one to wonder about its signification, situation, and qualities. Second, as a boundary moment of analysis, judgment defines an internal path linking the artwork's statements and the analyst's point of view, involving her/his drives and desires. The artwork faces the world (or turns against, or away from it) in its own time and space, while the analyst judges from another context and following criteria that may be similar (and even homological), or not. Third, evaluative criteria – as beauty, necessity, newness, truth, relevance, etc. – orient the very choice of the object of analysis, and inform its own deployment. For instance, "masterpieces" are often considered the most creative, thoughtful, intense configurations, and also the most productive for analytical activity. Finally, the interpretative moment in analysis cannot help to open analytical process to judgment. As Adorno wrote: "understanding and criticism are one" (1997: 262).

Judgment informs the very presuppositions of the analysis: the simple alternative between analyzing and judging is a false one, or better an ideological one, because methodical choices are far from neutral. For instance, limiting its means to words, and to a specific, reduced language, analysis tries to make us discover something more regarding the artwork's work, but reveals also its own partiality, as a practice separate from the proper movement of art. An artwork always posits itself and intervenes in a social, cultural, historical, political frame. The analyst's judgment arises from the encounter between the positions expressed within the artwork and the fundamental desire of the analyst, and the site of his/her pleasure. The most immanent analysis, the

most objectivist one, cannot escape the question of judgment: while trying to evacuate it, the "scientific" posture can only repress, not eliminate it. On the other side, analysis differentiates itself from a simple "everything's subjective" post-modernist posture, assuming the necessity for searching objective validation in the artwork's matter.

There are also historical reasons for the repression of judgment in analytical activity. In modern times, judgment has been hypostatized as a partial activity, a "job": criticism. Nowadays, we observe criticism's crisis (also on economic grounds), which is a sort of etymological paradox, because the "criticism" involves the act of putting in crisis something in order to judge it. Such a remark makes us understand the analysis of the artwork from a sociological basis: it develops itself as a specialized activity within academic institutions, and is mainly reserved for paid professionals of analysis, and to university students. More generally, when academic disciplines try to wonder about the objects they study, they often pretend to evade the question of judgment. Analysis, like scientific research, has to create a fracture from moral, religious, or aesthetic rules, which could give a predetermined dimension to its proper activity. Analysis's autonomy inscribes the price of its separateness, but its solitude is full of memories: among them, critical judgment may become the most important one, that which gives the direction to go through the "post-modern" desert.

The paradigms of judgment may be resumed in the following way:
a. internal coherence between means and ends (Aristotelian);
b. normative adequacy (for instance, "necessity");
c. aesthetic comprehension;
d. judgment of taste;
e. denial of judgment;
f. dialectical judgment.

All of these approaches to judgment may unfold in a key moment of analysis, for instance at the beginning or at the end, to explain the choice of an artwork or a particular way of analyzing it. That is the moment where analysis shows it is aware of its limits, but also of its necessary grounding in something external to the analytical process. Judgment represents the border and the place for conciliation between aesthetics and analysis, between the necessity of theorizing art and the everyday practice of understanding artworks.

An Example of Judgment by "le Silo"

"Leaving the factory" looks in many ways like cinema's own attempted depar-
ture for the rooms of museums, as it turns its back on the historical arrange-
ment of the theater after a century of existence. The trajectory outlined by
Farocki's installation does not ignore this departure, nor does it omit a detour
through video (and television). Still, and notwithstanding the many qualities
we acknowledge in the work, the concern for questioning this recent "museal
condition" of cinematographic images distinguishes Farocki's output from
countless others, interested in this change of scene only for the new formal
possibilities it promises. Farocki's work, under few illusions as to the "ruses of
museal reason," does not fail to engage in a genuine dialogue with the forms
of discourse privileged by the institution. *Workers Leaving the Factory in 11
Decades* therefore presents the advantage of proposing a reflection which is
more than necessary on the pillars of the regime of meaning conveyed by the
museum: the collection, the exhibition, the transfer of knowledge, notably,
and, more particularly, the heuristic value of analogy (the system of resem-
blances) predominantly orienting museal practices (incidentally, the sphere
of influence of analogical thought largely exceeds this field). Indeed, the prox-
imity of Farocki's rhetoric with this form of thought is real – compiling (*Der
Ausdruck der Hände / The Expression of the Hands* [1997]), comparing (*Verleigh
über ein Drittes / Comparison via a Third* [2007]), assembling (*Deep Play* [2007]),
taking apart and putting back together – but it clearly appears as a subtle
shield against the rapture of "correspondences" even as it refers to Baudelaire,
Malraux, Warburg... Farocki does not mix up means and ends: the horizon of
his work is not the revelation of resemblances (an operation he leaves for the
images he calls "operative images," subject to the intelligence of machines,
that is, essentially, solely to their capacity for recognition). On the contrary,
this horizon is the production of differences. What is striking in *Workers Leav-
ing the Factory in 11 Decades* (as in a Vertov interval) are discontinuities: formal
discontinuities (chromatic ones, for instance), generic discontinuities (fiction
vs. documentary), and above all historical discontinuities (those which mark
the history of work, of public space, of women, etc.). While we have never been
as much in need of experiencing the distance between images, Farocki's gaze
may be one which, going against the grain of museal reason, contributes to
sharpening differences with the monomaniac mind and the discourses of the
"same" that tend to set themselves up as a method.

NOTES

1 Its main adaptation to philosophical thought is to be found in Aristotle's logic, and in particular in the Analytics' theory of the syllogism.

2 "The process of breaking up a concept, proposition, linguistic complex, or fact into its simple or ultimate constituents." (from "Analysis" in Audi, 1999).

3 Coming from an analytical philosopher, such a statement should be deflated, but it interests us to underline the particular dominance of "decomposition" within modern analysis.

4 A more subtle link between Hegel's quote and our concerns about art may be traced: Hegel writes on the analysis of a "*Vorstellung*" (from *vor-stellen*, "to put forward, in front of"), which also means "(re)presentation," "mental picture," "imagination."

5 "Rational" has to be understood as a coherent argumentation, which follows the drive for clarification affirmed by modern culture of the Enlightenment (the "Age of Reason"). In Kantian terms, it should be assumed that what is at stake in an analysis of artwork is "theoretical," not "practical," analysis (thus, always in Kantian terms, the analyst seems to represent within his/her gesture the main character of art, its "disinterestedness").

6 Starting from his very passionate interpretation of Japanese culture in *Empire of Signs* (1983), and the pluralistic explosion of interpretative possibilities represented by *S/Z. An Essay* (1975a). See also Barthes (1975b).

7 It should be evident that the comparison with Panofsky is meant to facilitate the understanding of possibilities more than to define an exact parallelism. Some noticeably great differences involve the second step, and the whole project is a synchronic coexistence of significations, in Panofsky's system, while our path develops in time through different moments, even if every moment may question its relationship to the other ones.

8 Harun Farocki, *Workers Leaving the Factory in 11 Decades* (2006). Video installation for twelve monitors, black and white/color, sound, 36', loop.

9 "The transposition or the translation of values and structures from one expressive sphere to another" (Pächt, 1999).

10 To be completed by this particular remark by Jacques Aumont: "The words are much less numerous than visual experiences, that are almost infinitely variable" (Aumont, 1996: 202).

11 In order of appearance, the following films may be seen: Auguste and Louis Lumière, *La Sortie de l'usine Lumière à Lyon* (*Workers Leaving the Lumière Factory*), France, 1895, 42 s; Gabriel Veyre, *Sortie de la briqueterie Meffre et Bourgoin à Hanoi*, France, 1899, 42 s; director unknown, excerpt probably shot in Moscow, 1912, 58 s; D.W. Griffith, *Intolerance*, USA, 1916, 2 min 30 s; Fritz Lang, *Metropolis*, Germany, 1926, 1 min 40 s; Charles S. Chaplin, *Modern Times*, USA, 1936, 42 s; Slatan

Dudow, *Frauenschicksale*, Germany, 1952, 33 s; Michelangelo Antonioni, *Deserto Rosso (Red Desert)*, Italy, 1964, 4 min 45 s; Jacques Willemont, *La reprise du travail aux usines Wonder*, France, 1968, 9 min 33 s; Jean-Marie Straub, Danielle Huillet, *Trop tôt, trop tard*, France/Germany, 1981, 10 min 15 s; Durchfahrtssperren DSP®, commisioned elkostar®, Germany, 1987, 1 min 11 s; Lars von Trier, *Dancer in the Dark*, USA, 2000, 1 min 47 s.

12 The seminal work by Cesare Ripa, *Iconologia* (1603), established the distinction between the simple description through written texts (iconography) and the interpretation of art images (iconology). At the beginning of the 20th century, Aby Warburg extended this approach to all sorts of cultural images, followed by Panofsky (1972).

13 Founded by linguistic methods like Saussure's, and the Prague or Moscow schools, structuralism was reinvented through Claude Lévi-Strauss' approach to anthropology. The structural method supposes the existence of a coherent structure to be discovered (for me: within the artwork).

14 Going back to Russian Formalism of the 1910s (see Steiner, 1984).

15 Linked to Marxist "de-sublimating" tradition, sociology of art has an influential landmark in György Lukacs's pre-Marxist *Theory of the Novel* (1974), originally published in 1916. See Tanner (2003); for the analysis of the sociological art "field" see Bourdieu (1996 and 1993).

16 After the seminal work of Ferdinand de Saussure and Charles S. Peirce, see Barthes (1967). See also (Nöth, 1997).

17 Sigmund Freud in 1910 himself started this approach to artworks with his book on Leonardo da Vinci (1990), in which he claims to find a latent homosexuality through biographical statements and formal analysis.

18 Noticeably, by Thomas Aquinas, see Sweeney (1994).

19 See D'zurilla and Goldfried (1971); Newell and Simon (1972). No need to repeat it again: the scientific drive for analysis is linked to the history of its concept, but it has to be questioned, as the aesthetic is not a scientific field.

20 William Kentridge, *Five Themes*. Curated by Mark Rosenthal in collaboration with W. Kentridge. Museum Jeu de Paume, Paris, 29 June – 5 September 2010.

21 Its most famous systematization is Thomas Aquinas, *Summa Theologica* (1265-1274).

22 According to Hugh of St. Victor's (c.1096-1141) *De scripturis et scriptoribus sacris*, allegorical and anagogical levels express – respectively – visible and invisible facts.

23 Friedrich Schleiermacher (1768-1834) considerably helped the art of interpretation to become fully applicable to non-sacred texts.

24 This idea appeared in Klaus Gronenborn's review of the 1995 film, published in the Hildesheimer Allgemeine Zeitung on 21 November 1995, and reproduced on Farocki's website (farocki-film.de, last access: 30 April 2012). It echoes a recurring

gesture in Farocki's cinema, that of analyzing images of the past in the light of later advances in knowledge.

25 The comparison becomes unavoidable with the seventh monitor: in the excerpt from *Frauenschicksale* (Slatan Dudow, 1952), leaving the prison leads to the factory (work being a path to redemption). Already, on the previous screen, the tramp was shown leaving the factory, only to board a police car (*Modern Times*, 1936).

26 Analysis would be "not evaluative nor normative" (Odin, 1977). This statement has to be corrected as a "relative autonomy" of analysis from judgment.

REFERENCES

Adorno, Theodor. *Aesthetical Theory.* London and New York: Continuum, 1997.

Audi, Robert (ed.). *The Cambridge Dictionary of Philosophy.* Cambridge University Press, 1999 (2nd ed.).

Aumont, Jacques. *A quoi pensent les films?* Paris: Séguier, 1996.

Barthes, Roland. *Empire of Signs.* New York: Hill & Wang, 1983.

—. *S/Z: An Essay.* New York: Hill & Wang, 1975a.

—. *The Pleasure of the Text.* New York: Hill & Wang, 1975b.

—. *Elements of Semiology.* London: Jonathan Cape, 1967.

Beaney, Michael. "Analysis." *The Stanford Encyclopedia of Philosophy (Summer 2012 Edition),* Edward N. Zalta (ed.). Http://plato.stanford.edu/archives/sum2012/entries/analysis/. Last access: 10 September 2012.

Birnbaum, Daniel. *Chronologie.* Dijon: les presses du réel, 2007.

Bourdieu, Pierre. *Rules of Art. Genesis and Structure of the Literary Field.* Stanford: Stanford University Press, 1996.

—. *The Field of Cultural Production. Essays on Art and Leisure.* New York: Columbia University Press, 1993.

Bourriaud, Nicolas. *Relational Aesthetics.* Dijon: les presses du réel, 2002.

Brenez, Nicole. *De la figure en général et du corps en particulier.* Paris and Brussels: De Boeck, 1998.

Cottingham, John, Robert Stoothof, and Dugald Murdoch (eds.). *The Philosophical Writings of Descartes*, vol. II, Cambridge: Cambridge University Press, 1985.

Derrida, Jacques. *Of Grammatology.* Baltimore: Johns Hopkins University Press, 1976.

D'Zurilla, Thomas J., and Marvin R. Goldfried. "Problem Solving and Behavior Modification." *Journal of Abnormal Psychology* 78 (1971) 1: 107-126.

Foster, Hal. *Recodings. Art, Spectacle, Cultural Politics.* Seattle: Bay Press, 1985.

Freud, Sigmund. *Leonardo da Vinci and a Memory of His Childhood.* Translated by Alan Tyson, edited by James Strachey. New York: W.W. Norton & Co., 1990.

Genette, G. *Paratexts. Thresholds of Interpretation.* Cambridge: Cambridge University Press, 1997.

Hegel, Georg Wilhelm Friedrich. *The Phenomenology of Mind*. Translated by James Black Baillie. London: Swan Sonnenschein & Co., 1910.

Heidegger, Martin. *Being and Time*. San Francisco: Harper & Row, 1962.

Hügli, Anton, and Poul Lübcke. "Analysis." In *Philosophielexikon. Personen und Begriffe der abendländischen Philosphie von der Antike bis zur Gegenwart*. Reinbek: Rowohlt, 2005.

Jauss, Hans. *Toward an Aesthetic of Reception*. Minneapolis: University of Minnesota Press, 1982.

Lacan, Jacques. *Écrits*. Paris, Le Seuil, 1966.

Lotman, Yuri. "Primary and Secondary Communication Modeling Systems." In *Soviet Semiotics. An Anthology*, translated and edited by Daniel P. Lucid, 95-98. Baltimore and London: Johns Hopkins University Press, 1977.

Lukacs, György. *The Theory of the Novel*. Cambridge, MA: MIT, 1974.

Marx, Karl, and Friedrich Engels. *On Literature and Art*. Nottingham: Critical, Cultural and Communications Press, 2006 (rev. ed.).

Newell, Allen, and Herbert A. Simon. *Human Problem Solving*. Englewood Cliffs, NJ: Prentice-Hall, 1972.

Nöth, Winfried (ed.). *Semiotics of the Media. State of Art, Projects, and Perspectives*. Berlin and New York: Mouton de Gruyter, 1997.

Odin, Roger. *Dix années d'analyses textuelles de films. Bibliographie analytique*. Lyon: Centre de recherches linguistiques et semiologiques de Lyon, 1977.

Pächt, Otto. *The Practice of Art History. Reflections on Method*. New York: Harvey Miller, 1999.

Panofsky, Erwin. *Studies in Iconology. Humanistic Themes in the Art of the Renaissance*. New York: Harper & Row, 1972.

Ripa, Cesare. *Iconologia*. Rome: Lepide Faeij, 1603.

Sontag, S. *Against Interpretation*. New York: Farrar, Straus & Giroux, 1966.

Steiner, Peter. *Russian Formalism. A Metapoetics*. Ithaca: Cornell University Press, 1984.

Sweeney, C. "Three Notions of Resolutio and the Structure of Reasoning in Aquinas." *The Thomist* 58 (1994): 197-243.

Tanner, Jeremy. *The Sociology of Art. A Reader*. New York: Routledge, 2003.

Methodologies of Multimedial Documentation and Archiving

6.1 ENJOYING THE GAP: COMPARING CONTEMPORARY DOCUMENTATION STRATEGIES[1]

Annet Dekker

Documentation is the process of gathering and organizing information about a work, including its condition, its content, its context, and the actions taken to preserve it. For the writing of art history one used to be able to rely on the art objects. When artworks become prone to obsolescence or are only meant to exist for a short period, documentation is the only thing people can fall back on. The traditional documentation strategy for the conservation of art is focused on describing the object, in the best objective way possible. But conservation as a practice is not as fixed as one might assume, and hence documentation strategies tend to vary a lot. Needless to say, like any other form of representation, documentation will always be arbitrary and incomplete in relation to the artwork. By analyzing the documentation practice of the performance group Blast Theory, I will argue in the first part of this chapter that documents (such as texts, videos, still images, instructions, etc.) can sometimes communicate more about a work and how it is experienced than its physical manifestation can.

In the second part of this chapter I will focus on documentation as a tool in conservation. Despite the recognized fact that media art will not survive or endure over time due to its often ephemeral and obsolescent nature, many conservators attempt to fix the processual and fluid nature of these works. I will compare various documentation strategies that are used in traditional museum structures and those developed by other organizations dealing with

conservation. The analyses will be compared to Blast Theory's project *Uncle Roy All Around You* (2003). Instead of working towards an object-oriented approach of fixation, by referring to current artists' practices, in this case Blast Theory, I propose to focus on preserving and documenting the process and experience of a work: that is, keeping the memory alive but accepting a loss in history. Furthermore, I argue that documenting media art requires a new understanding of conservation theory, which will have an influence on current documentation methodologies in conservation.

In order to analyze what documentation consists of, I will first briefly trace the meaning of "document." The term document is used in various contexts, often referring to different things. I will concentrate on the development of the meaning of "document".' in as far as it connects and is relevant to the practice of conservation of multimedia artworks.[2]

From Document to Documentation in Conservation

The word "document" derives from the Latin verb *docere*, which means to learn, show, and inform, as well as *documentum* that signifies instruction and/or teaching.[3] Although we have lost this sense of *documentum*, meaning something that teaches or informs, the root of the word shows that the original Latin meaning was not just an object, but rather a testimony, an example, an instructive demonstration of some principle or idea (Windfeld Lund, 2003). From the 17th century onwards, it was the emergence of the European state bureaucracy which became an essential part of the creation of a public bureaucracy across and independent of local customs, that added two other meanings to the word document. Firstly, a document was constituted as a written object that states and provides transactions, agreements, and decisions that are made by citizens. This in turn implicated the second notion, the document as proof – turning the authenticity of the document into a subject of investigation (Windfeld Lund, 2003). However, it was not until the 1900s that a new professional was born: the documentalist.[4] Notable in this respect are the writings by Paul Otlet, *Traité de documentation* (1934), and Suzanne Briet, *Qu'est-ce que la documentation* (1951). Both argued for an expanded notion of the document that would include artifacts, natural objects, and works of arts; documents were regarded as examples or groupings of things that derive meaning from their context.

Although the term is used differently in museology, conservation, art history, and the art trade (Fluegel, 2001), documentation in the field of art is generally understood as the process of gathering and organizing information about a work, including its condition, its content, its context and the actions

taken to preserve it. At present, several types of documentation can be distinguished: first, documentation produced for publicity and presentation; second, for purposes of reconstruction or preservation; third, for describing processual changes in the appearance of a work; fourth, for developing an aesthetical and/or a historical "framework" or reference; fifth, for educational purposes; sixth, for capturing audience experiences; and seventh, for capturing the creative or working process of the artist(s). In conservation practices, documentation is primarily used for reconstruction and preservation. The traditional documentation strategy for the conservation of art is focused on describing the artwork in the best objective way possible. In some cases, intuitive knowledge (information about the artists' intent and aesthetic and historical considerations) is taken into account, but most methodologies rely on material measurements, emphasizing a way of structuring, a use of systems and logic that is reminiscent of scientific research.[5] With the arrival of more and more live, ephemeral, networked, processual, and obsolete works of art, documentation – as the physical remaining trace of a work – became the center of conservation strategies, and new ways of thinking about documentation practice emerged.[6] Moreover, the instable character of media art often grants documentation the status of the only remaining trace of the work (Depocas, 2001). At the same time, the notion that documentation is a subjective process where selection criteria are of great importance is more widely acknowledged.[7]

What happens with documentation after it has been produced? As said before, in most museum practices the core of documentation strategies is focused on the preservation of a work. Other documentation, for example, flyers or video that are produced for publicity and presentation, is also kept but is often regarded as being of secondary importance and stored in the "documentation archive" instead of the "collection archive." As such, for a long time the documentation was not considered of great relevance for the recreation of a work. By focusing on artists' documentation strategies, I will show that material in a documentation archive can actually be very helpful when recreating or presenting a work.

Blast Theory: An Individual Case

Blast Theory is renowned internationally as one of the most adventurous artists' groups using interactive media, creating groundbreaking new forms of performance and interactive art that mixes audiences across the Internet, live performance, and digital broadcasting. The UK-based artists group is led by Matt Adams, Ju Row Farr, and Nick Tandavanitj. From the early 1990s, they have explored and questioned the social, cultural, and political facets and

influences of technology. Blast Theory confronts a media-saturated world in which popular culture rules, using performance, installation, video, mobile, and online technologies to ask questions about the ideologies present in the information that envelops us. Their art- and research-focused interactive projects have been created for gallery, street, and television spaces. Their most recent work centers on conceiving new uses for location-aware technologies (such as navigational instruments) in public spaces, creating non-commercial content by means of already-present technologies. Blast Theory's interest and use of technology, and the innovative possibilities that arise from this, stems from an interest in communication.[8] They approach technology as an ideology, a constraint, a cultural space, a communication medium, or platform and not only as a mere device.

A survey of their works offers a number of different case study possibilities for examining documentation strategies. For the purpose of this research I selected their work *Uncle Roy All Around You* that premiered in London at the Institute of Contemporary Arts in London in 2003. Being part of a large funding program, *Uncle Roy All Around You* required extensive documentation. Because they had to work and communicate with different collaborators from various fields on different levels, the documentation strategies were also diverse. This made the project into an interesting case because the different angles demonstrate the various aspects of documentation problems that occur in relation to media artworks. What this case will show above all is how documentation functions in the work of artists: in the conceptual and production phases as well as in the presentation, archival, and possible future preservation phases. As such, the case could serve to complicate the issue of documentation in preservation further, necessitating an expansion of the term into different types, and the different phases in which documentation of these different types occurs.

Uncle Roy All Around You is a mixed reality game played by players in the street of a city, and online by players in a virtual city. The city space of the online environment is an exact replica of the actual city space. Finding Uncle Roy is the mission of the game, where online players and players in the street work together to find him. Using handheld computers, the street players are sent on a quest around the city, being offered directions by Uncle Roy via the devices (see Fig. 6.1 in color section). When the street players start they state their location using the handheld computer, where an avatar of them is revealed in the virtual world as a direct correlation to their physical location (see Fig. 6.2 in color section). Here, online players can select street players, enabling them to send private messages to them including assistance in finding Uncle Roy, and street players can choose whether or not to send audio messages back. At the end of the game after street players have been led to various locations through messages by Uncle Roy, online players and street players are asked a series of

questions regarding trusting strangers and whether or not they would make a commitment to someone they don't know. Online and street players who agree to make a commitment to the unfamiliar person are then matched up and offered the opportunity to meet face-to-face.[9]

The Value and Meaning of Documentation in Artists' Practice: Blast Theory[10]

Blast Theory has a rather extensive and meticulous documentation process during both the period of creating the work and presenting it. As one of its founding members, Matt Adams, states, "those bits of documentation have to do multiple jobs for us – they are marketing things, explanatory tools, and appendices to the research, they act as records." As such, documentation exists beyond the time of the work and testifies to the company's creative process and practice. Considering documentation as both testimony and a tool for making decisions about the nature of the work, I am following the assumption that what is documented and how this is documented reveal the framework within which artists understand, conceive, and develop their work.

Part of Blast Theory's practice and creative working process is to be constantly inventive and flexible in terms of techniques and strategies. They sometimes start from a thematic or narrative perspective and other times from a set of questions or issues that they would like to tackle, or a particular kind of experience they would like to explore. In the conceptualization and development of their projects, Blast Theory employs a number of methods and strategies. While they have stated a number of times that they would not say they have any coherent or continuous methodology – that working methods are contingent on the project at hand – a common thread is the methods they do use (although varied) work within a process that attempts to maintain the creative fluidity of a project's development. I discerned three different phases in which documentation played an important role. I define these, often parallel, stages as follows: *documentation as process*, in which documentation is seen as a tool in decision-making processes during the development of the work; *documentation as presentation*, or, the creation of audiovisual material about the work; and, *documentation for recreation* in the future.

DOCUMENTATION AS PROCESS

Documentation as process refers to the notion of documentation as a tool for making decisions about the nature of the work. Blast Theory places the malle-

ability of a work's development as key to their creative process: any "method" that appears too static – that would possibly hinder the expansion and growth of ideas in any direction – is a territory hardly ventured into by the group. Even up until the very moment of presentation, Blast Theory is highly reliant on oral communication as a creative medium, using conversation as a way to develop and flesh out ideas with one another. As Adams outlined, oral storytelling is used as a way to find the core elements of a project they are working on. Referring to the conceptual development process of scriptwriter Paul Schrader, Adams states that never writing anything down and just telling people the story allows a space for things that are extraneous, or "superfluous" to a story, to naturally be removed or "fall away" over time, leaving the core elements. Furthermore, by abstaining from writing too much down they all gained equal access to the work. In Adams' words: "It means that the project stays mobile."

While the creative flexibility afforded by development through conversation is integral to Blast Theory's way of working, they do often find a necessity to textually communicate complex ideas and relations to one another, particularly when they are dealing with a project like *Uncle Roy All Around You* that involves both online players and players in the physical world. They have increasingly turned to using whiteboards for this purpose. The whiteboard allows them to write down ideas and issues they are working with that day, photograph it for documentation, then wipe it clean for the next session and start again from scratch. They have also employed private notebooks, allowing each member to individually jot down ideas, and then type them up and share those they feel are important.

In the development process Blast Theory employs a number of creative strategies to develop their works including creating questionnaires, interviews, role playing exercises for each other, paper tests, and trails through the city. For example, during a residency at Banff New Media Institute just over a year before the release of *Uncle Roy*, the three core members of the group each designed different questionnaires, interviews, and exercises for each other. For example, Ju Row Farr designed a questionnaire and interview for the other Blast Theory members exploring their relationship to the city, with questions like: Where do you walk? How close to the building do you walk? Where do you put your arms when you're walking? Do you look at other people? How do you feel on city streets? Through these "role-playing exercises" they realized they shared a similar sense of detachment in the spaces they often frequent. These exercises thus lead to further conceptualization of the piece. Besides, they also conduct interviews with people external to the project in order to develop different aspects of the project. These exercises and the group's reflection on them enable the group to try and consider what people in the game play would and would not do, whilst aiming to create a process that is not too difficult and mentally stimulating.

Testing is another documentation method in the process and development of the technological aspects of their projects. Blast Theory test the characteristics and possibilities of mobile devices by creating a series of interface prototypes and devices to test whether or not they correspond to the concept of the specific project, and whether they feel these technologies are accessible to a broad public in understanding their use. Members of Blast Theory are often the first testers and at varying stages in the development participants from outside are brought in to test the setup devices. Sometimes they invite testers with a deep knowledge of the technology to get precise and descriptive feedback.

It is interesting to see that the emphasis on oral communication is reflected in their internal working process. Their ambivalence towards written documents, which according to them often leads to a hierarchical structure with the person in charge of the writing having more power and control over the process, shows the importance of having an equal collaboration of decision-making and conceptual and design development within the group. This working process of creating a non-hierarchical and decentralized internal structure is thus informed by a desire for openness and fluidity within the conceptual development of a work.

DOCUMENTATION AS PRESENTATION

By referring to "documentation as presentation" I am focusing on the material that is made by Blast Theory to explain and communicate their work. Such documentation can be a manifestation of a registered or captured event and can take on many forms: notation, mapping, written description, photography, film, or video.[11] Audiovisual recordings provide us with a unique perspective on the history of art, a perspective that moves beyond the image in a book, words on paper, or abstract notations. They provide us with a fuller sense of what it was like to be there and then. Needless to say, with media art consisting of multiple objects, interactive components, or uses of multiple spaces (real and virtual), the use of video documentation can be extremely valuable, especially when trying to capture the working of a piece or show the experience it evokes with the audience. Nevertheless, as Adams remarked, it is not something that is easy to do. Referring to the video documentation that was produced for their interactive virtual reality-based piece *Desert Rain* he explains: "The problem here was to register the non-linear character of the piece. Therefore, the crucial question was how to bring together examples of different types of footage (and not so much which "bits" to use) so that the non-linear character of the piece would be sufficiently "represented" (Lycouris, 2000).

Nor is video documentation uncontested. Especially in case of live performance art and dance, video documentation (or even other forms of documentation) is seen as betraying the vivacity of the art form. The prospect of experiencing a mediated performance, even in written words, has disturbed many performance art scholars.[12] Obviously any form of documentation will be a substitute for the original, but perhaps there are other ways of thinking about documentation. For example, can or should documentation evoke its absent object or event, or would it be enough to provide an impression or translate the atmosphere? Is it possible to think of an expanded understanding of documentation as presentation?

When it comes to capturing or documenting the final result, the live event, Blast Theory try as best as possible to show people the atmosphere of the experience, as Adams states: "It's about getting that atmosphere correct where you can imaginatively engage with what it must have felt like to do that or be there." The audiovisual documentation is partly directed, taking the point of view of one player and following that person while s/he is playing the game – at times asking the player to repeat a movement, but at the same time trying to be as unobtrusive as possible. Becky Edmunds, a "specialist dance videographer" for among others Blast Theory, tries "to enjoy the gap" between the live and the recorded by "providing small pieces of information through which a viewer might be able to actively reconstruct an imagined version, myth, or memory of what the event might have been."[13] Edmunds is not interested in providing the viewer with an "authentic" recording, and by showing restricted views of the body or small glimpses of the action, she even draws attention to the gaps that documentation creates. Moreover, she is not trying to assess how the artist wants her to document the work; Edmunds engages with the work as being inside and part of the work, instead of being a neutral outsider. This approach reveals a new way of thinking about documentation that reflects the process of the event while at the same time informing the work and serving as a way to preserve "tacit" knowledge.[14] Documentation is thus regarded as an important aspect of the process, which can be as creative and as challenging as the live event.[15] In this way documentation can be thought of as a form of dialogue, reflection, and response which can be used both as a tool in the creative process and as a document containing tacit knowledge.

This way of looking at video documentation is also taken up by Fiona Wilkie. She proposed that watching video documentation can disclose alternative dimensions of the work (2004). She considered the meaning of the video documentation of Blast Theory's performance installation *Desert Rain* and compared it to participating in the installation. By looking at the video documentation from a framework of site specificity she treats the work through a discourse of spatial engagement, in which the work operates between differ-

ent spaces and contexts – in the case of *Desert Rain*, real (the physical instal-
lation) and virtual space (the online participants as well as the context of the
Gulf War on which the work reflects). More importantly, video documentation
when viewed in a new context will evoke different connotations, which as
Wilkie suggests, could add other layers to the work.[16] As such, it implies that
Blast Theory's video documentation adds new layers of meaning to their per-
formances, which could potentially deepen the conceptual idea in new – and
perhaps unforeseen – ways.

Documentation of media art leads to a situation where diverse practices
respond to a variety of needs and ideas around artistic work. This potentially
allows documentation to develop as a critical space in its own right where the
issues and concerns of the work are addressed through appropriate forms
without necessarily becoming reproduction (Lycouris, 2000). From this per-
spective documentation is understood as a mode of production as well as a
mode of critical interpretation, which helps to overcome the fragmented view | 157
inherent in documentation.

DOCUMENTATION FOR RECREATION

Next to their intense documentation strategies, both during the process of
creating the work and in presenting the work, Blast Theory is also putting a
large emphasis on archiving the gathered materials.[17] As a performance group
working and communicating directly with the audience, they consider the
voice of the audience as a central element in their archival practice. One goal
for keeping an archive is to preserve the potential and importance of live art,
which is often marginalized due to the ephemeral nature of the work and, in
the case of Blast Theory, technically complex, collaborative, and conceptually
heterogeneous. Besides, making documentation and building an archive for
them is a means to show that artistic creativity is open to everyone.

By using *documentation as process* and making specific documentation
that reflects the intention, concept, and atmosphere of the live performance,
documentation as presentation, and combining these in an archive, at first sight
Blast Theory seems to be focused on future *recreation*. But what are the chanc-
es that such a technically complex work consisting of obsolete equipment
could be recreated? When asking them if it would be possible to recreate the
work, they replied that it would probably take a few weeks but would certainly
be possible. But digging a bit deeper and asking if it would also be possible
by someone else in 50 years, it became more problematic. Not only because
of the obvious obsolescence of technical hardware or network dependencies,
but foremost because changes in software configurations, notation, or com-

menting on version updates happened at irregular intervals, making it hard to decipher all the code and decisions involved. Similarly, one needs to know the historical context of the technology because it could have (un)willingly influenced the aesthetic and the functioning of the work. A lot of the technical issues around recreation also come down to the availability and rights-free use of the information. In the case of Blast Theory, because they work with the Mixed Reality Lab (MRL) of the University of Nottingham on the development of code, this could present future problems. Although a lot is written down in academic papers about the code and programming, this does not necessarily mean it is also freely available.

Moreover, next to the technical difficulty there is of course the performativity of the work that needs to be recreated, as Nick Tandavanitj remarks: "There is all sorts of specific learning about how you manage people in a specific situation. The front-of-house is probably well documented. But the scenography – the managing of getting people into a car without them noticing it, the way you give directions to people, the minutiae of dealing with people in those experiences – is probably not documented very well." It is interesting to make a short detour to other disciplines like gaming or contemporary dance and music that struggle with similar problems, where a score, notation, or rules are easy to preserve but the interpretation of these becomes more difficult. In gaming, rules of the game can be kept and the game play can be recorded to a certain extent. Furthermore, because of its digital nature it is easy to capture all kinds of data about the game. But what do these recordings and saved data reveal about the types of experiences the players had? With the aid of information technology like sensors we can save more data *about* performances than we could previously, but not the performance itself. Similarly, a contemporary dance performance is a living system that continues developing, and because it is passed on through body movements it is always in a state of development. Sometimes strategies from the field of oral history or ethnographic "in-game" research (following developer's processes or participant behaviors in games) are used to capture the participants' experience or to shed light on the development process, the design choices that underlie the work, or the relationship between design decisions and the experience players had while interacting with the work. The idea is that this will shed light on the process and hence involve transference of knowledge about the design, process, and experience, which will help to sustain or recreate the work.[18]

Although Blast Theory thinks it would be possible to recreate the work, not everything is written down, annotated or documented in a way that it is easily traceable. A documentation model might help to document the work in a systematic way in order to recreate it at any future day. Of course the question of desirability should be addressed, but more importantly the question

whether and in what way such a strategy will change the work is important to take into reconsideration.

From Object Dependencies to Behaviors

Because of their complex, variable, and interactive nature, it comes as no surprise that most museums and institutes have not taken up the challenge to collect and consequently start to think of ways and methods to document interactive projects like *Uncle Roy All Around You*. But in the past decennia, some attempts have been made to see the documentation of these variable works in another light. The best known is the work by Forging the Future (FtF), formerly known as the Variable Media Network (VMN).[19] With an interest in the preservation of contemporary artwork, the strategy of the VMN is very much focused on methods of documentation. The VMN proposed a strategy where artists are encouraged to define their work independently from medium so that the work can be translated once its current medium becomes obsolete. The approach is centered on the content of the work rather than its medium or physical manifestation. In addition, what they seek to concentrate on is less on the individual technical components that an artwork comprises, but rather on what one of its founders, Jon Ippolito, has coined as the "medium-independent behaviors" of the work (Depocas, Ippolito, and Jones, 2003: 48). By using the performative term "behaviors" the VMN tried to come up with a methodology that would work across mediums and therefore could still be recognized in the far future – where we might not understand the term "U-matic" (a videocassette format used in the 1970-1980s) but will still recognize the meaning of the term "installed." Whereas traditional methods for describing an artwork consist of object dependent terminology – name of the artist(s), date of the work, medium used, the dimensions (height, width, and depth), and the collection – shifting the focus to a work's behavior tells something about the presentation and perception of the work, such as that works can be installed, performed, reproduced, duplicated, interactive, encoded, networked, or contained. In order to distil the most desirable way for future presentations the VMN developed a questionnaire, the Variable Media Questionnaire (VMQ), to get at the core or, as Ippolito calls it, the *kernel* of the work (Depocas, Ippolito, and Jones, 2003: 47).

The questionnaire prompts questions for each inherent artwork behavior that requires preservation. However, it is not intended to be exhaustive. The VMQ is foremost a vehicle to incite questions that should be answered in order to capture artists' desires about how to translate their work into new mediums after expiration of the work's original medium. By bringing perspectives from

conservators and curators together with artists and if possible their technicians, programmers, and engineers the VMN approach tries to establish a better understanding of how the work should evolve and be handled over time in order to preserve its ephemeral character: "A questionnaire [stimulates] responses that will help to understand the artists' intent. The questionnaire is not a sociological survey, but an instrument for determining how artists would like their work to be re-created in the future – if at all. [...] The results of the questionnaire, the variable media kernel, enter a multi-institutional database that enables collecting institutions to share and compare data across artworks and genres" (Depocas, Ippolito, and Jones, 2003: 47). The VMQ is an invaluable guide for conducting artist interviews, as the medium-independent line of questioning often elicits highly descriptive responses to questions about a work's past and future incarnations.[20]

The VMQ is very valuable as a tool for interview practices because it takes into account both the concept of the work and the context in which it evolves. It confirms the necessity to let go of traditional preservation methods that focus on the recreation of the work as it originally appeared and instead try to think of new ways to document and reinstall obsolete artworks. The VMN approach was highly praised and welcomed by both practitioners and scholars in contemporary art conservation science. Whereas the VMQ certainly enticed new ways of thinking about the preservation of variable artworks, many questions remain: Is an answered questionnaire based on artist interviews sufficient in order to understand the working of the artwork? Does it give sufficient insight into the creative and working process? Does it reflect the interaction and experience the artwork invokes, both in relation to and between the participants and the context in which it is enacted? These and other questions were taken up and further developed in new models and methods by other organizations that share the concern for the documentation practice of obsolete artworks. In order to discuss the advantages and limits of the different models I will elaborate on three different approaches that have received high acclaim over the past years mostly because of their unconventional approach and as such have been adapted and used by other organizations in various ways.

V2_: CAPTURING UNSTABLE MEDIA CONCEPTUAL MODEL

One of the first new approaches came from V2_Organisation, Institute for the Unstable Media in Rotterdam, the Netherlands. The Capturing Unstable Media Conceptual Model (CMCM) was developed in 2003 as a conceptual model for documenting and describing newly created electronic art installations, rather than recreating or preserving existing works.[21] Notwithstanding,

it provides multiple potential applications for documenting every aspect of a design process, which could potentially influence preservation. V2_ distinguishes three phases in the development of a work that all require different documentation strategies: 1. The research phase, in which the draft of the concept for a project, the researching of required know-how, the design, and the first conceptual developments of the project take place; 2. the development phase, in which the actual hardware and software development takes place and its outcomes are tested and put together in a specific configuration or setup, and 3. the implementation phase, in which the results of research and development are implemented in a specific environment. Each of these phases is associated with different types of documentation.

More than any of the other documentation models, V2_'s perspective balances the intersections of art, science, and technology. Their strategy is to document the environment in which electronic art functions. This notion of "capturing" details about a work is considered complementary to the traditional preservation methods. V2_ reused the set of attributes, components, and behaviors of variable media, as distinguished in the VMQ. They complemented the VMQ with missing components and essential aspects that they identified as: definition of concepts; focus on several manifestations in a line of work, rather than on the reconstruction and display of a finalized artwork; all possible components of these manifestations and the interplay of these components.

NEW ART TRUST, MOMA, SFMOMA, TATE: MATTERS IN MEDIA ART

Matters in Media Art (MMA) is a multiphase project designed to provide guidelines for taking care of time-based media works of art (e.g., video, film, audio, and computer-based installations).[22] The project was created in 2003 by a consortium of curators, conservators, registrars, and media technical managers from New Art Trust, MoMA, SFMOMA, and Tate. The consortium launched its first phase, on loaning time-based media works, in 2004, and its second phase, on acquiring time-based media works, in 2007. The aim is to blend traditional museum practice with new modes of operating that derive from and respond to the complex nature of media art installations.

MMA provides a practical response to the need for internationally agreed-upon standards for the handling, installation, and care of time-based media artworks. The research resulted in a template that can be used in the acquisition process of a work, which is divided in three overlapping phases: pre-acquisition, accessioning, and post-acquisition. As such it is a basic framework to prepare the artwork for long-term preservation and future installation. At the

moment MMA has entered its third phase, and is looking specifically at challenges around Internet-based art (SFMOMA with Bay Area Video Coalition, BAVC) and computer-based arts (Tate). Many organizations have used and adjusted their best practices guidelines to their specific needs.

RICHARD RINEHART: THE MEDIA ART NOTATION SYSTEM

The Media Art Notation System (MANS, 2005) is the result of research by Richard Rinehart in which he proposes a new approach to conceptualizing digital and media art forms.[23] His research is an outgrowth and continuation of two earlier projects: Archiving the Avant Garde and the Variable Media Network. Rinehart intends to inform a better understanding of media art forms and to provide a descriptive practice for preservation. MANS has three levels of implementation progressing from simple to more complex. The layers consist of the *conceptual model* of documentation, the preferred *expression format* (vocabulary) for the model (the interpretation of DIDL XML), and, its top layer, the *score*, which serves as a record of the work that is database-processable (Rinehart, 2004). The core concepts form a "broad strokes" description of the work. This broad description could be used by the artist or museum at the time the work is created or collected. Further details, alternate accounts, and audience annotations can be filled in later in the life of the work. MANS provides a framework for reflection on the logical arrangement of collected elements, which can be distributed and archived through a website simply by broad type or general categories (for example, interviews, installation views, technical details and hardware, exhibition context, other installations, and audience interviews). This way any structure can be applied to it and connections can be made through tags, keywords, or other visualization tools.

The theoretical approach was explored through issues raised in the process of creating a formal "declarative model" (alternately known as a metadata framework, notation system, or ontology) for digital and media art. Rinehart used the metaphor of the musical score because media art follows a similar composition in which the essential concept or score is more important than the instruments or hardware that are used to perform or install a piece: "As long as the essential score performed is the same, the musical work itself will be recognizable and retain its integrity" (2004: 2). The MANS score represents a media-independent logical backbone for the work that relies on the original files to provide detailed functionality and appearance. By taking the musical score as a metaphor and method, the model has "a flexible yet robust structure and incorporates the passage of time and the possibility of change" (MacDonald, 2009: 63). The conceptual idea of a score, as a fixed form yet variable

in its execution, is interesting. Using the musical score as an example is, on the other hand, also questionable because nowhere is the difference between the written score and the performance so contested as in musicology (Cook, 1999). Besides, MANS is presented as a metadata framework. As such it does not overcome the problem inherent in any text-based representational framework describing non-textual information. In other words, it is extremely difficult to describe and translate an artwork into a formal system, also (or even more so) for an artist. For example, emotions and symbolism are hard to communicate in a traditional sense and at times an artwork by intention negates such interpretation (Svenonius, 1994).

Comparing Strategies

The models of MMA and MANS allow for levels of description related to the work as a whole (in its final presentation phase) as well as more detailed descriptions of specific iterations/occurrences of a work. This immediately presents the most urgent problem, which is the emphasis on the final work – the end product. Whereas in archival literature there is a recognition that "preservation begins with creation," these models hold on to traditional ways of dealing with objects and documents and are resistant to moving towards a more holistic approach (Waters and Garrett, 1996).[24] Important to note in this respect are observations by people who have conducted case studies that it is easier to document a work when it is presented. When a work is in storage it is much harder to talk about specific issues. The installation of a work facilitates the detection of problems and provides a better view on the specific decisions taken or methods used in the creation of the work.[25] It is for this reason that some people argue for more presentations to enhance the visibility and understanding of the way art *works* (Dekker, 2010). It could be argued that presentation leads to preservation. From this point of view the CMCM model is more interesting as it highlights the creative and production process of the work by focusing on the interaction between the work and the stakeholders. Next to a detailed description of the resources it focuses on the relationships between entities in the construction and the execution of the work. It is unfortunate that this part of the model is also the least described. For example, the complex elements of interaction are left to "well-chosen documentation." V2_ acknowledges that more research needs to be done in this field and suggestions are made to look at appropriate models in the social sciences, where methods or standards for registering social behavior and intercommunications between humans and machines are under development. Even though the CMCM model is not intended for preservation, it provides interesting opportunities for a

form of documentation that moves beyond mere descriptive, comparative, or mapping exercises. Although attempts are made to expand and elaborate on the model, these are currently still under development.[26]

Compared to the other systems, the models of CMCM and MMA prove to be most relevant to the context of media art because they focus on the process of production and creation (CMCM) and on the artist intentions (MMA). However, the artists' intent is not easy to distract, formulate or even comprehended either by the creator or interviewer and as such it can be a difficult and problematic strategy.[27] It is important to realize that an interview is always a reflection of a specific moment in time. It is never value-free and always influenced by the specific background, expertise and personality, of the interviewer and artist as well as the interaction between them (Van Saaze, Dekker, and Wijers, 2010). Nevertheless, a slow movement in this direction can be seen especially concerning contemporary artworks where the artist's involvement in conservation practice is regarded as a necessity, and where the artist becomes *the* stakeholder in the perpetuation of the work (Van Saaze, 2009: 106-111). A related phenomenon is the concept of group creation, a common practice in media art but new for many museums, conservators, and curators. This new form of working in artistic practice manifests itself through people from multiple disciplines and can lead to unstable, networked, variable, or different versions of an "end" project (that again can be influenced by the participants), which in turn has implications on collection, documentation and conservation. The notion of variable or different versions is not new to digital media, and can even be found with physical and "stable" objects or installations. For museums and galleries it is not uncommon to have exhibition copies of a work that they have acquired (Van Saaze, 2009). In other words, most media art practices deal with multiple creation practices and contexts that are uncertain. At the moment this is partly reflected in the models as the ideal state, the past and the present state, but these different parameters might not be sufficient to account for the level or need of variation that is inherent in the work. As Megan Winget suggests, a deeper understanding of the general creation behaviors and methods used by new media artists in general will augment the discussion regarding the challenges of digital art collection and preservation (2008).

Notwithstanding the high value of their theoretical underpinnings, one of the pitfalls of all the models discussed, especially those of VMQ, MANS, and CMCM, is their highly prescribed structures which, as said before, makes it difficult to implement a realistic and easily repeatable documentation project in conservation practice, especially outside the field of installation art. These findings show that in any documentation process a multilevel approach is preferred. Such a structure should emphasize the tension between the "ideal"

notion of the artwork (as a composite, theoretical idea constructed from artist statements, technical schemas, and the accumulation of many iterations) and the "real" individual experiences of the audience and/or expert members (curators, archivists, etc.) (Jones, 2007). Most of the models are established by the conventions of information classification with which they are familiar. This is not only important to realize from an ideological point of view but, on a more practical note, it means that once classifications, tags, or expressions change, so will the usability of these models. Therefore, the recreation of a work requires a thorough understanding of the context in which the information and organization about the work was made – there is a need to document the context of documentation creation, as it were. The vocabulary initially suggested by the VMN is exemplary in this respect. The third-generation VMQ that was presented at the DOCAM Summit in Montreal (March 2010) looks at artworks as ensembles of components, instead of behaviors as discussed in the earlier version, because this would be more intuitive for registrars, conservators, and other arts specialists. As Ippolito explained:

| 165

> The purpose is to understand the key elements of a work that are critical to its function, such as source code or media display. Acknowledging the relational character of much contemporary art, these parts extend beyond hardware to include environments, user interactions, motivating ideas, and external references. Structuring the Questionnaire in this way makes it easier to compare different artworks created with similar parts (email to the author, February 22, 2010).

The VMN questionnaire remains a valuable tool for discussing the work and discovering the core intentions, that is, the most important parts of a work. Even though the VMN approach to documentation and its emphasis on behavioral elements might not prove successful, it certainly enticed new ways of thinking about the preservation of an artwork. More specifically it confirmed the necessity to let go of traditional preservation methods that focused on the recreation of the work regardless of the artists' intent, and think of new ways to document obsolete artworks. Nevertheless, questions remain. For example, is a written questionnaire sufficient in order to understand the experience the artwork invoked? And in the case of many time-based artworks, and especially of media art, where the actual experience of the work by its audience is regarded as crucial, can documentation also be a potential for actual experience? A description and photo of a work can give an understanding of the piece, but these are still far removed from actually experiencing the work.

Piotr Adamczyk explored the working of the VMQ and CMCM for describing human-computer interaction in new media installations (2008). His analy-

sis showed that the models work on the level of documentation or accession in a museum context, but that they often fail when recounting the participatory context. Where Adamczyk suggests using human computer interaction (HCI) ethnographic methods, others are more inclined to using strategies from the field of oral history (Muller, 2010). The two strategies meet in the belief that accounts from participants' experiences "would offer rich and varied portraits of how the artworks existed in experience and would necessarily widen our understanding of the relationship of media art to its social and cultural context" (Muller, 2010: 6.1). The attention to audience experience and contextual information is as of yet not provided in any of the models.[28]

Already it can be concluded that the existing models are not ideal when dealing with technical specifications that are connected to the experience of the work, nor do they provide much information about the experience as such. But are these elements more visible in, or can they be extracted from, artists'

documentation?

Uncle Roy All Around You in a Model

Uncle Roy All Around You is a participatory multiplayer, multilayered (combining virtual and real worlds) game and, as the title suggests, the participants' surroundings play an important role. The conceptual idea, the technical interface, and the game play and its locations are defined, but they are all susceptible to change. With so many changing parameters it is no surprise that the participants also experience the working of GPS, WiFi, and the interfaces in very different ways. As Steve Benford, one of the technical collaborators in Blast Theory's projects, noted: "Our study reveals the diverse ways in which online players experienced the uncertainties inherent in GPS and WiFi, including being mostly unaware of them, but sometimes seeing them as problems, or treating them as a designed feature of the game, and even occasionally exploiting them within gameplay" (2006). It is precisely such subtle differences that are not taken into account in the previously described models, and they are also hard to pinpoint in an interview.

Moreover, Blast Theory used these circumstances as tactics and elements in the game as well; anticipating but never knowing for sure when, for example, technical failures would occur and an according action should be taken. Therefore such (technical) failures were used to enhance the dramatic narrative of the story. This did not mean, however, that the actual occurrences were planned. Although the game play was extensively and carefully orchestrated, there were many moments of uncertainty and these were hard to pin down. Instead of discarding them, the limitations of the technology became inte-

gral elements in the performativity of the work. In other words, the technical dependencies of the art form emphasize the meaning and the experience of the work. This ambiguity and uncertainty in the work do not have a place in models like CMCM or questionnaires like VMQ. This became apparent when asking Blast Theory if the GPS interface system could be replaced in the future by other technology (one of the key questions in the VMQ); the answer was simply yes. However, the discussions about their working process, their way of creating documents, and their attitude towards technology showed that the working of the technology, its current failures, and the inherent uncertainties, had influenced both the concept and the performativity of the work and, as such, were integral when experiencing the work. Replacing the technology at any future time may thus prove to be problematic at the experiential and conceptual levels of the work.

These examples already show that, for some specific but integral information, the models as described do not suffice. One of the main problems is that the documentation models are often (with the exception of CMCM) extracted from earlier dominant discourses (paintings, sculpture) and mapped onto a marginalized one (media art, performance, games), imposing a model according to which meaning is reproduced through the end result but is not emerging from the interaction of multiple agencies that create the experience.[29] Especially projects like *Uncle Roy* need a multilayered approach that takes into account relationships between objects in the construction and the execution of the work as well as provides insight into participants' interaction and experience. In other words: the documentation of such a work requires insight into the conceptual, creative, and working process from a technical, relational, and experiential perspective. All these play important roles in what makes the artwork and are not external to the artwork. In this respect, Jeroen van Mastrigt (2009) hints at the conservation of "an ecosystem instead of an object," and a similar remark was made by Geoffrey Bowker.[30] A framework of a documentation model for media art should therefore address the creative process, reflect the work's variability, relate to the context, and take into account the participants' experience.

Looking into the Future: Media Art in a Museum Collection

Suzanne Briet stated: "the forms that documentary work assumes are as numerous as the needs from which they are born," and, coming to the end of this chapter, this statement is as strong as ever (2006: 36). It is important to know the meaning and value of documents and documentation, but it is just as important to know their relationship, the context, and, in addition to

Briet, the process of their creation. Analysis of artists' documentation methods and comparing these to the information that is given or asked for in traditional museum documentation models showed that specific and inherent qualities of media artwork are not taken into account in the models up until now. Closer analysis of Blast Theory's creative processes indicated that crucial information on details of the project and the experience it yielded, most importantly the behavior of the technology and the influence this had on the performativity of the work, might get lost when using standard questionnaires or applying emulation methods that transfer the game play to new platforms. It is clear that multimedia artworks are technically complex, not only in their final presentation but also in their production phase. For a recreation of the work it is therefore important to understand the technical choices that were made in the context of the time they were made (see also Lurk and Enge, 2010, and Winget, 2008). As such, it is important to recognize that meaning is often constituted *through* an object and is not solely held *within* the object (Clavir, 2002). This means that it is also important to allow for media-archaeological research when recreating a multimedia artwork.

Taking into account what I have termed *documentation as process* will yield a better understanding of the inherent qualities of the work. It is important to be aware of decisions and their consequences that are made in the development of the work and accurately describe or record them. Theoretically, it is possible to recreate complex media artworks like *Uncle Roy All Around You*, but the level of success would increase when artists' strategies are integrated into museum practices or by adapting existing models by giving more attention to the creative process. But would it be possible for *Uncle Roy* to end up in a museum collection? This is of course a difficult question with multiple entries, but aside from the issue of money or artistic value, what would be needed of the museum staff to conserve the work? What are the possible implications for them to care for and recreate the work at any time in the future? But, even more importantly: would it be desirable at all? Would not the documentation that is gathered, made, and collected communicate more about a work, and how it is experienced, than its physical manifestation? Referring to the documentation videos by Blast Theory I argued for an expanded understanding of *documentation as presentation*. This treats video documentation not merely as a way to capture live events, but also as a form of dialogue, response, and reflection. Furthermore, when brought into new presentation contexts, documentation has the potential to deepen the conceptual idea in new ways, adding new layers to the work. In other words, documentation becomes a critical space in its own right, opening the prospect to elaborate on the original work.

It seems an obvious statement: documentation might guide the decision-making process in conservation, but the gaps or blind spots will influence the

work. In order to make the most of these, more emphasis should go to the roles and responsibilities of curators and conservators. In this article I argued that a first step would be to recognize the need for an extended conception of documentation, distinguishing different types of documentation, and phasing their role and function in the dynamic, performative practice of contemporary media art. Whereas more and more collaborative approaches are undertaken to develop documentation models, the practical implementation of the work often remains with individual curators or conservators. A more collaborative practice of knowledge production and documentation may overcome this situation, including also artists, information scientists, and programmers. This will also lead to a better understanding of the work and could potentially lead to opportunities for creating new versions, thus building, elaborating, and commenting on a previous state. If this approach would be followed it not only opens new ways of thinking about what conservation means but it can entice new ways of dealing with the structure and the function of the museum (see Kraemer, 2007, and Van Mastrigt, 2009). A museum could move from being a custodian of "dead objects" to a "living space" where presentation, preservation, discussion, and active exploration go hand in hand.

6.2 CASE STUDY: *NO GHOST JUST A SHELL* BY PIERRE HUYGHE, PHILIPPE PARRENO, AND MANY OTHERS

Vivian van Saaze

Introduction

No Ghost Just a Shell, a seminal project initiated by French-based artists Philippe Parreno and Pierre Huyghe and acquired by the Van Abbemuseum Eindhoven (NL) in 2002, consists of more than 25 artworks by over a dozen artists and artist groups, each work evolving around the virtual character of "Annlee." The history of *No Ghost Just a Shell* goes back to 1999 when Philippe Parreno and Pierre Huyghe decided to buy a virtual Manga character (developed for the cartoon industry), modeled the image in 3-D, gave it a name (Annlee), a voice, and started off with making two short real-time animation films on the character (see Fig. 6.3 in color section). Between 1999 and 2002 they shared the figure with other artists and artist groups, inviting them to give Annlee a life by creating artworks using the figure as a point of departure. From 1999 onwards the figure of Annlee appeared in many different places and eventually accumulated into an exhibition in Zurich (entitled *No Ghost Just a Shell*), which later traveled to San Francisco and Cambridge.[31] There were paintings (by Henri Barande and Richard Phillips), videos (by, for instance, Liam Gillick, Dominique Gonzalez-Foerster, François Curlet, and Melik Ohanian), toys for Annlee (Angela Bulloch and Imke Wagener), wallpaper and posters (M/M Paris), music (Anna-Léna Vaney), a magazine (Lily Fleury) and even a coffin for Annlee by Joe Scanlan.

In order to prevent other artists from using the image, in 2002 Parreno and Huyghe hired a property lawyer to draw up a contract transferring the copyrights of Annlee back to her imaginary character. The wish was "to protect Annlee" and "to ensure that the image of Annlee will never appear beyond the existing representations" (Huyghe and Parreno, 2003: 25). On 4 December 2002 at 9:30 pm, the vanishing of Annlee was celebrated by means of a staged fireworks display during the inaugural night of Art Basel Miami Beach. As curator and author Maria Lind notes: "That was the end of this particular collaboration" (Lind, 2007: 15). By that time, however, the Van Abbenmuseum was already in the process of acquiring *No Ghost Just a Shell* for its collection. Right from the start, *No Ghost Just a Shell* was depicted as a "special purchase" and a breakthrough in collection activities; instead of an individual object, an entire exhibition was being acquired.

This case study description will focus on the issue of collaboration and the

problem of multiple authors in relation to the process of documentation and archiving in a museum context.[32] Since the preset entry descriptions of many existing digital collection management systems do not leave much room for variability, artworks produced by multiple contributors are in danger of being reduced into fixed categories such as: single date, single artist, and single dimensions. How then to capture the hybrid character of *No Ghost Just a Shell*? Before going into the case study, let us first take a closer look at the increasingly popular phenomena of multiple authorship in art production, also known as "collaboration art."

Multiple Authorship

No Ghost Just a Shell is arguably one of the most noted and well-known examples of collective practices in art in recent years. Although cooperation and collaboration in art production has happened for many years, since the 1990s, collaboration as a conscious strategy and an intentional mode of production has become increasingly popular in artistic work.[33] The modes of – and reasons for – collaboration are diverse and vary from a pragmatic choice or necessity (for example: the artwork can only be produced by a number of people because its making requires specific, often technological, know-how) to a form of activism (for example: challenging the art market and questioning the common notion of authorship or art as the product of an individual genius) and simple curiosity (as the outcome of a collaborative effort will always be unpredictable). The current surge in collaborative art projects is related to an increased usage of digital media in the arts and can be understood, for example, as an offspring of the "new media critique" of the 1990s that strongly argued for new production methods based on sharing, cooperation, common ownership and open source structures.[34] Although the Annlee project consists of a multitude of art forms (such as video works, paintings, a book, installations, and objects), the story of its inception and how it was set up encompasses many features of digital media and media art: multiple contributors, decentralization, networking capacities, open source structure, variability, versioning, and so on.

The initiating and coordinating artists, Huyghe and Parreno, have not been very outspoken about the specific nature of the collaboration, nor have they elaborated on the selection criteria for inviting artists and other contributors. Rather than really working closely together on a single product, each artist produced an independent artwork starting from a shared point of departure: the Annlee figure. Maria Lind describes the process as follows: "The participants shaped episodes which could function as independent art works, but

which together constructed not only a collaborative art project and exhibition but also a new order of identity. Into the bargain, a temporary community of 17 persons was created" (Lind, 2007: 15).[35]

There was never a prefixed list; friends and other artists seemed to be invited in a more or less haphazard way. In an interview, Huyghe refers to the book *Esthétique relationnelle* (1998) by French philosopher and curator Nicolas Bourriaud as being "instrumental to setting up this group of artists." Huyghe: "In a certain way, Nicolas's book was like the production of a new scenario; in the manner I discuss this in my own practice. His book and his words provided a linkage between various artists and people" (2003: 100-110).

Others such as Van der Beek describe the project as creating its own network with connections in different social and artistic spheres (2003: 42). In a similar fashion, Hal Foster labeled *No Ghost Just a Shell* as "archival art" in a special issue of *October*. He explains: "...much archival art does appear to ramify like a weed or 'rhizome'" (Foster, 2004: 6). In interviews, the initiating artists also refer to this rhizome-like structure that grows organically, appearing and disappearing depending on the connections that it is able to make. Huyghe: "It is less a question of 'process,' which is too linear, but of a vibrating temporality" (Huyghe quoted in Baker, 2004: 88). This way of working can be said to be exemplary for both Philippe Parreno and Pierre Huyghe. Rather than being studio bound and creating fixed and finished art objects, their projects develop in diverse settings and often in close interaction with other projects and people. It starts with a plan, but the plan, as they say, may change along the way.

Acquisition, Registration, Documentation

With the acquisition of *No Ghost Just a Shell,* the Van Abbemuseum has intentionally confronted itself with problems that are typical for many of today's collaborative (time-based or media) artworks. The acquisition of an exhibition undermines the traditional notion of the artwork as a single, autonomous product of an individual artist. First of all, unlike a more straightforward transaction involving the buying or selling of an art object, this acquisition took the Van Abbemuseum's director, the curator of exhibitions, and other museum staff members at least one year to agree with the artists and their dealers as to which works could and should be purchased, as well as to sort out the required legal apparatus of the project.[36] The artists Huyghe and Parreno acted as intermediaries between the museum and all individual artists who had contributed to the project. Each Annlee work had to be purchased separately from the relevant artist or gallery because there was no specifically developed economic

system within which the works had been produced. However, the curator of exhibitions stressed the conceptual necessity of considering the acquisition as an *exhibition*: as a whole rather than a collection of independent artworks. Thus, rather than providing all individual objects with an inventory number, as common practice would have it, he wanted the exhibition to become registered under one inventory number.[37]

Registration of the acquisition under one single inventory number, however, would cause several administrative problems due to the collection management system used by the museum. The existing protocols stipulate that when individual artworks are not registered in the museum database system, they are administratively not visible and simply do not exist in terms of collection management. If, in other words, the exhibition *No Ghost Just a Shell* would have received a single inventory number, there is a danger that each individual Annlee artwork and the contributors would be overlooked or simply be lost because they are not registered. Moreover, if artworks are not registered, they might not be insured, for example, and they may end up existing outside all museum protocols, which are developed for single objects.

On the other hand, it was also problematic if each Annlee work was recorded as an individual entry in the system: how could its relationship to *No Ghost Just a Shell* remain visible? The curator of collections was thus confronted with a problem stemming from the limitations of the museum's management system, The Museum System (TMS). TMS is a standardized commercial collection management system developed by Gallery Systems and is used by many museums. The system is mainly developed for more traditional, stable works such as paintings and sculptures and thus represents the single artist, single object paradigm. As such, it leaves little room for variability and provides no possibility to address multiple authors or specific interactions.[38]

In order for *No Ghost Just a Shell* to be accounted for as an acquisition, it needed to be fragmented into single objects or registered under one entry. The museum was thus left with two choices: *No Ghost Just a Shell* was either reduced to being considered as one artwork (with the danger of losing sight of the individual artworks), or all artworks had to be registered separately (running the risk of the relationships between the individual artworks and their connection to the exhibition being lost). Either way, crucial relationships would be lost. In the end, this administrative problem was solved by creating special "work sets" in TMS that created a link between individual Annlee works while also allowing the person entering the data to designate one inventory number to the project as a whole.[39]

In addition to the information stored in TMS, the museum also houses an extensive paper archive, and for each individual Annlee work, there is also a paper documentation file. In these paper files, the connection between the

individual work and *No Ghost Just a Shell* is demonstrated by a copy of the acquisition proposal document stating that the artwork belongs to the *No Ghost Just a Shell* project. Due to the complex history and hybrid character of the project, much time was spent on producing documentation on the project as a whole and the exhibition history of each individual artwork.[40] Moreover, because installation guidelines for the works were lacking, each individual artist had to be consulted by the museum so as to reach agreements on how the individual works and the project could be displayed in the future. The collaborative nature of the project and the lack of overall control after its acquisition did not make things easier for the museum. As the director of the Van Abbemuseum notes: "There are certain conditions which they have agreed to but then those conditions change depending on what moment and who you are talking to."[41]

In Conclusion: Continuous Collaboration

Collaborative art projects like *No Ghost Just a Shell* challenge the acquisition of such works for a museum collection in various ways. *No Ghost Just a Shell* is both an exhibition and a set of individual artworks. Registering the acquisition into a commonly used collection management system, however, meant working around the pre-set categories of single artist, single artwork and single date. These and other limitations of standardized collection management systems and documentation models have been subject to much discussion in contemporary art museums and have lead to the development of several alternative models and systems especially designed for those categories of art that fall outside of more traditional art forms.[42] Arguing from the position of new media, curator and researcher Jon Ippolito advocates a more differentiated and precise tagging system that would capture the variability of artworks and would allow for captions and wall labels to do so, too. As collaborations are the rule rather than the exception for new media art, Ippolito (2008) advocates new documentation strategies that are designed to document and even encourage "expandable" and changing authorship functions.[43] In the wake of the development of these new models, existing systems such as TMS are also encouraged to adapt to the needs of non-traditional artworks. In terms of collaborative art projects, this would mean acknowledging the various specific relationships and interactions between artworks and their contributors.

In addition to the problem of registration and documentation, such collaborative projects also ask for a collaborative attitude from their collectors. Although the particular collaboration between the artists may have ended, the collaborative aspect of the project was extended to the museum; by acquiring

No Ghost Just a Shell, the Van Abbemuseum needed to continue collaborating with the individual artists, their galleries, and former exhibition places. The acquisition of *No Ghost Just a Shell* transforms the museum's role: rather than an "end point," the museum becomes a collaborator as well. Moreover, in 2007, private collector Rosa de la Cruz donated another version of *No Ghost Just a Shell* to the Museum of Contemporary Art (MOCA) in North Miami and Tate Modern in London. The Van Abbemuseum is now exploring how these two different versions of *No Ghost Just a Shell* relate to each other and what collaboration between the different museums could mean. Arguably, to ensure the perpetuation of *No Ghost Just a Shell* and its vibrant and hybrid character, it is precisely this collaborative aspect that the museum will need to endorse.

6.3 THE ARTIST'S INTERVIEW AS A TOOL FOR DOCUMENTING AND RECREATING A COMPLEX INSTALLATION: THE EXAMPLE OF *MBUBE*, AN AUDIO-INSTALLATION BY ROBERTO CUOGHI IN THE MUSEO DEL NOVECENTO, MILAN

Iolanda Ratti

Introduction

Milan's Museo Del Novecento (the Museum of the 20th Century) houses a collection of over 4,000 works that document the development of Italian art from the historical avant-garde movements to the 1980s. This new museum of contemporary art also features a group of more recent works acquired by the City of Milan that involve the use of new media.

Having been closed to the public over the past few years has allowed the museum to dedicate itself to a careful study of its collections. It conducted several experimental restorations and established a collaboration with the History of Art Techniques Department of the University of Milan. The aim of the synergy, by now in its concluding phase, was to support a number of dissertations focused on one or two of the living artists featured in the museum's collection, either with a single artwork or with a small set of works. Students were first expected to conduct general research on the thematics of the chosen artist and on the techniques and materials used in the scope of his/her production, along with a more detailed study of the work(s) featured in the museum's collection. Next, students conducted a technical analysis of the artwork(s), with the support of the museum curator and of a restorer. The intended objectives of this stage were to gain a precise sense of the methods of production of the work and of its material and theoretical peculiarities, and to define the potential conservation problems it might pose, spanning from the inherent frailness of its materials to the installation criteria to adopt in future exhibits. In the final stage of their research the Ph.D. students were asked to measure their analysis of the chosen work against the artist's own perspective of it, by means of an interview. The goal was to further define the artist's aesthetical and technical approach and to shed light on his or her position regarding the work's future and its conservation.

Interviews were carried out following a format developed in collaboration with Professor Giuseppe Basile of ICR (the Higher Institute of Conservation and Restoration) and featured two parts. The first part was centered on collecting information about the techniques the artist used in his/her creative process, his/her thoughts regarding conservation, and his/her stance regard-

ing the role of the public in the fruition of his/her artwork. The second part approached the same themes, but through a discussion of the specific work(s) housed in the museum.

The interview format was applied for the first time in 2006, on occasion of the publication of Marina Pugliese's 2006 book *Tecnica mista. Materiali e procedimenti dell'arte del XX secolo* [*Mixed Technique. Materials and Procedures of Art of the 20th Century*]. Specifically, it was used to study two installations featuring audiovisual elements: *Mbube* (2005), an audio installation by Roberto Cuoghi, and *San Siro* (2000), a video projection by Grazia Toderi. I will here treat the first, briefly describing the work and then presenting an extract of the interview with the artist, which is particularly interesting since the work was reinstalled in the 2008 *Electronic Lounge* exhibit, allowing to test the interview's effectiveness and define its limits and problem areas.

Roberto Cuoghi, *Mbube* (2005), Audio Installation

Roberto Cuoghi (born in Modena in 1973) has made a name for himself as one of the most interesting young artists on the Italian scene since the mid-1990s, taking part in important exhibits such as the Venice Biennale and the Berlin Biennale.

Cuoghi created *Mbube*, his first sound installation, in 2005, exhibiting it first at the Rivoli Castle of Turin's first Triennale and later that year also at the CAC in Vilnius. That same year, thanks to a generous donation by the collectionist David Halevim, the work then became part of the City of Milan's collections. The installation was then exhibited again in 2008 in the scope of Electronic Lounge in the Exhibair space of Milan's Malpensa airport. The installation consists of the playing of the artist's cover of the song *Mbube*, a 1939 piece composed by the South African musician Solomon Linda made famous by the Western re-make entitled "The Lion Sleeps Tonight."

The creative process consisted in stratifying several layers of sound material, using different instruments and recording a separate track for each one based on the tune of *Mbube*. The instruments used, none of which require knowing how to read music in order to be played, included: the lotus flute, the Budrio ocarina, claves, the jingling Johnny, the vibraslap, the güiro, the djembe drum, the tambourine, the cuckoo call, the balafon, the cabasa, different other bird calls, nut shells, and various shakers.

Cuoghi first recorded each instrument on a MAC G5 pc using an AKG/Behringuer UB 802 condenser microphone and then mixed the tracks using the Cubase SE software. The song was created solely by the artist, who only sporadically consulted online forums of musicians and IT experts.

The interview was fundamental for understanding how the artist works and how he reacts to the materials chosen, but also for determining the aesthetic value of the installation in view of its future re-exhibition, a necessary operation given the work's inclusion in a permanent collection (see Fig. 6.4 in color section). The three exhibits of the installation are quite different. The interview with the artist allowed to define the audio aspect as the only truly "essential" element of the work from a conservation point of view, while allowing to set specific, though flexible, diffusion criteria for environments that are (and always will be) necessarily different.

Interview Extract (Milan, 26 May 2006, the Artist's Studio)

We here report a very brief extract of the interview, specifically the answers that define the artist's approach to conservation and the work under review.

1. What is your take on the conservation of your works? Do you accept the idea that they will age naturally? When do you think intervention becomes necessary?
 I don't really know what destiny the things I'm doing will have. Aging ceases to be acceptable only when the work begins to be objectively compromised. Intervening becomes necessary when the work's "functioning" starts to be compromised.

2. What does it mean to speak of conservation referring to new multimedia technologies? What role do you think that video and sound art, both analogue and digital, will play in relation to the rapid changes in software and technical support? In your opinion, what are the most efficient methods to conserve and archive video and audio material?
 It is software that affords the most concrete possibility to recreate a work's original conditions at any given time: so I'm not pessimistic about it. On the other hand, today we can play Pac-Man on a last generation laptop using a 25-year-old software program, thus reproducing a "condition" in the system that has to run it. There are now software "packages" that utilize portions of MS-DOS to run obsolete programs.

3. Do you think that emulating a 25-year-old software program in order to read an original work, instead of translating the work itself into a more recent format, plays a role in maintaining its quality and "uniqueness"?

Not exactly. If a work is digital in nature its quality isn't compromised by translation into another format, because it's just a matter of number sequences. Besides, I don't think we can speak of uniqueness in the digital era. Digitizing a video captured on film – now that is a real change of support. But works that are born-digital simply require an operation of transcription. I find the signing of CDs already pretty grotesque ...

4. Are there preliminary studies of *Mbube*? Are there other versions of the work?
 There are tests, slightly different versions, without some of the instruments – for instance, there are ones where the shaker plays a lesser role. They're not really other versions, they're trials. The only one that gets close to being an alternative version is the first trial, put together the year before, so two years ago. It has more or less the same structure, but is performed entirely with an electronic keyboard.

5. Are there different copies of your work? And if so, where are they? How do you protect yourself from the production of replicas and fakes?
 The work was purchased first by the Rivoli Castle and then by the Halevim Collection (which then donated it to the Museum). There are officially five copies of it, by which I mean five physically distinct CDs, each "signed and numbered": the Rivoli one, the Halevim, and the others of the De Carlo Gallery.

6. How should this work be exhibited? Do its nature and identity change, depending on its spatial context?
 The work should be exhibited using professional amplifying material and ensuring a rather sustained reproduction volume, so as not to seem background sound. My only worry regards the acoustic aspect. The work's identity is compromised more by poor volume than by the type of spatial context it's in. In Turin, where it was on exhibit, the music played in loop, but with at least two minutes of pause between one run and the other. They set up two huge speakers, like the ones used in concerts, in the corridor of the long side of Rivoli Castle. They played it at high volume in a space with nothing around – there was nothing in the range of twelve per seven meters, absolutely empty. Instead when they exhibited at the CAC in Vilnius they used the Center's system of loudspeakers. But at the end this produced a chaotic effect, because of course we're talking about a home recording so sound that is not clean at all. This means that when installing the piece it's extremely important to bear in mind that this is

not a CD produced by a record label. Another thing that needs to be kept under control is the boom effect, for instance through the use of absorbing panels. It really doesn't make a difference if the amplifying system is hidden or not. A method I use to see if the volume is high enough is standing in front of the amplifiers and checking if the low-pitched notes boom in my chest.

7. At what distance from other works should this work be placed?
 Given the reproduction volume required, it's best to invert the question: at what distance from this work should other works be placed? Ideally the work should be treated as a solid body, so the song should be allowed to fill empty space without the fear of it being empty.

In conclusion, this interview excerpt informs us on the standpoint of the artist on preferred manners to exhibit *Mbube* and also suggests guidelines for its preservation. In only a few statements, Roberto Cuoghi has provided, for instance, information on the creation of the work and on his conscious choice to make a home recording rather than a professional one. Therefore, it is crucial to document this feature of the work in order to respect its nature and its peculiarity as a work of art in the first instance and as a sound recording at a second instance.

6.4 MAXXI PILOT TESTS REGARDING THE DOCUMENTATION OF INSTALLATION ART

Alessandra Barbuto and Laura Barreca

Guidelines for the Documentation of the MAXXI Collection

Cesare Brandi's 1963 definition of "preventative restoration" (Brandi, 1994: 7 and 54) is highly relevant for activities associated with the conservation of works of contemporary art in museum collections:

> [...] preventative restoration is to be understood as any action aimed at anticipating the necessity of an intervention of restoration, making preventative restoration no less important than effective restoration. [...] It is clear, at this point, that to no lesser a degree in preventative restoration results, discoveries, and scientific interventions reference fields that interest the subsistence of the work of art: from research into lighting and its effects on the choice of light sources, as well as heat, humidity, vibrations, air conditioning systems, packaging, hanging and disinfestation (33-34).

Because the works in the collection of a museum of contemporary art like MAXXI Rome belong to different linguistic and technical typologies such as complex installations, works in progress, performance events, works of net art, video art, ephemeral or immaterial works, or process art, it is fundamental to operate from the perspective of preventative restoration, with the aim of anticipating all possible risks resulting from the perishable or variable nature of these works. This involves processes of constant monitoring, including the control of the general conditions of exhibition (lighting, the use of barriers or separations), temperature and humidity conditions, both in exhibition spaces and storage areas, methods of storing works of art,[44] and the proper choices to be made in the event of works on loan.

During recent years, MAXXI's research activities have focused on current international trends, in parallel with a critical investigation of Brandi's theory and its possible applications to the specific problems and terminologies of contemporary art. The practices of documentation consider the radical changes that have affected contemporary aesthetics and the new identity of the work of art in instances where it is no longer a unique piece created by an artist but a process of cultural participation involving the public, the work itself, and the museum. The interpretation of the work of art as an *idea*, and not only as

a physical object, is now a trend that is broadly confirmed in contemporary artistic practices. This condition has manifested itself over the course of the 20th century, with the opposition of two different ideological positions: the intentionalists and the anti-intentionalists, two attitudes described by Steven Dykstra (1996) as the primary axes of debate regarding the conservation of contemporary art.

Dykstra stresses the importance of the artist's intentions and the method of interpreting the function of material (or support) in relation to the conservation of the work of art (1996: 204). The artist's intention is defined as the control exercised over a specific form, and becomes fundamental not only to the cultural meaning inherent to the work of art, but also to the correct interpretation of its functions. At present, a number of international museums consider the artist's intent as the guiding principle for the documentation of contemporary artworks (Hummelen, 2005: 24). This is achieved by acquiring information about the artist and the work such as letters, interviews, notes, annotated texts, invitations, catalogues, preparatory sketches, as well as any information relative to materials and techniques of realization, all part of the identification of those aspects essential to and coherent with the original aesthetic and historic meaning of the work, without which future presentations of the work risk becoming a discretional act made by the curator or the museum's conservator.

The documentation of a complex artwork includes the direct involvement of the artist and requires information related to the "existential" elements of the work. Of the most suitable instruments, the video interview represents an optimum method for tracing the conceptual identity of the work, focusing on problems of conservation, creating dialogue between the museum, and the direct testimonial offered by the artist. Since 2002, the International Network for the Conservation of Contemporary Art (INCCA) has been working on the creation of a database of documents and information gathered by museums and institutions around the world.[45] Within this methodological framework of documentation, MAXXI has focused part of its research on the works in its permanent collection, in particular on methods of re-creating works of art, analyzing the process of conservation through the relationship between the museum's conservator and curator, and the way in which these professional figures interact with the documentation of the works – whether it be with the artist or in his or her absence. Another fundamental line of research recently initiated by the museum focuses on those activities of documentation propaedeutic or parallel to temporary exhibitions, and the analysis of conservation practices performed on a daily basis by its restorers.

Methodologies and Tools of Documentation

The aspect that, more than any other, distinguishes the conservation of contemporary art from that of the past is our coexistence with the author. However, this aspect does not eliminate problems of conservation; in many cases it actually complicates them. The collaboration between the artist and the museum is the starting point of the process of documentation, but sometimes the conservation choices taken by the museum may not coincide with the expectations of the artist. In fact, only in ideal cases does the artist, aware of issues of conservation, collaborate by sharing with the museum his/her intentions and indications about how to show, present, conserve, and maintain the work of art. Notwithstanding that documentation has become widespread practice, many artists are not available, or appear disinterested in providing fundamental and coherent information over a longer period of time. Vice versa, it can happen that the artist (or his/her studio or heirs, above all in the years immediately following his/her death) is overly present, pretending to act autonomously, or to rework the work acquired by the museum, as if it were still entirely within his/her domain.[46] Finally, it may also happen that the involvement of the artist in a conservation problem leads to requests by the artist to make substantial changes to the work that extend beyond the restorer's domain into the curatorial one. Working in between these different attitudes, it is always useful for the restorer to evaluate all available information with a critical spirit, attempting as much as possible to cross reference all data in the museum's collections.

The corpus of data, information, and declarations regarding the meaning of the work gathered directly from the artist represents the first nucleus of documentation for the works of new media art in the MAXXI collection.[47] The methodology of documentation defined by the museum during recent years (through participation in a pilot project promoted by the MAXXI, in cooperation with other Italian museum institutions, and through the promotion of interdisciplinary research groups[48]) includes the compilation of a "general chart" that brings together a wealth of information about each single work: a brief introduction to the artist and notes on his/her work; historic dates related to the work; information, photographs, projects, and publications about each previous exhibition, even prior to its acquisition as part of the museum's collection. The chart also archives material data: the numbering and cataloging of each single part relative to the analysis of the single components of the work (in the case of complex installations, each of the various parts is listed and measured) and the typology of packaging and labeling. The technical charts related to the exhibition of the work, provided at the moment of acquisition from the gallery or artist, are united with all of the material produced during the planning of its exhibition in the museum: photographs during installa-

tion/exhibition, sketches, tests, samples. In some cases, especially for complex or environmental installations, it is necessary to commission an architectural survey and 3-D images of the work installed in the museum. When the work is removed at the end of a show, existing documentation is integrated by a condition report, used to list the detailed conditions of the work, from the moment of opening its packing crate(s), and its behavior during the period of display. This approach is particularly suitable for works with variable supports. This type of chart also contains indications related to improvements to the conditions of the work to be observed during storage and eventual details or measures to be employed in the event of shipping or loans.[49]

An exceptional case of documentation emerges when the museum commissions a site-specific installation from an artist. In this case it is possible to follow the creative iteration of the work, recording the ideas that, for various reasons, were not realized, and possibilities that were not tested. It is clear that, with respect to the vast and rich documentation that can be collected in this case, one must make a selection: some of the material gathered, if left unexplained, may be misleading in the future, precisely because it relates to working hypotheses that, for one reason or another, were abandoned by the artist during the development of the work in favor of others that were effectively realized. So here, too, it is fundamental to interview the artist, establishing the specific moment of choices, practices of conservation, and possible variations that can be made during future presentations of the piece.

Case Study 1: The Documentation of an Environmental Installation: Alfredo Jaar, *Infinite Cell* (2004)[50]

Acquired and exhibited on the occasion of MAXXI's inaugural exhibition, *Infinite Cell* is an architectural space constructed inside the museum. Alfredo Jaar (Santiago, Chile, 1956), a trained architect, was strongly affected by the architectural space of the museum and carefully considered the position of the work inside Zaha Hadid's building.

The piece is an exact reconstruction of the dimensions of the cell in which Antonio Gramsci was imprisoned for 20 years. A steel grate, with a single door, separates an interior from an exterior space. The space inside the cell, illuminated exclusively by a window that emits light, is infinitely multiplied by two mirror-clad walls on the short sides of the rectangular cell. On a wall near the cell, five ink drawings on parchment entitled *Gramsci* represent details of this intellectual and political thinker's face, while the silkscreen *20 anni 4 mesi 5 giorni* presents the exact number of days Gramsci spent in prison.[51]

The interview with the artist clarified a number of points regarding the

184 |

choices behind the construction of the cell and indications on how to position the work in space, together with suggestions related to its conservation during the exhibition and expectations associated with the interaction between the work and the public. Jaar also declared to have carefully considered and selected the colors of the exterior walls and the interior ceiling and pavement, as well as the texture of the material that clads the exterior of the cell; in his view, these elements must constitute a clear separation from the architectural finishes inside MAXXI. Furthermore, the artist described his expectations for a powerful interaction with the public, which is invited to experience the work by entering the cell through the door, such that the infinite physical reflection of the body in space alludes simultaneously to Gramsci's thoughts, rooted in the past and projected into the future.

This work is the object of a pilot project of interviews involving those responsible for choices related to its exhibition and maintenance: the director of the museum, the exhibition curator, the restorer/conservator, and the general public. A comparison of the different answers provided will eventually allow for the establishment of guidelines for the future presentations of the work.

Additionally, all documentation gathered during the exhibition is currently being archived: plans, sketches, project drawings, the list of wall colors, and an architectural survey of the space. Given that the interior of the cell contains no objects, 3-D images were considered superfluous. After being removed, a number of material elements will be maintained and stored by the museum: most likely, for reasons related exclusively to the possible reuse of materials in the event of future presentations of the work, these elements are the mirrors, prison bars, and the window. The artist does not confer a value of originality upon the materials utilized; in fact, the work was acquired by the museum in the form of a project, meaning that once the installation is taken down, the work exists only as documentation that allows the project to be reconstructed for future exhibitions.

Case Study 2: The Conservation of a Project in Progress: Bruna Esposito, *e così sia…* (2000)[52]

Ten years after the acquisition of the work *e così sia…* (2000) by Bruna Esposito (Rome, 1960), winner of the *Premio per la Giovane Arte Italiana* in 2000, the museum once again contacted the artist with the intent of discussing a number of important issues of conservation and documentation that were not fully verified previously. The work, defined by the artist herself as "non-permanent," is a mandala, a sort of mosaic of pieces that are not glued together, but simply placed on the ground, in which legume seeds and grains design the

form of a swastika (see Fig. 6.5 in color section). At the center of this composition, a Pyrex dish sitting on an electric hot plate contains boiling water and laurel leaves. The installation is connoted by a strong component of performance: during the setup and disassembly of the exhibition, both the action of "placing" and that of "removal" are accompanied by music selected by Bruna Esposito. During the exhibition the public is allowed to take a small bag of grains and legumes with them; each bag contains a poem by Paola d'Agnese.

The strong performative value, the explicit desire for interaction with the public, and the ephemeral nature of the work (the perishability of its components, together with the fact that it is not fixed to the floor, but simply sits on it), are the distinctive characteristics of the piece, beyond its objective materiality. Precisely these qualities complicated the acquisition of the work in 2000, documented in a video authorized by the artist. Bruna Esposito considers this video, whose rights were only recently conceded to the museum by Mara Chiaretti, and the photographs taken during its installation, as documentary materials and thus in no way a substitution for the work itself. In consideration of this condition, together with the fact that the museum had not acquired any other elements such as drawings or installation instructions, it was necessary to contact the artist again about the presentation of this work. The central question clarified with the artist was whether she considers the work to be replicable or not, taking into account that after 2000 the work was presented on three other occasions, with a few variations, related above all to the aspect of performance, in particular the music.

The result of this dialogue between the museum and artist was an agreement signed a year ago that has allowed the curators and conservators to define the status of the work, the editions, and the conditions of future exhibitions, especially with regard to preventing the risk of any possible misunderstandings of the use of the swastika.

It was also possible to identify an "other" form, with respect to the material, to ensure the persistence of this work within the collective memory and conscience: regarding the present and the future of *e così sia...* in the MAXXI collection, discussions with the artist focus on the hypothesis of developing a new form of video presentation, together with the possibility offered to the public to simply take (as in 2000) or purchase the small bags of legumes, grains, and poetry. According to the artist, this would actualize the persistence of the element of the dispersion of the materiality of the work, a memento of one of the distinctive traits of the work itself. Another possibility being evaluated is founded on the idea of the impossibility of reproducing a work designed to be ephemeral and non-repeatable, rendering the piece constantly visible and accessible on the Internet (not only during an exhibition), and thus offering a different form of persistence within the collection.

NOTES

1 This research is made possible with the support of Virtueel Platform and SKOR | Foundation for Art and Public Domain, both in Amsterdam. Thanks also to the members of the research group New Strategies in Conservation, in particular Renée van der Vall and Vivian van Saaze who commented on an earlier version of this article.

2 For an extensive account on the background and discussions on "document," see for example Buckland (1991 and 1997), Day (2001), and Francke (2005).

3 See Oxford Dictionary of Latin.

4 The term "documentation" , and "documentalist" was mostly used in Belgium, the Netherlands and Germany and, to a lesser extent, in France and Great Britain. The United States very soon started to adopt the term "information science." A full account on the meaning and implication of the different terminologies goes beyond the scope of this research; instead, I will focus on the use of documentation in as far as it is relevant to conservation. For more information on the history of the term "documentation" see, among others: Woledge (1983).

5 In the arts there is little research on the notion and implication of artists' intent. Conservator Steven W. Dykstra (1996) is one of the few conservators who attempted to develop a clear understanding of the notion of artist's intention in art conservation.

6 For an elaborate account see among others: Muñoz Viñas (2005); Laurenson (2006); and the recent anthology by Richmond and Bracker (2009).

7 Choices are inherently subjective, but the consequences of this subjective stance have only recently been addressed and acknowledged, most noticeably in the writing of Clavir (2002).

8 Matt Adams. personal interview between Blast Theory, Annet Dekker (Virtueel Platform), Liesbeth Huybrechts (BAM), and Priscilla Machils (BAM). Brighton, UK, 5 February 2010.

9 For more information about *Uncle Roy All Around You*: http://www.blasttheory. co.uk/bt/work_uncleroy.html.

10 Unless stated otherwise all the information about Blast Theory is taken from two interview sessions. The first with Matt Adams in Amsterdam (7 December 2009) and the second with the core members Matt Adams, Ju Row Farr, and Nick Tandavanitj in their studio in Brighton (5 February 2010). These interviews are conducted by Dekker and Huybrechts (BAM / Media & Design Academy, Genk, Belgium). For more information about Blast Theory see: http://www.blasttheory. co.uk.

11 The word "capture"' means that something has been seized or taken control of. However, when applied to video, nothing really gets "captured" or seized. "Video merely makes marks on a magnetic tape – marks which offer no guarantee of

knowledge of the object that it is representing." Becky Edmunds. "A Work of Art from A Work of Art." (2007). http://beckyedmunds.com/#/on-documentation/4531976852. Last access: 12 September 2012. Nevertheless, in media art the term is now widely used for the process of documentation: "To record or make a lasting representation of (sound or images); as, to capture an event on videotape," glossary, *Inside Installations* http://www.inside-installations.org/onlinecoursevideodocumentation/module1/glos01.htm.

12 See, for example, Phelan (1993: 146-166).

13 Becky Edmunds. "A Work of Art from A Work of Art." (2007). http://beckyedmunds.com/#/on-documentation/4531976852. Last access: 12 September 2012.

14 The notion of tacit knowledge refers to the range of conceptual and sensory information, i.e., all forms of knowledge that cannot be represented: knowledge that cannot be fully articulated, expressed in formulas, or described in documents (Polanyi, 1966). The notion of tacit knowledge is not uncontested and is often viewed as subjective in conservation; it refers to the artist's intent and the social and cultural context in which a work is presented or performed.

15 Becky Edmunds. "A Work of Art from A Work of Art." (2007). http://beckyedmunds.com/#/on-documentation/4531976852. Last access: 12 September 2012.

16 This way the object, the video document, can also be regarded as a boundary object, passing between communities where it faces different interpretive strategies in each one. For further reading, see Star and Greisemer (1989). Massumi (2002) and Leach (2010) take the notion of the object further, claiming that the object has its own agency besides being merely a mediation tool.

17 An impression of the size of their archive: "Over the last 16 years we have meticulously archived every aspect of each project: creative notes, correspondence, publicity materials, press, design work, software, production manuals. The archive held by us includes 90 box files, 20 virtual models of cities and 900Gb stored on servers. Because we work in collaboration so frequently archival materials relating to our work are held elsewhere (such as the University of Nottingham), usually for technical or intellectual property reasons. These include logs, messages sent and received, audio recordings, etc.." Notes taken from a proposal that was used for Legacy, a one-off initiative developed in collaboration between the Live Art Development Agency and Tate Research, 2008.

18 See Winget (2008) and Dekker (2010: 7.1) on preservation strategies for gaming.

19 For more information see: http://forging-the-future.net/ and http://variablemediaquestionnaire.net/.

20 Or, in the case where an artist has passed away, his/her collector, programmer, or technician – those closest to the artist and the work as it was made and exhibited.

21 http://capturing.projects.v2.nl.

22 http://www.tate.org.uk/research/tateresearch/majorprojects/mediamatters/.

23 http://www.bampfa.berkeley.edu/about/formalnotation.pdf.

24 See also: Delahunta & Shaw (2006), Winget (2008), Dekker (2010).

25 See, among others, Fauconnier & Fromme (2003), Jones (2007), Van Saaze (2009).

26 The idea of providing relations between different components (technical speci-
 fications) and occurrences (various situations and presentations: the ideal situ-
 ation and minimal requirements) is further developed in the context of *Inside
 Movement Knowledge*. Elements of different models are adapted to the specific
 needs of contemporary dance documentation, see: Van Saaze, Dekker, and Wijers
 (2010).

27 See, among others: Van de Wetering (1989), Sloggett (1998), and Beerkens et al.
 (2012).

28 A method to capture different audience experiences was conducted by the
 research group during the Creator project (in which Blast Theory's project Rider
 Spoke was developed). The "digital replay system" shows an interactive juxtapo-
 sition of materials generated by different communities over time. "The system
 allows for new and unexpected discoveries as the work could be viewed through
 growing numbers of disciplinary lenses." (Chamberlain, 2010).

29 In the museum context this happens regularly, even with more traditional art
 forms. See Van Saaze's contribution to this chapter.

30 Geoffrey Bowker during his presentation at Memory of the Future, Ghent, June
 2010.

31 Kunsthalle Zurich, 24 August 2002 – 27 October 2002; San Francisco MoMA, 14
 December 2002 – 16 March 2003; the Institute of Visual Culture in Cambridge
 (UK), 14 December 2002 – 16 March 2003.

32 This text is based on literature research as well as on fieldwork conducted at the
 Van Abbemuseum, Eindhoven (NL), for my Ph.D. research (Van Saaze 2009). Inter-
 views with (former) staff members were conducted between 2004 and 2008. I am
 particularly grateful to the staff of the Van Abbemuseum for their generosity and
 time in our conversations.

33 See also: Lind (2007). For a historical account of the collaborative aspect in the
 arts, see: Green (2001).

34 Lind (2007). On the increase of collaboration practices in new media art, see also:
 Diamond (2008).

35 It is interesting to note that, in addition to several artists, other cultural producers
 such as the authors of the book *No Ghost Just a Shell* (Huyghe and Parreno, 2003)
 were also considered contributors to the project.

36 In May 2006, the Van Abbemuseum lists 27 inventory numbers representing
 works by the following contributors: Pierre Huyghe, Philippe Parreno, Henri
 Barande, Angela Bulloch and Imke Wagener, François Curlet, Lili Fleury, Liam
 Gillick, Dominique Gonzalez-Foerster, Pierre Joseph and Mehdi Belhaj-Kacem,

M/M Paris (Matthias Augustyniak and Michel Amzalag), Melik Ohanian, Richard Phillips, Joe Scanlan, Rirkrit Tiravanija, and Anna-Léna Vaney (source: museum registration system Van Abbemuseum, May 2006).

37 Interview Phillip Van den Bossche, curator of exhibitions Van Abbemuseum, 13 January 2005.

38 See also Jon Ippolito (2008) on the limitations of standard collection management systems.

39 Interview with Margo van de Wiel, registrator collection at Van Abbemuseum, 15 May 2008 and email correspondence 26 October 2009.

40 Particularly noteworthy are Kristel Van Audenaeren's M.A. thesis (2005) and Anne Mink's research and internship report (2007).

41 Interview Charles Esche, artistic director Van Abbemuseum, 27 March 2007.

42 See the contribution by Annet Dekker in this volume. I would also like to add the documentation models developed within the European research project Inside Installations (http://www.inside-installations.org/research/detail.php?r_id=482&ct=model).

43 See also: http://still-water.net/.

44 In the organization of the contemporary museum, the warehouse is conceived as the functional space for all museum activities and not, as was often the case in the past, as space dedicated to storage only. Inside MAXXI, which does not have a permanent exhibition of its collection, the warehouse plays a role of primary importance. It is worthwhile recalling how the Schaulager in Basel is organized neither as a simple "warehouse by design," nor as a museum with all works on display. The works are all installed and visible, though as if they were in storage, one beside the other, in closed and monographic spaces.

45 The INCCA now represents a platform of convergence for the most up-to-date research in the field of conserving contemporary art; it offers a guide for the realization of interviews with artists ("Guide to Good Practice: Artist's Interviews") that the MAXXI will use as a tool of research for documentation. See www.incca.org (last access: 20 August 2012).

46 We must carefully distinguish between a restoration done by the restorer, and an intervention by the artist. The latter should lead to an additional, second dating of the work.

47 Operating retroactively, the first critical act is already that of making a selection of the works to be documented, obviously beginning with those works in the collection that already present critical issues of conservation, or which may present problems.

48 DIC – *Documentare Installazioni Complesse* (Documenting Complex Installations) is a pilot project promoted and conducted by the *Civiche Raccolte di Milano* and the Italian Ministry of Cultural Heritage, involving the MAXXI and other Italian museums. During 2007, it was used to test the methodology of documentation

employed by the international group as part of the project *Inside Installations. Preservation and Presentation of Installation Art*. During the same year, the MAXXI *Installazioni* series presented three exhibitions of works from its permanent collection as the analysis of case studies of different problems related to the exhibition of complex installations with a technological basis. See Pugliese and Ferriani (2009).

49 The OAC – *Opera Arte Contemporanea* (Work of Contemporary Art) chart was proposed and developed by the Italian Ministry of Cultural Heritage's *Istituto Centrale per il Catalogo e la Documentazione*. This chart is easy to fill out, consult, and update. Focused substantially on the analysis of material components and conservation issues, the chart was developed based on international models that were first proposed at the end of the project *Inside Installations*; it was reworked in light of the specific research pursued by the museum. Recent work has focused on the issue of archiving data and the possibility of creating connections between the two types of charts, to avoid repetition and integrate the most developed sections of the two models.

50 Installation: steel bars, painted wood, mirrors, 525 x 550 x 570 cm. MAXXI Collection.

51 The drawings and silkscreen print are not a part of the installation, but works on their own. The five drawings in the MAXXI collection belong to a series of 20 in total.

52 Project in progress of installation and destruction with epilogue singing by the artist (legumes, grains, laurel, hot plate, Pyrex container, water, bags containing a mix of legumes, grains, and poetry by Paola D'Agnese), final overall size approximately 400 x 400 cm. MAXXI Collection.

REFERENCES

Adamczyk, Piotr D. "Ethnographic Methods and New Media Preservation." In *Museums and the Web 2008. Proceedings*, edited by Jennifer Trant, and David Bearman. Toronto: Archives & Museum Informatics, 2008. Http://www.archimuse.com/mw2008/papers/adamczyk/adamczyk.html. Last access: 25 September 2012.

Baker, George. "An Interview with Pierre Huyghe." *October* 110 (2004): 81-106.

Beerkens, Lydia (et al.). *The Artist Interview. For conservation and presentation of contemporary art. Guidelines and practice*. Heijningen: Jap Sam Books.

Benford, Steve, et al. "Can You See Me Now?" *ACM Transactions on Computer-Human Interaction* 13 (2006) 1: 100-133.

Brandi, Cesare. *Il restauro. Teoria e pratica 1939 – 1986*. Rome: Editori Riuniti, 1994.

Briet, Suzanne. *What is documentation?* Translated and edited by Ronald E. Day and Laurent Martinet with Hermina G.B. Anghelescu. Lanham, MD: Scarecrow Press, 2006.

Buckland, Michael K. "What is a 'Document'?" *Journal of the American Society for Information Science* 48 (1997) 9: 804-809.

—. *Information and information systems.* New York: Greenwood, 1991.

Chamberlain, Alan, Duncan Rowland, Jonathan Foster, and Gabriella Giannachi. "Riders Have Spoken: Replaying and Archiving Pervasive Performances." *Leonardo* 43 (2010) 1: 90-91. Http://www.crg.cs.nott.ac.uk/~azc/Riders/riderreport.htm. Last access: 25 September 2012.

Clavir, Miriam. *Preserving What Is Valued. Museums, Conservation and First Nations.* Vancouver: University of British Columbia Press, 2002.

Cook, Nicolas. "Words about Music, or Analysis versus Performance." In *Theory into Practice. Composition, Performance and the Listening Experience – Nicolas Cook, Peter Johnson, Hans Zender*, edited by Peter Dejans, 9-52. Leuven: Leuven University Press, Orpheus Institute, 1999.

Day, Ronald E. *The Modern Invention of Information. Discourse, History, and Power.* Carbondale, IL: Southern Illinois University Press, 2001.

Dekker, Annet, ed. *Archive 2020. Sustainable Archiving of Born Digital Cultural Content.* Amsterdam: Virtueel Platform, 2010.

Delahunta, Scott, and Norah Zuniga Shaw. "Constructing Memories. Creation of the Choreographic Resource." *Performance Research* 11 (2006) 4: 53-62.

Depocas, Alain. "Digital Preservation. Recording the Recording. The Documentary Strategy." In *Takeover. Who is doing the art of tomorrow. Ars Electronica Catalog*, edited by Gerfried Stocker and Christine Schöpf, 334-339. Vienna: Springer-Verlag, 2001.

Depocas, Alain, Jon Ippolito, and Caitlin Jones (eds.). *Permanence Through Change. The Variable Media Approach.* New York: The Solomon R. Guggenheim Foundation & Montreal: Daniel Langlois Foundation for Art, Science and Technology, 2003.

Diamond, Sara. "Participation, Flow, and the Redistribution of Authorship. The Challenges of Collaborative Exchange and New Media Curatorial Practice." In *New Media in the White Cube and Beyond. Curatorial Models for Digital Art,* edited by Christiane Paul, 135-162. Berkeley: University of California Press, 2008.

Dykstra, Steven W. "The Artist's Intentions and the Intentional Fallacy in Fine Arts Conservation." *Journal of the American Institute for Conservation.* 35 (1996) 3: 197-218.

Fauconnier, Sandra, and Rens Frommé. *Capturing Unstable Media. Summary of research.* Rotterdam: V2_, 2003. http://www.v2.nl/archive/articles/capturing-unstable-media/view. Last access: 25 September 2012.

Fluegel, Katharina. "Dokumentation als museale Kategorie." *Rundbrief Fotografie, Sonderheft 6. Verwandlungen durch Licht. Fotografieren in Museen & Archiven & Bibliotheken*. Esslingen: Museumsverband Baden-Württemberg, 2001: 19-29.

Foster, Hal. "An Archival Impulse." *October* 110 (2004): 3-22.

Francke, Helena. "What's in a Name? Contextualizing the Document Concept." *Literary and Linguistic Computing* 20 (2005) 1: 61-69.

Green, Charles. *The Third Hand. Collaboration in Art from Conceptualism to Postmodernism*, Minneapolis: University of Minnesota Press, 2001.

Hummelen, IJsbrand. "Conservation Strategies for Modern and Contemporary Art. Recent Developments in the Netherlands." *Cr* 3 (2005): 22-26.

Huyghe, Pierre, and Philippe Parreno (eds.). "*'No Ghost Just a Shell'. Un film d'imaginaire*." Eindhoven: Van Abbemuseum, 2003.

Ippolito, Jon (2008). "Death by Wall Label." In *New Media in the White Cube and Beyond. Curatorial Models for Digital Art,* edited by Christiane Paul, 106-130. Berkeley: University of California Press, 2008.

Jones, Caitlin. *State of the Art (of Documentation). Three Case Studies for the Daniel Langlois Foundation's Ten Year Anniversary Exhibition*. Montreal: Daniel Langlois Foundation, 2007. Http://www.fondation-langlois.org/html/e/page.php?NumPage=1988. Last access: 25 September 2012.

Kraemer, Harald. "Art Is Redeemed, Mystery Is Gone. The Documentation of Contemporary Art." In *Theorizing Digital Cultural Heritage. A Critical Discourse*, edited by Fiona Cameron and Sarah Kenderdine, 193-222. Cambridge, MA: MIT Press, 2007.

Laurenson, Pip. "Authenticity, Change and Loss in the Conservation of Time-based Media Installations." *Tate Papers. Tate's Online Research Journal* (Autumn 2006). Http://www.tate.org.uk/download/file/fid/7401. Last access: 25 September 2012.

Leach, James. "Intervening with the Social. Ethnographic practice and Tarde's image of relations between subjects." In *The Social After Gabriel Tarde*, edited by Matei Candea, 191-207. London: Routledge, 2010.

Lind, Maria. "The Collaborative Turn." In *Taking the Matter into Common Hands,* edited by Johanna Billing, Maria Lind, and Lars Nilsson, 15-31. London: Black Dog Publishing, 2007.

Lurk, Tabea, and Jürgen Enge. "Sustaining Dynamic Media Objects and Digital System Environments. An Assessment of Preservation Methods for Computer Based Artworks." Unpublished paper, Bern University of the Arts, 2010. Http://www.hfg.edu/images/b/b4/LurkEnge_SustainingDynamicDigitalObjects.pdf. Last access: 25 September 2012.

Lycouris, Sophia. "The Documentation of Practice. Framing Trace." *Working Papers in Art and Design* 1 (2000): http://sitem.herts.ac.uk/artdes_research/papers/wpades/vol1/lycouris2.html.

MacDonald, Corina. "Scoring the Work. Documenting Practice and Performance in Variable Media Art." *Leonardo* 42 (2009) 1: 59-63.

Massumi, Brian. *Parables for the Virtual/ Movement, Affect, Sensation*. Durham, NC: Duke University Press, 2002.

Mink, Anne. *No Ghost Just a Shell. inhoud, context en praktijk*. Research and internship report, Radboud University Nijmegen, 2007.

Muller, Lizzie. "Oral History and the Media Art Audience." In *Archive 2020. Sustainable*

Archiving of Born Digital Cultural Content, edited by Annet Dekker, 6.0-6.9. Amsterdam: Virtueel Platform, 2010.

Muñoz Viñas, Salvador. *Contemporary Theory of Conservation*. Oxford: Butterworth-Heinemann, 2005.

Otlet, Paul. *Traité de documentation. Le Livre sur le Livre. Théorie et Pratique*. Brussels: Editiones Mundaneum, 1934.

Phelan, Peggy. *Unmarked. The Politics of Performance*. London: Routledge, 1993.

Polanyi, Michael. *The Tacit Dimension*. London: Routledge & Kegan Paul, 1966.

Pugliese, Marina. *Tecnica mista. Materiali e procedimenti nell'arte del XX secolo*. Milan: Bruno Mondadori, 2006.

—, and Barbara Ferriani. *Monumenti effimeri. Storia e conservazione delle installazioni*. Milan: Electa, 2009.

Richmond, Alison, and Alison Bracker (eds.). *Conservation Principles, Dilemmas and Uncomfortable Truths*. Oxford: Butterworth-Heinemann in collaboration with Victoria and Albert Museum London, 2009.

Rinehart, Richard. "A System of Formal Notation for Scoring Works of Digital and Variable Media Art." Unpublished paper. Available online: http://www.bampfa. berkeley.edu/about/formalnotation.pdf. Last access: 12 November 2012.

Sloggett, Robyn. "Beyond the Material. Idea, Concept, Process, and Their Function in the Conservation of the Conceptual Art of Mike Parr." *The American Institute for Conservation of Historic & Artistic Works* 37 (1998) 3: 316-333.

Star, Susan Leigh, and James Griesemer. "Institutional Ecology, Translations and Boundary Objects. Amateurs and Professionals in Berkeley's Museum of Vertebrate Zoology, 1907-39." *Social Studies of Science* 19 (1989): 387-420.

Svenonius, Elaine. "Access to Nonbook Materials. The Limits of Subject Indexing for Visual and Aural Languages." *Journal of the American Society for Information Science* 45 (1994) 8: 600-606.

Van Audenaeren, Kristel. *Het Kunstenaarsproject* No Ghost Just a Shell: un film d'imaginaire. *Van netwerkvorming tot tentoonstelling*. M.A. thesis, Ghent University, 2005.

Van der Beek, Wim. "AnnLee: No Ghost." *Kunstbeeld Cahier. Het Nieuwe Van Abbe* (2003): 41-44.

Van de Wetering, Ernst. "The Autonomy of Restoration. Ethical Considerations in Relation to Artistic Concepts." In *Historical and Philosophical Issues in the Conservation of Cultural Heritage*, edited by Nicholas Stanley Price, M. Kirby Talley, and Alessandra Melucco Vaccaro, 193-199. Malibu, CA: J. Paul Getty Trust, 1996.

Van Mastrigt, Jeroen. *PLAY. Utrecht Playground for Games and Playful Culture*. Utrecht: Gemeente Utrecht, 2009.

Van Saaze, Vivian. *Doing Artworks. A Study into the Presentation and Conservation of Installation Artworks*. Ph.D. diss., Maastricht University and the Netherlands Institute for Cultural Heritage, 2009.

—, Annet Dekker, and Gaby Wijers. "The Interview as Knowledge Production Tool in Contemporary Art and Dance Documentation." *RTRSRCH. [NOTATION]* 2 (2010) 2: 18-22.

Waters, Donald, and John Garrett. *Preserving Digital Information. Report of the Task Force on Archiving of Digital Information.* Washington, DC: Council on Library and Information Resources, 1996.

Wilkie, Fiona. "Documenting Live and Mediated Performance – the Blast Theory Case Study." In *A Guide to Good Practice in Collaborative Working Methods and New Media Tools Creation (by and for artists and the cultural sector)*, edited by Lizbeth Goodman and Katherine Milton. London: Kings College, 2004: http://www.ahds. ac.uk/creating/guides/new-media-tools/wilkie.htm. Last access: 25 September 2012.

Windfeld Lund, Niels. "Doceo + mentum – a ground for a new discipline." Unpublished paper presented at the *DOCAM '03* conference, 13-15 August 2003, SIMS, University of California-Berkeley. Http://thedocumentacademy.org/resources/ 2003/papers/lund.paper.html#_ftn14. Last access: 25 September 2012.

Winget, Megan. "Collecting and Preserving Videogames and Their Related Materials. A Review of Current Practice, Game-Related Archives and Research Projects." Unpublished paper, presented at the *Annual Meeting of the American Society for Information Science & Technology (ASIS&T).* Columbus, OH, 24-29 October 2008.

Woledge, Geoffrey. "Historical Studies in Documentation. 'Bibliography' and 'Documentation.' Words and Ideas." *Journal of Documentation*, 39 (1983) 4: 266-279.

PART III

TECHNOLOGICAL PLATFORMS, PRESERVATION, AND RESTORATION

INTRODUCTION

Cosetta G. Saba

Within a framework of the system of relations between "technology" and "culture," the third part of this book is dedicated to preservation and restoration theories and practices, and has two sides. On one hand (in chapter 7), the history of research and technological innovation in the media area is highlighted, also in the case of "low cost" examples, emphasizing the deconstruction and reinvention processes produced by artistic practices with respect to the industrial structures of cinema (7.1), television (7.2), and information technology (7.3). On the other hand (in chapter 8), epistemological frameworks are introduced, as well as working methodologies, projects, and experimentations, case studies, decision-making models for film, video (8.1) and digital artworks (8.2), and issues of preservation and restoration, focusing on their progressive levels of institutionalization (best practices, recommendations, protocols, etc.)

The two chapters in this part of the book introduce a history of the use of "cinematic" technologies and treat the question of the treatment of the expressive material (physical, chemical, analog, or digital) in the context of preservation strategies, documentation, archiving, and access techniques elaborated by museums or universities. Here, the material of these works is defined as being coextensive to the image. The approaches discussed define the degree of relevance that technology assumes with respect to the composition modes of these works, the reproduction devices and specific exhibition context needed to experience artworks based on cinema, television and information

technology devices. The complexity of these artworks' composition – more precisely, the complexity of the practices that generate them – requires the production, storage, accessibility, and interoperability of contextual information on the works' cultural history (that implies the history of the transmission of the artwork and its documentary corollary), the "textual" and "contextual" reconstruction of the artistic intention (see Eco, 1990), as well as its reception modes (see the contribution on media art and digital archives in chapter 4 of this book). The relationship between the artist intent, the work's identity, and the use of technical equipment can reveal the degree of relevance and meaning that the equipment has, with respect to the artwork itself. This provides a basis for determining the preservation strategies that can be adopted to confront the obsolescence of the work's components (7.4 and 8.3).

In the current cultural industry, where different media forms coexist (see Jenkins, 2006, and, for the film archival field, Fossati, 2009), artists use both the latest and obsolete forms of media technology. When applied in artistic work, these media technologies and the practices related to them are transformed, in the process reconfiguring the way these works refer to the "sensory" (Rancière, 2000). The "phenomenology of the moving image" that descends from this, passes through different media, stratifying, transforming, and expanding their languages into new composition forms, and into complex platforms which are subject to obsolescence or deliberately based on obsolete technology. Given the physical and artistic instability of these artworks, as José Jiménez (2002) says, the museums and art institutions of the future will have much more to do with generation, archiving, and transmission of information than with the safekeeping and classification of material pieces. Yet, as the practice of media art preservation shows (7.4 and 8.3), developing strategies of preservation that do justice to the concept and appearance of these works requires that the material and technical components as well as the documentation of its functionality, appearance, and experience are taken into account.

REFERENCES

Eco, Umberto. *I limiti dell'interpretazione,* Milan: Bompiani, 1990.

Fossati, Giovanna. *From Grain to Pixel. The Archival Life of Film in Transition*. Amsterdam: Amsterdam University Press, 2009.

Jenkins, Henry. *Convergence Culture. Where Old and New Media Collide*. New York and London: New York University Press, 2006.

Jiménez, José. *Teoría del Arte*. Madrid: Editorial Tecnos, 2002.

Rancière, Jacques. *Le Partage du Sensible. Esthétique et Politique*. Paris: La Fabrique, 2000.

Technological Platforms

INTRODUCTION

Simone Venturini

Technological systems are dynamic entities, the stability of which relates to temporary *convergence* phenomena[1] within a cultural set that establishes the media system, based on industrial and communication standards and protocols. The dynamics of convergence do not only relate to the physical and technical identity of media, they also work in terms of individual and social imagery. In this sense, the aesthetic experiment in the arts *sub specie* technology has always worked as much on technological innovations as it has on protocols.[2] The protocols (like standards and recommendations) are the results of an economic and socio-cultural negotiation; they are a place for the redefining of the convergence or divergence between different kinds of media. Furthermore, when the new technology is up and running, operations are activated (an example being aesthetic finality) which explore the characteristics and the potential of the new arrivals.

The technological innovations are a starting point for talking about mapping with regards to sensory factors and therefore invoke activity to produce sensory remapping and expressive training practices, which are useful in the reconfiguration of what Derrick de Kerckhove has called *brainframes* around this new technology (Kerckhove, 1991).

In chapter 7, some of the operations and the modes that distinguish the aesthetic actions from cinema technology and analogue and digital video will be highlighted. The first "place" in which the aesthetic practices of research operate is *techniques* (Altman, 2001), which can be interpreted as an *alchemi-*

cal, *laboratory*, or *handmade* environment for using the technology available and the human and corporal reclaiming of technology. The place of technique requires choices, solutions and decisions that bypass and anticipate the supposed linear nature of the use of the technology, systems, and materials.

The aesthetic decisions about the use of the technology can at the same time be informed by actions that look beyond the normal use of the object and the immediacy of a functional representation. They are practical operations on the technology and materials of a reflexive nature, aimed at creating aesthetic planning, which means a project that is not immediately useful, a "planning forecast of many possible aims." From this point of view, aesthetic experimentation is to be understood as "a mainly *meta-operational* activity" (Garroni, 1977).

The *breaking practices* (Shand, 2008) are other sensitive stimulating cultural points of techno-aesthetic experimentation. The error and breakdown become features that allow for the recognition and reconfiguration of the basic aesthetic and technological project and the subjectivity that produced it, revealing the astonishment and the sense of uncanny that hides behind the habituation to technological innovations (Gunning, 2003).

Aesthetic experimentation has always interacted with the category and modes of amateurship (Zimmerman, 1995; Ishizuka and Zimmerman, 2007; Shand, 2008) for financial reasons, for the opportunities of control upon the process and the possibility of creating flexible use, exchange and communication protocols. In addition, amateur film can be considered as a liminal space of transit and continuous experimentation. Therefore, the amateur area functions as a place where innovations can be checked and also as a place where the starting utopian potential of technology can be maintained. The astonishment and unawareness that amateur film maintains as a *reserve* and a *resource* is something "out of place" that must be considered as an *unintentional* approach, which is preparatory and complementary to what is "out of mode," revealed by obsolescence as a precondition for the discourse *intention* and action of reinventing the medium (Krauss, 1999).

The obsolescence includes its opposite, the industrial structures of production and reproduction (preservation and transmission) that affect and guide artworks and preservation arenas. The changes of standards produce obsolescences, remains, and destruction. Damage and decay are included in the language as aesthetic idiolect, as indicators of a "breaking" practice. The aesthetic aspect establishes the possibility of its own existence, too, in the dialectic created by technology between "product" and "process," between norms and the deviation, "industry" and "craftsmanship," and between "professional" and "amateur."

THE HISTORY AND TECHNOLOGICAL CHARACTERISTICS OF CINEMATOGRAPHIC PRODUCTION AND RECEPTION DEVICES

Simone Venturini and Mirco Santi *

Standard 35mm Film

In the first decade of the 20th century, Edison's perforated 35mm film and the aspect ratio of 1:1.33 was the format that was establishing itself and would be taken on as the industry standard from 1909. Between 1923 and 1924, the standards for the negative (BH) and positive (KS) perforations were set, together with the positioning settings for full-frame. With the introduction of the optical soundtrack, halfway through the 1930s, the standards for sound film were achieved (the Academy format, 1:1.37) and during the 1950s, panoramic and anamorphic formats and magnetic sound were introduced.

The physical characteristics of film were used at an expressive level. For more than just a few filmmakers (including George Landow, Peter Tscherkassky, Paolo Gioli) the perforations, the area of the soundtrack, and the frameline became expressive visual and audio elements. The physicality of the film became material for aesthetic practices derived from the collage and from found objects, and operates within a dialectic between norm and deviation, between use (functionality) and out of use (breaking), between the invisibility of the technical standards and the exhibition of protocols and structures.

From this point of view, Tscherkassky's trilogy *L'Arrivée*, *Outer Space*, and *Dream Work* from the end of the 1990s is exemplary. Through the use of cinemascope, the artist achieved three objectives from his own experimental research: making structural elements of the film such as the perforations visible, thus working on the concept of "outer space"; using a "classic" cinematographic format in an experimental context where paradoxically filmmakers have often not considered alternatives to the 1:1.33; placing in the contemporary transition a format, which imposed itself on a previous moment of transformation and crisis of cinema (the introduction of electronic television images) (Bardon, 2001).

Substandard Film

The evolution of photography from a practice of only professional photographers to a personal and common experience – think of George Eastman and his motto, "You press the button, we do the rest"[3] – and the birth of amateur

cinema offer various analogies. In both cases, the easy-to-use instrument was essential in making photography and cinematography an everyday affair.[4]

The first attempts were linked to the reduction from 35mm format to 17.5mm, and the production of the first film cameras such as Birtac (1898) and Biokam (1899), for example, as well as different experiments such as Gaumont's Chrono de Poche (1900), 15mm.

The introduction of the safety film (cellulose diacetate) together with the Pathé Kok 28mm format (1912) gave life to the first system for cinema at home. The 28mm combined safety and ease of use, good quality, the possibility to project films from a dedicated library, and to have a camera specifically designed for home cinema purposes.

Amateur cinema therefore had to satisfy two requirements – practicality and security – to which a third would later be added: the use of reversal material. These requirements would form the basis for the first small and popular models: the 9.5mm Pathé Baby and the 16mm Kodak.

In 1922, Pathé put the 9.5mm on the market. Pathé's slogan was "Petit, simple et bon marché." As well as the miniaturization, a key factor in the growth and development was the accessory kit: tools to print and do the film processing by themselves; rotary discs with color filters to "simulate" the colors; and accessories to "extract" and enlarge single frames.

In 1923, Kodak put the 16mm on the market, although it was too expensive for many people. These were heavier cameras (4.5 kilograms compared to Pathé's camera which was barely one kilogram). It was possible to load the camera with 30 meters of film (compared with the French format's nine meters). The loading of the spools required greater skill than the loading of the 9.5mm's "cartridge." The 16mm was a more troublesome system, reserved for the elite but also aimed at semi-professionals in schools and institutions. The 16mm was an open system: the cameras were not the exclusive preserve of Kodak, instead, the patent was made available to many different brands (Bell & Howell being one noteworthy example) which would bring improvements and developments. The double perforations guaranteed remarkable frame stability. At the beginning of the 1930s, with the introduction of sound,[5] one row of perforations would be sacrificed to leave space for the soundtrack. From the 1950s onwards, the spread of the magnetic medium would allow for easier shots and sound recording.

The 16mm format started to be used at the end of the 1930s by Len Lye and Norman McLaren. In the 1950s, amateur filmmakers, visual artists, students from art schools, and ordinary fans used the completely manual 16mm cameras because their extreme versatility allows for a lot of experimentation (think of the Bolex-Paillard H16). Much of the Underground Cinema and New American Cinema of the time was made with such cameras (Maya Deren,

7.1
Paillard Bolex H16
with turret with three
lenses. Source: Archivio
Nazionale del Film di
Famiglia – Associazione
Home Movies.

Gregory Markopoulos, Harry Smith, Kenneth Anger, Jonas Mekas, Stan Brakhage, and Robert Breer).

In 1932, Kodak put a new format on the market, known as 8mm (Standard 8 or Double 8). It was 16mm film which was seven-and-a-half meters long, with twice the usual number of perforations; the spools were mounted in metal casing to be loaded and exposed twice. In the area of the 16mm frame, after the processing and before the lengthways cut, four images were printed. From the cut and spliced film, fifteen meters were left, which corresponded to about four minutes of film at sixteen frames per second.

The miniaturization of the filming and projection equipment would make the format the most popular until the middle of the 1970s. From the 1950s onwards, the Kuchar brothers would work on Kodachrome's chromatic capacity and the Standard 8 format's grain. Brakhage also used the format for filming as well as for hand-painting the film.

From 1965, Kodak started to sell Super 8, which was the same size as the 8-mm format; the improvement was made by redesigning the film, increasing the area by 40 percent, thanks to the modifications of the perforations. At the same time, a new emulsion was released: Kodachrome II. Kodak aimed it at family cinema. Amateur filmmakers remained loyal to the Standard 8 for a long time (as long as stock remained available). In contrast, the Super 8 was also the format of self-awareness, of the affirmation of the film diary, for example *Walden* (1969) by Jonas Mekas.

Cameras

The artistic use of the film camera started with its basic elements, working around its optical and mechanical principles. The early avant-garde movements used many effects created with the camera; some of these included optical distortions in *La Folie du Docteur Tube* (1915) by Abel Gance, as well as multiple overlays, kaleidoscopic multiplications, positioning of the filters, and surfaces in front of the lens, and slow and fast motion in *Emak Bakia* (1927), *L'Etoile de Mer* (1928) by Man Ray, *Ballet Mécanique* (1924) by Fernand Léger, and *Filmstudie* (1926) by Hans Richter.

In the experimental context, the cameras were chosen according to their characteristics. The range of possibilities offered by Bolex-Paillard (speed and variable shutter, interchangeable optical systems, rewinding of the film for double exposures and fading) allowed many tricks to be carried out on the camera: from slow motion and animation to time-lapse and pixilation. For this reason, these cameras could be found in many of the American art schools and they were used in television for reporting. Beaulieu was another important brand in the construction of 16mm film cameras. The R16 resumed Bolex's tradition, compactness and versatility, not to mention the Angenieux 12-120 high quality zoom, which made it an instrument that was valued for difficult filming in mainstream production.

In the experimental context the cameras were freed from normative constraints (Deren, 1965) or they were constrained with set movements or kept still (as with certain structural and pop cinema). Finally, they were liberated from human presence, as was the case for the camera in continuous and automatic movement at the core of *La Région Centrale* (1971) by Michael Snow, a film that took conceptual action to its limits: the moving devices and the mobility that was created in the 1960s with the transfocal lenses, the dolly, the spider, and the camera-car; and in the 1970s firstly with the *louma* and then with the Steadicam.

Film cameras could then be recognized as complete craftsmanlike or idiosyncratic devices, for example: Alexandre Alexeieff's pin-screens or tools; László Moholy-Nagy's Light-Space Modulator, precursor to kinetic machines, whose movements and light games were the basis for *Lichtspiel* (1930). Another example was the "infernal machine" made to shoot Oski's painting that was the basis of Fernando Birri's *La verdadera historia de la primera fundación de Buenos Aires* (1959).

Film cameras were also related to their original and fundamental role in the camera obscura, like the example of Gioli's "pinhole camera" (a small empty metal rod with holes that was pulled manually) in *Film Stenopeico* (*L'Uomo senza Macchina da Presa*, 1973-1981-1989).

7.2
Camera mounted on rotating arms and
automatically moving counterweights for
Michael Snow's *La Région Centrale* (1971).
Courtesy Michael Snow.

The liberation of film from the camera's "dictatorship" involved abstract, painted, and artistic cinema with drawing, painting, collage, engraving, rayographic practices (Christian Schad, Man Ray, and László Moholy-Nagy), and abstract animation (Len Lye, Norman McLaren, Stan Brakhage, Marcel Thirache, Harry Smith, Aldo Tambellini, Thorsten Fleisch, and Ian Helliwell).

In addition to finding the first attempts at cameraless cinema[6] in Man Ray's rayograms, as in the case of Barbel Neubauer, there was also the *postproduction* or archival cinema that used material that had already been exhibited, hidden, and found in assemblages that had roots in photomontage (John Heartfield, Alexander Rodchenko). A practice that was also tied to the development of editing and optical printers and therefore also the possibility of revising and reframing the film. This was a practice that was put in motion in a way that was not dissimilar to "archival impulse" (Foster, 2004) and continued as an analytical, mnemonic, and imaginative exercise on various visual repertoires (Dziga Vertov, Joseph Cornell, Ken Jacobs, Ernie Gehr, Al Razutis, Martin Arnold, Gustav Deutsch, Tscherkassky, and Douglas Gordon).

Emulsion – Base

At the beginning of the 20th century, different cinematographic emulsions began to appear together with the first emulsions dedicated to the printing of copies (in 1908 Kodak's "Regular Positive"). Early in the second decade, orthochromatic film increased the zone of sensitivity, to the radiation of the visible spectrum. The spread of filming and projecting techniques that were not professional became associated with the use of safety film. The difficulties in the development of a stable safety film base and guarantee of basic conditions of transparency, resistance and flexibility persist, and a mixture of acetate, butyrate, and nitrate was used until the 1930s and 1940s, even for smaller formats. The beginning of the 1920s saw the spread of panchromatic emulsions, the majority of film production companies included pre-tinted stock materials. Around halfway through the 1920s, fine grain emulsions started to arise, able to produce positive and negative duplicates from which the final copies could be obtained. The reversal process was successful in cinema thanks to the 9.5mm, 16mm, and 8mm substandard formats. The substandard format experience was a fundamental forerunner and, in 1965, Fuji put the Single 8 on the market, the first polyester film. After the Second World War, the cellulose triacetate base spread, destined to replace cellulose nitrate as the standard for 35mm films from 1951 onwards. Around halfway through the 1970s, the polyester base replaced the triacetate in perforated magnetics, and then took over as the base for 35mm prints in the second half of the 1980s.

The use of negative or intermediate film or mixed elements in projection was widespread in the experimental field, for example, the use of the negative in *The Very Eye of the Night* (1958) by Maya Deren; *Berlin Horse* by Malcolm Le Grice (1970); in the works of Maurice Lemaître, Douglas Gordon, and Peter Tscherkassky; the structural, pop, flickering elements in *T.O.U.C.H.I.N.G.* (1968) by Paul Sharits; the interposition between negative and positive in *Film Feedback* (1972) by Tony Conrad; or the use of negative, positive, black and white, and color in the multi-cameras and multi-screens of *After Manet* (1973) by LeGrice.

From the beginning of the 20th century, reproducing natural colors was experimented with in different ways (Lumière, Urban's Kinemacolor in 1906, Chronochrome Gaumont in 1913). In 1905, Pathé introduced Pathé Color for the coloring of positives with a mechanical system for color application. The system was in use until early in the 1930s, but the techniques that asserted themselves up until the end of the 1920s, in terms of symbolic and referential representation, were tinting and toning. As the 1920s approached, the production of subtractive systems began. In 1922, the American film *The Toll of the Sea* gave the first example of a color film created using the second Techni-

color system, and 1935 saw the use of the fourth Technicolor system, with the film *Becky Sharp* – this was a subtractive system with three colors that would remain in use until the end of the 1970s.

The first color systems beneficial for smaller film formats were Kodacolor and Agfacolor, interesting but complex systems that were available from early in the 1920s until halfway through the 1930s on 16mm format. During the 1930s the first systems of lenticular color reproduction began to spread. At the start of the 1930s, Dufaycolor was also available on the Pathé Baby format. But it was with Kodachrome (1935) and Agfacolor Neu that remarkable results were obtained, firstly on 16mm and then on 8mm. The single-layer subtractive Kodachrome emulsion for reversal film was the first real trichrome monopack. Initially designed for 16mm, it was soon applied to 35mm slides, and 8mm slides in 1936. The emulsion was cheap, with great chromatic stability, it was much loved, had great success and did not go out of production until 2009. The 1950s were the decade that saw color assert itself with monopack by Eastmancolor in 1950, Ferraniacolor in 1952, and Fujicolor in 1953.

The color system found a fertile testing ground in experimental cinema, for example *Composition in Blue* (1935) by Oskar Fischinger, which used Gasparcolor (Fischinger himself helped to develop it), a system then used by Len Lye and Alexandre Alexeieff. Another example was *Colour Separation* (1974) by

7.3
Reproduction of a frame from Isidore Isou,
Traité de bave et d'éternité (1951).

Chris Welby, based on the color separation process. The experimentation with color then went in many different directions, from filters to flashing, from toning to all artistic cinema, experimental animation, and the early avant garde, for example, *Das Wunder. Ein Film in Farben* (1922) by Walter Ruttmann, colored by hand.

The transforming action of the photo-chemical characteristics of film was also at the root of alchemic practices (bleaching, modification to the processing and printing of the film, over- and underexposure) and went as far as favoring the visionary lyricism and the ready-made of chemical physical decay (the decay of nitrate and certain colors) and to propose an idea of cinema as art of destruction, for example: *Trasferimento di modulazione* (1969) by Pierfrancesco Bargellini, and the works of Jürgen Reble's Schmelzdahin group. The layers of emulsion were also subjected to scratching, engraving, and heating (Brakhage, Isidore Isou, Lemaître, Olivier Fouchard, Karl Lemieux, Yves-Marie Mahè, Jürgen Reble, and Thorsten Fleisch).

Sound on Film

From the beginning there were many experiments in synchronized sound recorded onto a disc, including Kinetophone, Phono-Cinéma-Théatre, and Chronophone. The techniques for the recording and photoacoustic reproduction of sound on film had their first important event in 1904 with Eugène Lauste, when the practice of live musical accompaniment would have great success, emphasizing cinema's performative characteristics.

At the end of the First World War, the experimentation began to intensify. In 1918, the German Joseph Engl, Hans Vogt and Joseph Massolle began to develop the variable area. In 1919, Lee De Forest started testing recording at variable density, creating the Phonofilm system in 1922. Between 1926 and 1930, the final phase of development in optical sound on film was started and the system with separate negatives and variable area gradually came to dominate for variable density and disc systems. In 1935, Gance presented the sound and stereo version of *Napoléon* and, in 1940, Walt Disney made the full-length feature *Fantasia*, in color and with stereo sound on the *fantasound* magnetic multitrack system. The electronic technology continued to spread in cinema, through recording and post-production of the sound on the magnetic tape. The main instrument for this practice was the Nagra-Kudelski recorder (1951).[7] This, and similar systems, laid the foundation for the live recording of sound that would spread in the following decades, until in the 1970s Dolby Stereo was introduced.

"Graphical" or "drawn" sound was an interesting experimental practice. In

the conversion period towards sound film, there was a rise in experimentation and practices that mix optical sound, graphics and animation, and synthetic music in many contexts and different countries; ranging from the abstract films of Hans Richter, Viking Eggeling, to those of Walter Ruttmann. At the end of the 1920s in the Soviet Union, the experiments and research of Alexander Shorin, Arseny Avraamov, and Evgeny Sholpo stood out. The practice of utilizing graphic signs evoked an ornamental, synthetic, artificial, and graphic idea of sound. Oskar Fischinger moved in a similar direction with the "sound ornaments" in *Experiments in Hand-drawn Sound* (1931-32), as did Rudolph Pfenninger, Moholy-Nagy with *ABC of Sound* (1933), Norman McLaren, Len Lye, and the Whitney brothers with *Variations* (1941-42).

In many other cases, from the Letterists to much experimental cinema from the 1960s onwards, the area of the soundtrack was engraved, scratched, and the perforations encroached onto the area of playback to become an expressive noise. The printing or insertion of images on the track connects the audiovisual media and the cinematographic manufacture to graphic media and the typographic manufacture, the visual writing of the sound, and the orality of the graphics. There are examples of this in *Halftone* (1966) by David Perry, who utilized the halftone screens used by newspapers to construct the image of the sound; *Soundtrack* (1969) by Barry Spinello with the characters and typographic symbols of the Letraset transferred onto a clear film stock. *Dresden Dynamo* (1972) by Lis Rhodes and *Newsprint* (1972) by Guy Sherwin contained typographic characters inserted in the area of the image and the sound. Sherwin would then film daily objects and images, printing and inserting them into the soundtrack in *Musical Stairs* (1977) and *Railings* (1977).

7.4
Graphical sound: filmstrip from Guy Sherwin, *Newsprint* (1972).
Courtesy LUX.

Multiscreens, Installations, and Cinematic Systems

Edison's Kinetoscope (1891) can be seen as a model for a system for individual viewing of moving images recorded on film, whilst the Lumière brothers' Cinématograph (1895) can be taken as the successful model for projection and collective viewing of images on a surface. From the beginning, the limits of vision were extended thanks to experiments with stereoscopy (Friese-Greene, Lumière).

In 1927 Henry Chretien's *Hypergonar,* in the anamorphic format with a 1:2.66 projection ratio, allowed for the expansion of images and screens, ideally complemented with the multiscreen "polyvision"[8] of Abel Gance's *Napoléon* and followed by the Fox Grandeur 70 mm format, in 1929. In 1952, the first Cinemascope film appeared (with Fox perforations, four magnetic tracks, 1:1.27/1:2.44 ratio), then standardized as Standard Cinemascope with a 1:2.35 screen image and with an optical track. The senses extend toward the third dimension during the "golden age of three-dimensional cinema" (during the first half of the 1950s).

The panoramic and anamorphic formats multiplied (Vistavision, Technirama, 65mm and 70mm) and, with them, new experiments and experiences appeared that continued for the whole of the 1960s (Circarama, Magirama by Gance, Cinemiracle, Circle Vision, Kinopanorama, and Circular Kinopanorama). The experimentation of the projection device went in many directions, which cannot be easily summarized in its entirety.[9]

MULTISCREENS

In 1927, Abel Gance first applied polyvision with his *Napoléon*. Even before this first application in mainstream film, the early avant-garde movement had already happily imagined (the futurists) or articulated (Moholy-Nagy) polyvision; they had also partly put the film in "situation" (Dada). At the end of the 1940s, Luigi Veronesi invoked "absolute films, projected by themselves or simultaneously, in space, on multiple transparent screens, on different layers, on screens of gas, permeable to bodies and colors" (Medesani, 2005).

The perceptive relationship between spectator and the projected image was the main issue of a lot of structural cinema's research practices, for example, through test effects, stroboscopy, and image flickering. *Razor Blade* (1965-1968) by Paul Sharits is an example that unites the stroboscope effect with a synchronized projection of two films on two identical screens (or on two identical portions of screen). *Globe* (1971) by Ken Jacobs, can be mentioned as an example of stereoscopy, a film that exploited the Pulfrich effect, an illusion of

three-dimensionality that was obtained by decreasing luminosity on one eye (in this case through a polarized screen).

With "polyvison," a narrative and aesthetic practice was introduced that needed more surfaces as an alternative to, and an extension of, the classic text editing and limitations that showed itself in the multiple and simultaneous projections that would find later examples (Glauber Rocha, Malcome Le Grice, Isaac julien, Eija-Liisa Ahtila, Douglas Gordon, and Gary Hill).

MULTISCREEN INSTALLATIONS

In 1952 with *Le film est déjà commencé?* Maurice Lemaître and the Letterist movement began to break down the centrality of the film as object, film as work, and the traditional modality of cinematic experience by putting the film in "situation." The screen became a target for objects, and lost its centrality, whilst the film was projected in other places (on spectators, walls, or ceilings). The protocol faded in favor of a *happening, a situation* in which everyone was required to take on an unusual role. Lemaître's following production was also exemplary in this way, with screens full of strange objects, slides projected everywhere within a room, putting the same screen in movement and invoking films that did not show themselves in their own materiality but only in the minds of the viewers, called upon to imagine and represent them.

The expansion and multiplication of the screens began from the "panoramic," environmental, and "ecological" idea that in 1896 gave life to the first *Cinerama* – ten projectors arranged in a circle for the Exposition Universelle in Paris (Crary, 2005): an exemplary experience that tied together the exceptionality and the ephemerality of these systems, the conception of environmental and open installation. Sound experimentation, loops, and the multi-polyvision was represented by *Varia Vision* (1965) by Edgar Reitz (Fig. 7.5).

The majority of these multiscreen installations were confined to temporary exhibitions, but for this reason they were perfect for the experimentation and expansion of cinema away from its usual environment, in many cases continuing a well-established tradition with theatrical (set design and lighting) and kinetic-plastic origins applied to large spaces.

At the Montreal Expo in 1967, the set designer and theater director Josef Svoboda presented the multiscreen installation *Polyvision*, composed of cinematographic and slide projections on three-dimensional moving objects.[10] Also at the Expo in Montreal, the installation (35mm and 70mm) *In the Labyrinth* included simultaneous projections on five screens that were able to combine multiple images into one like the tesserae of a mosaic. The installation was conceived and codirected by Roman Kroitor, who in the

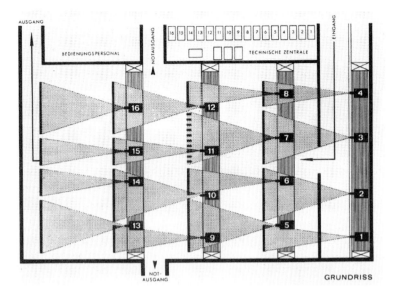

7.5
Installation plan, seen from the top, for Edgar
Reitz, *Varia Vision* (1965). Copyright: Edgar
Reitz Filmstiftung.

same year co-founded the society which in 1970 would become the IMAX
Corporation.

Another type of installation practice was concerned with the traditional
duration of the projection. *Cinématon* (1978-2009) by Gérard Courant, is a 154-
hour film, made using Super 8 and composed of single shots (portraits of art
and culture personalities) assembled together. *Holes* (started in circa 1990) by
Ian Helliwell, on the other hand, is a never-ending movie composed of pieces
of unwanted footage in Standard 8 that the director continues to splice and
add to with every new finding.[11]

VISIBLE PROJECTION SYSTEMS

The projected image can also be made up of many superimposed levels, like
the 16mm *Altergraphies I* (1981) by Fréderique Devaux which included the pro-
jection of the film on an *écran hypergraphique* achieved by projecting a slide.
The graphic superimposing of the screens was added to the sculptural nature
of projection machines. Another example of superimposing was represented
by Marcel Broodthaers' screens as typographical backgrounds onto which the
16mm *Le Corbeau et le Renard* (1968) was projected.

Further experiments could be found in the performances that place absorbent, masking surfaces and reflecting surfaces between the projector and the screen as was the case of the body and the mirror in Guy Sherwin's *The Man with the Mirror* (1976). The projection surfaces also vary according to their materiality: bodies, solid, liquid, and gas objects. Anthony McCall's *Line Describing a Cone* (1973) outlined – through the projection of a line in a dark environment, immersed in a gaseous atmosphere produced by a smoke/fog-machine – the space of the room as a space progressively shaped by the line that can be freely traveled over (see Fig. 1.5 in color section). On the contrary, the room of the Invisible Cinema, conceived by Peter Kubelka in 1970, became a ritual space of pure, orthodox and disciplined vision.

It is worth mentioning some of the obsolete and post-media machines (harking back to the initial utopia of Bauhaus and the Avant-garde movements of the 1920s), such as *Megatherm* and *Hellioptical* by Helliwell, which work on a Super 8 loop. Other recent works reuse obsolete devices whose functioning was based on circular and repetitive dimensions of the duration such as the Kodak Carousel, or elements from pre-cinema (Phenakitoscopes) and from its origins (Kinetoscopes).

Digital and Electronic Cinema

At the end of the 1970s, the electronic image became commercially viable: starting with Michelangelo Antonioni's experiences with electronic color correction in *Il mistero di Oberwald* (1980) and Francis Ford Coppola's *One from the Heart* (1982), and Zbigniew Rybczynski, pioneer in the convergence between cinema and video, and experimentation in high definition. It is also worth mentioning experimentation carried out firstly by Jean-Luc Godard and Peter Greenaway and then by Aleksandr Sokurov, Lars von Trier, and David Lynch.

At the end of the 1980s, non-linear editing devices became widespread, devices which had been in development since the beginning of the 1970s, for video. In 1987 Sony introduced the Digital Audio Tape for the recording of digital audio tracks and at the beginning of the 1990s, multichannel audio coding systems spread in cinemas: the Digital Theatre System, Dolby Digital (1992), and Sony Dynamic Digital Sound (SDDS) introduced in 1993. Computer-generated imagery (CGI) and computer-generated animation (CGA) constructed digital worlds, mixing real and virtual scenery, reinventing and restoring images from history and the history of cinema in a way never seen before. The need to mix analog and digital images in post-production inspired a renewed use of previously obsolete formats for filming and post-production such as the 35mm Vistavision and the 70mm.

The spread of both "light" and "heavy" digital hardware and software, in terms of cost and production, made way for two experimental possibilities: the aesthetic and expressive research, that is therefore limited, but also widespread and fundamental in practical terms; the research of spectacular and global simulation in terms of its impact, though limited to a few centers due to high costs. For the first situation see Abbas Kiarostami's *ABC Africa*, for the second see *Star Wars: Episode II – Attack of the Clones* by George Lucas, both films using digital means in 2001.

The second half of the 1990s saw the introduction of digital intermediate process and digital grading. In more recent years the technology of projection has seen innovations in the area of digital light processing (DLP). Three-dimensional vision has also been brought back, made with 3-D digital cinema. Digital cinema had to take on agreements, standards ,and protocols (such as the digital cinema initiative, or DCI, 5, as well as JPEG 2000 and digital cinema packaging, or DCP). Standards and protocols which aimed to include backward compatibility, able to correctly reassert the aspect ratio, frame rate, and speed of archive film.[12] Finally, there are more and more born-digital films, which are created with digital audiovisual recording equipment, from the digital cameras on mobile phones to the new professional cinematographic cameras (such as Arri Alexa, Red Camera, Panavision Genesis, CineAlta, Canon, Viper, and Fusion).

Today the digital cinema workflow is complete: starting in post-production (since the 1980s), and continuing with the production of professional digital cameras and projectors, the digital workflow is now running in a complete way, from digital capture and digital screening via the digital post-production phase. The digital intermediate workflow, with digital film scanning and sometimes re-recording the digital frames onto analog film stock, will still remain, mainly for the preservation and exhibition of film heritage.

216 |

7.2 THE HISTORY AND TECHNOLOGICAL CHARACTERISTICS OF VIDEO PRODUCTION AND RECEPTION DEVICES

Alessandro Bordina

The video system cannot be studied and described as a single technological development but, according to Paul Conway's analysis (1996), must be understood as an open and interconnected set of various related technology *subsystems* (for example, the screens and the equipment for viewing, the encoding of the signal, the cameras, the devices and the equipment for recording and reproducing). Each subsystem is subject to its own cycles of technological change and obsolescence, which therefore leads to different system structures over the years. The following description of the evolution of the devices for the production and reception of electronic images will focus on the three main subsystems that make up the "video technology set": the display equipment, the encoding and broadcast of the signal, and the equipment for recording and reproduction.

1. Viewing Equipment

CATHODE RAY TUBE SCREENS

The construction of equipment for receiving live images is based on the research William Crookes did and products he made between 1858 and 1897, as well as successive experiments by Ferdinand Braun. Representing the cathode ray tube's "ancestor," the instrumentation created during this research period (known as the Crookes tube and the Braun tube, respectively) was not designed for the reproduction of electronic images, but for the study of electron flux behavior.

In 1906, Max Dieckmann and Gustav Glage were the first to develop research into the cathode ray tube (CRT) project, specifically for viewing the electronic image. The images obtained using this method were not captured using cameras, but drawn onto a Cartesian axis with a special pen that sent an electronic signal to a $1\frac{1}{4}$ -square inch CRT display (Magoun, 2007: 10).

The creation of a functioning reading and recording system, based on the mechanism known as the "Nipkow disk," took place between 1925 and 1928. In this phase the television equipment was based on both electronic and mechanical components, but the low quality of the images obtained, and the difficulty in overcoming problems connected with the amount of illumination

necessary in recording, made for an unlikely commercial exploitation of the television system.

The first, very limited, commercialization of electro-mechanic screens happened in 1928, when Charles Jenkins got his experimental license for the transmission of video signal from the Federal Radio Commission (FRC) for Washington DC's W3XK station. In 1929 Jenkins could rely on there being 30 viewers as his daily program of animated silhouettes was transmitted with a definition of 48 lines at 15 frames a second. Various other transmission tests would follow in the 1930s, especially as a result of the Radio Corporation of America (RCA) and the development of television systems. In Europe, the first electro-mechanic broadcasts, made by the Baird Company, were launched by the BBC in September 1929.

The first public presentation of completely electronic viewing systems took place in Japan in 1926 with the work of Kenjiro Takayanagi, and the following year, Philo Farnsworth demonstrated how his electronic screen prototype worked.

In the United States, in concordance with the transmission standard defined by the National Television Systems Committee (NTSC) in 1941, the first real mass commercialization of television equipment began; however, it was soon interrupted by the Second World War. The production of television screens was restarted in 1946 with the introduction of two new RCA models (630TS with seven- and ten-inch screens), which were much more affordable compared with pre-war commercial equipment.

Despite later developments, the viewing mechanism of the electronic signal, based on the output and orientation of electronic beams, remained the working principle from the 1920s until the later developments that saw CRTs replaced with plasma screens and liquid crystal displays (LCD).

The technology of television's first forays into the artistic world was concerned with the use and modification of the viewing equipment. The video signal would be altered by means of the manipulation of the signal's viewing system, for example in *TV-Dé-coll/age* by Wolf Vostell (1961) the images broadcast were deformed using magnets which interfered with the direction of electron flow. Similarly, Nam June Paik modified various TV sets in his *Exposition of Music-Electronic Television* (1963), distorting the flow of electrons generated by the cathode ray by using magnets and integrating the audio and video signals to create abstract forms (*Zen for TV,* 1961).

The changes to and the combination of television screens were fundamental aspects of the video art process, also in the output that followed. Monitors became the basic element for the construction of installations (for example, associated with the body in *TV Bra for Living Sculpture*, Nam June Paik, 1969 or *Inasmuch As It Is Always Already Taking Place*, Gary Hill, 1990) or they were

deconstructed until their working mechanisms were stripped bare (*Between Cinema and a Hard Place*, Gary Hill, 1991), or used in a more sculptural way that was not related to the viewing signal (*Family of Robot*, Nam June Paik, 1986; *Filz-TV*,[13] Joseph Beuys, 1966).

VIDEO PROJECTION

For at least 30 years of commercial use, the CRT remained the only way of exploiting the video signal on the mass market. However, the desire to make use of the electronic system in environments outside homes led various companies to investigate the possibility of a projection system that also used to broadcast videos in the cinematographic circuits (Kitsopanidou, 2003).

Research relative to the construction of equipment for video projection dates back to the early 1940s and the experiments in electronic image projection with RCA's CRT projector (1940), and Fritz Fischer's Eidophor (1943) and Scophony (1936). Although the Eidophor system attracted the interest of various companies in the 1950s,[14] it would be the CRT system that became the commercial standard for video projection, especially due to the launch of the Advent Videobeam 1000 and 1000A (Advent Corporation) in 1972. The projector was made up of three cathode ray tubes, each of which projected the image in one of the primary colors, the beams of light converged to compose the final image on the screen, whose dimensions were four and a half feet by five and two thirds.

The CRT projection system remained dominant until 1989 when the Sharp Corporation[15] put the first LCD projector onto the market (Sharpvision XV100). The XV100 projector allowed for the construction of an image that was 100 inches wide and, compared to CRT, was smaller, cheaper, and lasted longer.

The use of video projectors in artistic techniques eliminated the sculptural element that had been created by screens, favoring integration between audio-visual components and performance (see *Interface*, Peter Campus, 1972). If on one hand video projection returned the electronic image to cinema (for example in *24 Hour Psycho*, Douglas Gordon, 1993), on the other hand it allowed for more interaction with other materials (*Judy*, Tony Oursler, 1994) or with urban environments (see *Projektion X*, Imi Knoebel, 1971; *Projection on South Africa House*, Krzysztof Wodiczko, 1985). As had happened with cathode ray screens, some artists altered how the signal was viewed by altering the electronic or mechanical components of the video projector (one such example being *One Candle/Candle Projection*, Nam June Paik, 1988).

The third key step in the technological innovation of viewing equipment was the introduction of LCD and plasma screens. In May 1968, RCA announced research on a new type of electronic display that would be lighter, cheaper, and structurally very different, compared to CRTs. George Heilmeier's research for RCA attracted the interest of the Sharp Corporation, which decided to invest in the possibility of using liquid crystal technology for the production of lighter, more portable calculators. In 1973, Sharp presented the Elsi Mate EL-805 pocket calculator, the first device to use liquid crystal technology in a viewing system. After this first achievement, LCD technology was applied and adapted to various kinds of products (alarm clocks, radios, watches). In 1988, Sharp presented the first 14-inch LCD television.[16]

In 1969 at the University of Illinois, at the same time as RCA's research into LCD, Donald Bitzer, H. Gene Slottow, and Robert Wilson were making the first experiments for the plasma display panel (PDP). The University of Illinois's research attracted the interest of the Japanese television network NHK and the companies Fujitsu, Hitachi and Mitsubishi. The first commercial application was in 1983 when IBM produced a 19-inch monochrome display that used plasma technology for the PLATO computer. It was Fujitsu, on the other hand, that introduced the first 21-inch full-color television screen in 1992. The PDP system went through a large expansion at the end of the 1990s, exploiting its technological superiority in larger screens (in 1997 Fujitsu put the first 42-inch screen onto the market). Despite the rise in plasma screens, companies' investments in LCD products increased in the first years of the new millennium, allowing for an increase in the performance of the liquid crystal display, so much so that many companies abandoned research into plasma systems.

The continuous abandonment of CRT viewing devices obviously signaled a change in the way works of art were displayed. The reduction in the depth of the screen allowed for more choice in the positioning and arrangement of the monitors, which in some cases mimicked the material characteristics of paintings and photographs (*The Actor*, Marty St. James, Anne Wilson, 1990; *Provenance*, Fiona Tan, 2008).

2. Encoding and Signal Transmission

The second technological subset to be taken into consideration relates to the encoding of the signal.[17] The first experiments in transmitting a television signal were undertaken in the 1920s, using an electromagnetic system for

recording and for the viewing of the signal. A few months later there was the public presentation of the first television, held by John Logie Baird in 1925 at Selfridge's Department Store in London, and the American Charles Francis Jenkins broadcast the silhouette of a toy windmill from five miles away in a naval station in Maryland to his Washington laboratory. In 1928, the Baird Company sent the first transatlantic signal from London to New York and at the end of the 1920s, a number of different electromagnetic television companies arose.

The demonstration of a completely electronic television system occurred at the same time as the spread of the electromechanical television. Before 1930, the only people who had completed an entirely electronic system for the production of a television image were Philo Farnsworth with the image dissector and Vladimir Zworykin with the launch of the iconoscope on behalf of RCA.

Without a shared standard for the quality of the broadcast, the television market had difficulties in developing. In the United States, the main hardware manufacturers such as Philco, Zenith, and DuMont pushed for a legislative definition for broadcast standards in order to avoid a monopoly in the sector. Towards the end of the 1930s, early negotiations about the standard that should be adopted began between producers, but it was not until 1941 that a definitive agreement was reached through the constitution of the National Television Systems Committee. In May 1941, the FCC gave the go ahead for 18 channels, using a six MhZ bandwidth and a signal of 525 lines at 30 frames per second.

In Europe in the 1930s there were three main systems for broadcasting a television signal: the Marconi-EMI (405 lines, 25 frames per second, five MHz of bandwidth) adopted in 1936 by the BBC Television Service; the system of 441 lines (25 frames per second, four Mhz of bandwidth) introduced in Germany in 1937; the system of 819 lines developed by René Barthélemy became the standard for broadcast in France in 1948.

The definitive standardization of the European broadcast signal arrived in 1956 with the introduction of the standard SECAM in France and PAL in the rest of Europe, which was developed in Germany by Telefunken in 1963. The two standards provided a definition of 625 horizontal lines at twenty-five frames per second, and the bandwidth for broadcast was seven MHz.

Although a large part of video art production existed outside the usual broadcasts, there were some examples of works designed specifically for network television (*This Is a Television Receiver*, David Hall, 1976; *The TV Commercials* Chris Burden, 1973-1977). Over the course of the 1970s the spread of video art production was also happening through public and specialized television channels, the latter of which, in addition to broadcasting programs

made up of video works, collaborated in the production (examples in the United States being the television station WNET-3, New York; WGHB-TV, Boston; LBMA, Los Angeles; and in Europe included SWR, Baden-Baden; SFB, Berlin; WDR, Cologne) (Huffman, 2008; Tamblyn 1987).

SATELLITE TRANSMISSION

Over the course of the 1940s, two modalities for encoding/sending/receiving video were developed, two alternatives to radio frequency: broadcasting through cable and via satellite. Both types of channeling technology redefined the television signal allowing for an increase in the number of channels available to the viewer and the development of pay per view. The first large investment for the development of satellite technology was started by a multinational consortium that was made up of AT&T, Bell Telephone Laboratories, NASA, the British General Post Office, and the French National PTT. On 23 July 1962, the Telstar satellite sent the first satellite video signal for civilian purposes, visible in Europe through Eurovision[18] and in the United States through NBC, CBS, ABC, and CBC channels. The commercial spread of satellite television happened towards the end of the 1970s but it was the 1980s that saw its large expansion. In an artistic field, the first attempt in using the satellite broadcast came with Sherrie Rabinowitz and Kit Galloway's dance performance, *Satellite Arts Project: A Space with No Geographical Boundaries* (1977), which was followed by Paik's collaborative experiences in the 1970s and 1980s (for example, the opening of documenta 6 in 1977 broadcast in 25 countries with performances by Paik, Charlotte Moorman, Joseph Beuys, and Douglas Davis; but also the later examples *Good Morning, Mr. Orwell*, Nam June Paik, 1984 and *Bye Bye Kipling*, Nam June Paik, 1986).

DIGITAL SYSTEMS

The third turning point for the development of encoding and broadcast technology was the switchover from the analogue system for encoding the video signal to digital technology. Research on the development of digital television began at the end of 1950s and was carried out by Richard Webb for the Colorado Research Corporation on behalf of the National Security Agency, which was funding a system for encrypted broadcast. In 1961, the first working prototype for digital video communication (AN-FXC-3 (ZE-1)) was installed in the White House, between the President, the Central Intelligence Agency, and Camp David. The images transmitted had a resolution of 405 lines and used a six

Mhz bandwidth. In the public sphere, the development of a digital television system was left to the commercial competition for high definition television (HDTV). At the end of the 1980s, the spread of the analogue MUSE HDTV system, developed by Nippon Hoso Kyokai (NHK), forced American developers to follow a method of processing a high definition signal that would not render the satellite and cable market obsolete.

In 1990, VideoCipher developed a system to digitalize the television signal that allowed for four digital channels on the same bandwidth used for the transmission of one analogue channel. This innovation led various companies to develop a completely digital HD system. In 1993 the FCC created the Grand Alliance (GA), a consortium of manufacturers for the definition of a digital standard. In 1996, the ATSC standard was approved for the United States. In Europe the definitive standardization of digital television took place in 1997 when the DVB-T standard was published, which would remain the standard throughout Europe between 2000 and 2011.

The transition to the digital encoding of the signal had important consequences for the production and consumption methods of works made in the video medium. The possibilities of editing and non-linear manipulation of the signal increased the repertoire of techniques and modes of expression available to artists. Describing his transition towards using digital video, Chris Meigh-Andrews remembers:

> I was then able to mix multiple videotape sources, produce video frame grabs [...] and perform image flips [...]. Not only these new image effects extended the visual complexity of my work at this time, they also opened up my ideas to embrace new themes and ideas, particularly those related to the nature of electronic imagery and its potential relationship to visual perception and the flow of thought (2006: 264-265).

Since the 1990s, the use of digital video has led to greater interaction between the audio-visual and information technology components, impelling many artists to make interactive audio-visual works (*Alchemy*, Simon Biggs, 1990; *Tavoli (perché queste mani mi toccano?)*, Studio Azzurro, 1995).

3. Recording and Reproduction of the Electronic Analogue Signal

Research on the production of a recording system for electronic images on a magnetic device began in 1951 at the RCA laboratories and the Ampex research centers. The main problem the two laboratories needed to resolve was opti-

mizing the use of the space on the magnetic device in such a way that it was able to record the largest amount of information on the smallest amount of tape possible. The first recording prototypes of the signal needed a large quantity of tape that had to pass over the reading/recording heads at high speed. In 1956, Ampex was able to present the first commercial recording system to CBS, ABC, the Canadian Broadcasting Corporation, and the British Broadcasting Corporation. The Ampex VRX-1000 was equipped with four rotating heads for recording and reproduction using tranverse scanning of the signal on a 2-inch tape. The tape was 4,800 feet long (1,500 meters) and was capable of recording an hour of video.

In 1965, Ampex produced the first system (known as 1 inch Type A by SMTPE) that used 1-inch tape and that performed helical scanning of the tape. The recording on 1-inch tape became the standard for television stations, big industry and governments over the course of the 1970s. In 1976 the type C system, developed by Ampex in collaboration with Sony, would become the most widespread format in broadcasting.

In the 1960s, whilst RCA and Ampex competed for leadership in the production of video recording systems aimed at broadcasting, Sony concentrated its research on the domestic market of video reproduction systems using magnetic tape. In 1965, Sony put two video recorder models (CV2000) on the market, designed by Nobutoshi Kihara and aimed at the mass market. The CV system used two rotating heads for the recording and helical scanning of a $\frac{1}{2}$-inch tape with a diameter of seven inches, capable of recording up to one hour of video. Sony's $\frac{1}{2}$-inch system opened up a market of similar consumer products that used the same sized tape (Panasonic NV-8100, Concord VTR-600-1) or smaller (such as the Akai VTS-100 that used a $\frac{1}{4}$-tape), but based on encoding and recording standards that were different for different companies. In 1968 the Electronic Industries Association of Japan introduced the EIAJ-1 shared standard for video recorders which used tape that was $\frac{1}{2}$-inch (among the most common systems to use EIAJ-1 were Sony's AV and Panasonic's NY3130). A few years later the EIAJ-2 was developed for color videos.

The year before the EIAJ standard was defined, Sony had launched the first portapack system. The Sony CV-2400 Video Rover was made up of a smaller camera and a compact VCR that used the standard helical CV scanner weighing ten pounds and thirteen ounces (around five kilos). Two years later (1869) Sony launched an EIAJ portapack (AV-3400) which had great commercial success and would go on to be one of the most used items in production, outside broadcast.

Despite the commercial success of the EIAJ system, public demand called for a more reliable system that was less complicated to use and this influenced Sony to direct its research towards the development of a video recorder that

used closed cassettes as recording devices, rather than open reels.[19] In 1968 Kihara made the first U-matic working prototype, which would be made commercial in September 1971. The system, which took its name from a peculiar way of loading the tape (U-loading), used cassettes that contained tape that was ¾ inch wide. Compared to the open-reel systems, the U-matic recorders offered higher quality and were more reliable both in the recording and the reproduction phase. However, the higher system costs,[20] the size and the excessive weight of the players (60 pounds) hampered the spread to the domestic market. The U-matic system would have success in the education sector, small businesses and television stations, gaining reputation as a semi-professional standard over time.[21]

If projects with television stations are excluded (for example the many projects broadcast by stations such as WNET-3, WGHB-TV, LBMA, SWR, SFB, and WDR), the majority of video art originally comes from the use of domestic video recorders, (mainly the ½ -inch system until the mid-1970s, and on the U-matic format after that). The low cost of the equipment and the ease in production and copying of the tape allowed the artists to work at the limits, or outside the norms of television broadcast production.

Video was also approved as a suitably ephemeral medium, existing only when animated by an electric current and capable of being copied, recopied, and disseminated like any other mass-produced merchandise. In spite of now having to negotiate the more recent traditions of broadcast media, video artists felt they were working on a clean sheet of paper (Elwes, 2005: 6).

The "amateur" characteristics of the systems used influenced and conformed to the aesthetic exploration of the video medium in this first phase of video art production. The absence of editing systems that were cheap to use with consumer video technology was evident (see Vito Acconci's first video works), it also led to a lack of editing in the camera. In some cases, artists decided to modify the hardware themselves, manipulating the recording mechanisms during the recording (*Tape I*, Bill Viola, 1972), or creating complex systems for recording and reproduction using more than one recorder at the same time (such as Woody and Steina Vasulka's video feedback).

The development of equipment and the manipulation of the signal (image processor and video synthesizer) designed by the same artists, gradually increased the possibility of altering the electronic image both in the recording and the post production stages. At the end of the 1960s and the beginning of the 1970s, several artists created their own devices for distorting and transforming the video signal. Amongst the most well-known was the Paik-Abe Synthesizer, constructed in 1969 and used to produce "Video Commune," broadcast by WGBH in 1970. Paik and Abe's synthesizer was a seven-channel mixer/colorizer able to change the chrominance information and make up to

seven image layers. In 1970 Stephen Beck created the Direct Video Synthesizer at the National Centre for Experiments in Television. Unlike Paik and Abe's machine, Beck's synthesizer was designed as an instrument for live performance and was not able to change images recorded on video camera. Being generated directly from the equipment to the CRT color screen, through electric impulses, allowed images and abstract patterns to be viewed. In 1974 Bill Etra and Steve Rutt produced the Rutt/Era Scan Processor which would be used to produce some of Steina and Woody Vasulka's videos (for example *C-Trend*, 1974; *Time/Energy Structure of the Electronic Image,* 1974-1975). The possibilities of changing the electronic image, created by Rutt and Era's device, were far superior to those previously synthesized. Thanks to a scan processor it was possible to control the positioning of the lines on the screen, creating animations and video wave forms and creating images from the sound signal and audio through the video signal. Using Rutt and Era's synthesizer, the production of artists such as Vasulka became focused around the deconstruction of the electronic image. In 1975, Woody Vasulka remembers that:

> Compared to my previous work on videotape, the work with the scan processor indicates a whole different trend in my understanding of the electronic image. The rigidity and total confinement of time sequences have imprinted a didactic style on the product. Improvisational modes become less important than an exact mental script and a strong notion of the frame structure of the electronic image. Emphasis has shifted towards a recognition of a time/energy object and its programmable building block – the waveform (Vasulka and Nygren, 1975: 9).

7.3 COMPUTERS AND DIGITAL RECEPTION DEVICES: HISTORY AND TECHNOLOGICAL CHARACTERISTICS

Tabea Lurk and Jürgen Enge

From a curatorial perspective, the history of the computer and the development of technological reproduction and computing machines are two quite distinct stories. Both formally and intentionally, they fall under different collecting categories and respond to different methods of display. They are also subject to historical change. Today, "technological cultural goods" are not only found in technology, science, and communication museums but have long become an integral element of media art. The resulting interaction between the two spheres has an impact both on the reception of history as well as on how the objects of the relevant field of research are presented and preserved.

Until recently, technology museums emphasized the object-like character of technological devices. The apparatus assumed the function of a (silent) witness of the past and its position in the history of technological development was contextualized with the help of descriptive explanations and (audio)visual models.[22] Nowadays, however, museums are expected to keep the machines operational and to exhibit them while still in service. Furthermore, curators have recently taken to illustrating the cultural position and development from the perspective of the history of technology with the help of artworks that make use of such devices (technology > art).

Where art is concerned, however, the meaning of technological instruments is considered less important than the general artistic / aesthetic intention of the artwork (art > technology). While it was common practice up until the turn of the millennium to merely replace or repair defect technical equipment, and the reproduction on specific hardware was rarely documented, the instruments that are condemned to obsolescence are nowadays frequently considered an integral part of the artwork, thus undermining the notion of their interchangeability.[23]

It seems, then, that the areas of interest of technology and culture have begun to overlap. In the following, we wish to further explore this phenomenon against the background of strategies of conservation.

History of Technology As Cultural History?

Going back to the dawn of the computer age, we find several prominent large-scale computers that are of sufficient historical interest to merit preservation.

These include computers such as the IBM 601 (1935, USA), the Z3 by Konrad Zuse (1941, Germany),[24] Colossus, the first computer programmable from memory (1943, UK), Howard Aiken's relay computer Mark I Computer (1944, USA), the ENIAC 1, developed by John Mauchly and J. Presper Eckert (1946, USA), and, finally the Electronic Numerical Integrator and Computer, to name but the most prominent rarities (Da Cruz, 2005; Cray-Cyber, 2006). Each of these has found a place in public and private special collections where they illustrate and document the history of technology.

Because many original devices were destroyed or lost during World War II, replicas of mainframe computers were constructed with the help of historic plans, including, for example, the replica of the Z1 (1937; 1989) in the German Museum of Technology (Berlin) and the famous Turing Bomb (1943; 2007) in the Museum Bletchley Park (London) which was designed to decode Enigma's radiograms (1917). The use of replicas is especially interesting in cases where a device's mechanical mode of operation is visible – that is, primarily in periods preceding the introduction of integrated circuitry – or in cases where a result that is computed in real time conveys cultural or historical values.

The Fascination of Computer Automation

Beginning in the 1960s, some of the instruments developed by computer scientists were introduced into the civil environment and were also made available as "multiprogramming devices." Large-scale computers found their way into the realms of scientific computation, research, and office automation (business and administration).[25] In the early 1960s, moreover, artists became increasingly fascinated with the laws of logic (concrete art) as well as with the unpredictability of chance which encouraged the creation of the first works of computer art, mainly on university campuses with the help of mainframe computers, but also occasionally with the help of machines at industrial computer centers. In some cases, the computer scientists themselves dabbled in art, such as Frieder Nake and Georg Nees in Stuttgart on the Grafomat of the Z64, Herbert Franke in Vienna on an ER56 computer (SEL programming), and Michael Noll and Bela Julesz at Bell Laboratories in New York (Herzogenrath and Nierhoff-Wielke, 2007; Anon, 2009). In other instances, designers commissioned computer-based calculations and then translated the results into sculptures and paintings. This approach was pursued by, for example, Gottfried Honegger (starting in 1970 at the ETH Zurich), Karl Gerstner (starting in 1982 at IBM Stuttgart), and Alfred Beuler (1969/1982ff).[26]

Because the majority of these works assumed a material shape of some sort, such as a sculpture, a painting, or a graphic, and only used the computer

228 |

for calculation purposes, anyone wishing to preserve the heritage of this first generation of "computer art" must distinguish between the preservation of the material works (graphics, paintings, and sculptures: classical conservation) and the history of the development of their programs. The latter is usually documented by providing a short text describing the program as well as excerpts of the program's text (Klütsch 2007). The punch card and the original programming, however, have mostly not been preserved, not to mention the software or the relevant reproducers.

Unlike the first generation, many works of the transition period since the early 1970s required running computer programs. Thus the PDP computers that were manufactured by Digital Equipment Corporation were used for artistic purposes. Hans Haacke and other artists were already using the PDP-8, built in 1963, by the late 1960s. Several such devices were employed at legendary exhibitions such as "Cybernetic Serendipity" (1968, ICA London) and "Software" (1970, Jewish Museum NYC) that also served to blur the boundaries between computer art and robotics or cybernetics. Only very few objects and applications of this period survived, although some of them were described for scientific purposes. While it is possible to imitate the functions of these obsolete applications with the help of certain technological devices (legacy approach) or to program the original artistic concept on present-day platforms (hardware + operating system) (reprogramming), museums mostly rely on text-, image- or video-based documentation.

Using Computers in the Home

We mostly associate the early age of the personal computer with IBM, the corporation that in 1974 introduced the IBM 5100 and in 1981 ushered in the standardization of PC components with its IBM 5150, thus allowing for platform-independent operating systems. Similar computers were manufactured by Apple (since 1976),[27] Commodore (since 1977),[28] Tandy Corporation (the TRS-80, 1977), Atari (1979-92),[29] Texas Instruments (e.g., TI-99, 1979), Sinclair Radionics (e.g., MK14, 1982), Amstrad (Alan M. Sugar Trading, e.g., CPC464, 1984), and, later, various portable calculators, for example, by Toshiba. Earlier developments also proved significant, such as the use of cathode ray tube (CRT) monitors starting in the early 1960s, which at first visually reproduced the results of the calculating operations as glass teleprinters, or the invention of the computer mouse in 1968 by Douglas C. Engelbart and William English.[30]

With the emergence of the first 8-bit home and office computers in the late 1980s, artists were now able to use these instruments for their ends without having to rely on an institution. At first, they worked directly on the code and

made collages of programming elements that were then published in computer journals. Besides Andy Warhol's famous sales campaign for the Commodore Amiga Product Launch (1985), where he used the Amiga to portray the actress Debbie Harry as part of a live performance, it was above all the TI99 / A4 (1981) that gained cult status among artists, before Apple's product lines became the market leader in the field of graphic design. While Herbert Franke with his art program "Mondrian" (1979) managed to make the transfer from the TI99 to more up-to-date operating systems (Windows XP), many works of this early period have only survived through their documentation, such as Alexander Hahn's *A Young Person's Guide to Walking Outside the City* (1988).

Another genre of "computer-based" art (as it was now commonly referred to) that survived from the late 1980s and early 1990s were interactive works and installations, some of which remain fully functioning to this day. These works not only involved the use of computers, but also incorporated computer equipment such as matrix printers and ink jet printers as well as extremely elaborate, self-made interfaces that were particularly popular in the mid-1990s. While independently working artists had to make do with whatever they had at their disposal – which is why their works reflect something like a status quo at a particular time in a particular country – other artists working at university research labs were able to launch much more complex developments. Everyday items such as plants, bicycles, suitcases, and many others were frequently turned into digital input devices with the help of self-soldered analogue digital converters, thus expanding the realm of experience of computer-based communication (Schwarz, 1997; Frieling and Daniels, 1997 and 2000; Wilson, 2002; Paul, 2003). The technological devices continued to produce artwork in real time (by means of feedback) but it was nevertheless the case that technology, metaphorically speaking, was considered less important than the experience of observing the artwork. Where artists were awarded grants for research stays at specific computer labs such as the MIT in Boston or later the Centre Pompidou or the Institute for Visual Media of the ZKM – Center for Art and Media Karlsruhe, they often had access to large-capacity computers made by SGI – Silicon Graphics International (1981-1996), a company that developed specific procedures for an accelerated representation of three-dimensional images which could be used to animate two- or three-dimensional spaces.

Besides the professional SGI line, it was once again IBM that defined the central standards for graphics cards with regard to home computers: the monochromatic representation of text with the monochrome display adapter (MDA) mode became available with the first PC in 1981, along with the color graphics adapter (CGA) graphics card (1981, resolution: 320x200 pixels in four-color mode / 640x350 pixels in two-color mode); in 1984, these were replaced by the enhanced graphics adapter (EGA) standard (resolution: 320x200 and

640x350 pixels in sixteen-color mode) and, in 1987, by the video graphics array (VGA). With a 256-bit color depth and an initial resolution of 320x200 pixels, the latter was capable of displaying around 250,000 colors. In the mid-1980s, the most common graphics cards (next to the IBM line) were those manufactured by HGC – Hercules Graphics Card (1982, resolution: 720x348 pixels, 2 colors: on / off). The graphical representation of image material and later also of colors was a special luxury unique to Apple computers, and these became standard features with the introduction of the microcomputer Apple II (1977); their processing power increased with every subsequent version. The Apple II had its own digital graphics and character generator (resolution: 40x48 or, in the high-resolution variant, 280x192 pixels, in 15 colors). From the mid-1990s onwards, 3-D graphics boards became available for the home sector (e.g. voodoo graphics boards manufactured by 3dfx) whose development was promoted mainly by the games industry.

Although product lines proliferated in the 1970s and 1980s, it is still possible to purchase original versions of most early home computers. Collecting specific types of devices, components, or series (e.g., of computer games, Apple Macintosh collections, etc.) has now become a culture of its own which is why the conservation and restoration of museum artworks relies not only on the reparation principle (where electrical engineers replace or repair individual components) but also, and especially, on what is known as the "storage principle." To this end, museums buy and store hardware that matches their pieces and then use this to replace or repair individual components if a malfunction occurs (ideally documenting the process). By contrast, museums have shown less interest in preserving and cultivating a passion for collecting software. Subcultures such as the gamer scene and the "demo scene" are an exception to this rule, having not only amassed many historical machines but also developed and promoted very intricate emulators, thereby practicing the "encapsulation principle" of original software components.[31]

From Hardware to Software

With the growing interest in "computer operating systems," historians of technology and media archaeologists now no longer restrict themselves to collecting and maintaining computing machines and other machine-like devices, but increasingly wish to expand the scope of relevant collections to include control technology and software development. In this context, it seems especially fascinating that present-day system architecture still bears traces of some of the groundbreaking innovations in the historical development of computer systems.

Thus in the early days of computer technology, electrophysical processes of the circuit path took place above the physical hardware, which was then still activated directly (e.g., the relay in the Z1), and its mode of operating was determined by the Von Neumann architecture (see Von Neumann, 1945). Since that time, data and programs use the same shared storage device, and their specification (header) identifies the type of information that was being processed.

With the development of procedural programming languages such as FORTRAN (1957), BASIC (1964), and C (1972), it became possible to address the individual memory locations to generate values, which in turn generated control commands for the hardware. The communication between programs and hardware thus became much easier. The procedures were executed in a linear fashion.

Beginning with C++, the 1980s saw the broad adoption of object-oriented programming languages that could compile data and functions into objects. At the same time, modularization, that is, the collection of commands in software libraries, made for easier programming, as certain functions / commands could be used repeatedly and did not have to be included in every program. With the introduction of the platform-independent programming language Java in the 1990s, a computer's operating system was finally no longer dependent on its hardware.

Other innovations, which we can only mention briefly, took place in the field of communication technology and the development of nets; the Petri net, for example, was based on a generalized automata theory, and one of its features was the concurrent execution of processes. The introduction of addressable addresses TCP/IP (1984, transmission control protocol and Internet protocol)[32] was another important innovation, as was the introduction of hypertext transfer protocol (HTTP, 1993), a description language which helped usher in the Internet age with its graphical user interfaces.

While artists only rarely questioned the system architecture itself, instead preferring to develop artistic programs and applications or creating artistic works with the help of the computer, the Internet age that began in 1993/1995 allowed them to explore completely new artistic practices. These spawned a new genre that came to be known as "net art," and, while it passed its zenith with the dot.com crisis of March 2000 and has since been reduced to a rather diffuse existence, net art nevertheless remains a productive field. Net artists mostly either draw on web services such as Google images, Amazon, Wikipedia, and others, or they provide – en route to the cloud – communicative structures of action.

Going beyond the Western art world, moreover, it seems likely that artists will increasingly make use of coding technologies. In this context, the asyn-

chronous, cryptographic coding of contents, such as the RSA (1977), can be considered a milestone.[33]

As for reproduction devices, it seems as if there are no longer any limits – artists avail themselves of new technologies as soon as they come on the market, or they continue to develop specific interfaces in research laboratories if the available ones do not meet their needs. Large-scale projections, where liquid crystal display (LCD) and occasionally digital light processing (DLP) projectors have replaced the old CRT beamers, now exist alongside with reproduction modes for classical screens (from the CRT screen to the LCD monitor) as well as portable end devices such as smart phones.

Since manufacturers do not offer much information about the durability of this new generation of consumer devices, there is no way of telling how long they will last. Nevertheless, it seems likely that the conservation and restoration of these artworks will become much more complex in the future, especially with regard to art forms such as App art that operate with closed systems and codes.

Conclusion

Now more than ever, scholars recognize the critical importance of technological developments when examining innovations in media art, sometimes emphasizing the artistic aspect, while at other times applying concepts of media studies, the history of technology, or, more recently, media archaeology.

However, because many technology-based art forms are somewhat similar to reproduction techniques, curators have tended to neglect the conservational aspects, believing it was possible to simply "reproduce" the material. We now know that a technical apparatus that actually looks quite robust can be especially fragile, a feature that scholars usually refer to as "obsolescence."[34] Instruments age and thereby become a weak point in the system.

But access to digital information is also fragile. It is, of course, possible to make lossless, identical reproductions of digital information – unlike print graphics or photomechanical or magnetic negatives / data carriers that are prone to mechanical abrasion. But we have long ago reached new limits of preservation: the problem of the readability of old data carriers, software-based components, dysfunctional software libraries, the interlinking between programs and operating systems, and, finally, active memorization efforts. In many cases, we can no longer intuitively operate vintage machines. Instead, where a machine has been out of use for a long time or had some corroded batteries replaced, a user must simply be aware of certain basic functions and

occasionally even settings, for example, of erasable programmable read-only memory (EPROM) programming, in order to get it started again. A computer's operating mode is not self-explanatory, that is, it cannot be logically deduced from the mechanics of the individual components.

The practical preservation of computer-based products has thus far mainly focused on two areas, namely the preservation of the object itself and the preservation of its function. Where object preservation is concerned, we may distinguish between, on the one hand, the preservation of the computing machines, of their mechanical and electronic elements (printers, monitors, input, and output devices) as well as the technological components (all technological cultural goods) and, on the other hand, the preservation of the paper- and plastic-based information and data carriers. Regarding the physical preservation of the latter, we may distinguish between the preservation of the data carriers and the preservation of information. Preventive conservational measures slow the natural degradation of the material substance. Objects must be stored in a constant climate[35] and protected against electromagnetic radiation, dust, sunlight, and mechanical wear, as well as against negligent handling. Furthermore, the contents/information are often transferred to a new platform (operating system + hardware), while occasionally recoding the data that is to be preserved.[36] Finally, emulators are also an option: contents are encapsulated in a digital environment pretending to be the original environment (Lee et al., 2002; Humanities Advanced Technology And Information Institute, 2009). Here, the preservation of information is similar to the preservation of functions. In contrast to the migration paradigm that is common in archive management, art conservators are more concerned with an artwork's specific authenticity.[37]

Surveying the field of preservation strategies from a museological perspective, it seems as though the traditional difference of content and form is repeating itself. While an emphasis on the preservation of contents focuses on a machine's functions, software components, and digital information, the material preservation is more concerned with maintaining its casing, thus placing greater emphasis on formal characteristics.

7.4 OBSOLETE EQUIPMENT: ETHICS AND PRACTICES OF MEDIA ART CONSERVATION

Gaby Wijers

The relationship between artistic intentions and technical equipment used is of crucial importance in the conservation of media art, where sustainability of artworks is threatened by an ever-shortening lifecycle of playback formats and equipment for playback and display. In their joint research project *Obsolete Equipment, Preservation of Playback and Display Equipment for Audiovisual Art,* (1 July 2009 – 30 June 2011), the Netherlands Media Art Institute (NIMk, Amsterdam) and PACKED vzw (Brussels), together with several Flemish and Dutch museums, investigated the lifecycle, storage, maintenance, and replacement of equipment in media art installations in order to provide best practices and guidelines.

This contribution highlights two of the eighteen cases studied in the Obsolete Equipment project: *Oratorium for Prepared Videoplayer and Eight Monitors*, a video installation made in 1989 by Belgian artist Frank Theys[38] and *I/Eye*, a computer-based installation made in 1984 by Dutch artist Bill Spinhoven van Oosten.[39] These cases provide insight into two divergent approaches explored in the project. The first case demonstrates what we call the "original technology" approach, in which storage is the key preservation strategy, and the second case is an example of the "updated technology approach" where emulation (as well as virtualization, in this case) is the principal strategy.

Introduction

Media art installations, whether they are film-, video-, or computer-based, have extremely diverse characteristics. Aspects including variability, reproduction, performance, interaction, and being networked are incorporated in many works. Media art is not one static, unique object, but often a collection of components, hardware, and software which together create a time- and process-based experience. Ready-made answers for preserving and re-exhibiting these works do not exist. Here, finding solutions for preservation or exhibition problems requires research, preferably conducted in interaction with the artist. The only accurate way to test if we have understood, documented, and transferred the constituent parts of a work of art and the work itself is by re-installing the work. The general research approach, therefore, is to conduct case studies and interviews with artists and other key figures involved in the

work. This approach was adopted for the Obsolete Equipment project by the Netherlands Media Art Institute, NIMk, Amsterdam[40] and PACKED vzw, Brussels.[41] Eighteen case studies from the art collections of Flemish and Dutch institutions and two artists were investigated, documented, and reinstalled in order to gain insight in the requirements regarding storage, migration, emulation, and virtualization, to identify the obsolescence of presentation equipment and storage formats.[42] Furthermore, research was done into the ethical and technical requirements to which the preservation strategies must adhere, both in relation to the original state of the artwork and with regard to its (future) presentation. Experts from Zentrum für Kunst und Medien – Karsruhe (ZKM), Tate – London, Imal – Brussels, and Bern University of the Arts – Bern (BUA) shared their expertise and gave feedback on the process.

Change and Challenges in Media Art Conservation

Since the end of the 1990s, media artworks and the obsolescence of the equipment associated with them have received considerable attention in conservation research and literature. Two divergent approaches can be distinguished: the "purist/original technology" approach, and the "adapted/updated technology approach". The first approach highly values the use of original technology and wants to preserve the work as it originally appeared. With this approach, the storage of old equipment and spare parts is key, and the lifecycle of the work is related and limited to the lifecycle of the equipment. The second approach highly values the use of new technologies and is known for the dynamic appearance of the work. With this approach, migration and emulation are essential, and the eventual loss of authenticity and historicity in relation to functionality and concept is part of the discussion about the possible strategies. Both approaches are valid but a suitable approach somewhere between these two has to be found. It would be an error on the part of collecting institutions to give up too quickly on old technology. Although storage is the usual museum conservation approach, it has never been common practice to collect all the equipment related to media artworks. Frequently, all the equipment required for an installation is no longer available and/or the equipment pool is used to display a number of artworks. In order to effectively deal with the problem of obsolescence, it is necessary to collect relevant and dedicated equipment including spare equipment and spare parts and to organize proper storage and regular maintenance. The equipment is necessary for purposes of exhibition and research, as a reference for defining an artwork's original appearance and as starting point for emulation.[43]

Once an artwork is no longer functioning properly, the next step is to analyze the root cause and select an appropriate conservation approach. There are some common acknowledged forms of conservation in the case of obsolescence:

- Storing/restoring/repairing the original equipment
- Acquiring spare equipment:
 - Historical copy: replacing the equipment with the same model or a type from the same period with the same or similar functions
 - New copy: replacing the equipment with the same model or type from a later period, i.e., a more recent model with the same or similar functions
- Migration: Reconstructing the equipment with contemporary technology
- Emulation: Reconstructing the equipment with contemporary technology while retaining the original look and feel[44]
- Re-interpretation: Replacing the equipment with contemporary equipment each time the work is recreated
- Reconstruction: A complete reconstruction of the work based on available information

Two key approaches that deal with the problem of transferral are migration and emulation. Case studies have shown that migration, transferring data to a new carrier, is a rather simple process of continual upgrade and does present a viable solution, assuring a high level of access and interoperability. In other case studies, emulation has proven quite effective at producing an aesthetically authentic iteration of art objects, evoking the "look and feel" of the original. These studies have also shown that emulation is always a temporary solution and, since time-consuming and complex, best suited for circumstances that justify a high investment (see Rothenberg, 2006). In order to circumvent the fact that emulation is only a temporary solution, in *Obsolete Equipment* we also explored the process of virtualization. Virtualization involves running software within a virtual environment.[45]

Despite all efforts to collect and preserve it, current technological equipment will wear out and become obsolete, which means that decisions have to be made about whether and how to update it. The main question is how to formulate specific requirements for the emulation process, taking into account both the original appearance of the artwork and its future accessibility. Pip Laurenson proposes an approach that involves assigning significance to display equipment, its relation to the work's identity based on conceptual, aesthetic and historical criteria, and the role the equipment plays in the work. She sees identifying functional significance as an initial step to

understanding the importance and use of the equipment (Laurenson, 2004).[46] The key questions are:

- – Is the equipment purely functional or is it (also) conceptually important?
- – Can the function of the equipment be mapped without discernible change?
- – Is the equipment visible or hidden from view?
- – Is the equipment mass produced, tailor made, or modified (by the artist)?

The significance of the equipment can be deduced from the meaning and value of the work. Some of the components may have significance beyond a purely functional level. The case studies in the Obsolete Equipment project demonstrated a clear distinction between the significance of playback and display equipment. The general tendency is to replace equipment or components with the same mass-produced model or with equipment that has the same functionality. The consensus is that, in most cases, the playback equipment can be upgraded without causing too many problems. Display equipment is more problematic, however. Replacing monitors and interactive features have the most greatest impact on the appearance of the artwork.

Choosing from all the various conservation strategies can be simplified by answering a series of questions using a decision tree developed by DOCAM.[47] This tool helps users focus on those aspects of a work that relate to its integrity and authenticity, while reflecting on how these aspects are impacted by the work's technological components. Besides the collection, preservation, or emulation of the playback equipment, the future preservation of works such as the cases studied in the Obsolete Equipment project requires collecting knowledge on the skills needed to service and maintain this equipment.

This brings us to another important aspect in media art conservation: documentation. Due to their many variations in technology, effects, and form, media artworks tend to follow a dynamic life cycle and require specific types of documentation ranging from the documentation produced by the artists and their collaborators in the production process to its use by conservators, curators, and critics in the mediation, dissemination, and history of the artwork and its life cycle of exhibition, preservation, and restoration. Eventually, documentation elements might come to compensate for the loss or deterioration of a work. As stated in the DOCAM Documentation Model: "Ultimately, it is the documentation that will survive the work, becoming its historical witness and sometimes supplementing any remaining fragments or relics."[48]

In Obsolete Equipment we conducted research, interviews, and case studies to gain knowledge on equipment for video- and computer-based instal-

lations from the 1980s and early 1990s in order to develop guidelines for emulation, migration, replacement, and storage of obsolete equipment. The project resulted in a strong research network that will help us to face the complex challenge of digital sustainability in media art.

Case study one: *Oratorium for Prepared Videoplayer and Eight Monitors* by Frank Theys, 1989 (M HKA)[49]

The primary focus of this case study was to determine what is important for the preservation of this artwork, and what an adequate conservation strategy would be (see Fig. 7.6 in color section).

The word "Oratorium" ("Oratory") in the title has two meanings: "Oratory" stands for a choral work usually of a religious nature consisting chiefly of recitatives, arias, and choruses without action or scenery, and is also the name for a prayer room with a small altar. In Frank Theys' installation, this small altar takes the shape of a U-matic deck installed on top of a bass guitar amplifier with speakers. Around these two stacked devices, eight video monitors placed on custom-made iron stands are facing each other in a circle. Each monitor displays a black-and-white close-up of a man playbacking the song You'll Never Walk Alone, the famous anthem of the Liverpool Football Club. The soundtrack is a polyphonic version of this song performed by the male choir of the Catholic University of Leuven (Belgium). The ¾-inch U-matic videotape, on which the two-minute-long sequence has been recorded more than once, has been taken out of its cassette and is looped. The loop runs in a circuit both inside and outside the player, physically extending the tape in the space of the installation. In this way, Theys uses the form of a video installation to create a sacred space in which ritual and alienation meet. At the same time he also pokes fun at grand emotions such as patriotism and rivalry. Because the work is installed in the exhibition space in a transparent way, viewers can understand how this video installation functions. They can walk around the circular installation and observe the videotape running as a loop in and out of the ¾-inch U-matic player. They can see how this ¾-inch U-matic player transmits the video signal through a set of cables to the eight cathode ray tube (CRT) monitors, and the audio signal to the audio equipment (and the CRT monitors). The display equipment transforms the signals into image and sound. Positioned in a circle around the video loop, with their screens facing the center, the CRT monitors seem to "encourage" their own support/carrier. After all, the image and the music cannot exist without the support/carrier (the ¾-inch U-matic tape).

The equipment used for this work comprised a ¾-inch U-matic top loader modified by the artist, eight identical CRT monitors, a guitar amplifier including the speaker and the ¾-inch videotape. The Sony VP2030 used in *Oratorium* belongs to one of the first generations of U-matic players. The deck's casing is made of wood, metal, and plastic and has a top-loading system. To allow the tape to go out the player, Theys modified the original U-matic player. Aside from the fact that the later models of U-matic players look very different from the VP2030, they also cannot be modified to run the work: their front-loading systems do not allow the tape to go out. One of the main issues with the functionality of *Oratorium* is the wear resulting from its use in working order. The U-matic player is not designed for several months of non-stop operation during eight-hour-long days.

240 | The original master tape was shot and edited on a U-matic BVU cassette. In 2010, Theys made a digital sub master of the video in DV format and provided a copy to M HKA. This video file is now the duplication master used to make new U-matic copies each time the work is installed. To be able to make new loops in the future, M HKA would have to create a stock of blank U-matic tapes and to keep at least one good U-matic recorder and spare heads (both no longer in production).

The current monitors, Profiline TV8121, are 15-inch black-and-white monitors designed for video surveillance systems. In order to preserve the work's integrity, it is essential that each of the eight monitors are identical and that they each fit on the metal stands made specifically by M HKA for this work, following the artist's instructions. For Theys, the minimalist, sculptural look of the current monitors and their grey color fits well with the work.

The amplifier currently used is a Marshall 4150 Club and Country Bass 100W 4x10 Combo Compressor Bass Amp. It has a dark brown covering and a beige grill cloth with a Marshall logo. The amplifier's physical presence and its historical reference conveys an image of rock music, and is visually very present in the installation. The electrical and video/audio cables restrict the size of the installation and the distance between the elements. The cables have to hang one meter from the floor.

CONSERVATION STRATEGY

At the beginning of the project, simulating the functionality of the installation and its equipment was considered as a possible way to preserve the artwork. A dummy tape would have been running in the installation while a digitized

version of the video displayed from a hidden player. Later, when discussing this with the artist, it became clear that this was not an acceptable solution; hiding how the video image appears from the audience would go against the original intent of the work, which was to precisely reveal its own mechanisms. The visual connection between the video image and its carrier, as well as the various video dropouts generated by the unstable tape path would be lost. The variable vacillation of the image due to the unsteady transmission of the video signal thus should be seen as an integral part of the work, which contributes to its "magic", especially today, in our "binary world". Furthermore, when attempts to digitize sequences of the video loop were made, the capture software was not able to catch all the different video artifacts visible on the screen. The continuous connection between image and support and the inherent analog quality of *Oratorium* render impossible any attempt to migrate or modernize its components, making the storage of spare equipment and tapes the only possible strategy for long-term preservation.

Collecting stocks of spare equipment, parts, and tapes, creating proper storage conditions and ensuring maintenance – including preventive measures such as a regular survey of the critical devices and available resources in terms of technical services – represents a continuous effort, but will help to avoid future expenses for repair or searching for equipment. Above all, these measures will push back the fateful moment when the equipment will no longer be available, meaning that the work can no longer be displayed and can only be partly experienced through documentation. *Oratorium* has been actively exhibited since 2010, and will soon be shown in China. This is the right occasion to make the necessary investment in equipment and expertise in order to show the work not only at this time but also in the future.

Case study two: *I/Eye* by Bill Spinhoven van Oosten, 1984 (NIMk)[50]

The primary focus of this case study was to determine what is needed for the preservation of this artwork and in particular to investigate if emulation and virtualization would be adequate conservation strategies (see Fig. 7.7 in color section).

I/Eye (1993/2011) is a software-driven installation in which the involvement of the viewer is essential. The artwork consists of a video monitor, a camera placed on top of the monitor, and a computer. The monitor shows a full-screen, watchful human eye that is triggered by the viewers' movements recorded by the camera. The eye on the monitor follows the viewer's movement, turning the observer of the work into the one being observed. If, for

some seconds, there is motion, the eye will continue to "look," but if there is no movement at all for some time, the eye will close completely. The closed eye suggests it is sleeping. Meanwhile, the eye moves slowly up and down suggesting breathing.

As formulated by the art historian and critic Jorinde Seijdel, the encounter with *I/Eye* provokes an overwhelming and unnerving experience within viewers as "it challenges their own secure position as observers." According to Seijdel *I/Eye* makes people aware that they are constantly being monitored and observed by others: "Big Brother is watching you" (Seijdel, 1997). According to Spinhoven, the artwork exists in at least two or three versions, and the hardware (monitor, camera, computer) was used in more than one version of the work. Spinhoven still continues to develop further versions of *I/Eye* and sees the project as an open-ended process. He is currently planning a web-based version.

EQUIPMENT

The aesthetic appearance and functionality of *I/Eye* has remained the same since its first exhibition in the window of NIMk's predecessor, the Montevideo Gallery in Amsterdam, in 1993. The equipment has changed over time, however, and was malfunctioning at the start of this research project. Spinhoven has emulated and virtualized the hardware and software at NIMk and compared the results of both strategies.

The early monitor (probably a spherical Philips monitor) was only used once and was soon replaced by a Sony Cube Monitor PVM 2130. The monitor shows a full-screen, black-and-white human eye (the artist's own), composed of five stills.

The camera on top of the monitor is equipped with a special fish-eye lens to have a wider registration area and an automatic iris lens to control light intensity. These lenses have been attached to the camera by the artist with tape. There are no specific requirements as to the model – it can be a web cam or FireWire camera – but it should have a show driver in order to connect it to the software. The current camera used for the presentation at NIMk in 2011 is a Monacor surveillance video camera type TVCCD-2000 CCD plus lens.

Through software processing, the computer recognizes the sense of displacement, thus causing an output image that gives the impression that the eye, the iris, is following the passers-by. The artist wrote the software using BASIC V Assembler language, which works on Acorn Archimedes Operating's systems and RISC OS. He stores the software on a Risc PC 600. Some modules have been added to the hardware; this implies that the original performance of the computer has been modified.

One of the main issues to keep *I/Eye* working is the threat of obsolescence of the hardware and software used. Generally speaking, with every new computer type its performance is enhanced and its processing becomes faster. The behavior and functionality of *I/Eye* has a strong relationship with the specific computer architecture. The first computer type implemented was an Acorn Archimedes 410 home computer and the operating system Acorn RISC OS, versions from 3.0 to 6.0. Due to the obsolescence of various components in the case study research, we decided to reuse the Acorn Risc PC. The program creates an eye with a pupil on the basis of motion detection and pre-programmed behavior. The artist encountered a number of setbacks while attempting to activate the software. The cause was found in the digitizer, responsible for capturing the camera image, which turned out to have been corrupted. After replacing it with an identical one, the problem was solved. Incorrect settings and the timing of its horizontal and vertical refresh rate caused differences between the historical display of the *I/Eye* and the current one. Once the functionality of one of the initial versions was recovered, the artist decided to develop an emulator for the program.

CONSERVATION STRATEGY

The hardware of this installation was emulated based on an analysis of its technique and functionality in a different way compared to the "original" hardware and software. The emulation does fully replace the original hardware and software. The re-installation of *I/Eye* in 2011 implied a balance between the formal technical principle of the artwork and its core concept versus the functionality of its components. Re-staging the artwork involved a number of practical questions and deep understanding concerning the obsolescence and (in)availability of the operating system, the hardware, and the display equipment, as well as the (in)operability and correct functionality of the software.

A major part of the experience of this installation relies on the viewer's participation, which can only be achieved if the installation is fully functional. For Bill Spinhoven, an artwork should have the possibility to grow and change by using new tools or equipment instead of trying to keep the old versions alive. Spinhoven still continues to develop further versions of *I/Eye* and he considers emulation to be more important than the authenticity and historicity of the equipment. The artist emulated and re-installed the work to a fully functioning condition.[51]

The recovered version is an assemblage of various historical hardware elements running the historic operating system, Risc PC. In this context, we

could speak about emulation of the old installation with the help of available historic parts from other computers. In this conservation of *I/EYE*, emulation and migration go hand in hand. Migration of the data was and will be necessary to assure the work's functionality. The emulation side of the conservation of this work can be comprehended in various ways dependent on the point of departure. Emulation of the installation as a whole may be conducted by means of extracting the data from the old system and implementing them on a newer one. To perform the work's previous functionality, though, the old version of the computer should be replaced by a similar version that closely imitates it. This process might be classified as emulation of the first version of the equipment, along with the migration of the data. In relation to the virtualization of computer systems, *I/Eye* demonstrates that once the crucial components of the artwork are isolated from the system and are stabilized, they can be enclosed in a virtual environments of any given virtual machine software. Potentially, they can be transferred an almost infinite amount of times, maintaining the work's logic and functionality.[52]

NOTES

* Chapter 7.1 was jointly written by Simone Venturini and Mirco Santi. Together, they wrote *Cameras, Emulsion - Base*; Simone Venturini wrote *Standard 35mm, Film Sound on Film, Multiscreens, Installations, and Cinematic Systems, Digital and Electronic Cinema* and Mirco Santi wrote *Substandard Film*.

1 See Jenkins (2006) and Thorburn, Jenkins, and Seawell (2003).

2 With "protocols" I have in mind the interpretation given by Lisa Gitelman in *Always Already New Media, History, and the Data of Culture* (2006).

3 It was George Eastman's advertising slogan, used in 1888 to promote his revolutionary photographic equipment: Kodak camera.

4 Eastman also had the idea of making photography (and later cinema) a mass phenomenon.

5 Regarding the unusual effects of the introduction of sound on the film multiplicity and plurality, see: Durovicova (2004); Bock and Venturini (2005); Quaresima and Pitassio (2005).

6 "Zelluloid – Films ohne Kamera", is the title of a recent exhibition that was held at the Schirn Kunsthalle in Frankfurt (2 June-29 August 2010), dedicated to the cameraless cinema.

7 Nagra III NP was introduced in 1958. From 1962 onwards, with the neo-pilottone synchronization system, Nagra became the standard in sound recording in film, and it was the standard up until the end of the 1980s.

8 Abel Gance's polyvision consisted of three 35mm cameras that were filming and three 35mm projectors that were projecting. Compare the name and concept of simultaneism with the polyvision conceived and theorized by László Moholy-Nagy.

9 A reference for the proper revival of the different formats and systems in modern projection environments is Sætervade (2006).

10 In addition, see another of Svoboda's inventions, the Polyecran, made of 112 moving cubes, each containing a pair of Kodak Carousels. It was shown in 1958 for the first time and presented at the 1967 Montreal Expo.

11 Regarding the widespread utilization of the loop, see for example *Sleep* by Andy Warhol, but also Martin Arnold, Bruce McClure, and Douglas Gordon.

12 See chapter 8.1 in this volume, "Operational Practices for Film Preservation and Protocols for Restoration."

13 Filmed on 16mm, the performance is a part of *Identification* created by Gerry Schum, broadcast on 15 November 1970 by the channel, Südwestfunk Baden-Baden (SWR).

14 The Eidophor system is used in cinemas, schools and various governmental organizations (such as NASA).

15 For the history and description of how LCD video projection works, see Hornbeck (1998).

16 The Sharp model mentioned was one of the first to be widely commercially available; before that, other LCD monitors had been produced but they were much smaller, such as the 2-inch screen made by Masataka Matsuura in 1983 (see Kawamoto, 2002).

17 An analogue video signal is made up from a low-voltage electrical impulse that contains information relating to the brightness of the pixels which form the electronic image's horizontal lines and those relating to the synchronization of the signal with the viewing equipment.

18 Eurovision is a European television consortium, the majority of which consists of state channels; it was founded in the 1950s with the aim of sharing public service broadcasting.

19 See the Sony site http://www.sony.net/SonyInfo/CorporateInfo/History/SonyHistory/index.html. Last access: 11 November 2011.

20 The price fluctuated around $1,300 for a recorder and $30 for a cassette.

21 The system was also used by television stations especially in reporting. In 1974, CBS covered Nixon's visit to Moscow using the U-matic recording system.

22 The preservation, documentation and exhibition of a historical computer usually includes a brief account of its technological development (genesis), a compilation of technological data (classification, market introduction (+ original price), processor, pulsing, RAM / ROM, operating system, mass storage device, input and output devices (keyboard, mouse, printer, screen / terminal), graphics (text, image), sound), an explanation of its capacities and modes of operation, an analysis of data input and output, and a reference to the machine's place in the cultural history of complex computing machines.

23 A good example is the research project *Obsolete Equipment. The Preservation of Playback and Display Equipment for Audiovisual Art* by Platform for the Archiving and Preservation of Audiovisual Arts (PACKED) and the Netherlands Media Art Institute (NIMk), see http://nimk.nl/eng/obsolete-equipment.

24 The Z3 is considered the first programmable, fully automatic computer that was capable of floating point binary arithmetic. It replaced the Z1 (1938, a mechanical computer for the calculation of floating-point numbers) and the Z2 (1939 with electromagnetic relay technology), parts of which were developed during the same period.

25 The transition from relays to the microchip took place in the course of four computer or technology generations: first there were relays and tubes (until around 1958), then came transistor circuits with transistors and magnetic cores (1958-1966), followed by integrated circuits (1966-1975), and finally highly integrated circuits (since 1975), also called large scale integration (LSI) (cf. Computer Sciences Collection Erlangen Friedrich-Alexander University of Erlangen Nuremberg, http://www.iser.uni-erlangen.de/). Regarding the home computer, relevant factors include, for example, the bus width (8, 16, 32, and 64 bit) which determines

the storage size (RAM), the processor's clock rate, which increased from 1-4 mHz to, at one point, 4-5 GHz and then decreased due to the use of multiple cores, as well as the parallelization of the CPU.

26 Lurk (2009a, 2009b, and 2010a). For the British history of computer art, see Brown et al. (2008).

27 Apple I (1976) with an integrated screen, Lisa (1983), the compact calculator Apple SE (1987) that features in several interactive artworks, and many more (cf. http://www.apple-history.com/).

28 PET 2001 (Personal Electronic Transactor, also known as CBM, 1977), VC20 (actually VIC – Video Interface Chip, 1980), the legendary C 64 (Commodore 64, with 64 kilobytes of main storage, 1982), and the Amiga 500 (1986).

29 The first one being the Atari 2600 games console (1977), followed by the Atari 400 and 800 (1979), the Atari ST (since 1985) and Atari TT (since 1990).

30 For the development of the graphical (reproduction) interfaces, see the Webbox History: http://www.webbox.org/cgi/_timeline60s.html.

31 For information about computer games in this context, see the website of the *Computerspielemuseum* Berlin (http://www.computerspielemuseum.de/index. php?lg=en); for the "demo scene," see Botz (2011).

32 While TCP controls data transmission, delivers the application's data stream, and, where necessary, takes measures against data loss, the addressable address (IP) ensures that the data packet reaches its destination.

33 The procedure was named after the initials of its founders Ronald L. Rivest, Adi Shamir, and Leonard Adlemen.

34 This is contrasted with concepts of longevity, cf. Howard Besser, *Information Longevity* – http://besser.tsoa.nyu.edu/howard/longevity/.

35 The recommendations for the preservation of data carriers are: a maximum temperature of 19-25°C, a maximum relative humidity of 40-50%, UV protection, and the use of acid-free protection films. In addition, data carriers should never be stored horizontally on top of each other or on uneven surfaces (due to danger of distortion and scratches), and direct handling of the reflective surface of optical data carriers should be avoided. Finally, objects should be cleaned using a soft cloth and a mixture of water and isopropyl alcohol (70%) (guidelines according to Lurk (2010a), Matters in Media Art (2008), State Archives of Florida (2009), Swiss National Sound Archive (2008)).

36 Common migration procedures are:
 – Refreshment of the readability and data carriers.
 – Replication, i.e., context checking the different information systems and checking the short cuts for proper operation.
 – Repacking information if the refreshment was not successful.
 – Transformation, i.e., transfer to new storage media and systems.

37 See chapter 8.2 by Jürgen Enge and Tabea Lurk in this volume.

38 Collection Museum of Contemporary Art, Antwerp (M HKA).

39 Collection NIMk, Amsterdam.

40 http://www.nimk.nl.

41 http://www.packed.be.

42 Participating institutions: the Netherlands Cultural Heritage Agency (RCE), the Kröller-Müller Museum (KMM), the Museum of Contemporary Art (M HKA), the Netherlands Media Art Institute, Amsterdam (NIMk), the Municipal Museum of Contemporary Art (SMAK), and the Stedelijk Museum Amsterdam. The case studies, interviews, guidelines, and other resources collected during the project are published at http://www.obsolete-equipment.org/?q=nl/content/obsolete-equipment.

43 A collection of representative cameras, players, recorders, computers, monitors, etc., is difficult to acquire and maintain. Attempts to build up such a collection have been made by the Bern University of the Arts (BUA) and the ZKM (Centre for Art and Media) in Karlsruhe.

44 In the realm of digital media, emulation has a specific definition. An emulator is a computer program that "fools" the original code into assuming that it is still running on its original equipment, thus enabling software from an outdated computer to run on a contemporary one, see http://www.docam.ca/glossaurus/view_Label.php?id=108&lang=1. In conservation vocabulary, to emulate an artwork is to imitate and upgrade it while still retaining the original look and feel of the work, as a facsimile.

45 Virtual environments are created when operating systems and desktop applications are emulated and made independent from physical hardware. Virtualization seems to be the next step in preservation of computer based art. Virtualization as conservation strategy is explored by Tabea Lurk and Jürgen Enge; see http://www.aktivearchive.ch/fileuploads/pdfs/Virtualisation_Summary.pdf.

46 See also Jürgen Enge and Tabea Lurk's contribution to chapter 8 of this volume.

47 http://www.docam.ca/en/restoration-decisions/a-decision-making-model-the-decision-tree.html (last access: 18 September 2012).

48 http://www.docam.ca/en/documentation-model.html (last access: 3 May 2012). See also Annet Dekker's contribution to chapter 6 of this volume.

49 The description of this case is heavily based on the case study report "Oratorium voor geprepareerde videoplayer en acht monitoren (Oratory for Prepared Video Player and Eight Monitors) by Frank Theys, 1989" by M HKA and PACKED, 2011, and Lorrain (forthcoming).

50 The description of this case is strongly based on the case study report "*I/Eye* Bill Spinhoven" by NIMk, 2011 – http://www.obsolete-equipment.org/sites/default/files/case_studies/ieye_bill_spinhoven_case_study_report_0.pdf (last access: 18 September 2012), and Hölling (forthcoming).

51 Emulation of Spinhoven's work *Albert's Ark* (1990) was researched in the project Inside Installations by NIMk and RCE. See Wijers (2011).

52 The work logic identifies the core components of the artwork and describes the interlocking of the digital modules involved. This is documented in terms of how it is anchored in the system environment and in relation to the overall artistic aesthetic concept. Lurk (2010b).

REFERENCES

Altman, Rick. "La parola e il silenzio. Teoria e problemi generali di storia della tecnica." In *Storia del cinema mondiale, vol. V, Teorie, Strumenti, Memorie,* edited by Gian Piero Brunetta, 829-854. Turin: Einaudi, 2001.

Anon. "Frieder Nake." *CompArt database Digital Art (daDA)*, 2009. Http://dada.compart-bremen.de/node/751. Last access: 18 September 2012.

Bardon, Xavier Garcia. "Entretien avec Peter Tscherkassky." Published on *brdf.net*, November 2001. Http://www.brdf.net/interviews/interview_peter_tscherkassky.htm. Last access: 16 September 2010.

Bock, Hans-Michael, and Simone Venturini (eds.). *Multiple and Multiple-Language Versions II/Version multiples II*. Milan: Il Castoro, 2005.

Botz, Daniel. *Kunst, Code und Maschine. Die Ästhetik der Computer-Demoszene*. Bielefeld: Transcript Verlag, 2011.

Brown, Paul, Charlie Gere, Nicholas Lambert, and Catherine Mason (eds.), *White Heat Cold Logic. British Computer Art 1960-1980*. Cambridge, MA: MIT, 2008.

Conway, Paul. *Preservation in the Digital World*. Report, published at the website of the Council on Library and Information Resources, Washington DC, 1996. Http://www.clir.org/pubs/reports/conway2/reports/conway2/index.html. Last access: 11 November 2011.

Crary, Jonathan. "Géricault, il panorama e i luoghi della realtà nel primo Ottocento." In *Il luogo dello spettatore. Forme dello sguardo nella cultura delle immagini*, edited by Antonio Somaini, 93-118. Milan: Vita e Pensiero, 2005.

Cray-Cyber. *Cray-Cyber.org Knowledge Base*. Http://www.cray-cyber.org/wiki/, 13 May 2006. Last access: 18 September 2012.

Da Cruz, Frank. *Columbia University Computing History. A Chronology of Computing at Columbia University*. Http://www.columbia.edu/cu/computinghistory/, 2005. Last access: 18 September 2012.

Deren, Maya. "Amateur Versus Professional." *Film Culture* 39 (1965): 45-46.

Durovicova, Natasa (ed.). *Multiple and Multiple-language Versions I/Versions multiples I*. Milan: Il Castoro, 2004.

Elwes, Catherine. *Video Art. A Guided Tour*. London: I.B.Tauris & Co., Ltd, 2005.

Foster, Hal. "An Archival Impulse." *October* 110 (2004): 3-22.

Frieling, Rudolf, and Dieter Daniels (eds.). *Media Art Interaction. The 1980s and 1990s in Germany*. Vienna: Springer, 2000.

—. *Media Art Action. The 1960s and 1970s in Germany*. Vienna: Springer, 1997.

Garroni, Emilio. *Ricognizione della semiotica*. Rome: Officina, 1977.

Gitelman, Lisa. *Always Already New Media, History, and the Data of Culture*. Cambridge, MA: MIT Press, 2006.

Gunning, Tom. "Re-newing Old Technologies. Astonishment, Second Nature and the Uncanny in Technology from the Previous Turn-of-the-Century." In *Rethinking Media Change. The Aesthetics of Transition,* edited by David Thorburn, Henry Jenkins and Brad Seawell, 39-60. Cambridge, MA: MIT Press, 2003.

Herzogenrath, Wulf, and Barbara Nierhoff-Wielke (eds.). *Ex Machina – Frühe Computergrafik bis 1979. Die Sammlungen Franke und weitere Stiftungen in der Kunsthalle Bremen. Herbert W. Franke zum 80. Geburtstag*. Berlin: Deutscher Kunstverlag, 2007.

Hölling, Hanna Barbara. "Versions, Variation and Variability: Ethical Considerations and Conservation Options for Computer-Based Art." *The Electronic Media Review, Volume Two*. Washington, DC: American Institute for Conservation of Historic and Artistic Works, forthcoming.

Hornbeck, Larry J. "From Cathode Rays to Digital Micromirrors. A History of Electronic Projection Display Technology." *TI Technical Journal* July–September (1998): 7-46.

Huffman, Kathy Rae. "Art, TV and the Long Beach Museum of Modern Art." In *California Videos. Artists and Histories*, edited by Glenn Phillips, 279-284. Los Angeles: The Getty Research Institute, 2008.

Humanities Advanced Technology and Information Institute (HATII). *Report on Emerging Digital Art Characterisation Techniques*. Unpublished report, Planets project, University of Glasgow, 30 November 2009. Http://www.planets-project.eu/docs/reports/Digital_Art_Characterisation_Techniques.pdf. Last access: 18 September 2012.

Ishizuka, Karen L., and Patricia R. Zimmermann (eds.). *Mining the Home Movie. Excavations in Histories and Memories*. Berkely etc.: University of California Press, 2007.

Jenkins, Henry. *Convergence Culture. Where Old and New Media Collide*. New York and London: New York University Press, 2006.

Kawamoto, Hirohisa. "The History of Liquid-Crystal Displays." *Proceedings of the IEEE* 90 (2002) 4: 460-500.

Kerckhove, Derrick de. *Brainframes. Technology, Mind and Business*. Utrecht: Bosch & Keuning, 1991.

Kitsopanidou, Kira. "The Widescreen Revolution and 20th Century-Fox's Eidophor in the 1950s." *Film History* 15 (2003) 1: 32-56.

Klütsch, Christoph. *Computergrafik. Ästhetische Experimente zwischen zwei Kulturen. Die Anfänge der Computerkunst in den 1960er Jahren*. Vienna: Springer, 2007.

Krauss, Rosalind E. "Reinventing the Medium." *Critical Inquiry* 25 (1999) 2: 289-305.

Laurenson, Pip. "The Management of Display Equipment in Time-based Media Installations." In *Modern Art, New Museums. Contributions to the Bilbao Congress 13-17 September 2004*, edited by Ashok Roy and Perry Smith, 49-53. London: The International Institute for Conservation of Historic and Artistic Works, 2004.

Lee, Kyong-Ho, Oliver Slattery, Richang Lu, Xiao Tang, and Victor McCrary. "The State of the Art and Practice in Digital Preservation." *Journal of Research of the National Institute of Standards and Technology* 107 (2002) 1: 93-106. Available online – http://nvlpubs.nist.gov/nistpubs/jres/107/1/j71lee.pdf. Last access: 18 September 2012.

Lorrain, Emanuel. "Anatomy of the Analogue. The Preservation of Frank Theys' Video Installation *Oratorium for Preparated Videoplayer and Eight Monitors* (1989)." *The Electronic Media Review, Volume Two*. Washington DC: American Institute for Conservation of Historic and Artistic Works, forthcoming.

Lurk, Tabea. "Lagerungsbedingungen für digitale Datenträger." Unpublished report, Bern University of the Arts, 2010a. Http://www.hfg.edu/textarchive/Lagerungs-bedingungen_2010.pdf. Last access: 24 September 2012.

—. "On the Aging of Net Art Works." In *Owning Online Art. Selling and Collecting Net-based Artworks*, edited by Markus Schwander and Reinhard Storz, 51-65. Basel: FHNW, Hochschule für Gestaltung und Kunst, 2010b. Available online – http://www.ooart.ch/publikation/inhalt/PDF/06-Tabea-Lurk-e.pdf. Last access: 18 September 2012.

—. "Programmes as space for thoughts? Annotations to the origins of Swiss computer art." In *India Habitat Centre's Arts Journal*, edited by Alka Pande and Nils Röller, 50-63. New Delhi: India Habitat Center, 2009a. Available online – http://www.prohelvetia.in/fileadmin/pro_helvetia_india/docs/New_Media_Journal.pdf . Last access: 18 September 2012.

—. "ComputerKunstGeschichte Schweiz." In *Computergeschichte Schweiz. Eine Bestandesaufnahme/ Histoire de l'ordinateur en Suisse. Un état des lieux*, edited by Peter Haber, 165-206. Zurich: Chronos Verlag, 2009b.

Magoun, Alexander B. *Television, the Life Story of a Technology*. Westport, London: Greenwood Press, 2007.

Matters in Media Art. "Condition Report Guidelines." Guidelines published at the website of the Matters in Media Art project, Tate, London/Museum of Modern Art, New York/SFMOMA, Los Angeles, 2008. Http://www.tate.org.uk/about/projects/matters-media-art/condition-report-guidelines. Last access: 24 September 2012.

Medesani, Angela. *Le icone fluttuanti. Storia del cinema d'artista e della videoarte in Italia*. Milan: Mondadori, 2005.

Meigh-Andrews, Chris. *A History of Video Art. The Development of Form and Function*. Oxford and New York: Berg, 2006.

Paul, Christiane. *Digital Art*. London: Thames & Hudson, 2003.

Quaresima, Leonardo, and Francesco Pitassio (eds.). *Multiple and Multiple-language Versions III/Version multiples III*. Milan: Il Castoro, 2005.

Rothenberg, Jeff. "Renewing *The Erl King*." *Millennium Film Journal* 45/46 (2006): 20-51.

Sætervade, Torkell. *The Advanced Projection Manual. Presenting Classic Films in a Modern Projection Environment*. The Norwegian Film Institute, Oslo 2006.

Schwarz, Hans-Peter (ed.). *Media-art-history. Media Museum. ZKM, Center for Art and Media Karlsruhe*. Munich: Prestel Verlag, 1997.

Seijdel, Jorinde. "I/Eye." In *The Second. Time Based Art from the Netherlands*. Catalogue of the eponymous exhibition, Netherlands Media Art Institute, Montevideo-TBA, Amsterdam, 24 January-9 April 1997. Amsterdam: NIMk, 1997.

Shand, Ryan. "Theorizing Amateur Cinema. Limitations and Possibilities." *The Moving Image* 8 (2008) 2: 36-60.

State Archives of Florida. "Preservation and Conservation. Protect your video and audio tapes, and floppy disks." Guideline published at the website of the Florida Department of State, Division of Library and Information Services, Tallahassee, FL, 2009. Http://dlis.dos.state.fl.us/archives/preservation/magnetic/index.cfm. Last access: 24 September 2012.

Swiss National Sound Archive. "Archiving conditions. The ideal archive." Guideline published at the website of the Swiss National Sound Archive, Lugano, 2008. Http://www.fonoteca.ch/yellow/archivingConditions_en.htm. Last access: 24 September 2012.

Tamblyn, Christine. "Video Art. An Historical Sketch." *High Performance* 37 (1987): 33-37.

Thorburn, David, Henry Jenkins, and Brad Seawell (eds.). *Rethinking Media Change. The Aesthetics of Transition*. Cambridge, MA: MIT Press, 2003.

Vasulka, Woody, and Scott Nygren. "Didactic Video. Organizational Models of the Electronic Image." *Afterimage* 3 (1975) 4: 9-13.

Von Neumann, John. *The First Draft of a Report on the EDVAC*. Unpublished report, Moore School for Electrical Engineering, University of Pennsylvania, 30 June 1945. Http://virtualtravelog.net.s115267.gridserver.com/wp/wp-content/media/2003-08-TheFirstDraft.pdf. Last access: 18 September 2012.

Wijers, Gaby. "To emulate or not." In *Inside Installations. Theory and Practice in the Care of Complex Artworks*, edited by Tatja Scholte and Glenn Wharton, 81-89. Amsterdam: Amsterdam University Press, 2011.

Wilson, Stephen. *Information Arts. Intersections of Art, Science, and Technology*. Cambridge, MA: MIT, 2002.

Zimmermann, Patricia R. *Reel Families. A Social History of Amateur Film*. Bloomington, in: Indiana University Press, 1995.

Theories, Techniques, Decision-making Models: The European Context

8.1 OPERATIONAL PRACTICES FOR A FILM AND VIDEO PRESERVATION AND RESTORATION PROTOCOL

*Alessandro Bordina and Simone Venturini**

Introduction

The operating practices of preservation and restoration raise complex questions of a methodological and theoretical nature. However, there are basically three questions that we must answer in order to work correctly: a) What is the identity of the material that we are analyzing? b) What are its conditions? c) How can we look after it? The first two questions are of a diagnostic nature, whilst the last one concerns the issues of prognosis.

First of all, the film materials need to be identified and classified, giving them historic-documentary, formal-aesthetic, and technological identity; in other words, reconstructing the internal and external history of film,[1] as well as its cultural history.[2] Secondly, we must proceed to recognizing pathologic symptoms and recording useful information for a diagnosis on the state of the material. Finally, the third question is of a prognostic nature and depends on the level of the intervention.

The first level of intervention is the *storage* (or passive preservation) and involves the safeguarding of materials in air-conditioned environments – or rather with certain temperatures, relative humidity, and air quality – and their periodic checks. Passive preservation guarantees the survival of the artifacts over time. A second level of intervention is the *preservation* (or active preservation) which "prolongs the existence of all that exists" (Païni, 1997), ensuring

the transmission, the right reproduction of the visual and audio information preserved on the artifact. The preservation procedures are finalized to transmit all the information, but they include an inevitable *hybridization* and *creolization* of the information transmitted and a correspondence – not always verifiable or repeatable in the results – with the hardware and software utilized and the decisions made, thus imposing extensive documentation of the interventions at this level of action. A third level is the restoration (and of the critical reconstruction of the text). *Restoration* is a process and an action that takes place at a different level. Restoration is not limited to preserving what exists or replicating or transmitting information preserved on originals, but aims to recover lost quality, former synchronic and authentic conditions and, in doing so, reveals approaches and finality that can be very different.[3]

Two appendices can be proposed for this initial synthetic description:

1) The materials – film and video – are not *human-readable,* but need technological mediation for their reproduction and transmission (they are *machine-readable/dependent*). The action of transmission represented by the preservation can be seen in systemic and set theory terms (transmission as *diasystem*);[4] in trans-historic and communicative terms (the transmission as *interface*); and in terms of transition and restoration of the experience (the transmission as *emulation, simulation,* and *remediation*).

2) Our frame of reference is mainly represented by film-based artworks and by video art, areas which require other factors being taken into account (the role of the artist and the time when the artwork was made, the technical and aesthetic experimentation) which call for the revision and interpretation of the basic principles set out above in a flexible way.

Guide to the Identification of Different Film Formats

The study of the physical characteristics of the materials[5] includes the analysis of the production process, the technological systems involved, and the degree of systemic, technical, and functional obsolescence with respect to the current standards. It allows for the identification of the film material typology and its origins. The method and instruments for analytical surveying also allow for the planning of the best ways for safeguarding and reproduction.[6]

The information to be researched can be split up into information relative to the *structure* and the *appearance* of the material. A useful subdivision of the film structure relates to the area of image, the area of sound, and the area of

the perforations. Another methodological suggestion calls for information to be revealed, dividing into information outside the image area and information inside the image area.[7]

The classes of information useful to the structural analysis of material can be synthesized into:

a. film format (35mm, 16mm, 9.5mm, 8mm, etc.);
b. format and shape of the image area (usually expressed through the relationship between the height and the width of the film: i.e., 1:1.33);
c. format and system for the recording of the soundtrack (area or variable-density optical, magnetic, mono, stereo, and on disc);
d. format of the perforations;
e. type of emulsion and of color system (black and white, color, hand-painted, tinted, toned);
f. type of element (negative, intermediate, duplicate, positive, reversal, etc.); type of base (nitrate, acetate, polyester, etc.);
g. information on the film's edge (edge code, duplication marks, cueing marks, etc.);
h. editing marks (tape and cement splices, blooping, signs for printing, for fading in and out and cross fading);
i. metadata (labels, note);
j. documentary data on the living and cultural history of the object.[8]

8.1
Edge code of camera negative, in the upper right displaying the notch for the activation of changing light on the printing machine according to the Debrie method, cueing carried out during the sight grading. Source: Società Umanitaria – Cineteca Sarda/La Camera Ottica, Università degli Studi di Udine.

| 255

Guide to the Identification of Different Types of Video Formats

The identification of the format of video materials is the basis for the understanding the recording system, the definition of technological obsolescence, and recognizing suitable hardware for reading the signal.

The most common type of magnetic device can be divided into five categories of width: 2 inch, 1 inch, ½ inch, ¾ inch and ¼ inch. However, such classification is not sufficient for recognizing the specifications of the recording system that uses one of these tape formats. Before proceeding to the evaluation of the support and signal's state of decay and the identification of the equipment, it is necessary to obtain at least three other types of information relating to the material:

- *Recording Format*: the recording system can be ascertained through identifying the traceable device, in many cases, through the indication on the case and on the tape's rims. By reading the identification codes it is possible to recognize the recording format.[9] It should

8.2 Metadata about recording systems, video content, previous filings and cataloging of materials in a ¼-inch tape of *Anna* (Alberto Grifi e Massimo Sarchielli, 1972-1975). Source: Fondazione Alberto Grifi/Centro Sperimentale di Cinematografia – Cineteca Nazionale/La Camera Ottica, Università degli Studi di Udine.

1.2

Nam June Paik and Charlotte Moorman, *TV Bra for Living Sculpture* (1969). Photograph of the performance by Moorman during the Nam June Paik exhibition at the Rose Art Museum of Brandeis University, Waltham, MA, 6 September-14 October 1984. © Charles Giuliano.

1.3

Still from *Andy Warhol's Exploding Plastic Inevitable* (1967) by Ronald Nameth. © Ronald Nameth, courtesy of the artist. ArtSiteIN KB.

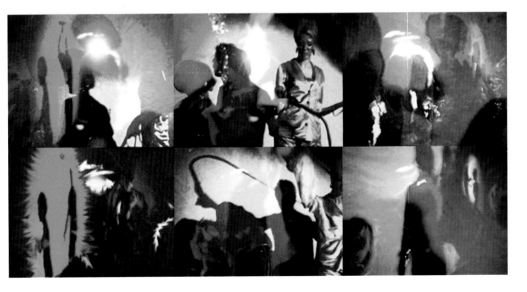

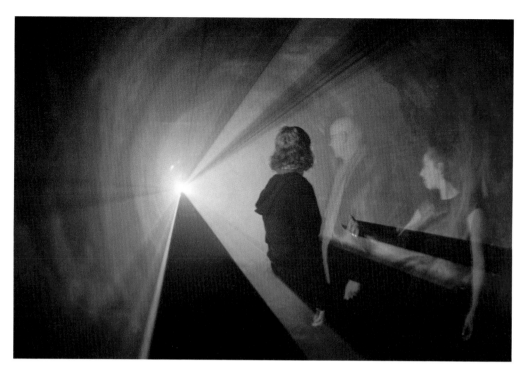

1.5
Anthony McCall, *Line Describing a Cone* (1973). Courtesy of the artist.

1.6
Jan Dibbets, *TV as a Fireplace* (1968-1969). Collection Stedelijk Museum Amsterdam c/o Pictoright Amsterdam 2012.

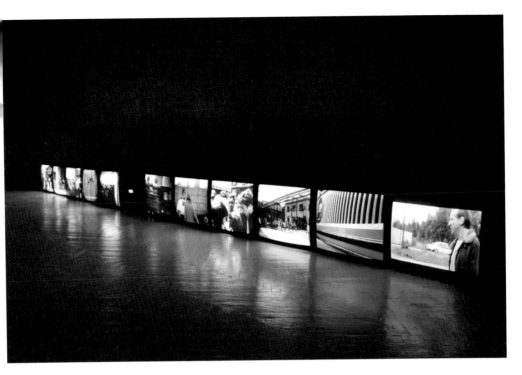

5.1
Harun Farocki, *Workers Leaving the Factory in 11 Decades* (2006).
Courtesy of the artist.

5.2
Michael Snow,
Wavelength (1967).
Courtesy of the
artist.

6.1
Blast Theory,
*Uncle Roy All
Around You*
(2007). Courtesy
Blast Theory.

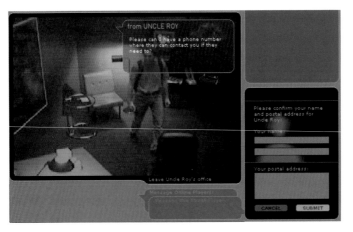

6.2
Blast Theory,
*Uncle Roy All
Around You*
(2007). Courtesy
Blast Theory.

Invoice

FROM			
Tax ID:	87-0460119	**Shipment ID:**	3X8W40G4VSP
Contact Name:	Ryou Sugiyama	**Invoice No:**	
Kenichi Konaka Inc	928465144		
K works	2-2-17 Kundan-minami	**Date:**	
	Chiyoda-Ku	**PO No:**	
	102-0054		
	Japan		
		Terms of sale (incoterm)	
		Reason for export: Sale	

SHIP TO		SOLD TO COMMERCIAL USES	
Tax ID:	87-0460119	**Tax ID:**	3X8W40G4VSP
Contact Name:	Pierre Huyghe	**Contact Name:**	
	Philippe Parreno	Same as Ship	
	1 rue d Hauteville		
	Paris, 75010		
	France		
Phone:	0142463829		

Units/UM	Descriptions of Goods	Harm.code	C/O	Unit Value	Total Value
1 ea	All Rights	4911100050	JP	¥ 46000	¥ 46000

Additional Comments:

Declaration Statements:

Shipper **Date**

These commodities, technology or software were exported from Japan in accordance with the Export Administration Regulations.

6.3

Invoice of K-work, a Japanese company specialized in designing manga and comic images for commercial sales. The invoice is addressed to Pierre Huyghe and Philippe Parreno and stipulates the rights to use the figure, which later became known as "Annlee".

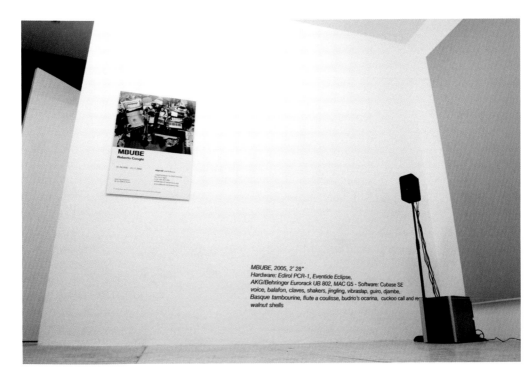

6.4
Roberto Cuoghi, *Mbube* (2005). Sound Installation, 2'30",
edition 3/5. Voice, balafon, claves, shaker, jingling, vibraslap,
guiro, djambe, basque tambourine, slide flute, Budrio ocarina,
cuckoo, and decoy calls, walnut shells. Hardware: Edirol PCR-
1, Eventi de Eclipse, Akg/Behringer Eurorack UB 802, Mac G5;
Software: Cubase SE. The IX Baltic Triennial of International Art,
Contemporary Art Center, Vilnius, 2005.

Right: 6.5
Bruna Esposito, *e così sia...* (2000). Project in progress of
installation and destruction with epilogue singing by the artist
(legumes, grains, laurel, hot plate, Pyrex container, water,
bags containing a mix of legumes, grains, and poetry by Paola
D'Agnese), final overall size approximately 400 x 400 cm. MAXXI
Collection. Photo by Giuseppe Schiavinotto.

7.6
Frank Theys, *Oratorium for Prepared Videoplayer and Eight Monitors* (1989). M HKA, Collection Presentation XXV, Antwerp, 19 March 2010–6 April 2010. Photo: PACKED vzw. Courtesy M HKA.

7.7
Bill Spinhoven, *I/Eye* (1984), as installed at Montevideo Spuistraat, Amsterdam. © NIMk.

8.7
Video preservation. Digitization of an ¼-inch open reel tape of
Anna (Alberto Grifi e Massimo Sarchielli, 1972-1975). Source:
Fondazione Alberto Grifi/ Centro Sperimentale di Cinematografia
– Cineteca Nazionale/La Camera Ottica, Università degli Studi di
Udine.

8.11
Installation view of *Liquid
Perceptron* by Hans Diebner
in the opera *Einstein on the
Beach* by Robert Wilson,
Berlin, 2001/2005.

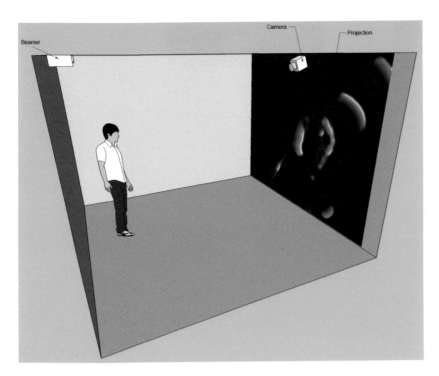

8.12
Installation schema for *Liquid Perceptron* (by Jürgen Enge, 2010).

8.14
Installation photograph of Carlos Garaicoa, *Letter to the Censors*
(Carta a los censores, 2003). © Carlos Garaicoa.

9.1
Christoph Oertli, *The Ground is Moving* (2010). © Christoph Oertli.

9.2
Patrick Keiller, *The City of the Future* (installation view, 2007).
Courtesy of BFI Southbank Gallery/Dave Morgan.

9.5
Videostill from Michael Langoth, *Retracer* (1991). Courtesy imai –
inter media institute, Dusseldorf.

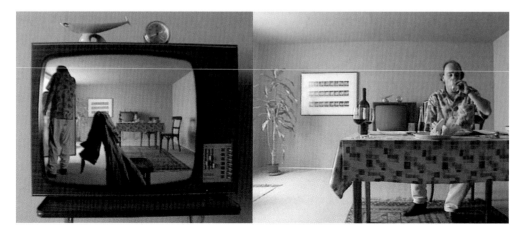

9.3
Max Neuhaus, *Times Square*, New York, 1977. View of site © the
Estate of Max Neuhaus. Courtesy of the estate of Max Neuhaus.

Anfrage | *Request*
Impressum | *Imprint*

>>ONLINE-KATALOG

Videoansicht | *Video preview*

 Video

Zurück zum
Suchergebnis
*Back to
search result*

Schauen

Metadaten

Künstler | *Artist*
Douglas Davis
>>
more

Titel | *Title*
The Last Nine Minutes /
Sequenz
>>
more

Synopse | *Synopsis*

Jahr | *Year*
1977
>>
more

Land | *Country*
USA
>>
more

Länge | *Length*
01:11 Min.

Produktionsformat | *Format*

Farbe | *Color*
color+sw

Ton | *Sound*
ch 1+2

Kategorie | *Category*
Videokunst Sequenz

Schlagwörter | *Keywords*
Bildschirm, Fernsehen, Zeit,
Hand, Taktilitaet, Interaktivitaet,
Telekommunikation,
Telepraesenz, Raum

Schauen

▶
Abspielen
Play

Sequenzauswahl
*Sequence
Selection*

↰
Vorherige
Ansicht
Last View

Einzelbildexport
Export Frame

Gesamtlänge | *Total length* 01:11 Min.

Nach oben | *To the top*

Anfrage | *Request*
Impressum | *Imprint*

>>ONLINE-KATALOG

Videoansicht | *Video preview*

 Video

Zurück zum
Suchergebnis
*Back to
search result*

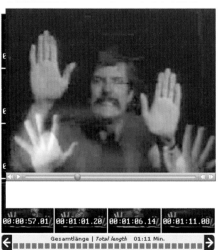

Schauen

Metadaten

Künstler | *Artist*
Douglas Davis
>>
more

Titel | *Title*
The Last Nine Minutes /
Sequenz
>>
more

Synopse | *Synopsis*

Jahr | *Year*
1977
>>
more

Land | *Country*
USA
>>
more

Länge | *Length*
01:11 Min.

Produktionsformat | *Format*

Farbe | *Color*
color+sw

Ton | *Sound*
ch 1+2

Kategorie | *Category*
Videokunst Sequenz

Schlagwörter | *Keywords*
Bildschirm, Fernsehen, Zeit,
Hand, Taktilitaet, Interaktivitaet,
Telekommunikation,
Telepraesenz, Raum

↰
Video
ausblenden
~~Schauen~~

Gesamtlänge | *Total length* 01:11 Min.

Nach oben | *To the top*

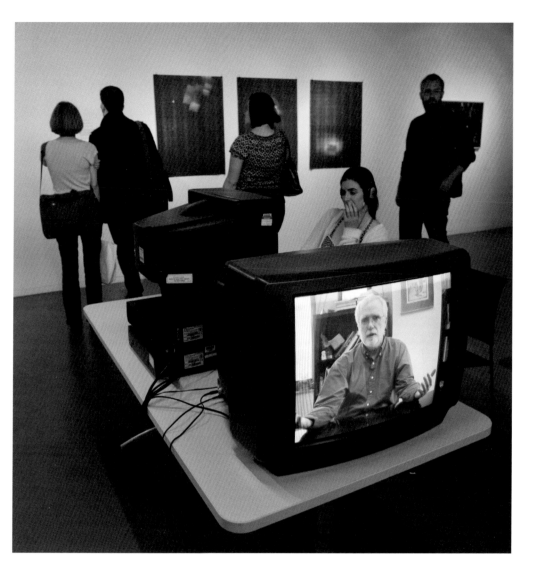

10.1
Visitors to the exhibition *Q.E.D.*, Liverpool John Moore's University
Art and Design Academy Galleries, September 2011, as part of the
AND Festival. Pictured in the foreground is *The New Artist* by Axel
Straschnoy and collaborators, and in the background prints from
the Xerox Astronomy project by Joe Winter. Photo courtesy of AND
Festival.

Left, top: 9.6
imai Online Catalogue with videostills from Douglas Davis, *The
Last Nine Minutes* (1977). Courtesy imai – inter media institute,
Dusseldorf.

Left, bottom: 9.7
imai Online Catalogue with videostill from Douglas Davis, *The
Last Nine Minutes* (1977). Courtesy imai – inter media institute,
Dusseldorf.

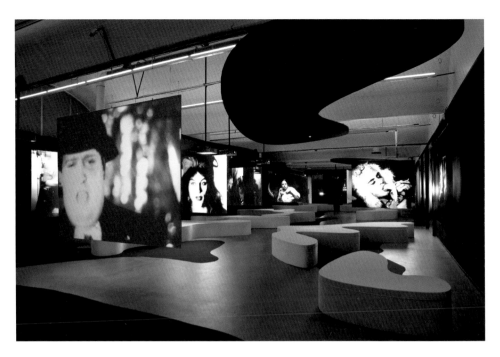

11.1
The *Filmscape* section of the exhibition *Andy Warhol. Other Voices, Other Rooms*, Stedelijk
Museum CS Amsterdam, 12 October 2007-14 January 2008. Photo: Gert Jan van Rooij.

11.2
The *TV-Scape* section of the exhibition *Andy Warhol. Other Voices, Other Rooms*, Stedelijk
Museum CS Amsterdam, 12 October 2007-14 January 2008. Photo: Gert Jan van Rooij.

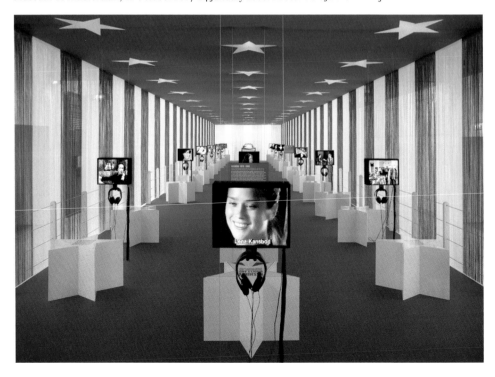

be noted that, in more than just a few cases, the same tape can be utilized by different generations of the same recording system.[10] In the playback phase, the alterations can be checked (for example, synchronism and chrominance), which can be interpreted as indications of a recording system that is different from the one recognized by reading an identification code.

– *Manufacturer of the tape*: The identification of the brand can provide useful information on the ways of treating and regenerating tapes.[11]
– *System of transmission of the signal*: The transmission standard utilized (NTSC, PAL, SECAM) can be obtained or deduced from the carrier's metadata. If the metadata does not explicitly refer to the system being used, it can be inferred from information relating to the time and place it was produced.

Once the format of recording, the manufacturer, and the transmission format have been identified, it is possible to proceed to the verification stage of the chemical, physical, and mechanical conditions (see below under "Guide to the Diagnosis of Physical, Chemical, and Mechanical Decay Syndromes of Video Materials"). After this stage follows the regeneration of the devices, then the playback stage and the digital acquisition of the signal (see below under "Operational Practices for Video Preservation and Restoration Protocols").

Guide to the Diagnosis of Physical, Chemical, and Mechanical Decay Syndromes for Film Materials

The alterations detected during the analysis of the physical and chemical state of the elements can be subdivided into *damages*, *errors*, and *defects*.[12]

By *damages* we mean *biological*, *chemical*, and *mechanical* alterations to the material due to use or negligence and the decay of materials.[13] By *errors* we mean the alterations present during the transmission of the contents, or rather during the duplication process of the materials. While the errors belong to the area of cultural history and the copying process, the *defects* are understood as signs and indications of limits, of the characteristics but also of incorrect uses of the recording system and the technology employed at the beginning.[14]

In the specific field of cinema of aesthetic experimentation, such a category must be reviewed and reconsidered in light of the strategy, intentions, and each artist's techniques, that often "play" and experiment with the alterations of the correct ways of recording, with the exaltation of the technological limits and with the research of damages as an expressive element (see chapter 7.1).

The characteristics and the processes of the decay of the film bases used in

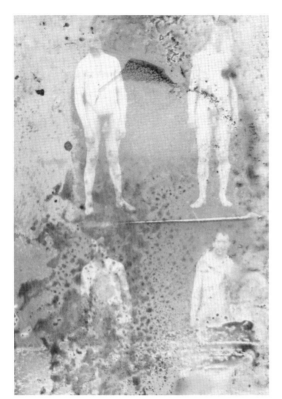

8.3
Frames of a film on a nitrate base
in an advanced state of decay.
Source: Collection Vincenzo
Neri, Archivio Nazionale del
Film di Famiglia – Associazione
Home Movies /La Camera Ottica,
Università degli Studi di Udine.

Below: 8.4
Cans with 8mm films on an acetate
base in an advanced state of decay.
Source: Collection Togni, Archivio
Nazionale del Film di Famiglia –
Associazione Home Movies /La
Camera Ottica, Università degli
Studi di Udine.

cinematography are known and have been described in literature. The intensity of the decay of cellulose nitrate can be visually and olfactorily detected and is measured conventionally through the five stages of decay.[15] The syndrome of the decay of the safety acetate base is known as the "vinegar syndrome".[16] An instrument for revealing and monitoring the state of a collection is made up from IPI's A-D Strips (Image Permanence Institute, 2001). Even in the case of cellulose triacetate, the survey can be carried out through visual and olfactory detection and can be identified with one of the five stages of decay defined in literature.[17] The polyester base, even if very stable, is subject to problems of *core set memory* and *delamination*.

The color image decay "can be manifested as color fading, color balance shift, yellowing, or color bleeding", whilst the *silver image decay* "can be manifested as microspots, silver mirroring, or overall image discoloration" (Adelstein, 2009: 9).

To "diagnose" the state of a material requires describing and interpreting the symptoms of the decay in order to assign a conventional value to them, to measure the intensity and put them onto the scales of decay. Finally, the result of the diagnostic survey defines a "health status" for an element or a collection.[18]

Guide to the Diagnosis of Physical, Chemical, and Mechanical Decay Syndromes of Video Materials

We can also adopt a classification for video materials, based on the difference between damages, errors, and defects. In the case of analogue video, the definition of errors also includes modifications to the signal caused by the playback equipment that was used. The reproduction of the video signal is closely tied to the technology of the time. Such equipment can produce changes in the display of the image (after the decay of mechanical or electronic components or as a result of a difference in the calibration between the playback equipment and that which produced the signal). The types of alterations (errors and defects) that can result from equipment malfunction in the production and playback stage are in many cases similar, complicating the analysis of the causes of alterations to the signal. However, in view of the recovery or restoration it will be an opportune moment to define, where possible, the origins of the alteration (productive and interpretative), to proceed to their compensation (for errors), or to their maintenance (for defects and elements of the work's aesthetic and material history).

The damages of the magnetic audiovisual carriers are determined by factors such as frequency and conditions of use, chemical composition of the tapes, and environmental conditions of conservation.

One of the most common causes of chemical decomposition of the magnetic tapes is the "sticky shed syndrome" (Association of Moving Image Archivists, no date: 7). The causes of *sticky shed* are generally the prolonged exposure of the tape to relatively high temperatures and humidity. It can be diagnosed through tactile, visual, and olfactory inspection of the device. The upper part of the tape becomes sticky to touch and the tape tends to become attached to the spool. At a visual level, dusty or gummy residues can appear (disintegration of the top coat); furthermore, the device emits a pungent odor. A tape affected by *sticky shed*, if used without appropriate regeneration treatment (see below) will present problems of drag, caused by the friction between the tape and the reading equipment. The friction inevitably leads to the detachment of parts of the magnetic layer, with the resulting irreversible loss of recorded information.

Another cause of chemical decomposition is the loss of lubricant. The lubricants are added to the binder to reduce the friction between the tape's top coat and the mechanism. Such substances are consumed, even in small measures, every time the tape is reproduced. The level of lubrication of the

260 |

8.5
Magnetic ½-inch tape suffering from biological decay (the presence of mold is due to the high humidity of the storage environments).

surfaces can reduce even in archived tapes due to evaporation caused by temperatures and humidity being too high or too low. Problems with drag of the tape in the reproduction phase can be traced to a loss of lubricant.

The tape surfaces can show biological decay, traces of dust, or crystalline residue indicating the presence of mold, caused by the tape being badly isolated, storing it either in a place that is not clean or that has increased temperature and humidity. This decay affects and damages the reading of the signal (with continuous loss of signal and impulsive noises on the screen) and the playback mechanisms (especially on the video and ACE heads).

Finally, there are faults of a mechanical origin which might affect the polyester base of the tape. The most common is the distortion on the base that can cause problems in the tracking in reproduction. Every time the temperature or humidity suddenly changes, the tape's flange expands and contracts, causing physical stress to the device and causing permanent distortion of the substrate.

In the same way as errors and defects, faults become apparent during the viewing of the video signal, in the form of image deterioration. The most common form of deterioration present is *dropout*, which results in the loss of one or more of the lines that make up the image. The losses are often due to lack of magnetic paste on the tape, but they might also be caused by the presence of dust, or other elements which impede the reading of the signal. Another frequent deterioration is that defined as *impulsive noise*. The defect becomes visible in the form of a white dot with a comet-like tail. When the signal is treated with time base corrector (TBC), the dot, along with the associated drag, is transformed into a white or gray line.

Another type of deterioration is *crosstalk* (the interference of one video signal with another), which can be caused at the recording stage by the overlapping of another video source, or as the result of a wrong reading of the video tracks by the heads.

Other common types of signal alteration include *jitter*, the disengagement of the vertical synchronism, and the disengagement of the horizontal and vertical synchronism. The jitter is caused by the partial loss of information relevant to the horizontal synchronism (see Fig. 8.6). It becomes visible in the form of the "flagging" of a part of the image. The lines, and especially those at the top and the bottom of the screen, appear not to be aligned with the rest of the image.

The disengagement becomes visible through a vertical instability of the image, which appears to be the correct shape. This is not really an inherent fault of the player, but compensation of TBC. Without TBC we would not have the disengagement of the picture, but the disengagement of the synchronism with complete loss of image.

Identifying the reasons for the signal's deterioration is often complex,

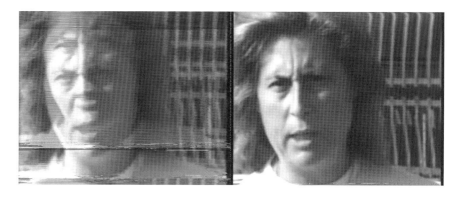

8.6

Comparison of a frame from *Quartieri Populari* (Anna Lajolo and Guido Lombardi, 1973). On the left: problems of synchronization of the lines of both fields of the image due to transportation problems and the loss of horizontal and vertical synchronism. On the right: the result obtained after regeneration of the physical-chemical support and stabilization of the video signal via TBC.

given that the same type of image alteration can be traced back to the device's decay, the malfunction of the reading equipment, and errors during copying or production. The analysis of errors in various versions of the same work, and the check on quantity and time for an alteration inside the same video, can help to construct hypotheses relating to the reason for deterioration. The reconstruction of the technological, productive, and aesthetic context of the finding and its original equipment give fundamental information for the diagnostic stage, the classification of the alterations to the signal, and for defining and evaluating the damage to the work.

Guide to the Care, Monitoring, and Storage of Film Materials

To formulate a prognosis on the future of materials, it is necessary to use tools and methods that are able to forecast a life expectancy based on the recorded level of decay and taking into account the predicted conditions of the preservation.[19] The diagnostic tools can be simple (such as the testing of acidity using A-D strips) or complex (such as mass spectrometry) and there are objective scientific tests and subjective surveys to clearly understand them and in order to distinguish them.

In recent years there have been studies on the stability and the behavior of color emulsions over time, and film bases in acetate and polyester based on two distinct methods. The first area of study used the technique of *accelerated ageing* (Arrhenius approach), a predictive method that produces the life expec-

tancy (LE) of the materials in conventional conditions at 20°C and 50% RH accepted by the International Organization for Standardization (ISO). The second has application in long-term aging, or rather the incubation of "test materials for a period of ten years in order to evaluate life expectancy predictions" (Bigourdan, 2002: 40-41). The two experimental situations have produced results that are to a large extent overlapping; with the capacity, therefore, to confirm the quality of the method of artificial acceleration of time.

The standards for the preservation of film bases are known and published in form of recommendations by the ISO.[20] The materials must also be preserved in horizontal positions inside the cans and wrapped around cores that have passed the photographic activity test (PAT).[21] The IPI recommends a simple protocol of long-term film collection preservation based on concepts and the key actions: identifying, assessing, and storing. The IPI has also developed a preservation management process based on systems of monitoring and tools for recording, analyzing, and interpreting data relative to the main variables represented by the temperature and relative humidity. The definition of "health status" and the methods and management tools for predicting the future state of materials provide a basis for outlining a plan and a strategy for passive and active preservation of single materials, as well as entire collections.

| 263

Guide to the Care, Handling, and Storage of Video Materials

To ensure a future readability of the information contained in the magnetic layer of the tape, it is necessary to keep the device in a clean environment, with a stable climate and an adequate temperature/humidity ratio.

The ideal conditions indicated by various organizations (Cuddihy, SMPTE, NARA) are a temperature of 18°C with a possible range of 2°C and the relative humidity at 40% (with a possible variation of about 5%). The ANSI standard allows for a maximum temperature of 20°C with relative humidity between 20% and 30%.[22]

A key factor in the correct conservation of the magnetic materials is the environmental stability. The variations in humidity and temperature over a 24-hour period must not exceed 2°C (for the temperature) and 5% (for the humidity). For this reason it is necessary to provide constant monitoring of the temperature and humidity of the environment and a period of acclimatization of the films before putting them in the archive and before taking them out again.

Although the risk of demagnetization is very low, it is advisable to guarantee that the environment in which the work is placed does not have an external

static magnetic field intensity that is over 4 kA/m and the external variable magnetic field over time is not more than 800 kA/m (Deggeller and Gfeller, 2006).

Operational Practices for Film and Video Preservation and Restoration Protocols

FILM PRESERVATION AND RESTORATION PROTOCOLS

Here we propose some protocols. The first protocol originally comes from the fields of art restoration and literary philology; the second is aimed at the remediation of sound recordings. The third and fourth protocols come from the experience of preserving experimental cinema, the fifth analyzes and represents the decision-making processes applied in the field of film preservation. Finally, the last protocol proposes a system of preservation, documentation, and digital access to cinema for film archives.

The first protocol is aimed at the preservation of specific versions and single textual occurrences. It is based on the principle that every act of preservation cannot be defined without being documented. This protocol (Canosa, Farinelli, and Mazzanti, 1997) provides for the creation of a *preliminary statement*, an *intervention report*, a *diary of works* and a *final report*. Alongside the expert diagnostic investigation on the state of the materials, the *preliminary statement* includes the description and documentation of the available film and non-film materials. The reliability and authenticity will be made problematic for all non-film materials described, they will be dated and measured in relation to the weight they have in defining the decision-making process. For the film materials described, the history and relations with other materials will be reconstructed. The *intervention report* will be based on the preliminary statement, according to verifiable limits (technical, economic, political, cultural) and prearranged objectives.[23]

The intervention report should contain experimental tests and should clarify the workflow that is predicted with diagrams and detailed protocols. The *diary of works* can be considered an accurate survey, the daily notes of the differences and modifications made during the work with respect to the intentions laid out in the plan. The final report represents the testimony to the work carried out and should be published in the most suitable places.

A second example of a protocol comes from the "remediation of sound documents." In musicology, a valid protocol for a "sound signal transfer on a new recording device" must minimally describe and include the following working stages: a) choice of sample to transfer; b) restoration of the recording device; c) choice of equipment; d) adjustment to intentional alterations of the

recorded signal; e) adjustment to incorrect recording settings; and f) adjustments to involuntary alterations of the recorded signal (Canazza, and Casadei Turroni Monti, 2006).

A third protocol is a series of guidelines proposed by Jon Gartenberg for the specific treatment of experimental cinema materials, starting from the experience accumulated over the course of many preservation projects (Gartenberg, 2007). The guidelines suggested by Gartenberg are "1. Know the history of the genre [...]; 2. Establish a working collaboration [...]; 3. Focus on the artist's creative process [...]; 4. Document the version of the work preserved [...]; 5. Shadow the economic models of the commercial film industry [...]" (2007: 40-45). Gartenberg continues with a schema for the technical restoration of experimental films based on the above principles:

> 1. Assemble and study detailed documentation about the artist's career and related individual works. 2. Track down all camera originals, prints, and related production elements. 3. Perform detailed physical inspections of each individual film element. 4. Perform detailed comparisons for all elements of a given film. 5. Make preservation and access decisions consistent with the guiding principles. 6. Document in written form the preservation history of the work and the preservation decisions made (2007: 45-47).

It is useful to compare Gartenberg's proposal with the restoration project of a large collection of Dutch post-war experimental films.[24] In these materials, "Non-standard techniques were constantly used to reach particular aesthetic and visual effects and no film or copy was ever made in the same way. [...] That's why these films are also so unique and at the same time so fragile." The organizer's opinion is that many artists' work must be thought of as "a constant work in progress," to which can be added, "the almost total lack of historical documentation." It is difficult to respond unequivocally to the choice between respect for the material or the aesthetic experience, "once we accept this a whole new range of possibilities become available as long as the restoration process is well documented and the filmmakers themselves still recognize in the new products their 'artistic intention'" (Monizza, 2008).

A fifth protocol is made up of the result of a qualitative study based "on the methodology of ethnographic fieldwork." A study made by investigating the context in which film preservation takes place in the United States aimed to document decision-making processes and the "individual tasks performed by archivists, curators, catalogers, and projectionists in specific situations and explored the many difficult decisions that they must make during the course of preservation work" (Gracy, 2003:3).

Here is the general process that was documented:

> [...] preservation is a linear process involving activities, inputs, and out-puts, from the initial stage of selecting a film to the final step of providing access to it through exhibition or other means [...]: 1. Selecting a film for preservation; 2. Procuring funding and/or resources; 3. Inspecting and inventorying a film; 4. Preparing a film for laboratory work; 5. Duplicating a film at the laboratory; 6. Storing the master elements and access copies; 7. Cataloguing the master elements and access copies; 8. Providing access to the preserved film (2003: 6).

Finally, the European project EdCine (2006-2009)[25] had, as an objective, in its archiving programs "Digital Storage and Access System for Film Archives with relevance to other digital born and film originated, digitally derived content" (EdCine/Archives, 2008: 1). The architecture of the proposal consists of:

> [...] two packages, the Master Archive Package (MAP), for long-term pres-ervation, and an Intermediate Access Package (IAP) designed to make the access to the stored items [...] where the content (image, sound, texts, etc.) is stored jointly to its technical metadata [...], to ensure that the con-tent is correctly displayed when accessed (2008: 3).

EdCine proposed some requirements to respect the film (or to put it better, the cinematographic experience) in the various forms that it had over the course of a century, amongst which: "[...] 1. The resolution of the projected screen image should not be visually lower than that of the original film image [...]. 2. The frame rate of a digital cinema projection should be the same as that of the original film. 3. The aspect ratio of the image should be that of the original film [...]" (Ibid.: 4).[26]

The protocols described a swing between the treatment of single materi-als and experiences and projects of digitization and large-scale migration,[27] through the preservation of entire collections. The importance of the docu-mentation, metadata and consequently of reversibility, the innocuousness and the criticism of the operations carried out, is evident in all the experiences that are described, but it rarely becomes reality in public and editorial forms.[28] The documentation should be at the basis of the definition and choice of more complex digital storage protocols, extended to hardware and software, which the reading and transmission of data (encapsulation) depend on, and to the construction and management of digital assets. For the latter, and in general, there must be a strong presence of detailed pertinent metadata, including human readable reports.

The debate on the definitions of decision models and protocols for the preservation and restoration of the video work has been developed in Europe and the United States since the beginning of the 1990s. The first publications make up a technical guide for archiving, care and preservation of analogue devices.

Over the course of the 1990s and at the start of this century, coinciding with the development of a series of projects on the preserving migration of video materials kept in museums,[29] some manuals that define the practical outline for a technique of treatment, regeneration of the chemical-physical characteristics and the digitization of the video signal were published.[30] The procedure described in these manuals can be synthesized in a process that has five phases: 1) *cataloguing, examination and documentation*; 2) *tape preparation*; 3) *remastering*; 4) *documentation of remastering and preparation*; 5) *keeping the original material and new masters safe*.

The first phase is the inventory, the collection of metadata and the photographic documentation of all the materials. There must be a check and documentation of the state of conservation for all the devices (Wheeler, 2002: 3). The modality for the inspection of materials for the diagnostic means of a single device or an entire collection are as set out above, under "Guide to the Diagnosis of Physical, Chemical, and Mechanical Decay Syndromes of Video Materials".

The tape documentation phase is followed by planning for interventions on materials for restoring the functionality of reading and digital acquisition (Hones, 2002).

The most common modalities for the preparation of tapes are the practices of *baking* and *cleaning*. The baking of tapes allows for the temporary readability of tapes affected by hydrolysis of the binder. They are put in a ventilated oven (see Rarey, 1995) at a constant temperature of 50°C for a minimum of eight hours.[31] This procedure temporarily restores[32] the consistency of the binder on the surface of the tape, therefore allowing the tape to pass through the reading mechanism without losing the magnetic paste. This is a controversial procedure, some conservers maintain that baking is too invasive and, in the long run, damages the tape.[33]

Cleaning is used to eliminate dust and biological contamination from the surface of the tape. As with baking, there are different conclusions on the effectiveness and the long-term consequences regarding the techniques used. The most common technique, known as *dry cleaning*, involves putting the surface of the tape under pressure, in contact with a dry cloth. This technique is the opposite of *wet cleaning*, which involves the addition of chemical agents to the cleaning. The latter practice is more effective than the former; however,

the long-term consequences of the chemical stability of the device are still being debated.[34]

The remastering stage includes the reading of the tapes, the stabilization of the signal and the digital acquisition of the signal (see Fig. 8.7 in color section). The main differences in this stage of the technical protocol regard format and the destination hardware of the new digital master. The digital signal's conservation format has to include all the information from the starting signal and has to have compensated for the possible alterations introduced by the system of reversing. The conservation copy is then divided based on the use of material preserved in terms of the access copy.[35]

During the preparation and remastering stage, the parallel process of documenting the interventions that have been carried out is introduced, allowing the recording of material history. At the end of the preservation process, the originals and the new digital masters are made safe and archived in ideal climatic conditions (see above, under "Guide to the Care, Handling, and Storage of Video Materials").

Despite the highlighted differences, the technical protocol that has just been mentioned represents a shared base of the main experiences of video art preservation gained over the last twenty years. This workflow does not however take into account the issues relating to the conservation of the aesthetic and historic designs of the work, which is subject to preservation. For this reason, alongside the study of operational practices aimed at preserving migration of the signal contained in obsolete devices, museums and research centers proposed decision models and action protocols aimed at verifying the effectiveness of the preservation procedures in relation to the transmission of works' aesthetic historic and cultural values.

A common reference point in the definition of the methodology of the intervention is the decision model outlined by the Foundation for the Conservation of Contemporary Art in Amsterdam, aimed at describing and regulating the process through which decisions are made, about the restoration and conservation of contemporary art.[36] The conventions and preservation trials that followed investigated and analyzed the critical points that emerged from the Dutch model, referring them to time based works. The main methodological points that have largely polarized the scientific debate on the preservation of time based works are the definition of acceptable alterations, the role of stakeholders in the preservation process and the replacement/emulation of the work's original components. The theoretical deepening and the completion of experimental preservation projects led to the production and testing of intervention models, working diagrams and instructions for interviewing artists.[37]

A comparative analysis of different experiences of video art preservation

highlights divergent methodological and protocol choices that are sometimes contrasting, in relation to issues such as the choice of the version to preserve, the involvement of stakeholders, the evaluation of the alterations definable as damage and acceptable corrective interventions. In comparing the preservation experience carried out by ZKM in Karlsruhe (Frieling and Herzongerath, 2006), the Netherlands Media Art Institute (Coelho and Wijers, 2003), and the *Laboratori La Camera Ottica* and CREA at the University of Udine,[38] important differences emerge, in the adopted decision model and the program of intervention in relation to the afore-mentioned points. If on one hand such divergences in action can result from a heterogeneity in the preservation objectives and the conditions of material, on the other hand it is clear that much of the methodological discordance is attributable to the lack of a shared model for intervention and documentation.

8.2 OPERATIONAL PRACTICES FOR A DIGITAL PRESERVATION AND RESTORATION PROTOCOL

Jürgen Enge and Tabea Lurk

The search for adequate preservation and restoration protocols that are capable of fulfilling the specific requirements for the conservation of complex digital cultural goods has revealed an ambivalence that is characteristic of the current situation in the conservation and restoration of computer-based art forms. On the one hand, documentation has assumed an increasingly important role in preserving art – not least because the objects, at the time of being recorded, seem so fleeting and fragile that a permanent preservation or access to them becomes difficult or almost impossible; many objects, moreover, assume different (physical) forms of appearance.[39] On the other hand, the objects themselves seem to resist this effort as it is sometimes not clear on which system of reference the documentation should rely. Finally, conservators – most of whom have not received a basic education in computer science – are nevertheless expected to analyze information objects in a technically sustainable way. Among other things one result is that very heterogeneous formats of documentation exists which cover just certain aspects and are often hardly compatible to each other.

Richard Rinehart, for example, presented a comprehensive "System of Formal Notation for Scoring Works of Digital and Variable Media Art" in 2004, based on the Extensible Markup Language (XML) and containing a "Survey of Related Work" (2004 and 2008). Metaphorically speaking, the system he proposes takes the metadata as its starting point; the question of how the relevant information is retrieved in the first place is, naturally, not touched on. By contrast, an outline of this latter approach is contained in the guidelines for the documentation of networks such as DOCAM, INCCA, Virtual Platform, and the Inside Installations Project as well as the guidelines for the acquisition of the Matters in Media Art Project; these, however, can only identify the relevant data up to a certain depth, and anything that lies beyond this point constitutes a gray zone.[40]

We greatly appreciate the different approaches and try to combine certain aspects. In the text that follows, we wish to introduce the concept of "work logic". This concept proposes to transfer the parameters of the classical, material based documentation in conservation science to the semantics of digital artworks. From these parameters, we develop a methodological procedure that has been tested on complex digital objects (artworks). We conclude with some practical routines that are suitable for the conservation and restoration of computer-based art forms.

Work Logic and the Structure of Complex Digital Objects

Since the late 1980s, we have seen a host of very different artworks and artistic applications whose visible appearance is calculated in real time by a computer. Based on digital instructions (algorithms), the system generates certain audiovisual or haptic effects that are embedded within a larger artistic concept and are either self-contained or "open" to the outside (Lurk, 2009b). In the latter case, artists may, for instance, start live meta-queries of web services such as Google, Flickr, Wikipedia and many other portals, and then display them as parts of an artwork (Lurk, 2010).

With their manifold appearance, many such digital artworks correspond to the definition of complex digital artworks. According to this definition, a digital object is complex if a) there is no simple description of its technical file format, its display or its reproduction, or if b) the object is dynamic, that is, it includes interactive components or embedded programming.

What makes these artworks so specific in their essence, then, is that software components are fundamental to what they are and therefore are essential for ensuring their authenticity. In the past, conservators approached the problem of preservation by focusing on a machine's casing, and often redundantly bought and stored reproduction devices in large quantities.[41] In the long run, however, a sustainable preservation policy requires an understanding of information technology. To this end, the concept of work logic was developed; this proposes to identify and classify the computer-based elements of an artwork in all their complexity, and to document how they connect to other system components.

The concept of work logic does not conceive of the artwork as a self-contained entity but instead distinguishes between, on the one hand, its "core" which constitutes its essence, and, on the other hand, aspects of its appearance, its artistic concept, and its historical context (see Fig. 8.8). All four areas contain definitions of significant properties that are key to preserving an artwork's authenticity and thus providing us with a differentiated and hierarchical picture (Laurenson, 2006).

In other words, the concept of work logic encompasses those (digital) components of an artwork that constitute its authenticity while distinguishing between core components and the hierarchically ordered work-relevant components. As can be seen from the system for the graphical classification of the components (see Fig. 8.9 as well as the case study at the end of this chapter), we develop a layered model that begins with the core and indicates a decreasing relevance as it moves to the periphery. A decrease in relevance means that a stabilization measure may become more invasive (such as when updating the operating system).

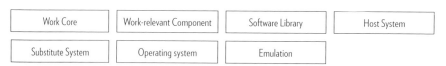

8.8
Graphic visualization of the four areas of work logic (by Tabea Lurk)

The discussion of possible changes should follow the standards of conservation and restoration (American Institute for Conservation of Historic and Artistic Works, 2009). Generally, one must ask whether the conservation strategy is one of fluid actualization (migration) or one of freezing the work in its current state – known as the "enclosing encapsulation" approach (virtualization/emulation) – and why one approach is preferable to the other. While fluent actualizations by migration seem less invasive in the short run (but may lead to significant changes in the long run), the enclosing encapsulation approach means that the adjustments that go along with stabilizing the work will stagnate as soon as the first preservation action has taken place. The latter method thus centralizes the preservation of the artwork's historical integrity. It is important to document and evaluate every preservation action in a transparent and detailed fashion.

The concept of work logic registers "hard facts" (in the sense of the technological facticity of the artwork) as well as "soft facts", in terms of the artwork's meaning. The meaning of an artwork triggers the preservation strategy and should be adjusted to the artist's intention and the specific environment

Work Core	Work-relevant Component	Software Library	Host System
Substitute System	Operating system	Emulation	

8.9
Schema for the classification of digital work components (by Jürgen Enge)

in which he conceived of his work. [42] Thus, it is important to evaluate the relevance of the technologies that were used. Furthermore, the work logic schema (Fig. 8.8) differentiates between the individual artist's intention and the more general historical context which the artist reflects on in one way or another (in the guise of the "Zeitgeist"). [43] It is also subject to very general historical conditions (Klütsch, 2007; Krameritsch, 2007; Lurk, 2009a).

From the Work Logic to a Structure of Documentation

The work logic principle does not only identify an artwork's (core) components. It can also be applied to the structure of conservational documentation, consisting of the identification and description of the object (semantically and in terms of cultural history), a documentation of examination (detailing the present state of the object), a treatment plan (generally including a specific risk management plan) and a documentation of treatment which fully and transparently documents all preservation measures (Falcão, 2010). Finally, where possible, handouts with information about further treatment are recommended; these should also provide information about monitoring routines.

A model for documentation that is based on these aspects would have the following format:

CHAPTER 0: FRONT PAGE

Title (and subtitle)
Illustration/image of the artwork (incl. caption)
Short record information:

Title	
Artist	
Year	
Type	Interactive, computer-based installation
Owner	Including version, e.g., (#1/5)
Preservation period	
Documentation date	
Author(s)	
Achievements	E.g., migration to virtual machine and stabilization of hardware (camera) interface

Summary: This brief summary (ca. 500 characters) identifies the object and the purpose of documenting it.

Table of Contents

CHAPTER 1: DESCRIPTION OF THE ARTWORK/INSTALLATION

Description: A semantic description of the artwork's external features.

Historical context: The historical context provides information about the meaning of the artwork; it may also include autobiographical information about the artist and about related works, either by the same artist or by other artists using the same technology.

Form and structure: A technical description that includes specific information about the type/genre, behavior, and handling (installation) and further elements regarding the participation by viewers.

Materials used and techniques employed: A description of technological components, including applications, software modules, and libraries that are needed for all kinds of technological interfaces and for the internal communication with the operating system.

Preservation history: If possible/accessible, provide information about earlier restoration measures or other changes made to the artwork (including modifications by the artist).

CHAPTER 2: IDENTIFICATION OF THE ARTWORK'S COMPONENTS

The following analysis identifies the components of an artwork or installation in detail. This type of object identification usually takes place during the object analysis as soon as more precise information (regarding, for example, the software components) becomes available.

Title	
Subtitle	
Acronym	
Date	
Artist	
Programming	
Concept/text	
Material/technology	E.g., computer, camera, beamer, software
Type/genre	E.g., interactive, software-based installation
Resolution/aspect ratio	E.g., 1024x768px/4:3 Or comments like: "Installation box is not exactly specified."
Components	Files delivered by the artist/addressed by the application, including software libraries Work-relevant components, such as the grabber Details can be specified below
Client-side software	Operating system (OS) information, further details can be specified below
Reproduction software	Media player if required/other tools required for display
Signature	
Remarks	Such as: "The artwork was part of the media production for Expo 2000."
Number of versions	
Further versions/editions	
References	E.g., the artist's website
Owner	Including number/edition index, e.g., (#1/5)
Inventory number	
Client/corperation	
License	

CHAPTER 3: DOCUMENTATION OF THE CURRENT STATE

The documentation of an artwork's current state lists all its relevant components. It identifies the significance of both the work's core and the work's relevant components, and explains the relation of the core software to the systemic environment as well as the communication with the hardware. This form of recording thus also provides curators with a first idea of the artwork's proneness to errors and identifies, within a risk management framework, those elements requiring stabilization.

Hardware

Even in cases where the artist did not provide any information about the hardware (because it can be replaced or otherwise procured by the museum), it nevertheless makes sense to roughly specify the requirements. Relevant information includes:

– Information regarding the operating system; these could be as vague as "Linux-compatible personal computer"
– Information regarding the graphics card, e.g., Open GL-compatible graphics card
– External interfaces: e.g., video input/camera; video output/beamer; intersections for audio devices or for homemade interfaces, etc. It is absolutely necessary to specify the latter's command structure (plug-in position, etc.).

Generally, the more specific the information, the easier it is to preserve the object and ensure its authenticity.

Operating system

Describe the version of the current operating system (OS). If possible, note the first OS to have ever been used for the artwork's application (first installation). This is important with regard to the technical context and the genesis/development of the artwork.

Work files[44]

It is important to document in detail the list of all available work files and all further data and information that were provided by the artist. The following information must be recorded: title/file name; specification of the software type used and its corresponding function; exchangeable/related software or hardware components; remarks about the license under which the work was produced; if possible, identify all possible alternative software tools/components that, for example, may have been used in earlier versions.

Explicit dependencies

This is a very important area in which dependencies that exist within the artwork are classified. We distinguish between explicit dependencies resulting from, for example, a specific hardware or software or the addressing of web services (for net art), and implicit dependencies.

Implicit dependencies

These frequently result from conceptual decisions or from chain of events within a program's process structure.

CHAPTER 4: CONSERVATION CONCEPT AND RISK MANAGEMENT

The conservation concept is based on a precise analysis of the work's core and of its individual components.[45] It discusses possible stabilization measures and weighs the necessity of conservational and restoration measures (see Hummelen and Sillé (1999); Kucsma (2008); Lauterbach (2010); Wijers (2010); Thibodeau (2002)). Frequently, there will be several options, and it is necessary to distinguish between the best possible and the minimally necessary options.

Because digital works of art allow for several approaches, and because the measures are often not performed on master files but on working copies (cf. the process definition given below), we may consider several parallel approaches.

Please note that a risk assessment must be carried out individually for all components mentioned above. Furthermore, a final comprehensive risk analysis is necessary. Contrary to the default risk, as was already determined for the individual components, here the interaction of the different components comes into focus. In this way, it is possible to weigh priorities and gauge future procedures as well as possible contingencies.

In order to ensure that a "return to 0/initial state" is possible at all times, backup copies must be stored in a safe location and remain untouched. Please note: one only ever works with the copy, never with the "original" artwork, which is stored in an "audit-proof" filing system. An audit-proof filing system ensures that an object will not be altered or lost once it has been stored in the archive (see below).

CHAPTER 5: DOCUMENTATION OF TREATMENT

The documentation must transparently record every intervention and operation. Here, it makes sense to use the structural analysis of the work that was developed as part of the conservation concept and often results in a graphical representation, and to add a list of the measures performed. Another important feature of digital objects is that they lend themselves to the possibility of a primary documentation, that is, documentation of the (original) object on the code level. This must be done by an expert who is proficient in programming in order to avoid irreparable damage to the object. Because of the possibility of "out-commenting" certain areas of a software, changes can be inserted right next to the original code and labeled accordingly. This double structure of the old code and the stabilized version can be rearranged as necessary so that either the original or the updated version of the artwork is used.

CHAPTER 6: RECOMMENDATIONS FOR FURTHER TREATMENT

The subsequent treatment identifies the artwork's weak spots and its fragility as well as the monitoring routines.

APPENDIX WITH REFERENCES

References may include detailed information and analysis protocols, the artist's biography, a bibliography, an exhibition history, correspondence, and additional professional literature.

Organization and Planning

The steps sketched above can be combined to form a relatively simple working model whose handling relies on the established OAIS model (Open Archival Information System). OAIS uses the term SIP (submission information package) to refer to archival material that, having been submitted to the owner, museum, or archive, must be inventoried or enhanced with specific metadata to create an archive master (International Organization for Standardization, 2012). Similarly, digital conservation produces a master copy only when the object is first recorded; this is then stored, preferably in an audit-proof filing system, as an archival information package (AIP). Audit-proof filing is a technical term that describes the most secure and reliable form of archiving documents.[46] Working copies and master copies that are produced at later stages are stored in the archive either before changes are made, or as soon as a condition has been achieved in which the object is worthy of documentation or preservation.

In order to be able to distinguish at all times between the source (original), the backup and working copies, and the object currently in use (the dissemination information package, or DIP), we recommend archiving/storing the digital masters and DIPs, together with the documentation, in an audit-proof

8.10
Schema of the documentation procedure (by Tabea Lurk)

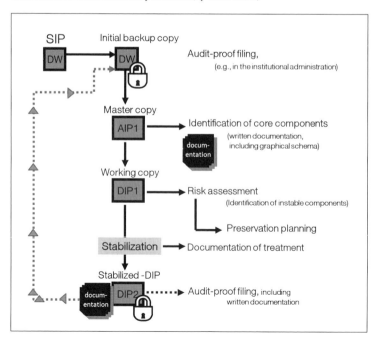

archive; for example, in the institution's administration department. As most damages are the result of negligent handling, this makes the whole procedure more reliable.

The procedure, then, is as follows: after the initial backup of all digital files/data carriers (hard drive of the main computer, all CDs/DVDs/floppy disks/other hard drives/flashcards, etc.), *two* copies are made: one copy, as the archive master, the other becomes the working copy which is used for identifying the core components.[47] This backup procedure should not be performed on the original, nor on the initial backup. If possible, the initial backup should be made without connecting the computer to a power supply or letting it boot automatically.[48]

The next step is the analysis of the computer system, that is, the location of the artwork in its technological environment. If the artist does not provide information about the artwork's core components (for example, in the form of a backup copy), the analysis can be conducted by means of the exclusion principle. This means looking for those components that differ from an equivalent "empty" basic installation.

As soon as the relevant hard- and software (interfaces) have been identified, a risk assessment must be made in order to identify unstable components. We recommend a prioritization beginning with the most fragile components (for example, hardware obsolescence -> software interface -> system libraries, etc.)

The next step is providing an executable working copy (AIP1). After that, the original can be booted and compared to the working copy. This is followed by stabilization measures and the establishment of monitoring routines.

In the monitoring process, all components are checked for functionality; it is also necessary to assess whether the risk of possible damage has changed in the meantime. In the above image (Fig. 8.10), the loop arrow on the left represents the repetition of the process each time something has changed.[49]

Case Study: *Liquid Perceptron*

The following excerpt of a conservation file applies to the above schema for the stabilization of an artwork and an artistic working tool.[50]

Description: *Liquid Perceptron* (2000) is an interactive computer-based installation by Hans Diebner, which simulates a dynamic, neural network. The neural cells are represented by pixels in a two-dimensional field, which displays an image of the user on a screen. The cells are stimulated by the user's movements and trigger wavelike structures/movements, thus irritating the simple video image (feedback) (see Fig. 8.11 in color section).

Form and structure of the artwork: *Liquid Perceptron* analyzes data from a video source and generates a real-time image from it. This is projected onto the wall as a full-screen projection. The only specific installation instruction by the artists is to fill the entire wall (see Fig. 8.12 in color section).

Materials and Techniques Applied: Because of the scientific character of the simulation, the source code, consisting of a looped differential equation (LiqPerFastClean.cc), was identified as the artwork's core.[51] The artwork is based on a Linux platform; the external hardware (camera, beamer) can be replaced without interfering with its meaning.

The following comparison of the original structure and the stabilized structure of the artwork summarizes the graphical schemas that were described in detail in the complete documentation file.[52]

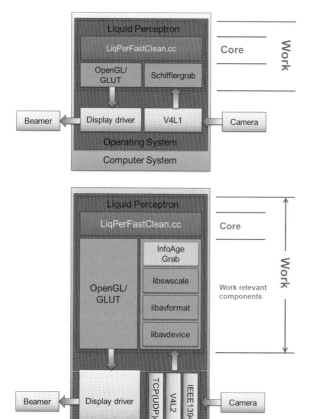

8.13
Work logic of *Liquid Perceptron*; the top diagram depicts the initial state, while the bottom diagram illustrates the stabilized version (by Jürgen Enge, 2010).

As can be seen from the comparative schema of the work's architecture in Fig. 8.13 (top: initial state, bottom: present state), the V4L1 (video for Linux 1) function was replaced by the current version of the same library (V4L2). This supports the usage of different video camera interfaces like Firewire (IEEE1394) and TCP/IP camera signals. In order to feed the video signal into the work core (LiqPerFastClean.cc), a new video grabber subsystem was implemented. This communicates with the V4L2 module and is based on a C++ class library. Open source components for grabbing video signals from various devices and for the decoding of the raw image frames are conducive to sustainability.

Conclusion

Preserving computer-based art is no trivial matter, and requires a methodological approach and transparent documentation. Where these requirements | 281 are met, artworks can be preserved for the future in a careful and sustainable manner. Thus digital conservation relies less on craftsmanship or on electrotechnical engineering than on an understanding of mathematics and logic which emerges at the interface of informatics and the humanities. In accordance with the standards established in 1994 by UNESCO's Nara Conference, this approach enables minimally invasive stabilization measures and avoids the inadvertent creation of dimension-reducing documentation.[53]

For this reason, artists should be asked for the source codes of the artworks that are to be preserved as soon as they are acquired; otherwise, seemingly simple applications may quickly present significant conservational challenges. Aside from accessing the source code, a work-specific analysis and a listing of the components means, metaphorically speaking, looking behind the screen's surface. A careful approach to the preservation of artworks, however, also implies the possibility of working in parallel and of employing alternative procedures and, in this respect, differs from classical conservation. The above account has detailed the conditions that are necessary for this approach to be successful.

8.3 CASE STUDY: THE CONSERVATION OF MEDIA ART AT TATE

An interview with Pip Laurenson (Head of Time-based Media Conservation at Tate[54]) by Julia Noordegraaf[55]

Tate's collection of time-based media art currently consists of approximately 350 works,[56] the majority of which have been collected from the 1990s onwards. Most of these works are artist's installations rather than single-channel pieces.[57] Tate is actively collecting and acquires about 50 time-based media works a year, which averages out at about one a week. The first permanent post for time-based media conservation at Tate was established in 1996; this grew to become a dedicated conservation section in 2004. Time-based media conservation is part of the Collection Care Division, and is responsible for the conservation of all works in the collection, for registration, art handling, photography and Tate's library and archive.[58] Tate's Conservation Department is divided into conservation sections for paintings and frames, sculpture, paper, time-based media, and conservation science. The guiding principle underpinning conservation at Tate is the idea that all works in the collection should receive the same standard of care regardless of medium. Within a contemporary art collection, this drives innovation to find solutions to challenges presented by new materials and new forms of artistic practice.

There are currently three time-based media conservators at Tate and one conservation technician. The conservators divide their time between work related to acquisitions, exhibitions and displays, loans, and collection care. Whilst the point of acquisition is critical for all works entering the collection, it is perhaps particularly so for time-based media works of art. One could say that at this point a work is prepared for its future life in the collection. When a work is acquired, information is gathered that will guide its care and display. Copies of the media elements are made in different formats for access, display, and archival purposes and information from the artist and their representatives is gathered which helps to establish what it is that is important to preserve. Conservators also consider any equipment needed to display the work and its significance for the meaning and identity of the work in order to determine its status and whether spares should be acquired. Tate's conservation department hold detailed information in the conservation files but core collection management data related to each component is also held on the collection management system. The cycle of display is invaluable for time-based media works of art as it provides moments of close engagement, and re-engagement, with the work. Many of these works are installed slightly differently each time they are displayed – perhaps because of technological changes or changes in

response to a space. For each display, conservators work with those involved in the exhibition, often the artist as well as the curator, to provide detailed floor plans and specifications. The conservation of time-based media installations goes beyond the care of the material components to also consider how best to preserve the performative aspects of the work which are only fully realized when it is installed. A proactive approach to the conservation of time-based media works of art is essential to their care. So in addition to the reactive work of responding to the loan, acquisition, and display programs, conservation has a structured stream of activity that maintains maintenance and migration schedules for the range of works in their care. This includes migrating video onto new stock and new formats, preparing items for cold storage, monitoring vulnerable software-based works, and managing the potential impact of and increased rarity of equipment.[59]

Laurenson trained as an object conservator at the City & Guilds of London Art School with a specialization in the conservation of polychrome, wood, and stone objects. She came to Tate as a sculpture conservator under a Henry Moore Foundation internship in 1992. During the period of her internship, Tate acquired Bruce Nauman's *Violent Incident* (1986). Tate's acquisition procedures for works of other media being accessioned into the collection were already highly developed, however, when working on this piece she realized there was little established to guide the acquisition of time-based media artworks. With a travel scholarship from the Gabo Trust she visited museums and artists who were working with time-based media to explore possible strategies for their conservation. Laurenson indicates that during this time she learned a great deal from the artist Bill Viola, who is deeply concerned about the preservation of his work and was supportive in helping her to understand what needed to be established at Tate. Laurenson's appointment as a conservator of time-based media coincided with the moment the collection of time-based media started to rapidly grow. She gradually developed a conceptual framework within which she could operate, particularly around the challenges of preserving installations (see, amongst others, Laurenson, 1999, 2004, and 2006). Inspired by Jonathan Ashley-Smith's book *Risk Assessment for Object Conservation* (1999) she developed an approach for assessing the most significant risks for time-based media works, for example, the risks posed by the failure and obsolescence of particular technologies, within the context of a work specific analysis to understand where value and meaning lies.

Where Time-Based Media Conservation Is Different: A Need to Think Ahead

In Laurenson's view, the practice of conserving time-based media works is firmly embedded in the wider practice of fine arts conservation. She indicates that in the context of contemporary art museums, conservators often act as brokers between a number of different people and activities as part of the team that facilitates various events, from acquisitions and loans to exhibitions and displays. The nature of time-based media does however impose a slightly different focus for conservation; where the traditional emphasis might be on technical skill associated with treatment, the focus of time-based media conservation is on understanding what is important to preserve both in terms of the tangible and the intangible from the moment of acquisition. As Laurenson indicates, the conservation of time-based media works entails a need to be pre-emptive because ensuring that a work is displayable in the future requires action to be taken as early as possible in the life of a work. Whereas for other types of art 'benign neglect' might not be immediately problematic, in the case of time-based media works this is not an option. Collecting detailed documentation on the concept, significance, production, display, and experience of the work is of crucial importance in order to be able to preserve and exhibit it in the future.

Conservators at Tate are deeply involved in the *collection* process. The curators identify and select key works, write interpretative texts indicating the importance of the works in the context of the collection, and work closely with the artist and the gallery on the details of the acquisition. However, it is the conservators and registrars who are charged with the responsibility of how practically to bring the works into the collection to enable them to begin their life in the museum, ensuring that the museum has what is needed to keep them displayable. Tate is a demanding environment for display, for example at Tate Modern time-based media works need to be fully operational for 70 hours per week.

When a time-based media work is considered for Tate's collection an assessment is made to establish clearly what it is that is being acquired, what is important to the conservation of that work and how it was made. Often, this is the first time artists are asked these detailed questions, especially if it concerns works from the 1960s or 1970s that were not made for the art market or museum system. Established artists, such as Bill Viola or Gary Hill, have large studios that support their practice and can provide detailed instructions about their installation. In other cases works may be more "thinly specified" (Laurenson 2006) and the artist may be less concerned with the production of the complete and tightly defined works. In other cases a work might be

acquired early in its life and the technical details may not be fully resolved. This was the case with the acquisition of Carlos Garaicoa's *Letter to the Censors* (2003), a sculptural installation consisting of a scale model of a fictional Cuban cinema theater in which a montage of the opening credits of censored films is screened (see Fig. 8.14 in color section). There were some practical problems with elements of the work overheating, presenting the potential risk of damage to the model. In addition, in order to see the work in all its detail it is necessary to get so close that the very act of viewing creates risks of damage, especially at Tate Modern where visitor numbers exceed five million a year. In this case, conservators and conservation technicians worked closely with the artist to resolve any outstanding issues, coming up with solutions to various practical problems, such as designing a special crate for the model and determining various conditions for the display of the work.[60]

As Laurenson indicates, in cases like this a time-based media conservator should adopt a more process-oriented model of documentation, whereby the museum stays in dialogue with the artist in understanding how the work may evolve over time while still remaining true to its conceptual core.[61] This balance, between allowing for evolution while still paying attention to the integrity of the work, is a core challenge in the contemporary practice of time-based media conservation.

| 285

The Conservator as Broker: Collaborating with Artists

Laurenson acknowledges that for many artists understanding the role of museum staff, in particular conservators can be difficult; specifically in the delineation of roles between the conservator and the artist or studio when dealing with works which are not fully technically resolved. She rejects the sometimes voiced opinion that these ways of working appear to reposition the conservator as co-author of an artwork.[62] In Laurenson's view, conservators are working in a professional context, acting as brokers between the artist and the museum in order to facilitate certain technical aspects of integrating works into the collection when a work is first acquired. In this context, she sees the role of the conservator as a facilitator and the conservation of time-based works as a process where decisions are based on a dialogue between the artist and the museum staff.[63]

As Laurenson indicates, exhibition plays an important role in the conservation of time-based media. The first installation of a new work in a museum exhibition may be the first time the artist experiences the work as fully installed. In fact, the exhibition of the work is the only moment it really exists as a whole: the synergy between sound, image, and environment that charac-

terizes a work in its installed form disappears when the work is dismantled and stored.[64] Although the inaugural exhibition may be an important point of reference for later exhibitions and for conservation decisions, a work may also evolve either to a fixed form or to an identity that is more fluid. Because of the link to the performative in the display of works as installed events in the gallery, the concept of the "original" that is so prevalent in traditional conservation does not operate in the same way for time-based media works. Tracking the different iterations of a work – its manifestation in exhibitions at different places and moments in time – provides a frame of reference for future conservation and display decisions (see also Jones and Muller, 2008). During the lifetime of the artist, he or she is one of the major stakeholders in decisions about conservation and display. Once the artist is no longer around, one can use this frame of reference to "intelligently install the work," as Laurenson describes it.

Challenges in the Preservation of Time-based Media Works

Time-based media conservators are currently caught between two equally urgent priorities: dealing with older technologies and issues around obsolescence, and addressing new challenges presented by software-based art. Despite the urgency of the questions raised, it remains difficult to secure research funding to develop sustainable solutions to these challenges.

With regard to the management of older technologies used in the production and display of time-based media works of art in Tate's collection, the disappearance of the knowledge on how to handle that technology is perhaps as great a challenge as the obsolescence of the technology itself (see also Laurenson 2010). A particularly apt example is the collection of works based on 35mm slides. These works are a cause of concern, especially since in the summer of 2010 Kodak announced the discontinuation of the production of Ektachrome 35mm slide duplication stock and can offer no replacement for this product. This is a good example of the fact that the preservation of technology-based works is often at odds with developments in a commercially driven industry.

Laurenson indicates that, as with all time-based media works, a first step is to establish the role, significance and function of the technology in the artwork. In the case of works based on 35mm slides, some artists have used this technology because at the time it was the most easily available material for their purposes. For these works the artist may be open to replacing the analogue 35mm slides with digital projections. Whilst a shift to digital technology might represent the loss of a link to a particular time and the role and status of 35mm slide technology at that time, and also a significant change

in the look and feel of the work, the museum might value these links to the original technology more highly than the artist. Other artists, however, value the analogue photographic material for its specific characteristics, such as a very high level of detail and a particularly rich rendition of color. A 35mm slide creates an image by light passing through the transparency. This creates a still image very unlike an image generated electronically; an electronic image is a constantly changing scan, trace, or pulse of light and is therefore never truly still. Tape slide technology is, for example, central to the practice of the artist James Coleman. In her extraordinary essay "...And Then Turn Away?" Rosalind Krauss explores the way in which Coleman has taken tape slide "from a commercial world of advertising or promotion and imported it into an aesthetic context" not simply adopting this as a novel support but, she argues, inventing a medium (Krauss 1997: 8). Structurally, the works of Coleman are dominated not only by the luminous quality of slides as large projected images that slowly dissolve and change: the medium and apparatus of tape slide is also significant in the circularity of the carousel, the choreographed rhythm of the images as they are repeated, and the way in which the voice-over works, or works against, the images. In this case, therefore, the relationship of the medium to the work of this artist is far from incidental or trivial.

Tina Weidner, a time-based media conservator at Tate, has invested a great deal of time and attention acquiring in-depth knowledge about the duplication of analogue slides, understanding all the parameters of working with sets of old slide stock and collaborating with labs. Slide-based installations require a large number of duplicates to be produced whilst the work is on display as the process of being projected causes the images to fade. Therefore, while master images can be preserved by cold storage, duplication is still necessary to ensure the work remains displayable. In the near future, alternatives to traditional methods of slide duplication will have to be found in order to be able to continue to show slides as 35mm transparencies. This requires detailed and focused research to ensure that the aesthetic qualities of slide-based works are understood in order to fully comprehend what it is we are trying to preserve and evaluate alternative conservation strategies. As Laurenson indicates, it is extremely difficult to obtain funding for this type of research; however, Tate has recently been awarded a grant from the Esme Fairbairne Foundation to pursue this work.

New Challenges: From Analogue Film and Video to Software-based Works

Laurenson explains that, contrary to film archives which may only hold an occasional viewing of a specific film, Tate needs many prints in order to display film-based works, since 16mm film works might be on display for periods of either six or twelve months or more and the lifetime of one print is only a few weeks.[65] Usually it is not possible to obtain the negative from the artist, so Tate acquires an inter-positive, two inter-negatives and two reference prints, one from each inter-negative, as well as an artist's proof supplied by the artist as reference for the sound, color, and contrast. All of this material is created when the work is acquired and is kept in a cold-storage facility. In addition, they archive sound elements of the film as a digital file and an optical sound negative (Laurenson, 2011: 38). For the production of accurate and high-quality prints from these materials, the time-based media conservation department closely collaborates with a range of film laboratories in various locations around the world who are still able to produce 16mm film.

For their video works, Tate has established what Laurenson describes as an "orderly migration programme." As with all the works in their collection, time-based media conservators work with the artist to document the way in which the piece was originally produced. This has become increasingly important now that artists can edit their video on laptops using a wide range of different technologies and software. The acquisition process, led by the conservator Kate Jennings, therefore begins with a series of questions regarding how the work was made. From this, a decision is made as to what is the most suitable form for the work to be supplied from the artist to the museum. This is known as the "artist-supplied master": a version of the work that represents the best available master. For example it may be a DV file within a QuickTime wrapper or a digital Betacam tape. From this, Tate produces an archival master in an uncompressed video format, which is migrated every seven years (although previously this has been to D-5, a professional, uncompressed digital video format, material is currently being moved to a file-based system). Uncompressed video is more resilient than compressed video as the greater redundancy of information helps to mitigate against errors. Uncompressed video also creates less risk of errors arising should there be a change of compression algorithms in a given migration path. This archival master is preserved alongside the native format in which the artist or their gallery supplied the video.

Tate is currently moving towards preserving uncompressed video as data on servers and data-tape formats such as Linear Tape-Open (LTO). For this, they are exploring the potential of using a system that has been developed by the BBC called Ingex. Ingex is a suite of open source software applications

designed for low-cost flexible tapeless recording, both for television production and for archiving (ingex.sourceforge.net). The suitability of this system for the preservation of Tate's video collection is being explored alongside other systems such as those which are based on the use of JPEG 2000.

Besides exploring digital data storage for video, Tate is also facing the challenges of preserving and exhibiting software-based works. Matters in Media Art, a collaborative project funded by the New Art Trust between Tate, the Museum of Modern Art in New York, and the San Francisco Museum of Modern Art, is currently looking at both the requirements of a digital repository for artworks and also the specific needs of software-based art. One of Tate's time-based media conservators, Patricia Falcão, has conducted research into the preservation of software-based artworks and is integrating the results of this research into the conservation of the works in Tate's collection. At present, the museum is in the process of acquiring a work, one element of which is a website: Sandra Gamarra's website of the fictitious but highly realistic Lima Museum of Contemporary Art, LiMAC (www.li-mac.org). This is a work in process, since the artist will continue to contribute and collaborate with others to create content for the website as it evolves. Tate has formed an internal working group to address the challenges of collecting Internet artworks with staff from the Information Systems Department, working closely with conservators and registrars to identify and develop the necessary infrastructure and skills needed in order to collect this type of work. The strategy being developed for this work is to create a mirror website, for which the museum will secure the assets, code and permissions from the artist, so that if a time comes when the actual site is no longer available, the museum can use this mirror site to ensure that the work will still be accessible to the public. Such an acquisition again requires new expertise, for example an understanding of the structure of servers and the dependencies and vulnerabilities of web-based artworks.

Laurenson sees the acquisition of a work like *LiMAC* as an opportunity to find out what is involved in the display and conservation of this type of Internet-based work. At the same time, the knowledge and skills obtained from this case study feed back into the bigger picture and informs the strategies for the conservation of other similar works in the future.

The Future of the Profession: Specialization

Laurenson indicates that it is difficult to generalize regarding the knowledge and skills needed for the conservation of time-based media works. A basic requirement is a good understanding of the broader context of conservation as a profession – an understanding of the ethical principles underpinning

conservation decision making, a structured approach to assessing risk and the development of strategies for the long-term care of works of art and the documentation of decisions made in the process of conservation. Laurenson again stresses the importance of taking the long view, of understanding from the start how these works might be maintained, how they should be revisited, both during exhibition and storage.

Conservators of time-based media art are dealing with a wide range of people and technologies – the field of expertise required is very broad and extends beyond the heritage sector, into the broadcast and media industries, for example. Therefore, it is crucial that time-based media conservators are able to communicate with all kinds of specialists in many different fields, such as technicians and computer programmers. Time-based media conservation is a rapidly evolving profession; dependent on a rapidly changing technological environment and emerging artistic practice. Time-based media conservators therefore have a steep learning curve throughout their career; in learning about new technologies, responding to changes in the industries on which those technologies depend, and also in understanding new meanings that technological mediums take on and the ways in which they are harnessed and exploited by artists. Often these conservators are dealing with problems for which there is little precedent within conservation.

Finally, even within the rather young profession of time-based media conservation Laurenson observes a gradual specialization towards certain types of time-based media works, such as analogue or digital ones. At Tate, for example, Tina Weidner has developed a thorough expertise in analogue slides and film. She collaborates with a range of professionals who work with film and photography, including those who work within laboratories and in the maintenance and production of equipment. It is Laurenson's expectation that this tendency towards specialization will only expand in the near future.

NOTES

* Chapter 8.1 was jointly written by Alessandro Bordina and Simone Venturini. Together, they wrote *Introduction*; Simone Venturini wrote the sections on film materials and Alessandro Bordina wrote the sections on video materials.

1 The analytical proposals in this musicological field become useful in the area of cinematography and video, see Orcalli (2006: 17): "The study and remediation of audio documents includes both the document's internal history (that is the set of transformations of the document in the process of making and transmitting the recorded sound) and its external history (or rather the characteristics of the materials, of the systems and the technological devices that produced it and made it accessible)."

2 Compare with the "cultural history" outlined in Cherchi Usai (2001: 1027, and 2000).

3 The canonical aims of film restoration, as they are theorized and can be found in the practice, coincide with the reproduction of the state of the copy ("the unrestored film as it has come to us"), the first public screening (the opening night: the film as it was seen by its first audiences"), or other confirmed historic occurrences, the will of the author ("the film that its creator intended to make") and the adaptation to contemporary taste ("a film that keeps in mind a modern audience and the way we may see things"). In musicology the aims and approaches to sound documents are partly the same as the documentary, sociological, reconstructive, and aesthetic approaches. See, respectively, Bowser (2006: 38-39), and Orcalli, (2006). The restoration practices involve other issues relevant to ethics and documentation, since they record (and at times sacrifice) the original material according to instances generated in the present, with aims of communication. The politics of access collide with the long-term preservation practices adopted to stabilize magnetic tapes, for example, or to postpone the difficulties and *aporiae* of recovery to future stages and more advanced technology.

4 See Segre (1979: 58-64 in particular).

5 This study must always be associated with the analysis of film-related materials. A pioneering text (the first version dates back to the 1950s), which is essential in identifying the materials of early cinema and, in a more general sense, to understand the "evidential paradigm" at the basis of the method of analysis, is Brown (1990).

6 The following books can be considered useful manuals: Farinelli and Mazzanti (1994); Read and Meyer (2000); National Film Preservation Foundation (2004).

7 See the "critical analysis of materials" which is described and summarized by Farinelli and Mazzanti (1994).

8 For a broader description, in terms of history and examples of the various elements of the classes that are quickly indicated here, such as color, see chapter 7.1.

9 A quick way is by looking up the guides to the identification of video systems; some of them can be found on the web. The Videotape Identification and Assessment Guide Texas Commission on the Arts (http://www.arts.state.tx.us/video/pdf/

video.pdf), the Video Format Identification Guide (http://videopreservation. conservation-us.org/vid_id/index.html), and the database of the Video History project (http://www.experimentaltvcenter.org/history-tools, last access: 23 October 2010) are the most complete.

10 For example, a U-matic tape that was produced before the production of SP recording systems can be used with SP recording systems.

11 Different brands of tapes react in a different way to the preservation environmental conditions. For example, the Sony ½-inch tapes seem to have more problems relating to the hydrolysis of the binder and the loss of the lubricant.

12 This division is well known and used in Italy. It has been recently used again by Wallmüller (2007). It should be emphasized that in recent years American literature proposed again part of the European scientific tradition, French and Italian in particular.

13 The Image Permanence Institute describes the three categories of "environmentally induced decay" as follows: "*Biological Decay.* Biological decay includes all the living organisms that can harm media. Mould, insects, rodents, bacteria, and algae all have a strong dependence on temperature and RH […] *Chemical Decay.* Chemical decay is due to spontaneous chemical change. […] Chemical decay is a major threat to media that have color dyes and/or nitrate or acetate Decay Caused by Improper Storage […] *Mechanical Decay.* Mechanical forms of decay are related to the changes in size and shape of water-absorbing materials such as cellulosic plastic film supports or the gelatin binder in photographic materials. RH is the environmental variable that determines how much water is absorbed into collection objects" (Adelstein, 2009: 2).

14 For a definition of the errors, see Farinelli and Mazzanti (2001), and Canosa (2001). Canosa, in particular, clarified how the regime variants belong to the regime of the original, whilst the errors belong to the regime of the copy. The methodology of the audio restoration adopts similar, but not identical, subdivisions. In this field, the defects roughly correlate to the category of "involuntary alterations" that result from imperfections and distortions in the recording system or incorrect settings in the recording. The intentional alterations relate instead to the equalization phase.

15 National Fire Protection Association (1994): "Stage 1: Film has an amber discoloration with fading of the image. Faint noxious odor. Rust ring may form on inside of metal film cans. Stage 2: Emulsion becomes adhesive and the film tends to stick together during unrolling. Faint noxious odor. Stage 3: Portions of the film are soft, contain gas bubbles (nitrate honey), and emit a noxious odor. Stage 4: Entire film is soft and welded into a single mass, the surface may be covered with viscous froth, and a strong noxious odor is given off. Stage 5: Film mass degenerates partially or entirely into a shock-sensitive brownish acrid powder." See also the 2011 update of the same publication.

16 For a first approach to vinegar syndrome see Reilly (1993) and Gamma Group (2000).

17 "1. The film begins to smell like vinegar. 2. The film base begins to shrink. As the base shrinks irregularly, the film resists being laid flat. It curls and warps along both length and width. 3. The film loses flexibility. 4. The emulsion may crack and eventually flake off. 5. White powder may appear along the edges and surface of the film" (National Film Preservation Foundation, 2004: 14).

18 See the sanitary and diagnostic analysis of the Danish Film Institute's collection, published in Nissen et al. (2002).

19 See note 20, and National Film Preservation Foundation (2004: Fig. 4).

20 Nitrate ISO recommendations: maximum temperature: 36°F (2°C). RH from 20% to 30%. ISO 10356 Cinematography: storage and handling of nitrate-base motion-picture films (Geneva: International Organization for Standardization), 1996. Acetate and Polyester ISO recommendations: maximum temperature depends on maximum RH: 14°F (-10°C) maximum temperature for 50% maximum RH; 27°F (-3°C) maximum temperature for 40% maximum RH; 36°F (2°C) maximum temperature for 30% maximum RH. ISO 18911 Imaging materials, processed safety photographic films, storage practices (Geneva: International Organization for Standardization), 2000, revised by ISO 18911: 2010 (Adelstein 2009). | 293

21 The photographic activity test (PAT) is an international standard (ISO 18916: 2007) developed by the Image Permanent Institute.

22 See note 20.

23 See note 5.

24 Restoring post-war DUTCH EXPERIMENTAL films, project organized by the former Nederlands Filmmusueum, now the Eye Film Institute, and in particular by Simona Monizza in collaboration with Guy Edmonds and Daniel Meiller.

25 The EDCine – Enhanced Digital Cinema project finance by the European Commission in the 6th Framework Programme (http://www.edcine.org).

26 For an update on the state of the digital camera and digital preservation of cinema see also the recent Mazzanti (2011). See also: Digital Agenda for European Film Heritage, "Challenges of the Digital Era for Film Heritage Institutions". Http://ec.europa.eu/avpolicy/docs/library/studies/heritage/final_report_en.pdf ; International Federation of Film Archives (FIAF), Technical Commission, "Recommendation on the deposit and acquisition of D-cinema elements for long term preservation and access v. 1.0 2012.09.02". Http://www.fiafnet.org/commissions/TC%20docs/D-Cinema%20deposit%20specifications%20v1%200%202010-09-02%20final%201.pdf. Last access: 17 July 2012.

27 For example, the project *PrestoSpace* (http://prestospace.org) and *Images for the Future* (http://imagesforthefuture.com/en); *Europeana* (http://www.europeana.eu). Last access: 12 July 2011.

28 See the pioneering experiences of Eileen Bowser (2006) and several essays and

reports on single restorations at the end of the 1990s. More recently, there have been the restoration reports on *Spione* (Fritz Lang, 1928) and *A Film Johnnie* (George Nichols, 1914). The fields of historic-critical texts and the documentary hypertexts deserve a mention. See Bowser (1975), and the magazine *Cinegrafie*. See also Wilkening (2010) and "*A Film Johnnie* restoration report" at http://chaplin.bfi.org.uk/restoring/casestudy. Last access: 12 July 2011. For the documentation of restoration practices, see also important works such as Canosa, Farinelli, and Mazzanti (1997) and Kromer (2010).

29 In 1991 Jim Linder coordinated the intervention of video art sources recovery for the Andy Warhol Foundation; the following year the Netherlands Media Art Institute/Montevideo, within a conservation project for the modern art of the Deltaplan Culture Conservation, started reformatting, for preservation purposes some tapes belonging to the Dutch institute; in 1996, Video Data Bank finished the preservation of 65 titles from the Castelli-Sonnabend collection.

30 One of the first conferences to propose a debate on the need for video art preservation, called the Symposium on Video Preservation, was organized by the Media Alliance at the Museum of Modern Art in New York in 1991. See Boyle (1993). Various other technical manuals followed this text by Boyle, see Miller Hocking and Jimenez (2000), Hones (2002), and Wheeler (2002).

31 Tapes that are particularly affected by hydrolysis can require more time; checking the weight before and after baking will show the quantity of water that has evaporated in the process.

32 The effectiveness of baking is limited to a few days, after which the effects of the procedure are nil.

33 Alternative treatments have been proposed by: Marie O'Connell (using an isopropyl drip), see http://richardhess.com/notes/2006/03/09/wet-playing-of-reel-tapes-with-loss-of-lubricant-a-guest-article-by-marie-oconnell. Last access: 23 October 2011; Roger Nichols (using the tape vacuum system), see http://rnmastering.com/VacuumPack.html. Last access: 23 October 2011; and Kromer (2008).

34 For a risk benefit analysis of wet/dry cleaning, see Boyle (1993: 24).

35 For a first approach to the correct conservation format and instruments, see Wheeler (2008).

36 "The various conservation and/or restoration options are considered within a framework of risks, meaning and limitations. In this way, technical possibilities might yield to ethical or economic considerations, or a treatment might be abandoned in the light of ideological priorities," Foundation for the Conservation of Modern Art (2005: 168).

37 See the models of intervention proposed in the following European experiences: Inside Installations. Preservation and Presentation of Installation Art (2004-2007) coordinated by the Netherlands Institute for Cultural Heritage (http://www.inside-installations.org/project/detail.php?r_id=643&ct=introduction, see also

Scholte and Wharton, 2011); the Media Art Resource Website created by Electronic Art Intermix in collaboration with Independent Media Arts Preservation (IMAP) (http://www.eai.org/resourceguide/preservation.html); and the Variable Media Network coordinated by Jon Ippolito and Alain Depocais (http://www.variablemedia.net/). Last access: 23 November 2010.

38 Compare the preservation and restoration experiences carried out by La Camera Ottica laboratories and CREA at the University of Udine on video sources of the Venice Biennale (2004-2011); by the Videobase group (2009-2011); and on the video archive *Anna* by Alberto Grifi (2011) documented in Saba (2007 and 2009).

39 Some authors have suggested supplementing text- and image-based documentation with videographic or even computer- and net-based documentation. See, for example, V2_ (2007), Wijers (2007). Others examine more methodological aspects, like Cramer (2002), Lavoie (2004), Van Saaze (2009), Obermann (2009), Dekker (2010).

40 See, for example, Inside Installations (2007), International Network for the Conservation of Contemporary Art (2008), Documentation and Conservation of the Media Arts Heritage (2009). A clear account of the preservation procedures can be found in Lee et al. (2002).

41 Until now, by contrast, the software components of computer-based artworks are often copied to equivalent hardware via cloning; these procedures and transformation processes resemble an (unreflected) black box procedure. However, if the reproduction hardware plays a crucial role, such as in Cory Arcangel's famous *Nintendo Game Cartridge Hacks* that was created in the 1970s and 1980s with obsolete hardware, this then constitutes the artwork's core.

42 While some artists consistently work with the most recent tools available, others make a point of deliberately using obsolete software because, for example, they may wish to critically question the immense speed of technological development.

43 See, for example, the different issues of the *Journal on Computing and Cultural Heritage*, Parikka (2007), and http://computerarcheology.com/ (last access: 21 September 2012).

44 According to Matters in Media Art (2007), these "work files" are also referred to as "assets" in the framework of the acquisition process.

45 This aspect can be illustrated with the help of schematic representations, examples of which are provided at the end of this chapter.

46 For security reasons we would suggest audit-proof filing. This ensures that even if someone accessed the stored documents – as should be possible for the revision of the material, for example – he/she technically cannot manipulate the documents without being caught.

47 While a flawed procedure may result in a dimension-reduced object that would then merely have a documentary function, a total loss frequently occurs only when the computer is started up again after it has been transported or stored for a long period of time.

48 A backup of the carefully dismantled hard drives can, for example, be made with the help of Clonezilla. This process requires a great deal of care, especially in determining the correct copying direction; otherwise, the object may be destroyed beyond repair (if in doubt, consult with a computer scientist).

49 Pitschmann (2001) has developed a concept for sustainable collections of web content. See also Frasco (2009).

50 The complete documentation of "Liquid Perceptron" will eventually be made available through the INCCA network, see http://incca.org/.

51 The artist is a physicist. The artwork can therefore also be understood as a comprehensive study of his scientific research. This becomes obvious in the programming's structure whose modeling relies on Fortran.

52 See chapters 4 and 5 of the complete documentation file that will be made available on the INCCA website, see note 21.

53 *The Nara Document on Authenticity*, passed by UNESCO in 1994 and included in the ICOMOS guidelines in 1995, examines the relevance of historical circumstances for the authentic preservation of cultural goods (Lemaire and Stovel, 1994).

54 Pip Laurenson changed positions shortly after this interview to become the Head of Collection Care Research at Tate.

55 The interview took place at Tate Britain, London, on 11 October 2010.

56 As of October 2010.

57 Single channel video works from distributors usually come under license. For a work to be part of Tate's collection it is legally necessary for Tate to hold legal title to the work. It is therefore not possible for Tate to acquire licensed works into its main collection.

58 As Laurenson indicates, the position of time-based media conservation within the division of Collection Care is quite distinctive in that in many modern art museums, for example the Pompidou in Paris, the conservation of time-based media is not done by the collection department but by the media art department, where curators of media art have developed quite a detailed knowledge on the preservation of time-based media works.

59 Tate is a family of four museums which are served by a central collection. Tate also loans out many of its works to other museums and exhibitions.

60 Because of the great level of detail and care with which this work was acquired Garaicoa himself jokingly referred to this work as the "Mona Lisa of Havana." See http://www.tate.org.uk/research/tateresearch/majorprojects/garaicoa/themes_1.htm.

61 For a discussion of this approach in relation to Garaicoa's installation, see http://www.tate.org.uk/research/tateresearch/majorprojects/garaicoa/themes_1.htm.

62 This point is often made in relation to curating media art. For example, new media art curator Christiane Paul states that: "The role of a new media curator is increasingly less that of 'caretaker' of objects (as the original meaning of the word

‘curator’ suggests) and more that of a mediator and interpreter or even producer”
(Paul, 2008: 65. See also Cook, 2008: 42).

63 For an example of how the collaboration with an artist can take place, see the discussion of the conservation of Tony Oursler’s *Autochthonous AAAAHHHH* (1995) in PACKED (2010).

64 For a detailed description of the storage of the various parts of installations at Tate, see PACKED (2010).

65 The exact number of weeks depends on the length of the film, the conditions of the gallery, and how well the equipment is maintained.

REFERENCES

Adelstein, Peter Z. *IPI Media Storage Quick Reference*. Rochester: Image Permanence
 Institute, 2009.

American Institute for Conservation of Historic and Artistic Works (AIC). *Code of
 Ethics and Guidelines for Practice*. Published on the website of the American
 Institute for Conservation of Historic and Artistic Works, Washington, DC,
 August 1994. Http://www.conservation-us.org/index.cfm?fuseaction=page.
 viewPage&PageID=858&d:\CFusionMX7\verity\Data\dummy.txt. Last access: 21
 September 2012.

Ashley-Smith, Jonathan. *Risk Assessment for Object Conservation*. Oxford: Butterworth-
 Heinemann, 1999.

Assocation of Moving Image Archivists. *Storage Standards and Guidelines for Film and
 Videotape*. Http://www.amianet.org/resources/guides/storage_standards.pdf. Last
 access: 23 October 2010.

Bigourdan, Jean-Louis. “Film Storage Studies. Recent Findings.” In *Preserve then
 Show*, edited by Dan Nissen et al, 40-51. Copenhagen: Danish Film Institute, 2002.

Bowser, Eileen. “Some principles of film restoration.” In *Il restauro cinematografico.
 Principi, teorie, metodi*, edited by Simone Venturini: 55-57. Campanotto: Pasian di
 Prato, 2006.

—. “Essai de reconstition de *A Corner in Wheat*.” *Cahiers de la Cinémathèque* 17
 (1975).

Boyle, Deirde. *Video Preservation. Securing the Future of the Past*. New York: Media Alliance, 1993.

British Film Institute. “*A Film Johnnie* Restoration Report.” Http://Chaplin.Bfi.Org.Uk/
 Restoring/Casestudy. Last access: 12 July 2011.

Brown, Harold. “Physical Characteristics of Early Films as Aids to Identification.” In
 Technical Manual. Brussels: FIAF, 1990.

Canazza, Sergio, and Mauro Casadei Turroni Monti (eds.). *Ri-mediazione dei documenti
 sonori*. Udine: Forum, 2006.

Canosa, Michele, "Per una teoria del restauro cinematografico." In *Storia del cinema mondiale. Teorie, strumenti, memorie*, vol. V, edited by Gian Piero Brunetta. Turin: Einaudi, 2001.

—, Gian Luca Farinelli, and Nicola Mazzanti. "Nero su bianco. Note sul restauro cinematografico. La documentazione." *Cinegrafie* (1997) 10: 191-202.

Cherchi Usai, Paolo "La cineteca di Babele." In *Storia del cinema mondiale*, vol. 5, edited by Piero Brunetta, 965-1067. Turin: Einaudi, 2001.

—. *Silent Cinema. An Introduction*. London: British Film Institute, 2000.

Coelho, Ramon, and Gaby Wijers (eds.). *The Sustainability of Video Art. Preservation of Dutch Video Art Collections*. Amsterdam: Foundation for the Conservation of Modern Art, 2003.

Cook, Sarah. "Immateriality and its Discontents. An Overview of Main Models and Issues for Curating New Media." In *New Media in the White Cube and Beyond. Curatorial Models for Digital Art*, edited by Christiane Paul, 26-49. Berkeley: University of California Press, 2008.

Cramer, Florian. "Concepts, Notations, Software, Art." Article originally published online on 23 March 2002 at http://userpage.fu-berlin.de/~cantsin/homepage/writings/software_art/concept_notations//concepts_notations_software_art.html. Http://www.netzliteratur.net/cramer/concepts_notations_software_art.html. Last access: 21 September 2012.

Deggeller, Kurt, and Johannes Gfeller. *Memoriav Emphehlungen Video. Die Erhaltung von Videodokumenten*. Bern: Memoriav, 2006. Http://de.memoriav.ch/dokument/Empfehlungen/empfehlungen_video_de.pdf. Last access: 23 October 2011.

Dekker, Annet (ed.). *Archive 2020. Sustainable Archiving of Born-Digital Cultural Content*. Amsterdam: Virtueel Platform, 2010. Available online: http://issuu.com/virtueelplatform/docs/archive2020_def_single_page. Last access: 23 July 2012.

Documentation and Conservation of the Media Arts Heritage (DOCAM). *DOCAM Documentation Model*. Montréal: Daniel Langlois Foundation, 2009. Http://www.docam.ca/en/documentation-model.html. Last access: 21 September 2012.

Edcine/Archives. *A Summary of the EDCine Project*, version 2, September 2008. Http://www.edcine.org. Last access: 12 July 2011.

Falcão, Patricia. *Developing A Risk Assessment Tool for the Conservation of Software Based Artworks*. Bern University of the Arts, M.A. thesis, 2010.

Farinelli, Gian Luca, and Nicola Mazzanti. "Il restauro: metodo e tecnica." In *Storia del cinema mondiale. Teorie, strumenti, memorie*, vol. V, edited by Gian Piero Brunetta, 1119-1174. Turin: Einaudi, 2001.

—. *Il cinema ritrovato. Teoria e metodologia del restauro cinematografico*. Bologna: Grafis, 1994.

Fossati, Giovanna. *From Grain to Pixel. The Archival Life of Film in Transition*. Amsterdam: University Amsterdam Press, 2010.

Foundation for the Conservation of Modern Art. "The decision-making model for the conservation and restoration of modern and contemporary art." In *Modern Art: Who Cares?*, edited by IJsbrand Hummelen and Dionne Sillé, 164-168. London: Archetype Publications, 2005.

Frasco, Lizzie. *The Contingency of Conservation. Changing Methodology and Theoretical Issues in Conserving Ephermeral Contemporary Artworks with Special Reference to Installation Art.* University of Pennsylvania, B.A. thesis, 2009. Http://repository.upenn.edu/cgi/viewcontent.cgi?article=1004&context=uhf_2009. Last access: 21 September 2012.

Frieling, Rudolf, and Wulf Herzongerath (eds.). *40YEARSVIDEOART.DE – Part 1 Digital Heritage. Video Art in Germany from 1963 to the Present.* Ostfildern: Hatije Cantz Verlag, 2006.

Gamma Group. *The Vinegar Syndrome. A Handbook, Prevention, Remedies and the Use of New Technologies.* Bologna: Gamma Group, 2000.

Gartenberg, Jon. "The Fragile Emulsion." *Journal of Film Preservation* 73 (2007) 4: 39-51.

Gracy, Karen F. "Documenting the Process of Film Preservation." *The Moving Image* 3 (2003) 1: 1-41.

Hones, Luke. *Reel to Real. A Case Study of BAVC's Remastering Model*, 2002. Http://experimentaltvcenter.org/book/export/html/5782. Last access: 23 October 2011.

Hummelen, IJsbrand, and Dionne Sillé (eds.). *The decision-making model for the Conservation and Restoration of Modern and Contemporary Art.* Amsterdam: International Network for the Conservation of Contemporary Art, 1999. Http://www.incca.org/files/pdf/resources/sbmk_icn_decision-making_model.pdf. Last access: 21 September 2012.

Image Permanence Institute. "A-D Strips." *Image Permanence Institute User's Guide for A-D Strips.* Rochester: Image Permanence Institute, 2001 (2nd ed.). Https://www.imagepermanenceinstitute.org/imaging/ad-strips. Last access: 12 July 2011.

Inside Installations. *Introduction to the project.* Amsterdam: Instituut Collectie Nederland, 2007. Http://www.inside-installations.org/project/detail.php?r_id=643&ct=introduction. Last access: 21 September 2012.

International Network for the Conservation of Contemporary Art (INCCA). *Documenta-tion.* Amsterdam: INCCA, 2008. Http://www.incca.org/resources/38-documentation. Last access: 21 September 2012.

International Organization For Standardization (ISO). *Open archival information system (OAIS) -- Reference model.* ISO-Standard 14721:2012. Geneva: ISO, 2012.

Jones, Caitlin and Lizzie Muller. "Between Real and Ideal. Documenting Media Art." *Leonardo* 41 (2008) 4: 418-419.

Krameritsch, Jakob. *Geschichte(n) im Netzwerk. Hypertext und dessen Potenziale für die Produktion, Repräsentation und Rezeption der historischen Erzählung.* Münster: Waxmann Verlag, 2007.

Krauss, Rosalind. "...And Then Turn Away." *October* 81 (1997), 5-33.

Klütsch, Christoph. *Computergrafik. Ästhetische Experimente zwischen zwei Kulturen. Die Anfänge der Computerkunst in den 1960er Jahren*. Vienna: Springer, 2007.

Kromer, Reto. "De la sauvegarde du patrimoine audiovisuel." *Arbido* (2010) 3: 44–46.

—. "Freezing Acetate Base Magnetic Tapes." Unpublished paper presented at the International Association of Sound and Audiovisual Archives Annual Conference, *No Archive Is an Island*, Sydney, 14-19 September 2008.

Kucsma, Jason. "Digital Preservation Code of Ethics." Unpublished report for the Ethics for Library and Information Professionals course in the University of Arizona School of Information Resources and Library Science program, 2007. Http://www. kuple.org/jason/?p=36. Last access: 21 September 2012.

Laurenson, Pip. "Vulnerabilities and Contingencies in the Conservation of Time-based Media Works of Art." In *Inside Installations. Theory And Practice in the Care of Complex Artworks*, edited by Tatja Scholte and Glenn Wharton, 35-42. Amsterdam: Amsterdam University Press, 2011.

—. "Time-based Media Conservation – Recent Developments from an Evolving Field." Unpublished lecture held at the symposium *Contemporary Art. Who Cares?*, Amsterdam, 10 June 2010. Http://vimeo.com/14632365. Last access: 10 September 2010.

—. "Authenticity, Change and Loss in the Conservation of Time-based Media Installations." *Tate Papers. Tate's Online Research Journal* (Autumn 2006). Http://www. tate.org.uk/download/file/fid/7401. Last access: 23 July 2012.

—. "The Management of Display Equipment in Time-based Media Installations." In *Modern Art, New Museums. Contributions to the Bilbao Congress 13-17 September 2004*, edited by Ashok Roy and Perry Smith, 49-53. London: The International Institute for Conservation of Historic and Artistic Works, 2004.

—. "'The Mortal Image' – The Conservation of Video Installations." In *Material Matters. The Conservation of Modern Sculpture*, edited by Jackie Heuman, 109-115. London: Tate Gallery Publishing, 1999.

Lauterbach, Lori. "The Ethics and Issues of Preservation in a Rapidly-Changing Digital Environment: An Annotated Bibliography." Unpublished report for the Information Access & Resources course at Drexel University, 2010. http://www.pages. drexel.edu/~lcl32/eport/Documents/Annotated%20Bibliography.pdf. Last access: 21 September 2012.

Lavoie, Brian. "Thirteen Ways of Looking at...Digital Preservation." *D-Lib Magazine* 10 (2004) 7/8: http://www.dlib.org/dlib/july04/lavoie/07lavoie.html. Last access: 21 September 2012.

Lee, Kyong-Ho, Oliver Slattery, Richang Lu, Xiao Tang, and Victor McCrary. "The State of the Art and Practice in Digital Preservation." *Journal of Research of the National Institute of Standards and Technology* 107 (2002) 1: 93-106. Available online – http://nvlpubs.nist.gov/nistpubs/jres/107/1/j71lee.pdf. Last access: 18 September 2012.

Lemaire, Raymond, and Herb Stovel. *The Nara Document on Authenticity*. Paris:

300 |

UNESCO, 1994. Http://www.unescobkk.org/fileadmin/user_upload/culture/
cultureMain/Instruments/Nara_Doc_on_Authenticity.pdf. Last access: 21 Sep-
tember 2012.

Lurk, Tabea. "On the Aging of Net Art Works." In *Owning Online Art. Selling and Collect-
ing Netbased Artworks*, edited by Markus Schwander and Reinhard Storz, 51-65.
Basel: FHNW, Hochschule für Gestaltung und Kunst, 2010. Available online –
http://www.ooart.ch/publikation/inhalt/PDF/06-Tabea-Lurk-e.pdf. Last access: 18
September 2012.

—. "Programmes as space for thoughts? Annotations to the origins of Swiss com-
puter art." In *India Habitat Centre's Arts Journal*, edited by Alka Pande and Nils
Röller, 50-63. New Delhi: India Habitat Center, 2009a. Available online – http://
www.prohelvetia.in/fileadmin/pro_helvetia_india/docs/New_Media_Journal.pdf .
Last access: 18 September 2012.

—. "ComputerKunstGeschichte Schweiz." In *Computergeschichte Schweiz. Eine
Bestandesaufnahme/ Histoire de l'ordinateur en Suisse. Un état des lieux*, ed. Peter
Haber, 165-206. Zurich: Chronos Verlag, 2009b.

Matters in Media Art. "Time-based Media Works of Art. Structure and Condition
Report." Unpublished template, Matters in Media Art Project, Tate, London/
Museum of Modern Art, New York/SFMOMA, Los Angeles, 2007. Available online
– http://www.tate.org.uk/about/projects/matters-media-art/templates-
acquisitions. Last access: 21 September 2012.

Mazzanti, Nicola. "Goodbye, Dawson City, Goodbye. Digital Cinema Technologies
from the Archive's Perspective. Part 2." *AMIA Tech Review* (2011) 3: 1-15. Http://
www.amiaconference.com/techrev/V11-01/papers/mazzanti.pdf. Last access: 20
September 2012.

Miller Hocking, Sherry, and Mona Jimenez, *Video Preservation. The Basics*, 2000. http://
experimentaltvcenter.org/book/export/html/5781. Last access: 23 October 2011.

Monizza, Simona. "Mission Impossible: Restoring Post-war Dutch Experimental
Films or How to Deal with a Collection that Resists Preservation." Unpublished
lecture delivered at the Amsterdam Film Seminar, Filmmuseum Biennale.
Amsterdam, 12 July 2007.

National Film Preservation Foundation, *The Film Preservation Guide. The Basics for
Film Archives, Libraries and Museums*. San Francisco: National Film Preservation
Foundation, 2004.

—. *A Handbook for Film Archives*. New York: Garland, 1991.

National Fire Protection Association. *NFPA 40. Standard for the Storage and Handling of
Cellulose Nitrate Motion Picture Film*. Quincy, MA: NFPA, 1994.

Nissen, Dan, Lisbeth Richter Larsen, Thomas C. Christensen, and Jesper Stub John-
sen (eds.). *Preserve then Show*. Copenhagen: Danish Film Institute, 2002.

Obermann, Arnaud. "Win, Place or Show. Eine 'retrospective' Dokumentation." Aka-
demie der Bildenden Künste Stuttgart, M.A. thesis, 2009. Http://www.incca.org/

files/pdf/resources/obermann_a_win_place_or_show_-_a_retrospective_
documentation.pdf. Last access: 21 September 2012.

Orcalli, Angelo. "Orientamento ai documenti sonori." In *Ri-mediazione dei documenti sonori*, edited by Sergio Canazza and Mauro Casadei Turroni Monti, 15-94. Udine: Forum, 2006.

Païni, Dominique. "Restaurare, conservare, mostrare." *Cinegrafie* (1997) 10: 23.

Parikka, Jussi. *Digital Contagions. A Media Archaeology of Computer Viruses*. New York: Peter Lang, 2007.

Paul, Christiane. "Challenges for a Ubiquitous Museum: From the White Cube to the Black Box and Beyond." In *New Media in the White Cube and Beyond. Curatorial Models for Digital Art*, edited by Christiane Paul, 53-75. Berkeley: University of California Press, 2008.

Pitschmann, Louis. "Building Sustainable Collections of Free Third-Party Web Resources." Unpublished report, Council on Library and Information Resources, Washington DC, 2001. Http://www.clir.org/pubs/reports/pub98/pub98.pdf. Last access: 21 September 2012.

Platform for the Archiving and Preservation of Audiovisual Arts (PACKED). "Interview with Pip Laurenson (part 1/2)." http://www.packed.be/en/resources/detail/inter-view_pip_laurenson/interviews/, and "Interview with Pip Laurenson (part 2/2)." http://www.packed.be/en///resources/detail/interview_met_pip_laurenson_deel_2/interviews/. Brussels: PACKED, 22 March 2010.

Rarey, Rich. *Baking Old Tapes is a Recipe for Success*, 1995. Http://www.airmedia.org/PageInfo.php?PageID=197. Last access: 23 October 2011.

Read, Paul, and Mark-Paul Meyer (eds.). *Motion Picture Restoration*. Oxford: Butter-worth-Heinemann, 2000.

Reilly, J. M. *IPI Storage Guide for Acetate Film*. Rochester: Image Permanence Institute, 1993.

Rinehart, Richard. "A System of Formal Notation for Scoring Works of Digital and Variable Media Art." Unpublished paper, presented at the Electronic Media Group Annual Meeting of the American Institute for Conservation of Historic and Artistic Works, Portland, OR, 14 June 2004. Http://cool.conservation-us.org/coolaic/sg/emg/library/pdf/rinehart/Rinehart-EMG2004.pdf. Last access: 21 September 2012.

—. "Appendices to A System of Formal Notation for Scoring Works of Digital and Variable Media Art." Paper, published at the Berkeley Art Museum and Pacific Film Archive website, 2008. http://www.bampfa.berkeley.edu/about/formalnotation_apndx.pdf. Last access: 21 September 2012.

Saba, Cosetta G. (ed.). *Nostalgia delle falene. "Follia", "Cinema", "Archivio"*. Triest: Erratacorrige, 2009.

—. *Arte in videotape*. Milan: Silvana Editoriale, 2007.

Scholte, Tatja, and Glenn Wharton (eds.). *Inside Installations. Theory and Practice in the Care of Complex Artworks*. Amsterdam: Amsterdam University Press, 2011.

Segre, Cesare. *Semiotica filologica. Testo e modelli culturali*. Turin: Einaudi, 1979.

Thibodeau, Kenneth. "*Overview of Technological Approaches to Digital Preservation and Challenges in Coming Years*." Unpublished report, Council on Library and Information Resources, Washington DC, 2002. Http://www.clir.org/pubs/reports/pub107/thibodeau.html. Last access: 21 September 2012.

V2_Institute for the Unstable Media. *Capturing Unstable Media*. Rotterdam: V2_, 2007. Http://capturing.projects.v2.nl/index.html. Last access: 24 September 2012.

Van Saaze, Vivian. "Doing Artworks. An Ethnographic Account of the Acquisition and Conservation of *No Ghost Just a Shell*." *Krisis. Journal of Contemporary Philosophy* 1 (2009): 20-33.

Wallmüller, Julia. "Criteria for the Use of Digital Technology in Moving Image Restoration." *The Moving Image* 7 (2007) 1: 78-91.

Wheeler, Jim. *CONVERT YOUR ANALOG VIDEOTAPES TO DIGITAL—NOW!*, 2008. Http://digitalforward.net/white_papers09.pdf. Last access: 23 October 2011.

—. *Videotape Preservation Handbook*, 2002. Http://www.amianet.org/resources/guides/WheelerVideo.pdf. Last access 23 October 2011.

Wijers, Gaby. "Ethics and Practices of Media Art Conservation. A Work-in-progress (Versio no.5)." Article published on the website of Platform for the Archiving and Preservation of Audiovisual Arts (PACKED, vzw.), Brussels, 2010. Http://www.packed.be/en/resources/detail/ethics_and_practices_of_media_art_conservation_a_work-in-progress_part_1/artikels. Last access : 21 September 2012.

—. *3D Documentation of Installations*. Report published on the website of the Inside Installations project, 2007. Http://www.inside-installations.org/OCMT/mydocs/3D%20Documentation%20of%20Installations.pdf. Last access: 26 September 2012.

Wilkening, Anke. *Filmgeschichte und Filmüberlieferung. Die Versionen von Fritz Langs* SPIONE *1928*. Berlin: CineGraph Babelsberg, 2010.

PART IV

ACCESS, REUSE, AND EXHIBITION

INTRODUCTION

Barbara Le Maître

This fourth part of this book, which focuses on what is generally referred to as "exhibition strategies," is structured in two parts. First, the ten contributions that make up chapter 9 explore the diversity of setups or principles of exhibition relating to film images that left behind their original cinematographic context (and its regime of projection in a theater with the lights off) to move towards museum spaces; or to works which come from the large and difficult to define category that is sometimes called media art or even time-based art. Second, Sarah Cook asks and discusses a fundamental question based on her experience as a renowned freelance curator of media art: *What now for curatorial practice?*

Without going into the detail of the following texts, I should probably emphasize an aspect which the outline given above pretends to conceal: even though the works of media art and films "defecting to the museum" may appear side by side in many exhibitions, even though they may be composed in part or in whole of similar moving images, they still raise markedly different issues. For lack of space I will mention just one of these, which is characteristic and crucial.

As its name indicates, media art became established more or less under the auspices of (contemporary) art, while cinema, if it may occasionally be credited with artistic value, is not immediately (or exclusively) a product of art. To put it better still: for film, entering the temples of art that are museums or galleries implies a journey which could be described in the terms once used by

André Malraux to refer to his "Musée imaginaire":

> To say that saints, Danaes, beggars, and jugs have become paintings, that gods and Ancestors have become sculptures, is to say that all these figures have left the world in which they were created for our own world of Art (which is not only the world of our art); it is to say that our Imaginary Museum is founded on the metamorphosis of where the works it selects belong.[1]

In short, when film is exhibited as "Art" in the "art world," for example, in a museum, it breaks from its "original affiliation," that is, the world of the film industry. This is not to say that the film has no aesthetic or artistic value outside of the museum. The problem raised here is institutional rather than aesthetic: when presented in the "art world," film brings up issues for the museum as an institution. For their part, works of media art do not go on the same journey to reach the temple of art, but they are also confronted with some problems inherent in this temple: often contravening the criteria that define the traditional objects of art, these works do force the institution of the museum, or any other party responsible for their presentation, to reconsider the ordinary modalities of the exhibition as well as that of preservation and restoration, incidentally.

Confronting moving images with different origins throughout this part of the book, we do not mean to forget these differences. However, the stakes are not so much about speculating on these differences as about questioning the fact that, *for film images as well as media art works, the exhibition is not self-evident.*

NOTE

1 This is Franck Le Gac's translation of the original French quote: "Dire que les saintes, les Danaés, les gueux et les pichets sont devenus des tableaux, que les dieux et les Ancêtres sont devenus des sculptures, c'est dire que toutes ces figures ont quitté, pour notre monde de l'Art (qui n'est pas seulement le monde de notre art), celui dans lequel elles étaient créées ; que notre Musée Imaginaire se fonde sur la métamorphose de l'appartenance des œuvres qu'il reticent" (Malraux, 1965 [1947]: 240).

REFERENCE

Malraux, André. *Le Musée imaginaire*. Paris: Gallimard: 1965 [1947].

Exhibition Strategies

INTRODUCTION

Barbara Le Maître and Senta Siewert

Titled *Exhibition Strategies*, this chapter is structured as a dialogue between, on the one hand, a reasoned panorama of the contemporary presence of film in museums and galleries and, on the other hand, a series of shorter approaches concentrating on visual objects, more specific phenomena and issues. The latter aims to put into perspective the questions raised in the panorama, which necessarily reach beyond the sole medium of film to affect the vast territory of media art.

At stake beneath what Philippe Dubois qualifies as "the cinema effect in contemporary art" (see his contribution to this chapter) is, first and foremost, the overview of the wide-ranging phenomenon of migration by which cinema, exceeding its traditional apparatus, took its independence from the darkness of theaters in which it had been projected until then to enter museum spaces where it is now exhibited. This phenomenon of migration is considered within a historical perspective (where video, as it turns out, played the part of a decisive relay between cinema and the museum) as well as an aesthetic perspective (in which changes involving the primary apparatus of cinema, spectators included, or the film-object, are traced).

Secondly, three sets of texts complement, comment, expand on, or clarify the questions already raised. The first set, entitled *Exhibiting Images in Movement*, articulates contemporary as well as less recent instances of the problem. Indeed, some exhibition choices recently made by the ZKM – Center for Art and Media Karlsruhe (Claudia d'Alonzo and the exhibition *Mindframes –*

Media Study at Buffalo 1973-1990, for instance) stand to benefit from a comparison with principles of arrangement preceding them, those implemented by Dominique Païni as part of his programming work at the Cinémathèque française, to mention but one example (see Stéphanie-Emmanuelle Louis's contribution to this chapter). Besides, once in the museum, film de facto finds itself compared to one of the emblematic objects of the place, the painting; the issue of "exhibited cinema" is thus also related to the predominant model of painting (see Barbara Le Maître). This first set of texts proposes a kind of travel in time, as the question of the exhibition of moving images changes according to various technical or technological eras.

A second group of texts titled *The Image Travelling Across Territories* outlines the underpinnings of the contemporary economy (in the usual sense of a distribution in social space) and geography of moving images. Some of the themes thus approached are the passages between art – in the 1960s and the 1970s, this consisted of performance, installation, and conceptual art – and cinema (Ariane Noël de Tilly), before the circulation of music videos, from television to museums, festivals, and the Internet (Senta Siewert), down to the multiple experiences of augmented reality and cyber technologies conducted through the media lab V2_ Institute for Unstable Media (Arie Altena).

Finally, a third section titled *New Dispositifs, New Modes of Reception* addresses the issue of changes in the cinematographic apparatus, raised by Philippe Dubois, notably by offering analyses of particular works which, each in its own way but always at a productive distance from cinema, rethink the film-object, its regime of representation, its mode of perception, or the spectatorial body it implies (see Teresa Castro on the conversion of the film into a map, or Térésa Faucon on the installation as an experience of montage). Elena Biserna's text proposes a reflection on the reinstallation of a work by Max Neuhaus which, though it does not refer to the cinematographic apparatus, may be related to some film practices: indeed, one may wonder what the contemporary practices of recreating installations or exhibitions share with the traditional film remake. Beyond the analysis of specific cases, this part of the book also features an essay on the online availability of representations of video art (Renate Buschmann).

Last but not least, this chapter does not claim to be exhaustive, as many other theoretical propositions and objects could have found a place in its construction. The structure has been laid out but it is not closed: it could integrate still more elements and is a lever more than a comprehensive survey. In our view, it constitutes an instrument designed for appropriation and further thought.

9.1 FROM CINEMA TO THE MUSEUM: A STATE OF AFFAIRS

9.1.1 A "CINEMA EFFECT" IN CONTEMPORARY ART

Philippe Dubois

Two Symptomatic and Symmetrical Exhibitions at the Centre Pompidou

There is ample evidence that international contemporary art, at all levels and in every way, is being "invaded" by what I call a cinema effect; this can both provoke irritation as well as pique curiosity, as shown by current events in the arts. One example perfectly epitomizes this phenomenon: in April/May 2006, the Centre Pompidou programmed two significant events, the quasi-symmetrical posture of which could not be ignored. The first of these events, an exhibition titled "Le Mouvement des images. Art, cinéma," which was designed and curated by art historian Philippe-Alain Michaud, aimed to *revisit* pieces from the collections of the Musée national d'art moderne in light of forms and "thoughts on cinema" – a light both real and virtual, literal and metaphorical. The exhibition aimed to confront the following question: how, and to what extent, may it be said that "the cinema" (insert as many quotation marks as necessary here) more or less subterraneously has informed, fed, influenced, worked through, inspired, and irrigated work (paintings, sculptures, photography, architecture, design, installations, performances, videos) by a number of artists of the 20th century whose categorization "on the side of cinema" was not necessarily evident (Matisse, Picasso, Barnett Newman, Frank Stella, Bustamante, Robert Longo, Chris Burden, and Wolfgang Laib, to name a few). The question – fascinating, open, bold – revolves around four structuring configurations, defined as four "components of cinema" (the run of the film in the camera or the projector, projection itself, narration, and montage) and is obviously very symptomatic of this "cinema effect" to which I refer. The exhibition was accompanied by a retrospective of experimental films, older as well as more recent, which also belong to the museum's collections and whose screenings were programmed thematically according to the same configurations. At more or less the same time at the other end of the Centre Pompidou – and it was not clear whether this was intentional or coincidental – another exhibition, much anticipated and somewhat disappointing, was featured. Entirely designed and developed by Jean-Luc Godard (with the assistance of Dominique Païni), it was to be titled "Collage(s) de France. Archéologie du cinéma, d'après JLG" in reference to/reverence for Godard's long-time fantasy

of an appointment to the Collège de France. The exhibition was eventually renamed "Voyage(s) en utopie, Jean-Luc Godard, 1946-2006. À la recherche d'un théorème perdu." This filmmaker's exhibition, the scenographic continuation of *Histoire(s) du cinéma*, is entirely structured as a huge installation, dreamed and left unfinished, a kind of cacophonous construction site full of traces and scattered fragments, bits of texts, images, and sounds (cinema, painting, literature, music) presented in every possible way (models as a series and even as a mise en abyme, more or less miniaturized screens in all positions, multiple reproductions, abandoned pieces, etc.). The whole organizes a sort of collage of ruins out of a vision of cinema that is at once poetic, metaphysical, and geopolitical, and crossed by its countless relations to art. Here again the exhibition is accompanied by a complete theatrical retrospective of films by (and on, and with) the author. All in all, then, two major exhibitions, almost simultaneously exhibited in the same major location, one that symbolizes art, each echoing the other like two sides of the same layered issue, that of the complex relations between cinema and contemporary art. Put schematically: on the one hand, cinema in art, on the other hand, art in cinema. Art as cinema, and cinema as art. Which is to say: "the cinema, contemporary art." It is the comma in that phrase that matters here, because it plays a pivotal role between "cinema" and "contemporary art" and leaves the link between the two poles open in all directions.

So let me repeat (and this is nothing new, dating back as it does to the mid-1990s): the world of contemporary art is increasingly marked by the insistent presence of what could be called a "cinema effect" both far-reaching and superficial, often monumental, fetishistic even, occasionally poetic, sometimes intelligent, and possibly sensible. At any rate, this "cinema effect" is extremely diversified, takes multiple forms, and operates at all levels (institutional, artistic, theoretical, or critical). What I would like to try and do in this simple introductory presentation is to lay things out. Not analyze this or that particular aspect or throw myself into this or that individual approach (by a museum, an exhibition, an artist, an oeuvre). Rather, I only want to deal with this "cinema effect" as a global phenomenon: to adopt a panoramic, categorical perspective, on the one hand, positing a framework and identifying the main forms of this phenomenon; and on the other hand, to offer a few thoughts on the historical and aesthetic causes and stakes it seems to entail. This is an introductory text that sets up the context, in a way.[1]

Exhibition Cinema? Post-cinema? Third Cinema? A Matter of Territory, Identity, Legitimization, Power, Gain, and Loss

First, on an institutional (or socio-institutional) level – on which I will not dwell – the pervasive resonance of this phenomenon, its omnipresence even, asks questions both from cinema and from art. Questions of (respective) places. Questions which I will not take so much as questions "of trend" (trendy) as questions as to "the world of art." From the moment when, 15 years ago, almost every major biennale (Venice, dokumenta, and others), every museum (of every size, from the Centre Pompidou to the MAC in the small Belgian city of Liège), every art center (such as the Villa Arson in Nice, Le Fresnoy in Tourcoing, Le Consortium in Dijon), and every more or less "trendy" art gallery started systematically featuring exhibitions or works involving "the cinema" in one way or another in its programming, it became evident that the stakes went beyond works and approaches to include territories. It seems to me that these are issues of territories (and therefore of a cartography of arts and of geostrategy), that is, issues of identity (of the cinema and of art) as well as reciprocal legitimation – and thus, of symbolic power.

Speaking of the exhibition of works involving "the cinema" in one way or another calls for quotation marks, so uncertain are identities these days, with mixes being the rule, sowing doubt and spreading confusion on the question of the "nature" of phenomena attended to. For one of the central points of the problem is there: is what we see in exhibitions (still) really "cinema"? Is it cinema as it "migrated," as it has been said, leaving the darkness of "its" movie theaters for the much brighter rooms of the museum? And, if that is the case, what for, to what end? Or is it cinema which has been diverted, disowned, transformed, metamorphosed? Into what? Is it a "beyond" or an "after" of cinema, as if cinema no longer was? Critics, ever prompt to react, or dramatize, have in fact come up with various terms to refer to it: I seem to remember, for instance, that Jean-Christophe Royoux was the first to use the expression "exhibition cinema" in the texts published in the periodical *Omnibus* (the expression was reused for a while by several other critics or institutions, from Régis Durand to Françoise Parfait, from *Art Press* to *Art Forum*, from the Venice Biennale to the Kassel dokumenta, before it was dropped). The phenomenon was also talked of as "post-cinema," which associated it with that of rampant digitization, the DVD market, and the distribution of films over the Internet. Pascale Cassagnau prefers the expression "troisième cinéma," literally, "third cinema."[2] And the list goes on... Exhibition cinema, post-cinema: labels do not matter. The issue raised is clearly that of the identity or nature of "the cinema," an *assumed* nature which proves or appears to be hypothetical (there where it felt self-assured, solid in its specificity), a *nature* which is now

called into question, relativized, shaken, transformed, betrayed perhaps, not to say fast disappearing (the cinema, a "vanishing art"?). This uncertainty with regard to identity is obviously fundamental on a theoretical level (and could be examined in the Deleuzian terms of "lines of deterritorialization"), but also at the level of institutions: it has implications for what Bourdieu called symbolic legitimization: in these transfers and translations, in these migrations and mixes, which stands to gain and which stands to lose, between cinema and contemporary art? And to gain or to lose *what*, exactly? A place in the sun? The gates of heaven? A descent into hell? What does each of these entities (art, cinema) bring to or take away from the other? In which direction has the balance of power settled at this point? Which of the two legitimizes or vouches for the other? Which one dissolves or gets lost in stretching to such an extent? Could cinema find rejuvenation in the museum, a youthful effect both positive and innovative, a noble sublimation for its ignoble (popular and commercial) origin? Or might it be a sign of weariness, flagging, exhaustion on the part of "the art of the 20th century," so viscerally tied to the idea of theatrical exhibition and its ritual, suddenly incapable, at the beginning of the 21st century, of finding a place to rest, to settle, of finding which way to turn in order to survive while diversifying itself? And could contemporary art, which was sometimes depicted as somewhat expressionless, abstract, and even abstruse, desiccated or drained of its substance, be given some degree of reality, embodiment, life, soul, breath, sound, and fury thanks to the arrival of photographic images in movement, light, and sound? Or on the contrary, has it lost itself and its bearings to the point of trying to hang on to any cheap spectacular effect to pretend it is alive? And are these changes in location of a symbolic nature, or are they a matter of sociology, of audiences? Is it an economic question involving markets and market shares? Who loses, who gains, and what is lost or gained? I am not going to proceed further on this line of thought, but the phenomenon should certainly also be questioned in these terms, and a doctoral thesis on the subject would be much anticipated.

The Spectator and the Question of the Apparatus

On an artistic level, on which I will elaborate in more detail, this phenomenon of a "cinema effect" clearly opens extremely diverse perspectives.

First, in aesthetic terms, and to expand on what has just been said, I should point out that this emergence of "exhibition cinema" has also taken place over a background of changing *apparatuses*. It thus raises the issue of the place of spectators: as images left "their" good old dark theaters to be exhibited in the rooms of art museums, a whole series of parameters on the "specific" modes

of reception of these images shifted, and with them a host of questions on the "nature" of each of them appeared. For instance, what happens (for the film spectator) in the move from the large, communal dark theater, where everything disappears into obscurity for maximum and exclusive concentration by all upon the rectangle of the screen, to a more individualized vision, often on several simultaneous screens, and in a brighter environment for the film in the whiteness of the museum space? Is it possible to see an image in the same way when it is projected in light as when it is projected in darkness? In what way may this change dilute the effect of absorption and fusion of the collective spectator? Does it contribute to transforming him/her into an isolated, divided, wandering subject? What happens with the change from an immobile, seated position in the movie theater, to the mobile, upright posture of the passing visitor in the exhibition? Can the hypnotized spectator become a distanced *flâneur*? What is experienced in the passage from the standard duration imposed by the single uninterrupted run of the film to more random | 315 modes of vision, often fragmented and repetitive (the loop), of images that are always there, that may be left aside and retrieved at will? Does the captive of temporal duration in the movie theater find freedom in the exhibition space? Is it a shift from the singular to the repetitive? Conversely, what is the consequence for the museum when lights have to be dimmed and spectators have to feel their way along in a darkened room? How should sound circulate when it cannot be located? What are the sensorial implications of the exhibition of a projected, luminous image, as immaterial as it is ephemeral, in a large format and in movement, poles apart from the object-images (photography, painting) which could play into classic perception in museums? How to guide the visitor through the narrative display of images telling a story? And the list of questions goes on... This whole set of modifications and interrogations deeply destabilizes what could until then be considered as established categories. The very idea of "cinema" or "art" (in the sense of work of art) finds itself strongly relativized. And institutional interrogations prove to be aesthetic as well.

A Generational Phenomenon

What is more, when it comes to individuals, we simply have to admit that there is a generational phenomenon: over roughly the past fifteen years, a whole array of artists seems to have taken over the object of "cinema" or the thought on that object. They have placed it at the center of their practice, as though the point was to revive, to (re)animate the world of contemporary art by providing it with a life and an imaginary; if it is not new, it is at least rich – historically,

culturally, and aesthetically. This is an objective fact, if only quantitatively. And if it does not represent a "school" per se, it is at least a movement that may almost be called *generational* (with some notable exceptions such as Anthony McCall or Michael Snow, whose pioneering works date back to the late 1960s or the early 1970s). At any rate, the names of these artists, many of whom are prominent on the current international art scene, are well known: Douglas Gordon, Pierre Huyghe, Pierre Bismuth, Stan Douglas, Steve McQueen, Mark Lewis, Doug Aitken, Pipilotti Rist, Eija-Liisa Ahtila, Sam Taylor-Wood, Tacita Dean, Rainer Oldendorf, Philippe Parreno, Dominique Gonzales-Foerster, etc. To these now established figures, an extraordinarily high number of younger artists should be added: lesser known, to be sure, they still massively contribute to the flood we are facing today. This emergence of a generation, it seems to me, cannot be thought about separately from its counterpart in cinema. For at the same time, but in the opposite direction, many (established) filmmakers are turning to the field of art to propose works, most often in the form of installations, sometimes new (made especially for a specific exhibition) but not necessarily, as many appear as (more or less original) spatializations of their films or worlds designed for museums and galleries. These are filmmakers' installations: those, now well known, by Chantal Akerman (who over the last few years has made them a personal specialty); Chris Marker's historical and original realizations, from his *Zapping Zone* at the Centre Pompidou first presented in 1990 to his recent *Prelude: The Hollow Men* at the MOMA and the magnificent *Silent Movie*; Agnès Varda's developing installations (her interesting *Triptyque de Noirmoutier* and the whole exhibition "L'île et elle"); not to mention the various, and more or less creative attempts by Johan van der Keuken, Abbas Kiarostami, Atom Egoyan, Peter Greenaway, the association between Yervant Gianikian and Angela Ricci Lucchi, and of course Godard's *Voyages en utopie*, already mentioned. As it appears from the names above, many of these installations were made by an often older generation than that of exhibition cinema: Varda, Marker, and Godard could be their parents and, in a way, they are.

Passing on Historical Images: Experimental Cinema and Video Art

Finally, to fully map things out, it should also be said that exactly midway between these two worlds between these artists-working-with-the-cinema and these filmmakers-thinking-of-themselves-as-artists-or-trying-their-hand-at-artwork, there is the whole world of experimental filmmakers and video artists: small yet intense, teeming with activity, diverse, and open. They are the

ones *passing things on* between the two worlds with which we are concerned. And they each have their history and their autonomy, which I cannot possibly recount here.[3] With respect to classic theatrical screenings, experimental film clearly instituted "the installation" (in a general, *expanded* sense, to use Gene Youngblood's term) as another form of existence for cinema: projection on several screens, on uneven surfaces, in space, etc. And, just as clearly, video introduced the large-format moving image in the world of contemporary art galleries and museums – especially as it moved from "video sculpture" (with the monitor, a multiplied, piled-up, aligned image-cube, as its totem) to "video projection" (on a large screen, in digital quality) in the late 1980s. As historical and aesthetic agents in the passages between art and cinema, experimental cinema and video art put into play the very forms of the encounter between these two major fields.

The Main Figures of the Cinema Effect: A First Attempt at Categorization

Staying within the perspective I chose, setting the scene by way of introduction, I would like to try and describe a few of the major modes of this cinema effect, simply and with examples to illustrate my points. This does not involve a systematic typology, nor does it stem from a will to be exhaustive or a desire to freeze what is moving, but rather to scan briefly, without a detailed analysis, and with a bit of rationality, the extremely diverse terrain with which we are dealing. Accordingly, I would like to go briefly through four figures which represent typical forms the relation between cinema and contemporary art can take, four figures of the cinema effect among many other possibilities: variations on the idea of *reuse*, starting from the most literal (or explicit, or direct) instances to move towards the most metaphorical (implicit, indirect).

Reuse as a Principle

Reuse is undoubtedly the most self-evident notion. The primary meaning of this principle, as its name indicates, points to a gesture – an effective gesture which constitutes each piece of art: the material and physical borrowing of filmic object(s). Reuse as a gesture may take many forms: recycling, reproduction, sampling, citation, reference, inspiration, reappropriation, absorption, diversion, reconversion, transformation, distortion, disfiguration, etc. Reuses may be integral or partial, faithful or altered, direct or indirect... They are what first comes to mind in discussions on the presence of a cinema effect in con-

temporary art. Yet this is not to say that they are the most explicit or immediately visible, or that what is at stake with them is simple or transparent —far from it. Several singular forms of reuse may be identified, whose variations, following a certain progression, illustrate the principle.

The Exhibited Film[4]

This is somewhat the matrix of the phenomenon, and a primary example immediately comes to mind in that area: Douglas Gordon's famous 1993 *24 Hour Psycho*. When he appropriated Hitchcock's film to turn it into a video projection on a large screen in the middle of a museum gallery, Gordon *reused* the movie *Psycho* (forcing it out of the cinema) to *exhibit* it (and not just project it) in a space and an institution devoted to art. He even exhibited it as a whole (in its totality) but did not preserve its *integrity*, subjecting the film to a fundamental distortion by using extreme slow motion. Indeed, the complete projection of the film in Gordon's version spans 24 hours instead of the standard hour and a half. This experiment on the duration of reception, the patience of the spectator, and the rules of the institution, still fully belongs to a performative inspiration quite characteristic of the 1970s. Most of all, though, the slowness of the projection completely metamorphoses the *visual sensation* of the film, (re)discovered in the minutest details, in the plasticity of each of its shots and decomposed movements. The experience proves as plastic as temporal: *Psycho*, the cult film we thought we knew by heart, feels as though it had never been seen before (not like *this*, in any case). Each gesture, each facial expression, each action finds itself almost analyzed, "contemplatively scrutinized." A thousand unsuspected, invisible facets are thus revealed in and through the thickness of the slow motion. In that regard, it would be interesting to compare this piece by Douglas Gordon with another reuse of the same Hitchcock film, Gus Van Sant's *shot by shot remake*, in which *Psycho* operates less as an "exhibited film" than as an "installed film" within another film. This is a new way of treating the old question of the remake in the light of practices of contemporary art, and from that standpoint, Van Sant is probably the most interesting filmmaker today: *Gerry* or *Elephant* could be viewed as formal responses in film to questions raised by contemporary art.

Many other cases could be mentioned to illustrate this figure of the "exhibited film," if only another installation by the same Douglas Gordon, *Déjà vu* (2000), not to mention his "impossible" *Five Year Drive-by* (1995): John Ford's *The Searchers* slowed down to the point of reaching a virtual screening time of five years, the time of the diegesis! Or the triple projection of the same Hollywood film noir, Rudolf Maté's *D.O.A.*, on three large screens juxtaposed edge

to edge. These three projections differ from one another by only the slightest temporal unit (one image/second). Maté's film thus runs at a speed of 23 images/second on the first screen, at 24 on the second, 25 on the third. Small causes, great effects. This minuscule variation in speed, imperceptible at first, gradually comes to undermine the synchrony of the three projections until the film splits into almost three different films and proves challenging to connect back to itself.

Another recurring manner of exhibiting a film in its integrality but not in its integrity consists in separating the soundtrack from the image. Various artists have more or less done away with the visible part of an original film, keeping only the continuity of its sound. This is the case of some of Pierre Huyghe's pieces such as *Dubbing*, which presents the viewer with a still, uninterrupted shot lasting 90 minutes of the whole crew of dubbers facing the camera and looking at a screen off the frame as they work on a film never seen but the French dialogues of which are heard throughout (and read thanks to the text appearing at the bottom of the image). Pierre Bismuth's work (*Post Script/ The Passenger*, 1996, or *The Party*, 1997, for example) also plays with the gap between sound and image, presenting transcriptions of these works by Antonioni and Blake Edwards typewritten in real time by a secretary who hears the films without seeing them.

What emerges from all these experiences, in the end, is a "museum version" of a film almost in the sense of the "multiple versions" known in film history. What is at stake is the film, the possibility of its exhibition, and how this possibility transforms, not so much the film itself as its reception and perception by the spectator. Each piece working towards a version of a film that may be exhibited proves a meta-perceptive analytical experience where the act of seeing images is itself questioned. To see an "exhibited film" is not to see it again, it is to see it (or hear it) differently, and therefore wonder about this alterity.

Cited Films

Things are very different with this second figure. Far from attempting to exhibit *a* film, to give spectators a (more or less altered) version of it to offer a new viewing experience, it seeks to look about anywhere, to tap into the infinite material of film, of all kinds of films, from different corpuses, whether heterogeneous or established, to take fragments, bits, selected passages, to piece together something "new." This is primarily a work of investigation, search, excavation, and secondarily a work of selection, cutting, carving out. And lastly, it is a work of re-organization, assembly, montage. Finding, disfig-

uring, (re-)configuring. Reuse here is less a gesture of presentation (exhibiting) than a gesture of de-/re-construction. The operation does not aim for an original object (the matrix film), but rather for a more general or transversal film imaginary.

Here again an established and sanctioned practice, which has placed this question at the center of its approach, immediately comes to mind: *found footage*. Found footage films lie precisely on the threshold between experimental cinema and exhibition practices, since they may be seen at screenings as well as installations in the spaces of art. When filmmaker-artists such as those from the contemporary Austrian school (Martin Arnold, Matthias Müller, Claude Girardet, or Peter Tscherkassky, for example) revisit cinema, and more particularly Hollywood's narrative cinema, they make films or installations which do not just "attack" the original filmic material (this physical dismembering is very pronounced with Peter Tcherkassky for instance, but also, though differently, with Martin Arnold): they also "enter" the films as cultural objects and work on the imaginary or the ideology for which these serve as vehicles, in order to give a sometimes critical, sometimes poetic, version of them. *Home Stories* (Matthias Müller, 1990) focuses on the stereotyped narrative and figurative postures of the 1950s Hollywood melodrama. Martin Arnold's *Alone* (1998) and *Pièce touchée* (1989) take apart – rather humorously – the gestural or postural unconscious of bodies and characters buried in the folds of ordinary images. *Outer Space* or *Dreamwork* (Peter Tscherkassky, 1999 and 2000) reinvent specifically figural modes of narration out of the same original material. In the same general sense, one could even include the films of Yervant Gianikian and Angela Ricci Lucchi (all films since *Du Pôle à l'équateur*), Bill Morrison (*Footprints*), Al Razutis and his *Visual Essays*, Mark Lewis and his "cinema in parts," and so on. All these operations play with the flesh of film images, take cinema apart and put it back together to draw new or renewed ideas or sensations from it. The installation-like presentation of these films is certainly not always a priority, but each film may in itself be considered quite exactly as a specific installation of fragments from other films. Either it assumes specific dimensions, as with the set-up of Chris Marker's 1995 *Silent Movie*, with its five video screens stacked into a column and its random program of infinite combinations of shots produced out of the images saved on the five video discs; or the arrangement on three screens placed in a row, one in front of the other in a kind of memorial stratification, as in Yervant Gianikian and Angela Ricci Lucchi's *La Marcia dell' uomo*. Or of course Godard's whole exhibition-installation at the Centre Pompidou, *Voyage(s) en utopie*, a boundless construction site of multiple citations.

What is left of this whole tradition of artworks comprising "cited films" is the general idea that cinema is unmistakably and par excellence the imaginary

of images that haunts our minds and occupies contemporary visual memory, whether we like it or not. The film image is at once material and specter, the hint at the fiction of an image, the ghostly flesh always there, strong and fragile at the same time. All these installations keep reiterating it, on a critical, ironic, denunciatory, or iconoclastic mode: the cinema, films were, by the end of the twentieth century, the backdrop for our relation to images, and as a consequence to the world. Our visual thought is a "cinematographic" one.

The Reconstructed Film

This third form still relates to the figures of reuse, yet with some distance (from literalness), insofar as it does not involve the material reuse of an image, but a reuse of sorts in the second degree, the creative reuse of the formal idea of a film, that is, a *reconstruction* (in the sense of the reconstruction of a crime). The reconstructed film may be to the (original) film, the matrix, what the tableau vivant is to the painting. Remade (a remake), with (more or less) new actors and in the spirit of a connection to the object of reference, the new film plays with all possible dialectics between faithfulness and inaccuracy, reproduction and transformation, sameness and otherness. These games of similarity and dissimilarity, in which the share of invention always vies with the share of reconstruction, are at the center of the operation – and at the center of the works relying on this principle. Here are a few examples.

Pierre Huyghe's *L'Ellipse* (1998) is a three-screen installation that "creates" a sequence shot "missing" in Wim Wenders' film *The American Friend* (1977). The screens on the left and on the right successively show a sequence of the film in two shots which originally produced an ellipsis. On the left, the character played by Bruno Ganz is shown in Paris, in a Left Bank apartment; on the right, the same character can be seen in a different place, this time on the Right Bank; between the two, Wim Wenders' film skipped what happened thanks to a cut. Twenty years after the shooting of Wenders' film, Pierre Huyghe (re)shot the ellipsis and exhibited it: he asked the same actor, Bruno Ganz, 20 years older, to walk from one place to the other again, and filmed an eight-minute sequence shot of him in 1998 as he crossed the Pont de Grenelle. The sequence shot is projected on the central screen between Wenders' two successive shots, the delayed reconstruction of an interstitial absence. A man walking – and thinking – in an interval between two dated shots, crossing a bridge to bridge between two places and two times. A memory going back and forth in the present, in the aftermath of the memory of a film with a hole in it. A spatial gap reconstructed in the production of a temporal gap.

The Third Memory (2000), another work by Pierre Huyghe, is a reconstruc-

tive arrangement comprising three layers. "Originally," as far back as sedimentation allows to go, there is a story which made the news in 1972: a stickup that went wrong that involved hostages at a Brooklyn bank. American television had already shot part of the action live (showing the police overdoing it as they surrounded the place). Then there was a famous film, Sidney Lumet's 1975 *Dog Day Afternoon*, which "staged" the story of the heist, *interpreting* it in a fictional reconstruction with Al Pacino playing the part of the hold-up man. Finally, Pierre Huyghe not only *reused* this double visual material, which serves as a counterpoint in his work: he also carried out a meticulous reconstruction of the attack of the bank in a studio, with simplified sets, extras standing in for the employees of the bank and the police, and most of all – this is where the whole project started – the actual aged hold-up man "in person": John Wojtowicz, playing himself. He had served his sentence, had been released from jail, and "(re)enacted the scene" for Huyghe in a way in which he could attempt to "give the real version of facts" while taking part in a reconstruction almost 30 years later. He is thus both the person and the character in this three-tiered arrangement; he is the actor and the main protagonist (which he really was), the author (in the full sense of the word), the director (he gives directions, directs extras), and even the distanced commentator after the fact, criticizing Lumet and Pacino's "inaccurate" version of his story.

Constanze Ruhm's work, with her project *X Character* and more particularly *X Characters/RE(hers)AL* (2003/04) and *X Nana/Subroutine* (2004), also proceeds from this logic of reenactment, but along still other perspectives. In short, the idea is to start anew from relatively well-known characters in fiction films who are already part of our memory as spectators. The Nana of the second example comes from Godard's *Vivre sa vie*; the seven female characters of the first example come from different films and filmmakers: Alma from Bergman's *Persona*, Bree from Alan Pakula's *Klute*, Giuliana from Antonioni's *Red Desert*, Hari from Tarkovsky's *Solaris*, Laura from Kershner's *Eyes of Laura Mars*, Rachael from Ridley Scott's *Blade Runner*, etc. The seven women, none of whom physically looks like her model, find themselves waiting in a stylized airport. Ruhm approaches these characters as belonging to a new fiction but with a cinematographic past and lived experience, an identity *already there*. These complex works involving films, photographs, books, and installations are very open mixtures of dialogues invented in contemporary situations and in more or less pregnant filmic imaginaries. They smoothly and subtly associate proximity and distance, resemblance and dissemblance, reconstruction and invention.

Formal Figures of a Virtual Cinema

The movement away from literalness continues with this new category of figures in material reuse, for here the relation to cinema plays out, not at the level of one or several films in particular, but at the more "abstract" or general level of "filmic forms" such as the shot/reverse shot, the eyeline match or the match on action, crosscutting or parallel editing... All these forms, which shaped film language, serve – not without some degree of adaptation – as models for the mise-en-scène of many artists' installations, whose formal debt to all these established figures in cinematographic writing is obvious. One recurring principle in this area is the transposition of temporal forms of cinema (notably the whole dynamic drawn from editing) into a *spatial arrangement* in the exhibition. The genuine fascination of post-cinema artists for the form of the multiple screen may be understood in this way. The co-presence of several screens in the gallery according to specific arrangements may be thought of as a kind of direct transposition in space of the figures of editing in cinema. Countless works cultivate not only the reference to forms, but also to typical filmic themes which are as many *topoi*, basic motifs, standards in cinema. For instance, many installations set up scenes of meals at a restaurant, domestic fights, encounters, declarations of love, escapes, etc., between two protagonists, which cinema has accustomed us to seeing in shot/reverse shot, crosscutting, matches on action, sometimes even crossing the axis of action or linking up certain angles or gestures. Many scenes presented in multiple-screen setups may be found in the work of Stan Douglas, Sam Taylor Wood, Steve McQueen, Doug Aitken, Rainer Oldendorf, and many others. The shot/reverse shot of cinema becomes a simultaneous projection on two screens facing each other, side by side, or at a right angle reproducing the positions of cameras during shooting. Generally, what film delivers in the succession of shots, the exhibition stages in the spatial simultaneity of its screens, playing with all possible "matching" effects *but* doing so in space (visual rhymes, symmetry, inversion, reversal, etc.). This is not without evoking the vertical montage (as opposed to horizontal montage) brought up by Abel Gance in relation to all the visual arrangements which his triple screen made possible, according to him.

This logic eventually raises the issue of the narrative, approached frontally by some artists (Doug Aitken, Steve McQueen, Pipilotti Rist, or Eija-Liisa Ahtila, for instance). Is it possible to tell a story in (and through) the space of installation, and if so, how? Multiple screens, in that they spatialize the succession of shots, may be used in this way by adjusting quite precisely to the very progression of visitors in the exhibition. Their path, moving from screen to screen, then functions as a shot by shot progression in the story told by the

film. The walk articulates narration, the figure of the narrator is the figure of a walker: I walk, therefore I am (the story). The path may be linear (though that is rather rare), it is more often than not complex, multiple, fragmented, labyrinthine, it may be open or closed, fast or slow, etc. Here visiting the exhibition amounts to "seeing a movie," and the (immobile, seated…) spectator turns into a *flâneur*, in Benjamin's sense.

It thus becomes apparent that this takes us into areas where the question of cinema in contemporary art works becomes increasingly secondary, virtual, abstract, implicit, and metaphorical. It is indeed about an *effect*. And Philippe-Alain Michaud's exhibition at the Centre Pompidou, mentioned at the beginning of this text, marks to some degree its end point. What "effects cinema" in some of the works presented in "Le Mouvement des images" often has to do with a sort of extreme virtuality: it may be a gesture, a posture, a form, a frame, a movement, a detail – sometimes a mere play on words, even, as with the thin *film* of dry milk in Wolfgang Laib's milkstones. The cinema effect is there indeed, haunting, as it does, our ways of seeing.

NOTES

1 For more information, analyses, or ideas, see the many published articles (notably in *Omnibus* and *Art Press*), catalogues (from everywhere), and books dealing with the subject, four of which deserve particular attention: Bellour (1990); Païni (2001); Parfait (2001); Cassagnau (2006).

2 Translator's note: this has of course nothing to do with the Third Cinema that emerged in Latin America in the 1960s.

3 See Chris Wahl's chapter 1 in this same volume.

4 Translator's note: the English term for the theatrical screening of films, *exhibition*, is obviously the same term as that used in the context of the display of art works in museums and galleries. In French, on the other hand, the term *exposition*, when applied to film, assumes full significance in that theatrical presentation is referred to as *exploitation*.

REFERENCES

Bellour, Raymond. *L'Entre-images 1. Photo, cinéma, video.* Paris: La Différence, 1990.

Cassagnau, Pascale. *Future Amnesia (Enquêtes sur un troisième cinema).* Paris: Sept/Isthme, 2006.

Païni, Dominique. *Le temps exposé. Le cinéma de la salle au musee.* Paris: Éditions de l'Etoile/Cahiers du cinéma, 2001.

Parfait, Françoise. *Vidéo. Un art contemporain.* Paris: Éditions du Regard, 2001.

9.2 EXHIBITING IMAGES IN MOVEMENT

9.2.1 EXHIBITING/EDITING: DOMINIQUE PAÏNI AND PROGRAMMING AT THE CINÉMATHÈQUE FRANÇAISE AT THE TURN OF THE CENTENARY

Stéphanie-Emmanuelle Louis

"After all, isn't programming also laying shots and sequences end to end with dramatic purposes in mind? To program is to *edit*." (Païni, 1992 : 30)

Ever since the 1930s, cinematheques have historically been the places where museums present films: in preserving films, cinematheques inscribe their exhibition within a heritage network. They thus systematize the re-release of the films and foster their anachronistic re-appropriation by audiences. Still, this practice of exhibition began to be approached as an issue in and of itself only in the late 1980s, in a context of transformation of the cinematographic and audiovisual landscape through the question of programming or, put very literally, of the organization of programs.[1]

It was Dominique Païni who, from his French base – the Cinémathèque française, which he headed from 1992 to 2000 – championed the debate through many texts and interviews which historicized the practice of programming and explored its contemporary implications. Païni probed the legacy of Henri Langlois, whose programs at the Cinémathèque française between 1936 and 1977 remained legendary. In that regard, his interpretation in terms of collage programming seems rather widely shared in the world of cinematheques (Rauger, 1995; Claes, 1995). However, Dominique Païni has put it into perspective using the practice of filmmakers, including, notably, that of Jean-Luc Godard, which has apparently met with more reservations. This theoretical reflection steeped in practice uses analogy as an exploratory process: programming is akin to editing, an ontologically cinematographic manipulation. Let us note in passing that, as far as we know, there is no text by Langlois that supports this reading.

This last aspect, which makes Dominique Païni's approach singular, seems particularly revealing of the cinema effect "which [haunts] our ways of seeing" (Dubois, 2006: 25). Following the chronological landmarks given by Philippe Dubois, I will highlight the generational roots of a perspective which tends to take over "the object of 'cinema' or the thought on that object" (Dubois, 2006: 18) to contemplate the exhibition of objects which are part of a cinematographic heritage. In the end, a new historical perspective for the cinema effect may emerge.

Cinema in the Age of Museums

1992, the year when Dominique Païni was appointed director of the Ciné-mathèque française, was marked by an increased mobilization for cinema in France, with the centenary of the invention fast approaching. Cinema, so it went, should be considered a cultural good to be preserved and passed on as the heritage of a community – hence its entrance into the museum. To recon-sider the legacy of the Cinémathèque française is imperative, as it has been the museum of cinema in France and the issue of the exhibition of the films featured in the collections has proved an impetus as much as a constraint throughout its history.[2]

The new director considered the centenary as a pivotal moment, arguing that "cinema has been conquered as an art, it has retroacted on other arts, it is time to demand that the Cinémathèque become a genuine Museum" (Jousse, Tesson, and Toubiana, 1992: 86). To introduce cinema into the museum thus associated two points of view: one attempting to define art within cinema, another considering it within a general artistic context. However, its collec-tions distinguish the Cinémathèque from museums of art in that they mostly comprise films, that is, works unfolding in time, in addition to the specific paradigm of their presentation, projection. This primary mission is the focus here.

While the question of programming had been a strong interest of Dominique Païni's since the 1970s, from his experiences leading discussions in film clubs, then as the owner of repertoire movie theaters,[3] his appointment at the Cinémathèque française inaugurated a new stage in his reflection. His formative years had been characterized by a constant commitment to the defense of the specificity of filmic objects, so that each could be acknowl-edged as a "signifying practice" (Païni, 1971: 65). He had also advocated adapted spaces to valorize these objects, "gallery-theaters" (Païni, 1984: VI) or "showcase theatres." (Le Péron, Toubiana, 1984: 45) Programming gradually emerged as a central element in this arrangement of relations, where films find their spectators and thereby become cinematographic works.

The new direction of the Cinémathèque française thus constituted an end point to this aspiration to a genuine presentation of cinema in a museum space – in a new environment, however, since programming had to be found-ed on a collection of film archives. This was not self-evident, because histo-riographic production, rather than simply being echoed (as at the time of the Studio 43[4]), now had to be put into perspective through the selection of films from an extremely diverse collection which did not only include masterpieces.

In accordance with its mission as a museum, the Cinémathèque partici-pates in the exploration of film heritage. As a consequence, programming

cannot be limited to an appendix of history: it constitutes in itself a particular form of writing. As it contributes to developing cinematographic taste, the Cinémathèque also proposes artistic hierarchies, even temporary ones, a practice which encourages comparisons and invites re-evaluations. The institution thus represents the place where a critical outlook on cinema has historically been able to exist. Programming may indeed be a way to think cinema solely through films.

Programming – Editing

Confronted with the collections, the "cinephile-turned-curator" found perceptive stakes likely to give direction to his heritage mission: "to speak of these films, to describe them, or more specifically, to describe the impressions they produced in me, appeared as the right method to contemplate their place within programming" (Païni, 1996 : 56). The act of programming was mostly informed by the knowledge of corpuses, yet it also rested on the subjectivity of the point of view. Moving beyond the conspicuousness produced by the exhibition of an old object in the museum then became possible, to enter a critical interaction between films, spectators, and programmer through a sensualist approach.

While film production may also be approached from a sociological standpoint, as was for instance the case at the Cinémathèque de Toulouse,[5] the project advanced by Païni had more to do with an iconology. The method consisted in "putting films side by side, finding the origin of a film image and tracing its destiny from film to film, from film to text" (Païni, 1995 : 29). Programming in a cinemathèque could thus amount to a "film aesthetic akin to a montage forcing thematic commonalities, reducing stylistic indifferences, and joining images and thought" (Païni, 1995 : 29). Consequently, the arrangement of filmic objects became not only a visual composition, but an iconological one as well.

Countless artistic references support the closeness between programming and editing, or montage; they also seem to introduce an analogical slippage towards a plastic conception of programming where a cinema-effect is expressed. Duchamp explained how "[the act of] showing made the work" (Païni, 1992 : 23). Cage and Boulez epitomized the practice of collage and the connections between works. Barthes, with *A Lover's Discourse: Fragments*, invited to "teach the history of a literature, no longer stemming from a chronological and evolutionist conception, but derived from an artistic project privileging intuitive associations and experimental comparisons, in other words a history of literature which would itself be a writing" (Païni, 1992 : 26). From one

end of this gallery of "portraits of artists as programmers" to the other, one found Henri Langlois and Jean-Luc Godard, whose respective oeuvres were compared to montages of attractions, in an explicit reference to Eisenstein.

From the Cine-Father to the B-Movie Filmmaker[6]

The analysis of *Histoire(s) du cinéma*[7] may be qualified as heuristic in the thought on programming developed by Païni: "such is Godard's project today, as Langlois's yesterday: to use passages to free themselves from certain constraints (one of which, the availability of films, is not the least). It is about covering a history of cinema thanks to the remains of cinema, 'scrap films,' if I may call them that, found in the garbage, salvaged from the apocalyptic history of an uncertain art which Langlois described as almost devastated and which a certain type of historian, comparable to a ragman, may write" (Païni, 1997 : 83).

If these two manipulators of films meet as they bring into play an imaginary museum of cinema, Godard benefited from video as a technical tool for historical comparison, whereas the ephemerality of projection always set objective limits to Langlois's impulses.[8] Still, like Godard's, Langlois's work comes down to "brutalizing films, twisting them, setting their signification ablaze, diverting them from the project of their author to reveal the madness in them – a madness repressed by Hollywood's industrial and moral system, and which is exalted (exhaled) as soon as programming edits films together in a montage like that of Eisensteinian attractions and irreversibly turns categories and generic or stylistic labels upside down" (Païni, 1997 : 179). A study of screening schedules[9] shows a method made of synchronous lines, comparisons, and juxtapositions tending towards cinematographic figurability; and where, in the end, "the association of films itself amounts to an image" (Païni, 1997: 173). On the scale of an evening, and more largely of a retrospective, programming heritage films thus becomes a signifying montage subject to the same constraint of temporal unfolding as a film.

The analogy between film and programming suggested by Dominique Païni – but never stated so literally by him – may help design the exhibition of films in cinemathèques. Its limitations are in the fact that professionals in film archives have not embraced it, which is why I propose, by way of conclusion and more generally, to question the historical context in which this interpretation appeared.

In the mid-1990s, the issue of showing the collections seemed to preoccupy museologists. In 1993 André Desvallées referred to the "know-how of exhibitions" as "expographie," or "exhibition writing," thus singling it out among

the many activities of museums (Desvallées, 1996 : 174). Dominique Païni's discourse should be read in the same climate of clarification in professional practices. One may wonder, then, whether the reference to cinema to explain programming in cinemathèques did not tend to legitimize the entrance of film into the museum in the eyes of rather reluctant cinephiles.

Clearly, however, this cinematic way of thinking about programming was steeped in a personal film culture nurtured on Bresson, Straub, and Godard, to mention but a few. This raises a more general question: could the consecration of cinema as part of the national heritage not also be translated in its re-appropriation as material for thought? Taking advantage of undeniable technological advances, contemporary artists, and exhibition places, through their respective practices, seem to have answered in the positive.

9.2.2 THE EXPANDED ARCHIVE: THE MINDFRAMES EXHIBITION

Claudia D'Alonzo

From 16 December 2006 to 18 March 2007, the ZKM – Center for Art and Media in Karlsruhe (Germany) hosted the exhibition *MindFrames – Media Study at Buffalo 1973-1990,* curated by Woody Vasulka and Peter Weibel (Vasulka and Weibel, 2008). The exhibition presented works by some of the most important artists from the Department for Media Studies at Buffalo (New York University) who, through their teaching, contributed to making this a leading institution in the history of media art: James Blue, Tony Conrad, Hollis Frampton, Paul Sharits, Steina and Woody Vasulka, and Peter Weibel. *MindFrames* spanned 30 years, the time during which the department was under the direction of Gerald O'Grady. As the founder and lead figure at Buffalo, O'Grady created an inter-disciplinary teaching structure based on the synergy between very different areas including technology, communication, art, and experimental cinema (Minkowski, 1978). The artists shown in the exhibition can be seen as pioneers exploring the relationship between art and technology, as demonstrated by their studies on techniques, tools and languages, as well as their theoretical research, developed in papers, conferences, and publications (Vasulka and Vasulka, 1992).

MindFrames represents an important event in the media art field for two main reasons. First, the exhibition has brought the Buffalo Media Study's experiences into the museum context, through the presentation of a large number of works that had not previously been shown in a single display. This represents an important act of cultural memory and documentation. Second, *MindFrames* is an exemplary case of innovative media art exhibition design. As we shall see, the curatorial project has re-edited the specific features of "the digital database as symbolic form" into an exhibition, as identified by new media theorist Lev Manovich (Manovich, 2001:194). The choices made by the two curators deal with a complex ongoing debate, which aims at establishing modalities for bringing media art to the museum. Whilst the exhibition is not a final response to the numerous issues raised by this debate, it has certainly suggested some interesting new directions. These two focuses of *MindFrames* have been made possible thanks to a third one, represented by the *digitization* of the works. Indeed, a large part of the analogue works (film, video) has been transformed into digital. The following text aims to show how *MindFrames* represents an original example of media art exhibition.

Within his analysis of the transformation of audiovisual contents caused by the migration from analogue to digital media, the German media archae-

ologist Wolfgang Ernst highlights that the most significant consequence is not the re-activation of audiovisual cultural objects but the creation of relationships between those objects through hyperlinks. Indeed, one of the main functions of the digital archive is not to record each single file, but to establish logistic links between them. In the same way, the Net is not characterized by its contents but rather by the protocols of information exchange (Ernst, 2010: 4). The digitization process implemented on the *corpus* of *MindFrames* thus has transformed each document in an ontologically dynamic digital object, participatory and located in a network of relations. The filmic and analogue video materials in this exhibition have been transformed into digital data not only in order to preserve them from deterioration, but also to transform them into digital information, recorded onto a server, connected to the Internet and the exhibition space. This setup allows the audience access through different modalities inside the exhibition space as well as via an online platform, as we shall see. *MindFrames* makes the digital archive structure of complex relations a fruitful model for exhibiting media art: it encourages each spectator/user to 'browse' through the hyperlinks network, moving through the relationships of connected artworks and consulting the network in interactive ways.

The exhibition setup, designed by Woody Valuska and produced by Shinya Sato, divided the large space on the ground floor of the ZKM Media Museum into three concentric rings, including separate areas within them (Minkowski, 2007: 57). The outside ring was a large circular space accessible from various directions. It contained artworks by all the artists, mixed together. Along the ring, the audience could find several kind of works, mainly video wall projections but also various installations which had been redesigned especially for the exhibition: from the Vasulkas' multichannel video matrix, Weibel's video installations, and Woody Vasulka's "interactive mechanical ambients" to Paul Sharits' film projections. Besides the installations, the outside ring also contained a "galleria," displaying a variety of paper documents and photographic material, as well as a film room, a video room, a documentary room, and a concert room, for audiovisual performances.

This variety of works faithfully represented the richness of personalities that characterized the Buffalo Media Study's scene. The same function was performed by the *Grand View,* a large projection on three screens showing footage of many of the exhibition's works. This screen was suspended in the center of the exhibition space that could be surveyed from the balcony on the second floor. The general overview from the first ring represented an exhaustive recognition of the languages and media experimentations that allowed the birth of what is now called media art.

From this collective space, the rest of the exhibition zoomed in on the work of each author: the audience had access to several small projection rooms ded-

icated to each artist, similar to black boxes, in which the works were projected on the walls. A circular room at the center of the exhibition was divided into eight media labs, one for each artist, showing a collection of works that aimed at increasing understanding of the individual artist. In this area, there were eight video jukeboxes, interactive workstations with a touch screen which allowed the viewer to select films or video artworks and archival video interviews with the artists. The whole audiovisual content – in total approximately 400 hours of film, video, documentary, and video interviews – were distributed into the exhibition spaces from a central server.

Three features that Woody Vasulka established as bases of the *MindFrames* project were fundamental in creating an exhibition of this kind. According to Vasulka, the whole exhibition should have been presented: first, in digital format; second, remotely controlled (thus delocalizing the connection between the exhibition and the actual artwork), and third, disseminated through the Internet using the OASIS Archive, which is a platform for the presentation and dissemination of audiovisual works and other documents independent of exhibition location, through the web.[10] Using such an interactive, online interface, the single users (individuals, researchers, and general public) have access to an interlinking database metadata system, collecting documents available by institutions taking part in the project.

The concept of the exhibition thus was that of a macroscopic database connecting the exhibition spaces of the ZKM in Karlsruhe to a server located in Cologne – a server which hosted the large number of audiovisual works/data. This method has never been applied to a media art exhibition. The OASIS platform is the element that has allowed the transposition of the exhibition process into an expanded online database access experience. The digital archive retains features described by Wolfgang Ernst: a relationship structure, represented in the exhibition by the net of hyperlinks connecting the documents; a dynamic nature, as represented by different access modalities; and interactivity, which is enabled through the exhibit's video jukeboxes.

Consequently, besides seeing *MindFrames* as an exhibition project, one should also analyze it as an innovative distribution model for digital cultural content. An apt reference for such an analysis is the definition of database as a cultural form, elaborated by Lev Manovich. Manovich defines the database not only as an organization of electronic data, but also as a cultural metaphor that has a determining role in the construction, registration, and spread of knowledge and contents in the digital era. Manovich's analysis shows how the technical procedures related to digital archiving are not just a media aspect but have important consequences for the intrinsic nature and dissemination of information: the computer ontology projects its consequences on the contemporary culture and society (Manovich, 2001:194). As I have already empha-

sized, *MindFrames* makes this essential shift from a technical realm into a cultural one visible, making the digitization and archiving processes useful models for designing the exhibition display.

In his discussion of the exhibition in the accompanying catalogue, John Minkowski acknowledges the exhibition's historical value but criticizes it for the possibilities of experience given to the audience. Minkowski states that the large number of works and documents presented in a way presents a limitation to the project: "Viewers may have been sated, gasping for breath, and at the same time frustrated at not being able to take it all in. After six days there, I still felt that I had only scratched the surface" (2007: 57). He thus indicated the impossibility of entirely observing the corpus of works and so to perceive the abundance of materials as an obstacle to interpretation. Minkowski here points out a weak spot of the exhibition, which, to refer once again to the database model of Manovich, we could call the subject of "interface."

One of the main repercussions that electronic document archiving produces on contemporary society is the requirement to design the ideal interface to reproduce information and elaborate access procedures. Manovich underlines that traditional cultures had little information but could find excellent interfaces for their diffusion in well-defined narrations such as myths and religions. On the contrary, the digital era is characterized by an information overload but still has not managed to develop satisfactory methods to interact with all these data. Once again, the main point is not the content in itself but the architecture of access to the data. This requires what Manovich has dubbed as *info-aesthetic*: a theoretical analysis of the aesthetic of access (Manovich, 2001: 193).

For these reasons, *MindFrames* represents a possible interesting case study addressing one of the main issues of digital media studies through a cultural project. Coming back to Minkowski's view, his analysis does not consider the innovative and deep structure of the exhibition. More specifically, whilst recognizing the value in the wealth of documents and access modalities, Minkowski is hopelessly searching for a linear and narrative model of interpretation. As becomes clear from the above discussion of the specific nature of digitized audiovisual content, linear narration is not the appropriate model for making sense of a database-style exhibition like *MindFrames*. In the same way as a user relates to a database, the viewer should completely renounce the claim to look up the whole artwork, finding an always different way to navigate through the corpus. So, *MindFrames* encourages the viewer to an exhibition experience which uses dynamic and interactive navigation at the same time, dislocated from the *hic et nunc* of the exhibition space.

9.2.3 EXHIBITING FILM AND REINVENTING THE PAINTING

Barbara Le Maître

Following up on Philippe Dubois's thoughts on the "cinema effect" and contemporary strategies of presentation of films in museum spaces, I would like to examine the encounter between film and painting. As the primary object in museum exhibitions, at least when it comes to art museums, the painting as an object operates according to a particular visual regime and falls within a system that regulates its perception.[11] Questioning the encounter between film and painting seems necessary insofar as the discussion inaugurated around the turn of the 1990s on the entrance of film and/or cinema into the museum has focused more on what happens to cinema in the era of its exhibition in museums (instead of its projection in movie theaters) than on what happens to the forms and objects that have historically constituted the museum in the era of their contamination by film.

Before getting to the heart of the matter, some specifications are in order. If, as this text proposes to discuss, the encounter between film and painting is vividly or intensely actualized these days on the contemporary art scene, on the one hand, this encounter takes place against the background of a history of cinema regularly confronted with the issue of painting and, on the other hand, the same encounter introduces a kind of dialectical reversal in the field of contemporary art.

On Contemporary Art (in General) with Regard to the Painting[12]

Indeed, it seems that contemporary art was established on the principle of a refusal, and even a firm dismissal, of the painting:

> For several decades, painting has alternately been declared dead and back. Painting does not come back any more than it dies. Yet the painting has disappeared or is disappearing. The unease produced among many sincere art lovers by the art of our time owes to the sense that artists today live and create on an absence and a lack [...]. The painting is par excellence an object that may be stored. It may be kept as easily on the walls as in compact reserve collections, safe and easily accessible. That is not the case of the majority of works produced over the past forty years, and more particularly of the large installations which are to contemporary art cent-

| 335

ers and major exhibitions such as the biennales and the Kassel Documenta what the paintings made for the Salons were to the eighteenth and nineteenth centuries. (Wolf, 2005 : 11, 31)

All in all, contemporary art has cast aside painting as a medium and as an art form, opting instead to materialize in other forms such as installation or performance – or so the story goes. In this context, if the contemporary exhibition of film does imply painting, as I assume it does, the event in the field of contemporary art is a considerable one: something like a "return of the repressed" or, to put it more precisely, a reappearance of the major issue of painting on the very site where it was contested (and from which it was even ousted).

On the History of Cinema (in General) Confronted with the Painting

While contemporary art was established without the painting, the same does not apply for cinema. Indeed, briefly put, cinema never ceased to be in confrontation with painting throughout its history, albeit in multiple and diverse modes – as if the film image had to negotiate its "visual logic" with its prestigious pictorial equivalent in order to exist as a valid image. The expression "painting shot" (*plan-tableau*) emblematically returns all the time in discourses related to cinema, in various texts and with different meanings, qualifying a form of autonomy of the shot inherent in early cinema for Noël Burch (1990), for instance, or a transposition of painting into a tableau vivant more strongly connected to modernity for Pascal Bonitzer (1987: 29-41). Still, can the question of the painting actually be addressed by any filmic object?

> Essentially, a painting is an object and it is 1) painted; 2) visible;
> 3) mobile (it may be moved without any other operation than transportation); 4) autonomous (neither its spatial organization nor its signification are modified by these movements; 5) symbolic (its symbolic value is always higher than its functional uses); 6) unique (there is only one original);
> 7) identity-related (it has an identified author and contributes to the identity of its individual or collective owner); 8) valued on a market (it draws its monetary value from demand) (Wolf, 2004 : 84).

Beyond the regular comparisons between certain types of shots and the model of the painting, cinema, for the most part, admittedly produces objects which do not really refer to pictorial objects called "paintings." And the multiple, moving, luminous images of cinema definitely involve effects of material and

medium that are quite different from those produced by the pictorial object. In addition, which is the medium of the image in cinema: the surface of its inscription, or the ever-ephemeral surface of its projection? Also, the distribution of the film in the form of multiple prints runs against the principle of uniqueness of the original which defines the painting – among other noticeable differences.

It is in the field of contemporary art, on the walls of galleries or museums rather than in traditional movie theaters, and precisely on the side of what Philippe Dubois describes as a "cinema effect," that such hybrid objects may be identified. While any confusion with their pictorial equivalents is unlikely, they still reinvent the painting object *in spite of everything*, reformulating its aesthetic as well as its economy (as far as the articulation between original and copy is concerned, for instance). This phenomenon of re-appropriation of the painting is best exemplified by two figures: Sam Taylor-Wood, whose *Still Life* (video stills, 2001), exhibited at the Tate Modern, is made up of components | 337 that disintegrate in speeded-up motion before the spectator; and Mark Lewis, with his single-shot films that look like "slow paintings," to borrow Julien Foucart's expression. But then, how does this re-appropriation play out?

On a Particular Encounter between Film and Painting on the Contemporary Scene:
The Example of *Algonquin Park, September* (Mark Lewis, 2001)

In a text devoted to the pictorial aspects of Mark Lewis's films, Bernhard Fibicher (2003) goes back over a few paintings which seem to lie behind *Algonquin Park, September*. He evokes more specifically *Boat on the Elbe in the Early Fog* by Caspar David Friedrich (1821). Sometime earlier, another commentator had also mentioned Friedrich while suggesting that the hybridity at work in the film was more complex and richer:

> Although it was shot in Ontario in Canada, it could easily be the setting for a Caspar David Friedrich painting [...]. Slowly, as the mist begins to clear, it reveals a small boat being rowed through the channel between the island and the shore. The allusion here is to the Lumière brothers, and their film *Boat Leaving the Harbour* (1895) – Lewis's own personal favourite of all the Brothers' films and, in his view, one of the seminal landmarks in the history of cinema (Bode, 2002 : 16).

In short, this is a film that, in some respects, repeats a project which was initially that of painting (Friedrich's, in the first place), while paying homage to

the cinema of the Lumière brothers (not to say *remaking* it). Yet exactly which aspects of this film belong in the pictorial realm? And how does the film alter or, perhaps, even reinvent the painting?

If *Algonquin Park, September* is so strongly associated with the painting, beyond the reference to Caspar David Friedrich, it is first of all because Mark Lewis renews the "aesthetic system of the painting,"[13] referring to "a principle of arrangement (as well as contained expansion) of a fable or a complex figure within the strict frame of a composition," in Jean-François Chevrier's words (1990 : 75). However, all things considered, this principle qualifies the views resulting from the filming setup typical of the Lumière brothers as well as the ordinary visual organization of the painting – a setup that, as is well known, combined a still, single frame and an uninterrupted recording lasting as long as the reel itself. Of course, in the Lumière films, as well as the Lewis one, and unlike the painting, some motifs or figures sometimes exceed the frame – but most of the time, representation does not follow them. In other terms, keeping to the still, single frame, the Lumière films did contain and even *curbed* the potential expansion of the fable and its figures. Incidentally, the history of cinema largely revolved around this site, this problem of an "expansion of the fable" beyond the edges of the frame, the strict frame of a composition... In the end, through this double – pictorial and cinematographic – reference (the coupled allusion to Friedrich's painting and to the Lumière films), Mark Lewis points out something like a complicity or a kinship between the aesthetic logic of the painting and a type of shot inherent in early cinema (see Fibicher, 2003). Most of all, Lewis gives this complicity, which more or less secretly runs and works through the history of cinema, a concrete, visual form.

Indeed, at a different level, "the impression of a painting" is evidently reinforced by the exhibition of Lewis's works on the white walls of museums or galleries, rather than in the darkness of cinemas. The reinvention of the painting thus implies qualities internal to the representation as well as other qualities relative to the places and modes to display this representation.

Finally, if the painting is a matter for discussion here, notably when it comes to its relation with the setup of the Lumière films and beyond, it is not only because the filmic painting brings its "luminous material," its "reproduced movement," and its "recorded temporal flow" to the painting, but also because the principle of the loop, which governs the exhibition of such films in museum spaces, allows something like an *intermittent painting* to appear suddenly, then disappear, reappear, disappear again, and so on.

NOTES

1 Raymond Borde, the curator of the Cinémathèque de Toulouse and a historian of cinemathèques, has published an overview of these questions (Borde, 1989).

2 The Cinémathèque française was founded in 1936 out of a ciné-club, Le Cercle du cinéma. The fact that screenings were privileged over the scientific preservation of prints caused a break with the FIAF in 1959 and spurred the creation of the Service des Archives du film of CNC in France in 1969.

3 In the 1980s, Dominique Païni was the programmer at the movie theaters Studio 43 and Studio des Ursulines in Paris.

4 Some examples from the program at *Studio 43*: "La France de Pétain et son cinéma" on the occasion of the publication of Jacques Siclier's book, "Le cinéma après guerre: Libération et moralité," relying on Raymond Chirat's *Catalogue des films français de fiction 1940-1949*, "Le cinéma français 1970-1980: de nouveaux imaginaires," inspired by François Guérif's book *Le Cinéma policier français*.

5 Founded by Raymond Borde in 1964, the Cinémathèque de Toulouse, in its first 20 years, was mostly a place where relations between cinema, history, and society were explored.

6 In an August 19, 1983 column, Serge Daney used this expression with respect to the French critic André Bazin, whom he then compared to Henri Langlois: "He was, with Henri Langlois, the other great B-movie filmmaker of his time. Langlois had an obsession: to show that all of cinema was worthy of preservation. Bazin had the same idea, but in reverse: to show that cinema preserved the real and that, before signifying it and looking like it, it embalmed it" (Daney, 1998 : 41).

7 A series of eight documentaries, *Histoire(s) du cinéma* was made between 1988 and 1998 by Jean-Luc Godard. Using excerpts from preexisting films, these documentaries are not structured chronologically. Instead, they rest on a montage proceeding by association of ideas, themes, and stylistic concepts. With the collage, spectators find themselves confronted with a subjective vision of history that draws its mode of expression from the resources of cinema itself.

8 Projections of excerpts were to punctuate the progression of the Musée du cinéma, but they could not be maintained on a long-term basis for technical reasons having to do with overheating projectors (Mannoni, 2006 : 425).

9 The study was carried out using the program from the retrospective *25 ans de cinéma* organized for the 20th anniversary of the Cinémathèque française (1 October 1956-31 March 1957 at the Musée pédagogique, rue d'Ulm in Paris). The catalogue can be found at the Bibliothèque du film in Paris (PCF 18-B1 : 1956).

10 See www.oasis-archive.eu/. The OASIS Archive is designed to be a user-friendly interface for digital document research and for the dissemination of individual works. At the same time, incorporation into the OASIS Archive assures the preservation of the digitized artworks.

11 This text deliberately refers to the painting as a particular object and thus uses the phrase "the painting" as the translation of "le tableau" in the French original.

12 For more developments on the relation of contemporary art to painting, please see my text "De *l'effet-cinéma* à la *forme-tableau*" (Le Maître, 2009). I wish to thank Luc Vancheri for allowing me to use some elements from that text here.

13 In French: "système plastique du tableau".

REFERENCES

Bode, Steven. "Orbital – Périphérique." In the exhibition catalogue *Mark Lewis*, London, Film & Video Umbrella. Oxford/Nice: Museum of Modern Art/ Villa Arson, 2002.

Bonitzer, Pascal. "Le Plan-Tableau." In *Décadrages – Peinture et cinéma*. Paris: Cahiers du cinéma & Editions de l'étoile, 1987.

Borde, Raymond. "Les cinémathèques patrimoine ou spectacle." *Archives* 25 (1989) October.

Burch, Noël. *Life to those shadows*. Los Angeles: University of California Press, 1990.

Chevrier, Jean-François. "Les aventures de la forme tableau dans l'histoire de la photographie." In the exhibition catalogue *Photo Kunst, Arbeiten aus 150 Jahren – du XXè au XIXè, Aller et retour*, 11 November-14 January 1989. Stuttgart: Staatsgalerie Stuttgart, 1990.

Claes, Gabrielle. "Montrer les films conservés." *FIAF Manual for the Access to Collections*, July 1995: 1-8.

Daney, Serge. "André Bazin." in *Ciné journal. Vol. II. 1983-1986*. Paris: Cahiers du cinéma, 1998: 41-46.

Desvallées, André. "L'expression muséographique. Introduction." In *Rencontres européennes des musées d'ethnographie. Actes des premières rencontres des musées d'ethnographie (1993)*, edited by Claude Badet and Jacqueline Kerveillant, 173-176. Paris: École du Louvre, 1996.

Dubois, Philippe. "Un 'effet cinéma' dans l'art contemporain." *Cinéma & Cie* (2006) 8: 15-26.

Ernst, Wolfgang. "Underway to the Dual System. Classical Archives and/or Digital Memory." In *Netpioneers 1.0. Contexualizing Early Net-based Art*, edited by Dieter Daniels and Gunther Reisinger, 81-99. Berlin, New York: Sternberg Press, 2009.

Fibicher, Bernhard. "Painterly aspects in Mark Lewis's new films." In the exhibition catalogue *Mark Lewis*. Bern: Kunsthalle Bern, Argos Editions, 2003.

Foucart, Julien. "Les peintures lentes de Mark Lewis." *Dits* (Fall-Winter 2006) 7: 36.

Jousse, Thierry, Charles Tesson, and Serge Toubiana. "Cinémathèque. l'Art de programmer. Entretien avec Dominique Païni." *Cahiers du cinéma* (September 1992) 459: 83-89.

Le Maître, Barbara. "De *l'effet-cinéma* à la *forme-tableau*." In *Images contemporaines –
Arts, formes, dispositifs*, edited by Luc Vancheri, 117-132. Lyon: Aléas, 2009.

Le Péron, Serge, and Serge Toubiana. "Court-Circuit. Entretien avec Dominique
Païni." *Cahiers du cinéma* (March 1984) 357: 41-45.

Mannoni, Laurent. *Histoire de la Cinémathèque française*. Paris: Gallimard, 2006.

Manovich, Lev. *The Language of New Media*. Cambridge, MA: MIT Press, 2001.

Minkowski, John. "MindFrames. Media Study at Buffalo, 1973-1990." *Film Quarterly*
61 (2007) 2: 56-62.

—. "The Videotape Collection at Media Study, Buffalo." *Afterimage* 5 (1978) 7 – http://
www.experimentaltvcenter.org/history/people/ptext.php3?id=59&page=1. Last
access: 20 September 2012.

Païni, Dominique. "Portrait du programmateur en chiff nier." *Le Cinéma, un art mod-
erne*, Paris: Cahiers du cinéma, 1997.

—. "La cinéphilie au risque du patrimoine, ou les états d'âme d'un cinéphile devenu
conservateur." *Cahiers du cinéma* (January 1996) 498: 54-57.

—. "Sans l'ombre d'un pli. *Falbalas* de Jacques Becker." *Cinémathèque* (Spring 1995)
7: 29-34.

—. *Conserver, montrer. Où l'on ne craint pas d'édifier un musée pour le cinéma. Pro-
gramme*. Paris: Yellow Now, 1992.

—. "Cinéma prénom musique. Note d'un montreur de films incertain(s)." *Cahiers du
cinema* (February 1984) 356: VI-VII.

—. "Lettre sur '*Les Clowns*'." *Cahiers du cinéma* (May-June 1971) 229: 64-65.

Rauger, Jean-François. "Misère de la monographie, monographie de la misère." *Ciné-
mathèque* (Spring 1995) 7: 106-111.

Vasulka, Woody, and Peter Weibel (eds.). *Buffalo Heads. Media Study, Media Practice,
Media Pioneers, 1973-1990*. Karlsruhe/Cambridge, MA: ZKM | Center for Art and
Media/MIT Press, 2008.

—, and Steina Vasulka (eds.). *Eigenwelt der Apparatewelt. Pioneers of Electronic Art*.
Linz: Ars Electronica, 1992.

Wolf, Laurent. *Après le tableau*. Paris: Klincksieck, 2005.

—. *Vie et Mort du tableau* (vol. I). Paris: Klincksieck, 2004.

| 341

9.3 THE IMAGE TRAVELING ACROSS TERRITORIES: CINEMA, VIDEO, TV, MUSEUM, THE WEB, AND BEYOND

9.3.1 ON PASSAGES BETWEEN ART AND CINEMA

Ariane Noël de Tilly

In the section *Passing on Historical Images: Experimental Cinema and Video Art* of his article on the cinema effect in contemporary art, Philippe Dubois briefly mentions how experimental filmmakers and video artists have operated in the passages between art and cinema. He argues, on the one hand, that experimental cinema has originated "installations" as another existing form of cinema and on the other hand, that it is video art that has introduced the large-scale moving image in museums and art galleries. In what follows, I would like to propose a few nuances and complementary perspectives by discussing historical examples. Firstly, because a few artists, such as Andy Warhol, have worked with both mediums from the start, and secondly, because these experimental filmmakers and video artists shared concerns with other flourishing art forms of the time such as minimalism, conceptual art, and installation art. The aim is thus to broaden the perspectives to examine these passages.

One of the first dialogues or passages between the universes of art and cinema is Andy Warhol's *Outer and Inner Space* (1965), a work that combined video and film in its making. In August 1965, the New York-based magazine *Tape Recording* lent a Norelco video recorder to Warhol in exchange for an exclusive interview (Goldsmith, 2004: 71). The artist first presented the videotapes in October 1965 in an underground space.[1] He eventually used two of the videotapes he had made, recordings of Edie Sedgwick, in the making of *Outer and Inner Space*. The film is made of two reels, each lasting 33 minutes. Each reel portraits a filmed Edie sitting next to a flattened Edie (the image prerecorded on video and played on a monitor). The actress is talking to a person outside the screen and, occasionally, when she turns a little towards the right it gives the impression that she is having a conversation with herself as if the filmed Edie is talking to the videotaped Edie. As stated by curator Callie Angell, the "outer" and "inner" of the title "refers not only to the dichotomy between Sedgwick's outer beauty and inner turmoil, so vividly diagrammed in this double portrait, but it also describes the two very different spaces of representation occupied by the video/television medium and by film" (2003: 14). By using both video and film for the making of *Outer and Inner Space*, Warhol was able to explore their similarities and differences. Working with both mediums was rather infrequent in the 1960s, but it became common practice in the

1970s, as some artists were using videotapes to record, but would then transfer the result to films (and vice versa). *Outer and Inner Space* was first screened as a double projection in January 1966 at the Filmmakers' Cinematheque in New York, a place where many experimental filmmakers were presenting their films at the time. Warhol's *Outer and Inner Space* is exemplary of this passage between the universes of video and cinema as it can nowadays either be *exhibited* in a museum or *screened* in a cinema; it has different presentation modalities: it can either be a single or double projection – in the former case, the two films are projected one after the other; and it finally combined, in its making, video and film.

Another type of passage that occurred in the 1970s was when experimental filmmakers and visual artists deconstructed the cinematic experience and exhibited the components making it possible in museums, art galleries, and alternative spaces. For instance, with works such as *Line Describing a Cone* (1973) and *Long Film for Ambient Light* (1975), Anthony McCall made visible to the audience elements that were not intended to be explicitly seen by viewers in the cinema: the projector, the beam of light, the screen, the projectionist, and the space itself in which the projection was taking place. *Line Describing Cone* "is dealing with the projected light-beam itself;" it "begins as a coherent line of light, like a laser beam, and develops through the 30 minute duration, into a complete, hollow cone of light" (McCall, 1978: 250). Rather than being projected on a screen, the film is projected on a wall. Artificial fog is also introduced in the exhibition space, to make the beam of light clearly visible as it develops into the shape of a cone. Because viewers are invited to walk about, around, and through the cone of light, *Line Describing a Cone* cannot be presented in a standard cinema; it needs an empty space, as it is a three-dimensional work.

In 1975, at the Idea Warehouse in New York, McCall proposed an even more radical experience: a film that did not use camera, filmstrip, projector, or screen. *Long Film for Ambient Light* used space, light, and duration instead. Over the course of twenty-four hours, McCall invited visitors to walk into an empty Manhattan loft where the windows had been covered with diffusion paper and lit in the evening by a single lightbulb hanging from the ceiling. In *Long Film for Ambient Light*, McCall stripped down the cinematic experience to its most fundamental feature: light. At the same occasion, it reminded the public that if there is no lightbulb in the projector, then the film remains invisible.

In this translation of the cinematic components from the cinema to the space of museums and art galleries – thereby turning them into "light cubes"[2] – the influence of other artistic movements evolving at the same time such as minimalism and conceptual art, has to be considered. After all, McCall and

| 343

other artists and filmmakers exhibited the minimal and necessary features of the cinematic experience, and, in many cases, this was done within a rigorous conceptual structure. Cinema is approached here as an idea and experiments were done about how the idea of cinema could be expressed through different means. The aim was also to remove the emphasis on the very medium of film, to trigger a shift of perception, and to stress the importance of the process. Like artists working in the field of minimalism or conceptual art, they questioned the very nature of art and eliminated all non-essential forms; they introduced a shift in the perception of the viewers.

While certain artists were conducting experiments with film to exploit its sculptural properties and its possible expansion in space, others began working with video.[3] Until the first Sony Portapak was released in 1965, artists such as Nam June Paik and Wolf Vostell made interventions on television monitors. Françoise Parfait has coined the term "vidéoclasme" to qualify their actions (2001: 21). As she explains, Paik and Vostell treated the monitors as sculptural forms and objects that they had to position and to connect in the available space. The artists initially distorted the TV signal and worked on the display of the monitors themselves; they were not yet dealing with videotapes. It is also important to point out that video art and video installations appeared almost at the same time. Indeed, Paik and Vostell's interventions can be called video installations, as the artists had taken into consideration the space in which the artworks were presented. These works were developed in the exhibition space itself rather than in the studio. The gallery space became their site of creativity. In that sense, video was just as important as film in rethinking the exhibition modalities of the museum.

Alongside these "vidéoclasmes," other artists, such as Peter Campus, were working with the real-time feedback property of video. In 1974, Campus created *Shadow Projection*, a closed-circuit video installation in which the viewer can see herself projected in the exhibition space as her presence was recorded live by a surveillance camera.[4] This interactive artwork uses a theatrical light, a surveillance camera, a screen, and a projector. The surveillance camera and the projector are connected in order to form a closed circuit. Once the visitor stands in front of the light, the surveillance camera records her body and the recorded image is projected in real time on the screen displayed in the exhibition space. If the visitor is facing the screen, then it is her back that is projected onto it; if she is facing the camera, then her front is projected onto the screen; either way, the visitor will never be able to see her front as she cannot look in both directions (towards the surveillance camera and towards the screen) at the same time. Campus' work made the visitors realize that *Shadow Projection* could not be apprehended by a unique and single point of view. A frontal perspective was no longer possible.

Like Paik's and Vostell's interventions discussed above, Campus's *Shadow Projection* has to be considered within a broader scope of artists who started making installation art in the 1960s and 1970s. In the beginnings, the artists were making ephemeral, temporary and site-specific works. One of the main features of installation art is spectator participation. As Campus has claimed, the work was interactive because "the projection really engaged the viewer to become, literally a part of the piece" (Hanhardt, 1999). Campus' closed-circuit video installations were perceptual experiments in which the viewers were invited to perform actions and to try to understand how their movements in the exhibition space were projected onto the screen. These works by Campus share the concerns that artists making installations had: turning the visitors into participants.

To conclude, the artworks discussed above have led us to adopt complementary perspectives to look at the passages between art and cinema. Rather than uniquely examining the passages between video art and experimental cinema, the present contribution attempted to contextualize the creation of video art and experimental film within the artistic production of the 1960s and 1970s, and more specifically, in relation to minimalism, conceptual art, and installation art. Firstly, the example of Andy Warhol's *Outer and Inner Space* has shown that video art and film were intertwined in his artistic practice. It was also used to point out that works such as *Outer and Inner Space* offer different exhibition modalities and that they do not have a unique destination (the cinema or the museum) as they can be screened and exhibited. Secondly, the study of Anthony McCall's *Line Describing a Cone* and *Long Film for Ambient Light* showed how McCall has deconstructed the cinematic experience and how he has questioned the very nature of the film medium. His approach shares similarities with the concerns of conceptual and minimal artists who were working at the same period and who were challenging the nature of the art object and the spatial experience with their interventions. This should be taken into account while looking at these passages. Thirdly, the last examples discussed (Paik, Vostell, and Campus) showed how the artists shared the concerns of contemporary artists making installations and how they attempted to turn the visitors into participants.

9.3.2 ACROSS THE TERRITORIES: EXHIBITING MUSIC VIDEO

Senta Siewert

In recent years, a particular genre of media art is increasingly finding its way into museums and art galleries without much recognition from art and film scholars, namely, the music video. Also in scholarly research on media art, the music video genre generally tends to receive only passing mention. The reason for this seems to be that music videos are usually perceived as a purely commercial medium, and not an art form.[5] The art world's failure to recognize the music video is compounded by its ever-decreasing presence on television, which has led some media critics to speak of the "death of the music video," not unlike the concerns around the "death of cinema" (see Cherchi Usai, 2008). By contrast, as I will show, music videos are alive and kicking, and the changes taking place within music television can be seen as an opportunity for music video to expand into other venues. Moreover, I argue that the music video deserves the same kind of attention as film and video art, since these accepted art forms often clearly borrow from the visual and narrative strategies of the music video. As this contribution will make clear, a volume on media art such as the present one should necessarily take the phenomenon of the music video into account.

Taking a cue from Thomas Elsaesser, who argues for museums as a permanent home of film art, I will make a similar claim for music video art within museums. Elsaesser writes that canonical films should be perceived from the perspective of art historians or film anthropologists. As Elsaesser explains, "[t]he archive and the museum can and must take over from the film studio, the distributor and the exhibitor, to save, restore, preserve and *valorise*: as artworks as well as heritage and cultural patrimony" (Elsaesser, 2009: 1).

Philippe Dubois is similarly interested in the relationship between cinema and the museum. With his concept of "cinema effects," Dubois describes certain video installations that introduce the cinematic apparatus into the museum context and which refer to cinema or to film history.[6] In what follows, I discuss how Dubois' idea of the "cinema effect" can be used productively when discussing the role and place of music videos in the contemporary exhibition scene. I suggest to call this phenomenon a "music video effect." While Dubois examines only video installations that reference films, it is noteworthy that music videos also refer to films and television, often using the technique of found footage.

In the museum, various exhibition strategies reveal to what extent an artistic work is shaped by a particular mode of presentation. In what follows,

new exhibition platforms for music videos will be analyzed on the basis of three examples: *VIDEO: 25 years of video aesthetics*, which was shown at the NRW Forum in Dusseldorf, *I want to see how you see* in Hamburg's Deichtorhallen, with works by over 50 artists from the Julia Stoschek Collection, and the New York Guggenheim show *YouTube Play: A Biennial of Creative Video*.[7] I will first examine the existing relationship between MTV and television before elaborating on new contexts for music video, namely, the museum, festivals, the Internet and urban space. These new platforms provide a basis for understanding the distinct operations of the "music video effect" in contemporary arts and culture.

TV and MTV

The official emergence of music television in the 1980s was predated by extensive experimentation in video art. During the 1970s, many artists attempted to liberate modern art from its static existence. Video art pioneers like Nam June Paik and Wolf Vostell focused on the technology at first, manipulating the equipment itself. Vostell called this method "dé-coll/age." Television sets were covered in tape, wrapped in barbed wire or set in concrete, to emphasize the passive spectator sitting apathetically in front of the TV screen and waiting to be entertained. Examples include Nam June Paik's *Zen for TV* (1963), Wolf Kahlen's *Mirror-TV* (1969-1977) or Joseph Beuys' *Felt TV* (1970). The embrace of the music video as a new form of artistic practice by television coincided with these experiments in video art. In this sense the new art form of the music video followed the earlier experiments with synaesthetic perception, color-light-music and visual music in films by figures such as Walter Ruttmann, Oskar Fischinger and Hans Richter in the 1920s and 1930s. All of these practices attempted to fuse images and music into a unified whole.[8]

Starting in the 1980s, musicians and visual artists began to make use of the new platform of music television, where they could work on forms of visual expression guided by the music, and thus develop a new aesthetic. The starting point for the creative process was a preexisting song: musical structures that shaped the time axis could be transposed onto the image axis.[9] Short units (intervals) would be repeated, analogous to the repetitive note or chord progressions (riffs) of pop/rock music. Besides the typical portrayal of subcultures, the aesthetic of the music video marks a specific interplay of image and sound as well as a rhythm of the montage and the creation of new visual worlds. Some music videos use music that follows the image, while others create added value with a contrapuntal arrangement of image and sound.

The American broadcaster MTV increasingly began to feature videos

with fast-paced editing for mass consumption, thus fulfilling the demands of both the music industry (promotion) and the TV industry (entertainment).[10] Steve Blame, one of the first and best-known VJs, describes MTV as a promotional platform where a completely new star image could be established in the short period of three minutes.[11] However, from around the year 2000 music videos began to recede into the background of MTV's programming, which increasingly focused on docusoaps and reality shows. Since then, in order to be seen, the music video was in need of new screening venues and exhibition platforms. As a result, music videos are finding their way into museums and gallery spaces, a phenomenon that can probably be explained both by a new acceptance on the part of the art scene and the adaptation of music video to the art world. I will now examine the re-positioning of the music video more closely, with particularly attention to display strategies within the museum.

348 |

Museum and Art Gallery

The exhibition *VIDEO: 25 years of video aesthetics* showed 100 videos. The videos were displayed on individual monitors set up in rows, presenting the most important contemporary tendencies culled from the workshops and archives of the video avant garde. Ulf Poschardt, the exhibition's curator, stated: "In contemporary video, reality and fiction, high and low, art and advertising, identity and virtuality, all coincide" (Poschardt, 2003: 10). The monitors displayed art videos, advertising commercials and – for the most part – music videos. This selection meant that visitors were given the opportunity to compare the visual styles of the different videos and the overlap between genres. The exhibition demonstrated that many videomakers no longer have any reservations about working within multiple artistic forms. Among the artists and filmmakers whose work was shown in the *VIDEO* exhibition were artists such as Matthew Barney, Marina Abramovic, Anton Corbijn, William Kentridge, Pipilotti Rist, and Bill Viola.[12] Chris Cunningham, for one, participated not only with music videos and commercials but also with his video installation *Flex* (2000). A surprise was that Damien Hirst did not show classical video art, but a music video. Ridley Scott's commercial for Apple Macintosh (1984) was included, as was David Lynch's *Adidas: The Wall* (1994). In addition, the exhibition included videos by Jean-Luc Godard and an episode from Andy Warhol's MTV show *15 Minutes* (1986). The combination of music and advertising in the work of a single artist was evident with Spike Jonze's music video *Praise You* (1999) for Fatboy Slim and his *Lamp* commercial for IKEA (2002). The exhibition design reflected the equal status given to the three genres of music, art,

and advertising: the monitors were set up in rows in such a way that the different genres and examples could coexist side by side.[13]

By contrast, *I want to see how you see* – a 2010 exhibition in Hamburg's Deichtorhallen showing works by over 50 artists from the Julia Stoschek Collection – followed a different display strategy. The industrial architecture of the Deichtorhallen made it possible to use special structures to create a multifaceted video path leading the viewer through the exhibition. The roof of the great hall was covered up, creating a mysterious semi-darkness that served to draw attention to the video works. The most distinctive feature of the show was the decision to accord a central place to Björk's music video *Wanderlust* (2008). The video's position within the hall lent it equal, if not to say privileged, status alongside video art classics by Monica Bonvicini, Douglas Gordon, Isaac Julien, Anthony McCall, Marina Abramovic, and Bruce Nauman.

The video for *Wanderlust* was directed by the artist duo Encyclopedia Pictura (Sean Hellfritsch and Isaiah Saxon). Spectators equipped with 3-D glasses could experience the cinema ambiance of the black box and got immersed in Björk's fairy-tale dreamworld. In the video, Björk drifts through fantastic mountain landscapes. The vivid stereoscopic 3-D images show animals and landscapes created through a mix of classical animation techniques, computer graphics, and live-action filmed sequences. The 3-D effects evoke a bizarre world with its own structures and perceptual possibilities, and thus help create a surreal, illusionary, sensuous, and immersive experience. The video reflects the music's rhythm, and makes reference not only to the videos Björk created together with Michel Gondry but also films such as *The Never-Ending Story* (Wolfgang Petersen 1984), and early cinema classics like *A Trip to the Moon* (George Méliès 1902) and short films from cinema's first decades.[14] After having discussed museum strategies, I will now examine the existence of the "music video effect" in the context of festivals and via Internet and DVD platforms.

Festival, Internet, and Urban Space

Early cinema shorts of the kind mentioned above were showcased in a retrospective program at the 2010 Short Film Festival Oberhausen, under the title *From the Deep: The Great Experiment 1898–1918*. Some of them, such as the film *Serpentine Dances* (France/USA ca.1896–1898), seem like precursors of the music video since they have certain features in common with the music video such as the short length, and the dancing and musical accompaniment.[15] Apart from these early works, the festival also showed current music videos in the MuVi section, which was initiated in 1999 and has since become a key

component of the Oberhausen festival program. MuVi, a competitive section, brings together artistically noteworthy music videos from Germany and around the world. Thus, in addition to music television, museums, and galleries, the music video has found yet another platform: the film festival. Oberhausen's festival director Lars Henrik Gass confirmed this in an interview:

> It is really striking that music television, which introduced the genre of the music video, now shows fewer and fewer of them. It's a completely absurd development, but it has led to the very real possibility that music video will outlive music TV. In other words, music video nowadays has a thriving life of its own. Videos are shown at film festivals, they are watched on the Internet, they are having a wild time and really no longer need promotion from music TV to survive.[16]

Gass refers here to the Internet as a new presentation platform for music videos. Reinforced by the recent popularity of YouTube and other video websites, artists can now present their work online as well.

One of the music videos that was shown in the MuVi-section of the Oberhausener Kurzfilmtage was also shown in the same year at the first video biennial organized by YouTube in cooperation with the Guggenheim. In the 2010 exhibition *YouTube Play: A Biennial of Creative Video*, the music video *Synesthesia* by Terri Timely (2009) was one of the 25 winning films out of the 23,000 clips sent in from 91 countries. The jury evaluated the videos according to the categories of music video, experimental film, and animation.[17] These videos were shown as large-scale projections on the walls in the Guggenheim Museum New York.

With this display at the museum, music videos left the apparatus of the television behind, as well as the classical cinema screen and the space of the black box. These videos even extended beyond the Guggenheim museum space and reached a bigger audience due to their projection on the outside walls of the museum, in public space. The barriers of the exhibition space were extended even further, since the videos were shown at the same time in other Guggenheim Museums (Berlin, Bilbao, Venice) and on YouTube in order to reach an even larger global public. With this exhibition, the music video (and also the other forms of short film) finally reached some of the most acclaimed museums as well as the Internet.

Music Video Effect

Having taken into account the various developments that have affected the music video, I propose that we speak of a "music video effect," comparable to the "cinema effect."[18] The music video aesthetic crops up in other artistic media and thus gains entry into the cinema, museum, festival, Internet, and urban space contexts. When the music video enters these various contexts, its avant-garde aesthetics of visual pastiche is foregrounded. The example of Björk mentioned above perfectly encapsulates the shifts undergone by the music video since its invention: a video abandons the TV monitor and is projected onto a film screen inside a black box in a museum space, thus becoming part of a complex exhibition strategy and is shown in the Internet and distributed on a DVD which can be purchased in the museum shop.

| 351

9.3.3　DEVELOPING, PRESENTING, AND DOCUMENTING UNSTABLE MEDIA AT V2_[19]

Arie Altena

Unstable Media

The origins of V2_ Institute for the Unstable Media go back to 1981, to the founding of an artist initiative in a squat in the Dutch city 's Hertogenbosch. During the 1980s their focus shifted to electronics, robotics, and the use of media and computers, and V2_ became a center for art and media technology. In 1987 V2_ issued the *Manifesto for the Unstable Media*. It was written out of dissatisfaction with the art world and its unwillingness or inability to take on new technologies. Since then, V2_ has taken up the name Institute for the Unstable Media, and has used the term 'unstable media' for the field it is covering.[20]

In the *Manifesto*, unstable media are defined as all media that "use streams of electricity and frequencies," and it states: "Instability is inherent to these media." Though the original manifesto is now a historical document, it still serves as an inspiration. V2_'s current mission statement contains not only a reference to unstable media, it still states that instability is a creative force that is essential to the continuous reordering of social, cultural, political, and economic relations in society.

V2_ organises events, exhibitions, lectures, and festivals. V2_ also helps artists to develop technology, it publishes books, and it documents its own activities. V2_'s basic attitude toward electronic art is one of taking it as self-evident that, in a world filled with new media and new technologies, there will be artists who work and experiment with these technologies to make art, to react to the world, to express their feelings, to take a critical stance, or to shape a different "world." The idea of a relation between the use of unstable media in society and in the arts is as self-evident for V2_ now as it was in 1987.

Presenting

In 1994 V2_ moved to Rotterdam. This move coincided with the upsurge of interest amongst artists in the possibilities of the Internet and the WWW for artistic expression and intervention. V2_ became one of the sites for this vibrant culture, and showed net art, as well as the work of artists working with virtual reality and 3-D projection. "Cyberspace" was the buzzword in

those days, and it was during that time that V2_ developed into a professional organisation with an international network. The Dutch Electronic Art Festival (DEAF) – organized more or less biannually – became the meeting ground for this network of artists and scientists. The first edition took place in 1994, the most recent one was the 2007 edition.

V2_has a series of events that run throughout the whole year and combine lectures with performances and presentations in various formats. *Wiretap* was the longest-running series (1993-2002); this was followed by *Tangents* (2002-2007). The *dot.nu* series (2000-2002) presented works in progress by many live cinema artists, who at the time were often still studying at art school. The *Test_lab* series, which started in 2006, is meant as a showcase of work in progress. These events show the current state of unstable media, and are also an occasion to show what the V2_lab is developing, and to test it on a critical audience.

V2_ takes a thematic approach with all of these events. Every DEAF, for instance, had its own theme, and even from the titles, one can see V2_'s particular approach toward technological art.[21] The emphasis lies on interaction, machine-body interface, and biological metaphors: *Digital Nature, Interfacing Realities, Digital Territories, The Art of the Accident, Machine Times, Information is Alive, Feelings are Always Local, Interact or Die!* These festivals were combinations of performances, concerts, an exhibition of mostly interactive installations, a film program, a symposium, lectures, workshops, expert meetings, and, occasionally, site-specific events. This has now become a standard format for new media art festivals.

The festival and presentation formats and the development of thematic programs probably have been more important to the curators and organizers of the DEAFs and other V2_events than theoretical curatorial considerations derived from the world of contemporary *visual* arts. For V2_ the context of technological arts and technological society with all of its fascinating developments (from computer games and scientific 3-D imagery to the uses of RFID, GPS, and biotechnology) comes first. But it is important to stress that technological arts are not about technology, they are about our world, about human feelings, our interactions with computers – or about any of the other "things" that contemporary art can be about. In that sense there is no difference between technological art and "traditional" art.

While organizing a festival, including an exhibition, the simple question of how to build (often complex) installations and how to place these inside the space available becomes a crucial concern. Works have to be set up properly so the audience can experience them fully. Because a festival often takes place at many different locations, it is possible to show performances on stage and computer installations in a semi-public space, as well as large installations in

a large space, and smaller works in separate rooms. Some works might be projected large on a wall, others screened on a monitor in a black (or white) box; other works might be screened on a monitor on a pedestal, and some works need a space as a playing field all on their own. Some works require a variety of exhibition modalities. Ideally, it is the work itself that determines the exhibition modality, yet in reality, compromises are also sought, necessitated by practical concerns.

New media festivals characteristically incorporate and accommodate different ways of presenting. Both artists and organizers are (or should be) conscious of the fact that "presenting" an artwork on stage or on screen during a lecture or artist presentation (talking about the work, showing clips), is something different than presenting the work itself as an autonomous work in an exhibition. As V2_ aims to stimulate debate and develops works in collaboration with artists, this type of artist's presentation is very important. They include also test setups and first public presentations of works in progress. Showing a work which is still in progress can give the artist important insights into how an installation is functioning and what needs to be calibrated or changed. In most cases, such presentations have to be distinguished, however, from an exhibition or a proper performance of a finished work.

Another issue is the fact that complex interactive installations and technological works are often further developed after the first "proper" exhibition of the work, often because with time, a better technology becomes available (for example, a new type of sensor, or better software). Works go through versions. On the other hand, several works might be developed using similar technology and a similar concept.

If this sounds as if mostly practical considerations determine the presentation formats, I could rephrase it by saying that the instability of the situation is taken as the starting point for finding the best way to present, exhibit, or even develop a work. In the end, it is the thematic approach that determines the choice of works to be shown. This is also true for the international exhibitions curated by V2_, such as Zone V2_ at MOCA in Taipei (2007).

Developing

At the V2_lab, artists collaborate on electronic art projects and technical research projects with hard- and software developers, technicians, and scientists. These long- and short-term projects focus on the use of new technologies for artistic means and on the cultural and social implications of these technologies. The research projects have resulted in software tools, mixed media applications, and artworks that have been presented at various V2_events.

Since 2010, the V2_lab has been researching the topics of augmented reality and wearable technology. Augmented reality is the term for the layering of digital information onto physical reality as we perceive it; wearable technology concerns technology that can be worn on the body, or becomes part of the body, and often looks for connections to the world of fashion. Both concern the naturalization of technology and the incorporation of technology by the body and the mind.

Dutch artist Marnix de Nijs has collaborated with V2_ on various occasions, including on an augmented reality game entitled *Exercises in Immersion*. This work is about how the body adapts to the world it perceives through its senses, even if the sensory information it receives is not congruent with reality. For this work, De Nijs required a system that senses a player's location in real time and tracks what the player is viewing. It took a long time to develop the technical aspects of this system and, to some extent, this stalled the development of the artistic concept. In the end, a workable solution was found, combining sensors with custom-made software, and a first public test of the installation was shown at DEAF in 2007. The installation needed a complete hall for itself (at Pakhuis Meesteren in Rotterdam); no other work was exhibited there. Now the work mainly "exists" for the public in the form of texts, photographs documenting the exhibition, and a number of videos, some of which are available at V2_'s website. One video shows De Nijs talking about the work, interspersed with footage from the installation and visuals explaining the technology.[22]

German artist Aram Bartholl developed his *Tweet Bubble Series* as an artist in residence at V2_. He started from the idea of showing Twitter messages on a T-shirt. Initially, Bartholl hoped to develop a T-shirt which could show any Twitter message, and code software that could connect the shirt to the Internet. This implied a very complex technological development process, which he (and others) assumed would not do justice to the simple, elegant concept. He subsequently realized four different versions of a shirt showing Twitter messages, using far simpler methods to get the idea across. *Pocket Tweets* used the mobile phone itself as screen: you put the phone in a special pocket on the front of the shirt; *Loud Tweets* used a LED name badge connected to the Internet; *Paper Tweets* lets you print out your most recent Twitter message on a sticker; and *Classic Tweets* is a thermochromatic T-shirt that can show three different classic Twitter messages. These versions were presented on stage in V2_ test lab, *Fashionable Technology*. This is a work that is very suitable for a type of artist presentation at an event. In addition to an artist talk in which the concept is shown, and maybe explained, it could include videos of former presentations or performances, a rehearsed performance, and/or an invitation to the public to try the works out for themselves. In fact, Bartholl often uses a mix of these forms – though a performative approach is important to him.

| 355

Documenting

Documenting works like *Tweet Bubble Series* and *Exercises in Immersion* includes recording both the conceptual and technological development as well as storing software and technical specifications. To preserve the work, one also has to store physical components. In the case of *Exercises in Immersion*, this is a complex and costly affair, as there is quite some hard- and software to take into account. Additionally, videos of presentations and performances should be stored, and it is also important to keep a record of the cultural contexts which were important to the development and the concept of the work; artist statements and interviews often give insight into this as well. For interactive works in particular, there is the issue of the calibration of the work (how fast or slow should it react?) and the preferred interaction. Such issues could be covered by descriptive texts, interaction diagrams, and video documentation of the work in action.

356 |

Because V2_ has documented its own activities from early on, there is an archive of hundreds of videotapes, digital video files, and over 15,000 digital and digitized photographs.[23] These are an invaluable resource for the history of electronic and new media arts in the Netherlands. They also accidentally and partially document some of the works that were shown or developed at V2_, and thus continue their visibility on a different platform. To give an example: the video registration of Dick Raaijmakers performance *Intona* is probably the only video of this work in existence. What once was "just registration" can become an invaluable resource for art history or reconstruction only 20 years later. Similarly, the archive contains a live stream of the V2_event at which Bartholl's *Tweet Bubble Series* was presented, and photographs that document it, just as is the case for *Exercises in Immersion*. The task of the V2_archive is to make this material, mostly digital born, accessible to the public through a website.

On V2_'s current website, items are connected through keywords, a related-items algorithm, and through editorial links (human-made connections between different items in the website). Works, events, people, organizations, articles, videos, and photographs are connected by both humans and machines, enabling the visitor to explore and discover the history of V2_ and technological art.[24] This can be seen as one of the presentation strategies of V2_ – many people will only get to know works through the online documentation. It is a way in which works "exist" for the public, although this type of "existence" should not be confused with the work itself. There are many artists who make work for online exhibition, but they are a minority among the artists who work and exhibit at V2_.

Ideally, documentation of works should grow over time. Essays and

reviews could be added over time, as could archival material dug up from V2_ computers. (An example of this are wikis used during the technical development.) Software used to run a work could be offered for download. When such documentation becomes very refined and rich, it seems almost possible to see it as a substitution for physical preservation. This, however, can never be the case for interactive installations, as these have to be experienced physically.

Video art – especially single-screen works – could indeed be preserved online. Additionally, screen-based digital or interactive work that can run on any normal computer can be preserved up to a certain extent in a digital archive. An example of this are several net artworks that V2_ hosted in the late 1990s that still have their original files on V2_'s server. One could give website users access to such works even if it means they just download the original files. Making a work function in a "sufficient" way, however, may or may not be possible at times, depending on the type of work. Often works made in the past were so technically simple (by 2011 standards) that they will still run without a | 357 problem. On the other hand, they might not run in the right way, as computers today are faster, browsers have changed, and some works made heavy use of the context of other websites that may have disappeared or radically changed since the 1990s. In other words: archiving the files is one thing, but the ways in which a net artwork can be brought to "life" can be best decided on a case-by-case basis, for instance when there is an opportunity to install or exhibit such a work again.

NOTES

1 In 1965, Warhol recorded at least eleven videotapes with the Norelco camera. As indicated by Callie Angell, "the only accessible footage from these early video exists in [*Outer and Inner Space*], which Warhol, in effect, preserved by reshooting them in 16mm" (Angell, 2002).

2 I borrow the expression "light cube" from David Joselit (2004: 154).

3 Of course, some of them, such as Andy Warhol discussed above, but also VALIE EXPORT and Peter Weibel, were working with both mediums.

4 *Shadow Projection* was initially shown at The Kitchen in New York 9-18 May 1974. See The Kitchen Calendar: http://www.eai.org/user_files/supporting_documents/MAY74EAI.pdf (last access 5 August 2010). It was then shown in the exhibition *Projected Images* (Walker Art Center, 21 September-3 November 1974) discussed previously in this chapter.

5 An example of this approach is Goodwin (1992).

6 Dubois defines the "cinema effect" as follows: "this 'cinema effect' is extremely diversified, takes multiple forms, and operates at all levels (institutional, artistic, theoretical, or critical)." See page 312 of the present volume.

7 *VIDEO: 25 years of video aesthetics*, exhibition held at the NRW Forum in Düsseldorf 24 January-18 April 2004; *I want to see how you see*, exhibition held at the Deichtorhallen Hamburg 16 April-25 June 2010; *YouTube Play: A Biennial of Creative Video,* exhibition held at the New York Guggenheim 21 October 2010.

8 See Cytowic (2002); Weibel (1987). See also chapter 1 of the present volume. Paik's background in music theory, and the influence of John Cage, are part of the context for his avant-garde musical practices and his attempts to break with Western musical conventions and representations, such as the live performances in which Paik destroyed a piano.

9 Links between the phenomenological qualities of sound and image as well as the possibility of creating new forms of experience are discussed in Siewert (2010).

10 MTV was launched in the US in 1981 with a video by The Buggles, aptly titled "Video Killed the Radio Star." Six years later, MTV Europe was launched.

11 Steve Blame, cited in the introductory episode of the seven-part documentary series *Fantastic Voyages –Eine Kosmologie des Videoclips* (Director: Christoph Dreher, Assistant Director: Senta Siewert, produced in 2001 for Arte). Three noteworthy publications on the music video: Keazor and Wübbena (2005); Krüger and Weiss (2007); and Vernallis (2008). The latter characterizes the music video aesthetic as determined by an intensified audiovisual continuity.

12 Further artists whose work was shown include Dara Birnbaum, Peter Callas, Ingo Günther, Mariko Mori, Joe Pytka, Jo Sedelmaier, Tarsem Singh, Klaus vom Bruch, Ridley Scott, Traktor, Sophie Muller, and Rotraut Pape.

13 Other comparable exhibitions include: "Exposition of Music Electronic Televi-
sion," Galerie Parnass, Wuppertal (1963); "Art of Music Video," Long Beach Art
Museum (1989 + 1999); "What a Wonderful World – Music Video in Architecture,"
Groningen Museum (1990); "Visual Music," Museum of Contemporary Art, Los
Angeles (2004); "Sons & Lumières," Centre Pompidou, Paris (2004); "The Art of
Pop," Museum für Angewandte Kunst, Cologne (2011). Another platform for
music videos are DVDs, especially DVD collections of the work of individual
music video directors, which have a wide potential audience: music fans, music
video enthusiasts, as well as art aficionados. They buy these DVDS, which are also
offered for sale in the gift shops of most contemporary art museums. To name
just a few examples: *The Work of Director Chris Cunningham, The Work of Michael
Gondry, The Work of Director Spike Jonze, The Work of Director Anton Corbijn, The
Work of Stephane Sednaoui, The Work of Mark Romanek* and *The Work of Jonathan
Glazer, Various Artists – Music Video Art* (all released by EMI between 2003–2005).

14 Gondry directed the videos for *Human Behaviour* (1993), *Army of Me* (1995), *Isobel*
(1995), *Hyperballad* (1996), *Jóga* (1997) ,and *Bachelorette* (1997).

15 *Serpentine Dances* (France/USA ca. 1896-1898), 60m, 3', 35mm, color, from the
archive of the Cineteca di Bologna. The film program was curated by Eric de
Kuyper and Mariann Lewinsky.

16 From an interview conducted during the 2010 festival, with students from my
seminar on "Media Art Institutions and Promotion" (Ruhr-Universität Bochum,
summer semester 2010). In the interviews, various film directors and organ-
izers noticed that music videos are increasingly less associated with television
and more often with visual art. Other important festivals in this context are the
European Media Art Festival (Osnabrück), transmediale (Berlin), Ars Electronica
(Linz), Internationales Bochumer Videofestival, and the International Sympo-
sium on Electronic Arts (various locations).

17 The jury members were Laurie Anderson, Animal Collective, Darren Aronofsky,
Douglas Gordon, Ryan McGinley, Marilyn Minter, Takashi Murakami, Shirin
Neshat, Stefan Sagmeister, Apichatpong Weerasethakul, and Nancy Spector.

18 The "cinema effect" can be found also in the Hamburg exhibition discussed
above. The installation *Destroy She Said* (1998) by Monica Bonvicini shows
selected film clips of various film divas, such as Monica Vitti in *L'Avventura* (1959),
Jeanne Moreau in *La Notte* (1961), Catherine Deneuve in *Repulsion* (1965), and
Brigitte Mira in *Fear Eats the Soul* (1973).

19 Many of the sources used for this article can be found on V2_'s website; Altena
(2008 and 2009), Bartholl (2009), Mulder (2010) Mulder and Post (2000) and Nijs
(2007) are referenced to directly.

20 For more information about V2_'s mission, history, and research, please see
http://www.v2.nl/organization, http://www.v2.nl/organization/mission, and http://
www.v2.nl/lab/research.

21 When I write "technological art" in this text I refer very broadly to art which in one way or another uses electronics and/or computers.

22 Available online at: http://www.v2.nl/files/retrospective/2007-EI4.mp4/view.

23 The current V2_archive should not be confused with V2_Archive, under which name V2_ released a large number of cassettes, some artist videos, LPs, and CDs in the 1990s. V2_Archive (as a cassette and record label) was run by Peter Duimelinks at V2_. V2_archive is now used as the name for the online archiving activities of V2_.

24 However, it needs to be said that the implementation of all the archive material on the website is far from finished. For instance, the presentation of a certain work developed in collaboration with V2_ would also ideally have descriptions of the software and hardware that was used, and would include links to software downloads (if developed by V2_) and technical documentation.

REFERENCES

Altena, Arie. "Take the tweets out there. Interview with Aram Bartholl." 2009. Http://www.v2.nl/archive/articles/take-the-tweets-out-there. Last access: 21 September 2012.

—. "Interview with Marnix de Nijs about EI4." 2008. Http://www.v2.nl/archive/articles/interview-with-marnix-de-nijs-about-ei4. Last access: 21 September 2012.

Angell, Callie. "Andy Warhol: *Outer and Inner Space*." In *From Stills to Motion & Back Again. Texts on Andy Warhol's Screen Tests & Outer and Inner Space*, edited by Geralyn Huxley, et al., 13-17. Vancouver: Presentation House Gallery, 2003.

—. "Doubling the Screen. Andy Warhol's *Outer and Inner Space*." *Millennium Film Journal* 38 (2002): 19-33. Available online – http://www.mfj-online.org/journalPages/MFJ38/angell.html. Last access on 12 July 2012.

Bartholl, Aram. *Tweet Bubble Series*. 2009. Http://www.v2.nl/archive/works/tweet-bubble-series. Last access: 21 September 2012.

Cherchi Usai, Paolo. *The Death of Cinema. History, Cultural Memory, and the Digital Dark Age*. London: BFI, 2008.

Cytowic, Richard E. *Synesthesia. A Union of the Senses*. Cambridge, MA: MIT Press, 2002.

Elsaesser, Thomas. "Ingmar Bergman in the museum? Thresholds, limits, conditions of possibility." *Journal of Aesthetics & Culture* 1 (2009): 1-9.

Goldsmith, Kenneth (ed.). *I'll Be Your Mirror. The Selected Andy Warhol Interview*. New York: Carroll & Graf Publishers, 2004.

Goodwin, Andrew. *Dancing in the Distraction Factory. Music Television and Popular Culture*. Minneapolis: University of Minnesota Press, 1992.

Hanhardt, John. "Peter Campus," *Bomb* 68 (Summer 1999). Http://bombsite.com/issues/68/articles/2236. Last access: 17 August 2010.

Iles, Chrissie. "Video and Film Space." In *Space, Site Intervention. Situating Installation Art*, edited by Erika Suderberg, 252-262. Minneapolis: University of Minnesota Press, 2000.

Joselit, David. "Inside the Light Cube." *Artforum* 43 (2004) 7: 154-159.

Keazor, Henry, and Thorsten Wübbena. *Video thrills the Radio Star. Musikvideos. Geschichte, Themen, Analysen*. Bielefeld: Transcript, 2005.

Krüger, Klaus, and Matthias Weiss (eds.). *Tanzende Bilder. Interaktionen von Musik und Film*. Paderborn: Fink, 2007.

McCall, Anthony. "Two Statements." In *The Avant-Garde Film. A Reader of Theory and Criticism*, edited by P. Adams Sitney, 250-254. New York: New York University Press, 1978.

Mulder, Arjen. "The Age of Instability." 2010. Http://www.v2.nl/archive/articles/the-age-of-instability. Last access: 21 September 2012.

—, and Maaike Post. *Book for the Electronic Arts*. Rotterdam: V2_ Publishers, 2000.

Nijs, Marnix de. *Exercises in Immersion 4*. 2007. Http://www.v2.nl/archive/works/exercise-in-immersion-4. Last access: 21 September 2012.

Parfait, Françoise. *Vidéo. Un art contemporain*. Paris: Éditions du Regard, 2001.

Poschardt, Ulf. *Video – 25 Jahre Videoästhetik*. Ostfildern: Hatje Cantz, 2003.

Siewert, Senta. "Re-Enactment of Music-Video Clips in Feature Films." In *Extended Cinema. Le cinéma gagne du terrain*, edited by Philippe Dubois, Frédéric Monvoisin, and Elena Biserna, 136-140. Udine: Campanotto Editore, 2010.

Vernallis, Carol. "Music Video, Songs, Sound. Experience, Technique and Emotion in *Eternal Sunshine of the Spotless Mind*." *Screen* 49 (2008) 3: 277-297.

Weibel, Peter. *Clip, Klapp, Bum. Von der visuellen Musik zum Musikvideo*. Cologne: DuMont, 1987.

9.4 NEW *DISPOSITIFS,* NEW MODES OF RECEPTION

9.4.1 VIDEO INSTALLATIONS AS EXPERIENCES IN MONTAGE

Térésa Faucon

Walking through spatial arrangements involving multiple screens, such as those evoked by Philippe Dubois in the conclusion, makes it possible to postulate a spectator-editor. Thanks to their mobility, spectators experience the gestures of the editor: moving (from one screen to the next), stopping, coming back, seeing the loops of images again. The multiplication of screens in space invites one to edit, tapping into a desire to transform the diverse into a universe, link scattered elements back together, interpret them, and to order them to perform a specific reading. However, spectators do not produce a montage (in the sense of a series of images given to see), their gesture is performative. It is the very act of editing which is at work there. To experience editing is to apprehend the virtuality of the interval, the movement of a shot towards another shot described by Vertov. Spectators then become aware and learn about what Thierry Kuntzel called "the other film," the physical medium of film but

> which should not be considered in its materiality as a strip of celluloid, in the succession of visual signs and sound signs laid out according to an axis (the ribbon laid flat, unwound) but rather, as in a virtual film, the film underneath the film. This other film would be like the ribbon wound up on the reel, as a volume; a film freed from temporal constraints, and in which all elements would simultaneously be present, that is, without any effect of presence (screen-effect), but ceaselessly referring to one another, matching up, overlapping, clustering in configurations "never" seen nor heard when the film runs in the projector. [...] A text-film, at last (Kuntzel, 2006: 113-4).

This film text reveals the "[original] virtuality of editing" (Bullot, 2003), and it points to its blind spot. It should be remembered that, for the first 30 years of cinema, editing techniques did not make it possible to see the image in movement. To edit was to touch images before seeing them, to feel the rhythm passing through one's fingers as they held the film, to count film frames and time.

Experiencing the interval is thus to apprehend the threshold (*schwelle*), in this instance, the space between screens, as a zone, a highly vibratory space. Benjamin noted that "transformation, passage, wave action are in the word

schwellen, swell" (Benjamin, 1999: 494). Spectators familiar with installations remember that, quite often, these spaces confuse one's bearings (scale and orientation) and are defined through a "geometry of the unstable," characterizing the fluid world of the screen according to Jean Epstein, who found new possibilities in these omni-audiovisual, immersive, and multisensorial "arrangements of images-spaces" (Bellour, 1994: 52). This singular kind of space, explored by spectators as

> the cinematographic space [...] does not have any homogeneity or symmetry, it represents a space in movement or, to put it better, a space created, not by the well-determined positions of solids with stable shapes of Euclidian space, but by ill-defined movements of specters whose form also evolves and which behave like fluids. Euclid reportedly drew his figures on the sand of Alexandria's beaches. [...] A fundamentally moving world requires a kind of geometry that works on quicksands. And this geometry of the unstable governs a logic, a philosophy, a common sense, a religion, an aesthetics founded on instability (Epstein, 1975: 215).[1]

One installation, *The Ground Is Moving* (Christophe Oertli, 2010), epitomizes particularly well the qualities shared by the cinematographic space and the space of installation at the same time as the fact that these spaces may give way, that they are variable and even fluid. The setup is simple: two screens are juxtaposed, linking spaces into urban panoramas (streets, places, gardens), most of the time without revealing the join (see Fig. 9.1 in color section). This recomposed contiguity is sometimes flaunted by the temporal continuity of the movement of passers-by from one screen to the other, sometimes betrayed by the temporal disturbances restoring the sharp edges of the frame and affecting the parts of a body (a hand, for instance) or causing cars to appear/ disappear at a crossroads on either side of the join. This "trick panorama" meets with the resources of a space conducive to all kinds of conjuring acts inherited from Méliès. The installation also trains the look of spectators to the movement inherent in editing through the movement of looks or bodies from one screen to the other. The movement of the camera sometimes mimics the mobility of the spectators' look, with sudden accelerations in the course of a very slow tracking shot, accelerations whose effect borders on that of a whip pan, all unwinding a panorama which could proceed indefinitely. The space slides along under the eye as would the ground under a chassé. This equation of eye and foot is often noted in experiences of walking/editing actualized in video installations. Another principle well known by walkers also governs editing, since the space is not only smoothed out by these effects of uninterrupted run. Darker areas (arcades, porches, and doors) and well-lit areas, points of

suture (posts, columns, trees) also define it as a striated space, made of folds, trap doors, the site of all disappearances where bodies seem to follow "secret smugglers' paths" (as notably described by Kracauer, see below) before reappearing somewhere else or substituting for other bodies. These movements do not occur only in space, but also in time:

> When I peered to all sides, from the sun into the shadows and back to the day, I had the distinct sensation that I was moving not only in space in search of my desired goal, but often enough transgressed the bounds of space and penetrated into time. A secret smugglers' path led into the realm of hours and decades, where the street system was just as labyrinthine as that of the city itself (Kracauer 2009 [1964]).

For *Electric Earth* (1999), Doug Aitken started from this temporal experience of space, which also problematizes the posture of the spectator in the space of the setup through the figure of break-dancer Ali Johnson. Eight screens distributed in a rectangular space recompose a deserted urban landscape, which sometimes unfolds from screen to screen, sometimes retreats into the next screen in a mirrorlike effect. The same goes for temporality, which seems to regain a continuity and a development through the circulation of the character or to go into a loop through the multiplication of the same shot on several screens. Spectators are invited to follow into the character's footsteps and experience the energy of that space. Everything begins with the man looking into the camera, facing spectators/visitors. This first shot makes the "according,"[2] or tuning, possible. Spectators follow into Ali Johnson's gaze just as they will follow into his step or even his dance. The character is lying in his bed in a state of prostration, a remote control in his hand, in front of a television screen showing just snow. His sleepy eyes express only boredom and lethargy, and he is as inexpressive as the flickering monitor. He whispers, "A lot of time, I dance so fast that I become what's around me. It's like food for me. I, like, absorb that energy, absorb the information. It's like I eat it. That's the only now I get." He then starts to move, walks, and seems to be receptive to the energy of the electrified earth he crosses, the surroundings of an airport and a deserted commercial zone at dusk, for instance.

"Taking a walk can be an uncanny experience. Propelled by our legs we find rhythms and tempos. Our bodies move in cycles that are repetitious and machine-like." The walk of the man, more and more mechanical and spasmodic, thus moves towards a strange dance that seems to mimic the rhythm of machines and automatons of the deserted urban space he crosses – with the stop by the laundromat probably being the most striking. Indeed, "the landscape is stark and automated, but the electricity driving machines is ultimately

more important than the devices it drives. It's what the protagonist responds to, and, in turn, what puts him in motion" (Doug Aitken, in Anton, 2000: 30).

Aitken seems to stage the abolition of "the double scene, the double way to exist" for the spectator, as Daney described it (1993: 32), if the setting into motion of the character in this space of fluxes is associated with the movement of the spectators' response in the installation as they enter into an interaction with the fluxes of images. The eight screens of the installation display close-ups of the different rhythmic and vibratory agents contaminating the movement of the dancer to give spectators of the installation the chance to experience it as well, to help this movement to spread to the body of the spectator. Spectators are thus caught up in this space of circulation, not in the sense of the immobilized or trapped captive, but rather with the idea of literally being *mobilized*, by conduction – of being plugged into these fluxes of images and taken away, swept along by them.

> We lose track of our thoughts. Time can slip away from us; it can stretch out or become condensed. But this loss of self-presence, it seems, can sometimes produce another kind of time, the speed of our environment becomes out of sync with our perception of it. When it happens it creates a kind of grey zone, a state of temporal flux. The protagonist in *Electric Earth* is in this state of perpetual transformation. The paradox is that it also creates a perpetual present that consumes him (Doug Aitken, in Anton, 2000: 31).

The walk of the character in *Electric Earth*, like the movements of bodies in *The Ground is Moving*, seems to unwind a perpetual, ungraspable present without aim nor incidents.

Consequently, it appears as though the most accurate term to refer to the movement of the eyes slipping from an image to the next, from a motif to another motif, may be a term borrowed from video, possibly in opposition to the usual definition of montage but corresponding to the idea that montage belongs in the flux, in vibration, in mutation rather than in fragmentation and articulation. *Processing* involves work on the image itself, its material, its flux. Is it not what spectators of the installation experience when they activate the energy of the interval? Do they not discover that the image has various possible becomings? According to Élie Faure, this definition of the image and of montage refers to the essence of cinema. *Process*, by way of "procession," thus takes us back to *cinéplastique*, to this ability to experience plasticity with "the constant unexpectedness forced on the work by a mobile composition, ceaselessly renewed, broken and reconstructed, vanished, revived, collapsed, monumental for a split second, impressionistic the next" (Faure, 1953: 26).

9.4.2 FROM THE FILM TO THE MAP: PATRICK KEILLER AND *THE CITY OF THE FUTURE*

Teresa Castro

Designed by English filmmaker Patrick Keiller, the source for the installation *The City of the Future* is an interactive DVD investigating the representations of urban landscape in early British cinema (1896-1909).[3] Based on the DVD, the installation was presented at the British Film Institute (London) from November 2007 to February 2008 (see Fig. 9.2 in color section). Combining 68 films from the period, it comprised five screens laid out in the room according to the geographic relations between locales represented in the films, thus using cartographic spatialization as its fundamental principle. Each screen featured a different sequence: introduced by maps, these were organized as a journey in the United Kingdom of the early 20th century. On the main screen, a strip of images reconstructed an itinerary from Nottingham to Halifax while two screens nearby presented films shot in Greater London and documenting a trip between Halifax and Barton as well as images recorded during a journey between New York and Dublin. Spectators were invited to stray from these predetermined paths and explore other British and overseas landscapes thanks to the maps.

Since the early 1980s, Patrick Keiller, who was originally trained as an architect, has been reflecting on urban spaces in contemporary Great Britain. The author of several "semi-documentary" films (in the artist's own words), often designed as travelogues or imaginary diaries tapping into the British documentary tradition (*London*, 1993; *Robinson in Space*, 1997), he set out on a different line of experimentation with *The City of the Future*. Conceived as an installation, the latter still centers on the urban environment and the figure of the city. The artist had already explored spatial and scenographic possibilities of this medium with *Londres – Bombay*, a monumental installation presented at Le Fresnoy (France) in 2006 and featuring about 30 screens. A new essential element appears in *The City of the Future*: cartographic images. Though they appear on all screens, their role should not be mistaken as that of a mere interface or even a nice-looking navigation menu. These images provide the key to understanding some aspects of Keiller's project, including the very choice of the installation as the device to explore images. Transforming – and dramatizing – the spatial relationships between its constituent elements in the substance of the work, Keiller saw a sounder option in the choice of the installation as an exhibition format. As he explained in a 2007 interview to *The Guardian*:

I embarked on an exploration of landscape in early film, with the idea of discovering something about the evolution of urban space (...). Early films are generally between about one and three minutes long and, lacking montage, close-up and other sophistications, they depict spaces in which one's eye can wander. Because of this they encourage repeated viewings. A compilation film, which had been my initial expectation, seemed to deny their most intriguing possibilities. I had the idea to arrange them spatially, on a network of maps, and set about making a "navigable" assembly that has since evolved to include 68 early films of UK and other landscapes, in which the films can be viewed in two interconnected ways: both by exploring a landscape of maps and films, in the manner of a flâneur, and as a linear sequence (Keiller, 2007).

Inviting the eyes to wander, these films encourage a "para-cartographic" look:

Maps involve imagined spaces and imaginative spatial exploration. The pleasure in viewing them is a form of journey: viewing maps stimulates, recalls, and substitutes for travel. Like engaging with a map, experiencing film involves being passionately transported through a geography. One is carried away by this imaginary travel just as one is moved when one actually travels or moves (domestically) through architectural ensembles (Bruno, 2002: 185).

The choice of the installation allowed Keiller to exhibit these films, not as documents, but for the wandering look that characterizes them. A visual phenomenon by nature, the cinematographic movement of the look gradually substituted for the multi-sensorial experience of conventional travel. If, in the films of the first decades of the 20th century, the movement of the spectator's look was inscribed in the images by the many panning shots punctuating them, in Keiller's installation such movement has become concrete again. Since the layout of the installation was dictated by geographic elements, the work also operates as a kind of three-dimensional diagram of possible paths, inviting spectators (and their gaze) to wander physically. In so doing, the installation elevates wandering to the status of a model for reading and interpreting images. In that sense, *The City of the Future* as a device succeeds in pacing a critical territory and in exposing some fundamental trends in the films of early cinema, thanks to the dramatization and the organization of images possessing a topographic value. These trends are related to the spectatorial gaze summoned by these films and the model of the journey underpinning them, as well as the geographic imagination in which they take part.

Insofar as *The City of the Future* is a device for arranging and displaying

images marked by the dramatic dimension of its spatializations and the cinematographic aspect of the movements it encourages, could it not be defined as a three-dimensional atlas, one shaping a wandering gaze quite literally? With Keiller's installation, the atlas as a form is brought up to date, and accordingly much transformed, in the space of an exhibition gallery. The approach chosen by the artist makes the films "navigable," as Keiller opts for a cumulative and analytical logic that defines atlases, considering films critically, from the standpoint of how they may inform us about the evolution of urban space. Also, his arrangement of images is subject to a conception of segmentation and progression which is at once geographic and internal to the film's space. Perfecting the atlas as the mise en scène of a totality – a geographic one, in this case – and as a device for articulating relations between places, *The City of the Future* is an atlas of filmic landscapes in the United Kingdom in the first years of the 20th century.

Still, the mapping impulse of Keiller's project is not limited to these aspects. Given the fact that the artist claims to use the installation device, not only to be able to archive, but also to observe differences between yesterday's and today's urban spaces, the main issue for this installation and its images is to map out a virtual landscape. With his installation, Keiller puts to the test Henri Bergson's hypothesis that the images of the past contain those of the future.[4] By confronting us with these images of the past in the present, the artist's avowed goal is to map out possible experiences of the city in the future. The idea of mapping invokes a new definition of the map here, such as the one advanced by Gilles Deleuze and Félix Guattari, for example:

> What distinguishes the map from the tracing is that it is entirely oriented toward an experimentation in contact with the real. (...) The map is open and connectable in all of its dimensions; it is detachable, reversible, susceptible to constant modification (1987: 12).

If this definition is often mentioned with respect to the appropriation of cartographic images by contemporary artists, in this context it makes the resort to ideas of map and mapping even more precise. Indeed, rather than freezing the relations between places in a closed, completed representation – which can thus be referred to tracing – Patrick Keiller's "atlas installation" looks like an open aggregate of relations, like a map whose moving coordinates are ceaselessly redefined by the movements of visitors and the users of the DVD. Conceived as a journey in a plurality of virtual "maps" tracing only possible paths, *The City of the Future* is an instrument of critical pacing inspired by the images themselves and the wandering gaze they give rise to. Finally, insofar as the installation generates its own "territories," it appears as a kind of uto-

pian fiction, translated physically as the circularity of the installation. At once closed and open, the latter is capable of turning its limits into a totality and multiplying its visual and critical horizons infinitely. The eminently urban subject matter of Keiller's project finds all its scope around this last idea, the "installation atlas" being in the end a "utopics of the city" in Louis Marin's sense: a real and imaginary construction of spaces showing incoherent places and spaces (Marin, 1984). As Marin noted, "a portrait, a city map is thus at once the trace of a residual past and the structure of a future to be produced" (Marin, 2001: 205). Bearing the trace of this old memory, Keiller's "installation atlas" recreates in the space of a gallery the figure of the map, understood both as experimentation on the real and as diagram producing a whole class of possible narratives. The part played by spectators and the trajectories they follow is essential, their bodies – like their gazes – becoming the source of a logic of composition of images.

9.4.3 SITE-SPECIFIC EXHIBITION AND REEXHIBITION STRATEGIES: MAX NEUHAUS'S TIMES SQUARE[5]

Elena Biserna

Times Square is a permanent sound installation created in 1977 by Max Neu-haus in New York. Often considered a pioneering example of sound art, this work should also be regarded as one of the first time-based site-specific art-works in public space. The installation was active until 1992, when Neuhaus decided to stop it because of his inability to continue to monitor it by himself. After ten years, thanks to the initiative of the Christine Burgin Gallery, the art-ist reinstalled *Times Square* on its site, making the work accessible again 24 hours a day and, subsequently, donating it to the Dia Foundation.

The reinstallation process is of particular interest because it took the form of a recreation of the work by the artist himself and can lead us to consider some core issues of the relationship between exhibition and reexhibition with a focus on site-specificity. The first part of this text aims at investigating *Times Square*'s relationship with context and audience in the framework of coeval site-specific and public art practices; the second part describes the reinstal-lation project, while the third discusses this work in the context of current preservation strategies taking into consideration the roles of the artist, of technology, and the notions of authenticity and identity of the artwork. These issues are involved in the multilayered relationship between preservation and exhibition decisions transforming reinstallation, as we will see, in a new "creative process."

Times Square, 1977: *In Situ* Sounds

Max Neuhaus' *Times Square* is a complex sound topography – a volume defined by acoustic, intangible boundaries – created by continuous synthetic sounds diffused in an underground chamber, part of the subway ventilation system, in a triangular pedestrian island on Broadway, between 45th and 46th streets: a crowded and cacophonous place crossed every day by thousands of passers-by (see Fig. 9.3 in color section).

Like all of Neuhaus's other installations, it was created through a long pro-cess of analysis, investigation and experimentation *in situ*. In the case of *Times Square*, as the artist declared,

I began making the piece by investigating what the resonant frequencies of the chamber were. The next step was a gradual process of selecting which resonances to use and how to use them. I finally determined a set of sonorities, four independent processes, which activate the resonances I chose, activate the chamber. These resonance-stimulator sounds are produced with a synthesis circuit and come out of a large loudspeaker horn, one by two meters (Neuhaus, 1994d: 66).[6]

The sounds audible in the pedestrian island, coming from the chamber through the grating, are the result of the interaction between the frequencies and the acoustic characteristics of the architecture: they result in a continuous drone, "a rich harmonic sound texture resembling the after ring of large bells" (Neuhaus, 1983: 17). The sound installation is thus physically bound to the architectural context: the underground space becomes a resonant chamber creating a continuous sound field, which can be experienced by the listener moving on the grate.

Max Neuhaus' *place works*, and *Times Square* in particular, should be considered in the framework of a wider area of research that – rejecting a conception of art as production of objects and refusing modernist art's self-

9.4
Max Neuhaus installing *Times Square*, New York, 1977 © the Estate of Max Neuhaus. Courtesy of the estate of Max Neuhaus.

referential autonomy – turned to the creation of site-specific works. In the case of Neuhaus, an artist with an important musical background, the medium is sound. Deliberately abandoning musical official circuits, the artist led some of the post-Cagean legacy's ideas to extreme consequences and reterritorialized them into the art system. Firmly convinced of the hearing's possibilities to strongly influence the perception of space, Neuhaus operated a fundamental change of paradigm, "that of removing sound from time and putting it, instead, in space" (Neuhaus, 1994a: 5), creating installations to be experienced perceptually by an audience which is free to manage both the spatial and the temporal dimension moving within them. These works are thus aligned with the phenomenology-oriented site-specific practices which, according to Miwon Kwon, "focused on establishing an inextricable, indivisible relationship between the work and its site, and demanded the physical presence of the viewer for the work's completion" (2002: 11-12). *Times Square*'s form is not autonomous, but dependent on the context and the audience's experience.

Moreover, the relationship with site is, in the artist's intention, not limited to its architectural level. He affirmed, "They [*place works*] shape, transform, create, define a specific space with sound only. They exist not in isolation, but within their context, the context of their sound environment, their visual environment, and their social environment" (1994: 58). *Times Square* was not commissioned; it is the result of an independent project carried out independently by the artist for about three years (See Tomkins, 1994). The artist stated repeatedly that the idea of this work was born by his fascination for this place, New York's "most public of places." This choice is based on the will to involve a wider audience outside the constrictive boundaries of cultural institutions. The necessity of expanding art's audience and working in everyday contexts is shared by a large group of artists between the 1960s and the 1970s and, since the mid-1970s, also some of the organizations promoting public art in the US – first of all the NEA, which provided funds for *Times Square* – acknowledged the new site-specific post-minimalist instances (Lacy, 1995: 21-24. For an overview of exhibition spaces at the origins of installation art: Reiss, 2001).

Seen from this perspective, the installation seems to elude the two public art paradigms which, according to Kwon, were prevalent during the 1970s and 1980s: the "art-in-public-spaces" – renowed artist's sculptures indifferent to their context installed in public space – and the "art-as-public-space" – design-oriented urban interventions (2002: 56-82). Neuhaus's approach appears more similar to Richard Serra' *Titled Arc* (1981): the two artists share the same refusal of the two public art models described by Kwon and the same understanding of site-specificity and permanence, even if the "interruptive and interventionist model of site-specificity" (Kwon, 2002: 72) proposed by Serra seems to differentiate the two works. The modes of relationship of *Times Square* with its

site and audience are subtle and unobtrusive. The installation is an elusive presence: it is invisible, unmarked by any sign, and therefore anonymous, not identified as "art"; the sound texture – which resembles a bell's resonance – is not plausible in that place, but nevertheless familiar; the equipment is not visible. The careless passer-by may cross this space every day without recognizing its presence. It is a place to discover personally: "my idea about making works in public places is about making them accessible to people but not imposing them on people", the artist explained (Neuhaus, 1994c: 72). Neuhaus's approach aimed at blending the work within the context and at creating an unexpected experiential involvement of the listener in his daily life.

Times Square 2002: Reinstallation

Since 1977, *Times Square* had been working day and night (except for brief interruptions for maintenance problems) until 1992, when the artist, unable to continue to maintain it by himself, finally stopped it. After some years, gallerist Christine Burgin began working on the reinstallation project with Neuhaus, obtaining the collaboration of the MTA/Arts for Transit and the financial support of Times Square BID and private residents. The work was finally reinstated on 22 May 2002.

As the underground chamber was accessible from the subway, the original technical equipment had been stolen or lost.[7] The reinstallation, thus, necessarily turned in a true recreation process carried out directly by the artist.

The original technologies were replaced by up-to-date equipment suitable for outdoor conditions. Neuhaus designed the new sound system in 2000 and this project was almost completely replicated during the reinstallation: the actual audio equipment consists of an MP3 audio player system (AM3 digital audio machine), two CROWN K2 amplifiers (one live and one backup), and two speakers; the entire setup is protected by airtight enclosures and a jail cell. The artist recreated the sounds on site using Max/MSP, a visual programming language that allows real-time synthesis and signal processing. The resulting MP3 files are stored in compact flash memory cards.[8]

From the beginning, the artist planned also a monitoring system which would allow the installation to be remotely controlled and to provide an alert in case of malfunction: a Sine Systems RFC-1/B Remote Facilities Controller connected to landline enables one to listen to the sounds (through a microphone placed in the speakers enclosure) and to check other parameters.[9] In addition, Neuhaus could also control the installation daily with the help of a webcam.

Following the donation of the work to the Dia Foundation in 2002, the

artist also instituted a long-term preservation program including biannual visits to the site (Cooke, 2009: 42). During these visits, Neuhaus continued to retune the installation: he increased the output volume because he felt that the ambient sounds had become louder, and the speakers installed in 2002 were changed to improve longevity.[10]

If the technological components were completely replaced, the anonymous nature of the 1977 installation, instead, was fully respected. Even when the work became part of the Dia Foundation collection, no signal or plaque was used: the installation is still an anonymous and elusive presence in urban space. The only change that denotes the transition of *Times Square* from an informal system to the "institutionalization" is the power supply, which in 1977 was obtained from the public light fixture and now by an appropriate power generator.[11]

Reinstallation as Recreation

The reinstallation of *Times Square* highlights some of the issues and challenges which conservators are facing with time-based artworks, problematizing them in the framework of site-specificity.

The first issue is the role of the artist, which is increasingly important for conservation and documentation strategies elaborated by international networks and projects such as Variable Media, Inside Installation, or Tate Modern's conservation department. In the case of *Times Square*, the artist had a central role to the extent that he seems to assume also the conservator's role: not only was the reinstallation carried out by him personally, he also planned a monitoring system and was directly involved in the maintenance program during the following years.[12]

Another important issue is, as Pip Laurenson states in her interview included in this book, "the role and function of the technology in the artwork" (chapter 8.3. See also Laurenson, 2004). The use of up-to-date display and production technologies confirms Neuhaus's strictly functional conception of technology (speakers are, in fact, never visible in his installations). In 1984, he stated, "When I start a work, I start a process of research in technique. I am looking for the best means available at this time for this particular piece [...]. I don't think it changes the essence of the work; it just changes the means I have to realize it" (1994c: 77).

In relation to these issues, the notions of authenticity and identity of the artwork become central. In *Times Square*, not only were the technologies changed, the sounds were recreated *ex novo* as well. We are not faced with a migration, but – using Variable Media terminology – with a reinterpretation of

sounds. Neuhaus refused a traditional notion of authenticity based on physical integrity. On the contrary, he was interested in reconstructing the work's "identity," adopting a notion of authenticity which we could compare to the one proposed by Laurenson – based on the "work-defining" properties – or by the Variable Media Approach's method – based on the "medium-independent behaviours" of the work (Laurenson, 2006; Ippolito, 2003: 51). He used to recall that, "In music the sound is the work, in what I do sound is the means of making the work, the means of transforming space into place" (Neuhaus, 1994b: 130). Sound has no value in itself. The properties significant to the work's identity were not identified in the material components, but in the relationship with context and in the listener's experience which, as we have seen, were at the basis of the "first" *Times Square* and of coeval site-specific practices.[13]

In that sense, *Times Square* shows how every reinstallation becomes also a specific and unique "creative process" in which, as Laurenson suggests, "decisions are revisited and sometimes remade as to what aspects of the work are significant to its identity" (Laurenson, 2006).

9.4.4 FROM ARCHIVAL MODEL TO EXHIBITION PLATFORM?
VIDEO ART AS A WEB RESOURCE AND THE IMAI ONLINE CATALOGUE

Renate Buschmann

Video art has become a dominant force in the contemporary art world since it began over 40 years ago, and many artists now work with this medium as a matter of course. Characterized by its dual visual and auditory nature and its flowing visual imagery, video art has, throughout its history, reacted to technological developments, not only continuously challenging habitual modes of seeing but also demanding unconventional contexts of presentation.[14] Whenever new technologies of information and communication became available in the past, they generally gave rise to new options for producing and exhibiting contemporary art.

With the advent of digital data transfer, it has become possible to spread videos over the Internet so that such "reproductions" can now be viewed on any computer with an Internet connection. Compared to more conventional localized exhibitions, this seems like an enticing prospect as it promises an unlimited transfer of those artworks whose audiovisual qualities can only be displayed with the help of a set of playback and display equipment (in this case, a server and a corresponding Internet platform as well as a PC with an Internet connection and a monitor). This enables audiovisual works to "travel" around the world, metaphorically speaking, without requiring transportation; theoretically, at least, they are available to every interested member of the online community. While such a global resource for the distribution of video art certainly constitutes an advantage, one must also ask whether an authentic reception of historical video art can or should legitimately take place within a new medium such as the Internet. Since the early 2000s, the World Wide Web has been used to preserve and promote video art, thus retrospectively creating – 30 years after the first major artistic video productions – conditions that seem adequate to the dissemination of this time- and technology-based art form beyond the museum's walls. One of the first initiatives that sought to popularize video art by means of the Internet was the Media Art Archive. Created in 2005, it became available as an "online catalogue," with the establishment of the Dusseldorf-based foundation imai – inter media art in 2006.[15] In this text, the imai online video pool will serve to illustrate the functions and requirements such a platform may fulfill, while also highlighting where this type of web-based presentation conflicts with present-day ideas of copyright, originality, and reception.

It seems useful to begin with a brief historical review which will show that,

interestingly, the shift from classical modes of display in exhibitions to innovative technical contexts was not only a feature of the history of video art but also of the early stages of concept art. In both cases, the underlying curatorial intention was to design an exhibition environment that was geared towards the requirements and conditions of a novel artistic genre. It would seem that curators were especially likely to make such decisions when faced with artworks whose materiality was of a limited or non-continuous nature. Beginning in the late 1960s, concept art, the defining feature of which is dematerialization according to art critic and curator Lucy R. Lippard, provided curators with manifold occasions for testing unusual forms of display and promotion. The one-time gallery owner Seth Siegelaub, for example, maintained that books or magazine issues designed by artists could replace conventional exhibitions, since concept art was about making verbal statements and sketching and documenting ideas rather than actually realizing them. In 1968, Siegelaub invited seven artists to contribute 25 pages each to his *Xerox Book* which later became famous and was produced with the help of the then-popular Xerox copying technology (Altshuler, 1994: 236-240).

In November 1969, the exhibition *Art by Telephone* at the Museum of Contemporary Art in Chicago demonstrated how a medium of communication, the telephone, could be integrated into the curator's work: the participating artists, among them John Baldessari, Dennis Oppenheim, Richard Serra, and Günther Uecker, were asked to communicate all relevant instructions concerning the production and montage of their sculptures and installations by telephone, and the museum staff was then entrusted with assembling them. The artists' telephone conversations were recorded and a disk record was published in lieu of an exhibition catalogue. On the one hand, the exhibition demonstrated that concept art should primarily be understood as providing ideas purely on the level of information; on the other hand, it showcased the beginning of the global age of information and of the "global village" that Marshall McLuhan had predicted, where local distances are rendered insignificant as long as the transmission of news and information is guaranteed.[16]

In 1970, *Information*, an exhibition curated by Kynaston McShine at the Museum of Modern Art in New York, similarly conceptualized the dissemination of information as the core of artistic activity and of the museum's educational function. Reflecting on these issues, McShine asked a question that remains relevant today: "How is the museum going to deal with the introduction of new technology as an everyday part of its curatorial concerns?" (McShine, 1970: 141). A progressive way of dealing with this matter was evident in the film and video section which included a cinematheque – an "information machine" – devised by the Italian designer Ettore Sottsass, Jr., especially for this occasion, where viewers could choose among a large selection of artis-

tic productions and watch them on one of 40 monitors. Here, the difference between concept and video art was palpable: while the former does not necessarily have to assume a material form and can instead rely on the spectator's imagination, visualizing the information stored on the videotape is an existential act if the artwork is to be perceived for even a brief period of time. While the first group exhibition of video art, *TV as a Creative Medium*[17] at the Howard Wise Gallery in summer 1969, remained committed to the traditional gallery space, Gerry Schum in 1968 began to pursue the far-reaching idea of a "television gallery" (Groos, Hess, and Wevers, 2003). Schum was committed to an effective fusion of the contents of concept art and their visualization by means of television and video and managed to persuade several influential concept artists to collaborate with him; together, they produced tapes that are now widely regarded as pioneering works of video art. Crucially, Schum's aim was to transform television into a theater stage for his concept art or rather video art exhibitions, to thereby overcome the borders of traditional art reception, and to use this increasingly influential mass medium to reach a wider audience.

378 |

What these historical models illustrate is that the promotion of the immaterial but technology-dependent genre of video art is usually associated with a reliance on new information technologies for the purpose of presentation. Accordingly, the Internet and its globally accumulated data network represent another challenging medium of dissemination. For the old Media Art Archive and today's imai's online catalogue, however, Internet accessibility was not the foremost concern; rather, it was an obvious implication of an extensive process of archiving and preservation. Beginning in the early 1980s, the Cologne-based media company 235Media had established itself as the only German distributor of video art, assembling, in the course of 20 years, an impressive archive of international video art. When it became clear in the early 1990s that the lifespan and stability of video storage media were limited, and that therefore backup procedures were necessary, the response was to initiate a large-scale conservation program. Between 2003 and 2005, the company's research team viewed some 3,000 tapes of video art and documentaries, drew up a list of priorities based on conservational and art historical considerations, and finally set out to digitize more than 1,200 videos. It was also decided that an Internet platform would be developed with a view to making this new video database accessible to the public. The Media Art Archive went online in 2005, interestingly, the same year that marked the beginning of the now-legendary video portal YouTube. The following year, the Media Art Archive, along with its stock of videos and video distribution network, became the basis of the newly founded Dusseldorf-based imai foundation. Currently titled the *imai Online Catalogue*, the video platform comprises several tasks: it provides a detailed

list of the foundation's collections, it serves as a catalogue for the video distri-
bution program, it provides students, instructors and scholars with a research
tool for audiovisual art, and it gives a general overview of artists and artworks
from the 1960s to the present.

Compared to other video databases,[18] the *imai Online Catalogue* has the
crucial advantage of allowing users to view every video in its full length. While
other databases only show selected sequences, often lasting less than one
minute, or only provide complete access to a limited number of users, the
imai Online Catalogue allows users to access all information free of charge and
does not require prior registration. All videos can be played in their full length
with a small-format QuickTime frame; metadata and additional documents
provide further information about the video and the artist, and search func-
tions (by artist, title, year and keyword) allow users to browse the extensive
database. The Online Catalogue differs from other databases precisely in that
it is not just a collection of facts but actually gives users the option of viewing
audiovisual works in their full length, which is what makes it an important
institution for conducting online research about video art in a visually con-
crete way. This sort of comprehensive online publication that does not merely
quote from the works in question requires a legal basis. As a rule, when muse-
ums, institutions, or private collectors buy a video work, they also acquire the
right to screen it exclusively in their premises, effectively prohibiting its online
publication. The imai foundation, however, in its capacity as a distributor of
video works, has signed legal agreements with the artists listed in its database
that permit the presentation of their videos via the imai website. The *imai
Online Catalogue* nevertheless deliberately refrains from showing videos in the
kind of high-resolution and full-screen mode that Internet users have come
to expect, instead opting for a preview quality that is designed to protect the
artworks against illegal distribution.

This restriction reveals the discrepancy that exists between the aim of
making video art accessible online on the one hand and the artists' legitimate
wish to protect themselves from copyright infringements on the other. When
artists decide to make their works available in good quality on popular plat-
forms, as many have done in recent times, they are simply exercising their dis-
cretion as copyright holders. An institution such as the imai archive, however,
must choose modes of online presentation that do not interfere with a work's
characteristic features, especially since many of them may now be considered
historical. On the one hand, transferring a video archive into a public terrain
such as the Internet affords the possibility of reaching a range of viewers that
is larger than, and different from, the sort that one would find in the con-
trolled environment of a museum, and of allowing them a greater degree of
flexibility. On the other hand, it is important to bear in mind that such tech-

nological innovations mean that online viewers necessarily adopt a mode of perception that is quite different from the way the artwork in question was originally displayed. Much has been made of the fact that the aesthetic impact of video art is very much dependent on its modalities of presentation (see, for example, Schubinger, 2009; Blase and Weibel, 2010). Even though the *imai Online Catalogue* mostly consists of single-channel videos whose instruments of presentation do not have definite sculptural qualities (unlike video sculptures and installations), one could still legitimately ask whether a screening that is not based on the technology that was prevalent when the video was first made does not effectively preclude an authentic reception.[19] This would mean that all videos from the 1970s, the 1980s, and even the 1990s should not be made available on the Internet as a matter of principle. However, this distinctly historicist attitude is countered by a host of other curatorial opinions whose influence can be observed (among other places) in several exhibitions where videos are displayed on almost standardized neutral black monitors, in a "black framing" (Amman, 2009: 217ff.). The *imai Online Catalogue*'s reduced viewing window accommodates such considerations and thus constitutes a compromise that enables an online presence of historic videos while simultaneously making it clear that their display on the Internet cannot be considered an equivalent to the original version.

The mode of display is, without a doubt, of crucial relevance where the works in question convey a message that relies on the nature and disposition of the television broadcast and the video recording or of the television set and monitor box. The *imai Online Catalogue* features some such examples: Douglas Davids, in his video *The Last Nine Minutes* (1977), refers to a spatial investigation inside the monitor box; Mike Hentz in *Green-Phase* (1978/80) experiments with the ambiguity of the monitor screen, even breaking it towards the end of his performance; Franziska Megert's video *Off* (1989) consists of electronic residual signals from CRT televisions, and Michael Langoth's video *Retracer* (1991) requires a conventional television set as a frame, because the events taking place on the screen are sucked into such a television by a zoom in the video (see Fig. 9.5 in color section). Where works like these are presented on a flat screen that is connected to the Internet, this will inevitably entail a loss of visual perception and authenticity that the viewer must compensate for by relying on his or her context sensitivity and abstracting from the present conditions of reception. Within the imai collection, however, such cases are relatively rare and it was therefore decided to integrate them into the catalogue for reasons of documentation.

Presently, the archival character of the *imai Online Catalogue* is very much in the foreground (see Fig. 9.6 in color section). The imai team has managed to establish a point of contact by way of the Internet that enables those inter-

ested to tour the video art archive which had previously received little attention and could not be visited at an actual location.

Viewers may now enjoy the flexibility of selecting videos based on their individual preferences, and of beginning, interrupting, resuming, and repeating the playback at any time that suits them (see Fig. 9.7 in color section). In 2008, imai launched the "video art kitchen" series which represented a first step towards providing online visitors with thematically arranged, "curated" compilations of videos from its archival collection.[20] These collections gather video works under diverse headings such as scratch videos, gender, dance, and audiovisuality, and do not only help viewers orientate themselves within the immense archival collection, but also accentuate contents and motifs that have been prominent in video art throughout the past decades. In this sense, the "video art kitchen" constitutes an experimental contribution to the project of probing the *imai Online Catalogue*'s exhibition potential, while remaining within its previously established framework.

It was observed above that the dematerialization of video art as well as the technical options for displaying it – which must be customized accordingly – are pivotal for inspiring a reflection on adequate modes of Internet presentations. It is possible that the reception of this genre requires a more subjective, private kind of "seeing," since it has been shown that in conventional exhibition contexts, spectators find it difficult to direct their attention towards the entire (and often unknown) duration of a video artwork (Graham and Cook, 2010: 100-103). The media lounges that have recently become popular in museums and exhibitions are rooted in the idea of showing video art in a private, pleasant atmosphere. Internet galleries and archives may have precisely this advantage of providing the comfort of bringing art into one's "own living room," the premise being that it is easier to focus on time-based artworks in one's own four walls than in a public space. But the opposing view, according to which the Internet induces people to consume a confusing wealth of information and images in a restless and superficial manner, is equally prevalent. The recent launchings of Google museums and online art fairs underpin the idea that a physical encounter with, and perception of, the original artwork is of secondary importance, and that consequently its online copy becomes a veritable replacement on account of its constant viewing and unlimited accessibility.

Although online presentations are becoming ever more popular, video art archives such as the *imai Online Catalogue* must perform a complex balancing act if they are to satisfy their users' wish for a maximum of high-quality information and simultaneously meet the necessary standards regarding copyright law and the authenticity of artworks. Bringing video art to Internet portals prompts many questions, especially where the archival character is

replaced by an exhibition format involving full-screen displays in high resolution. These questions have yet to be conclusively answered. Is it admissible for all videos – no matter which period they belong to – to homogenously appear on the computer screen, whose appearance and material character is rooted in contemporary technological culture? What sorts of transformations occur where playback parameters such as contrast, brightness, color, and volume are no longer determined by artists and curators but are subjectively determined by the viewer? How can, where larger screen displays are available, original specifications regarding format and basic settings be guaranteed every time the video is viewed? Will it be possible in the future to provide not just single-channel videos but also video installations with an adequate mode of online presentation? In theory, the web-based distribution of video art presents a great opportunity for drawing attention to an artistic genre that, on account of its difficult accessibility, has long been neglected by scholars and museums alike. In practice, however, it remains necessary to develop viable database models for video art so that an adequate interface design and innovative software may respond to the specifics of historical and contemporary video art.

NOTES

1 More and more installations whose architecture was conceived in the white cube are thus seen out in the city dialoguing with the environment and exposed to all interactions and mutations, depending on the projection sites.

2 The term ["accordage"] was borrowed from Daniel Stern (1985) by Raymond Bellour to define the relation of the spectator to the film. See Bellour (2002).

3 The DVD was produced as part of a larger research project that also included a database on films shot between 1896 and 1973, which is available at http://vads. ahds.ac.uk/resources/CF.html.

4 The following quotation from Bergson's *Matter and Memory* was projected at the entrance of the installation: "Images are perceived when senses are open to them. These images react to each other in accordance with laws I call laws of nature and, as a perfect knowledge of laws would probably allow us to calculate and foresee what will happen in each of these images. The future of the images must be contained in their present."

5 I would like to deeply thank Silvia Neuhaus, Patrick Heilman, Christine Burgin, and Cory Mathews for generously providing valuable and essential information and documents without which this text would not have been possible.

6 Even if some details of the original technical equipment are not clear, comparing the documentation I was able to find, I may suppose that, in 1977, the sound system was composed by custom sound synthesis electronic circuits, an amplifier, and the large horn-like loudspeaker Neuhaus mentions. In a proposal submitted in March 1974 to the Rockfeller Foundation, and conserved in its archive ("Subway Vent. A proposal for a sound installation for Times Square," 1974, p. 5, folder entitled "Hear.Inc. 2 1975-1978," box R1672, series 200R, Record Group A81, Rockefeller Foundation Archives, Rockefeller Archive Center, Sleepy Hollow, New York) Neuhaus described the project technologies (Max Neuhaus, "Electronic components and sub-assemblies; Loudspeaker – Klipsch model K-D-FB; Amplifier – Bozak CMA-1-120") and mentioned the "Design of sound generating unit" suggesting the design of specific electronics for the installation. One of Neuhaus' *drawings* (Neuhaus, 1983: 17) shows that this resonance system was originally located at the left side of the triangular-shaped chamber's base. It remains unclear if other speakers were used: in one photograph (Fig. 9.4), it is possible to see also two high-frequency horns. Some images of the equipment installation are included in a video by John Sanborn and Kit Fitzgerald (1982, http://www. max-neuhaus.info/neuhaus-tsq.htm) and in the poster for *Times Square*.

7 Christine Burgin, email to the author, 17 June 2010.

8 During my research, detailed technical specifications were not found. The information about the technical equipment, the monitoring system and the maintenance program (unless otherwise specified) is the result of several email

exchanges (8-28 February 2011) with Patrick Heilman, Dia Foundation's digital media specialist, who worked with Neuhaus after the donation of *Times Square* to the Dia Foundation. The information about the project designed in 2000 is drawn from Neuhaus's equipment block diagram and a quotation form by audio consultant David Andrews dated 18 July 2000.

9 The RFC-1/B is programmed to call every day and also to report on four possible modes of system failure: "loss of signal from the loudspeaker," "opening of the locked door to the cage," "loss of AC power," and "change in the loudness level of the loudspeaker" (letter by David M. Andrews to Christine Burgin, 14 May 2002). The equipment block diagram shows that, in the first project, Neuhaus thought to use another system: a Sine System DAI-1.

10 A new, more resistant formulation of speakers was chosen by the artist, who personally retuned the installation on this occasion as well, because this altered the installation's sounds.

11 Christine Burgin, email to the author, 17 June 2010.

12 This fact, on the other side, could also be the reason for the lack of detailed documentation on both the 1977 and the current installation. We could also suppose that, in the future, when the technologies used to produce and display the work may become obsolete, replacing them without the artist's intervention may be problematic.

13 This case seems antithetical to the examples of relocation or refabrication of site-specific artworks from the 1960s and 1970s on the occasion of important exhibitions which took place in the last decades (Kwon, 2002: 33-43): site and ways of exhibition remained unaltered.

14 Two books have recently been published that explore the exhibiting of video and media art: Amman (2009); Graham and Cook (2010).

15 See http://www.imaionline.de/onlinekatalog.

16 McLuhan first adumbrated this idea in *The Gutenberg Galaxy*, published in 1962, and subsequently expanded on it in *The Global Village* (1989) (McLuhan and Powers, 1989).

17 Ira Schneider published a filmic documentation of the exhibition which can be viewed in the imai Online Catalogue.

18 For a comparison of online archives of media art, see Blome (2009).

19 Christoph Blase remarks: "In actual fact one could say that playing vintage videos on modern screens is almost tantamount to falsifying the artwork." (Blase, 2010: 380).

20 See http://www.imaionline.de/videoartkitchen.

REFERENCES

Aitken, Doug. *Broken Screen*. New York: D.A.P., 2006.

Altshuler, Bruce. *The Avant-Garde in Exhibition. New Art in the 20ᵗʰ Century*. New York: Harry N. Abrams, 1994.

Ammann, Katharina. *Video ausstellen. Potenziale der Präsentation*. Bern and Berlin: Peter Lang, 2009.

Anton, Saul. "A Thousand Words: Doug Aitken." *Artforum* 38 (2000) 9: 160-161.

Bellour, Raymond. "Le dépli des emotions." *Trafic* 43 (2002).

—. "La chambre." *Trafic* 9 (1994).

Benjamin, Walter. *The Arcades Project*. Cambridge, MA: Harvard University Press, 1999.

Blase, Christoph. "Forgotten Videos and Forgotten Maschines." In *Record – Again! 40yearsvideoart.de – part 2*, edited by Christoph Blase and Peter Weibel, 376-383. Ostfildern: Hatje Cantz, 2010.

—, and Peter Weibel (eds.). *Record – Again! 40yearsvideoart.de – part 2*. Ostfildern: Hatje Cantz, 2010.

Blome, Gabriele. "Archiv-Inszenierungen. Zugänge zu Online-Ressourcen zur Medienkunst im Kontext." *MAP – Media | Archive | Performance. Forschungen zu Medien, Kunst und Performance* (2009) 1 – http://perfomap.de/current/iv.-digitale-archiv-szenarien/Archiv-Inszenierungen. Last access: 28 February 2011.

Bruno, Giuliana. *Atlas of Emotion. Journeys in Art, Architecture and Film*. London and New York: Verso, 2002.

Bullot, Erik. "Virtualité du montage." *Cinéma* (Fall 2003) 6: 53-69.

Cooke, Lynne. "Locational Listening." In *Max Neuhaus. Times Square, Time Piece Beacon*, edited by Lynne Cooke and Karen Kelly, 29-43. New Haven and London: Dia Foundation-Yale University Press, 2009.

Daney, Serge. *L'Exercice a été profitable, monsieur*. Paris: P.O.L., 1993.

Davila, Thierry. *Marcher-Créer*. Paris: Éditions du Regard, 2002.

Deleuze, Gilles, and Felix Guattari. *A Thousand Plateaus. Capitalism and Schizophrenia*, vol. 2. Minneapolis: University of Minnesota Press, 1987.

Dewey, John. *Art as Experience*. London: Penguin, 2005.

Epstein, Jean. *Écrits sur le cinéma*, vol. 2. Paris: Seghers, 1975.

Faure, Élie. *Fonction du cinéma. De la cinéplastique à son destin social (1921-1937)*. Paris: Plon, 1953.

Graham, Beryl, and Sarah Cook. *Rethinking Curating. Art after New Media*. Cambridge, MA and London: Leonardo Books, 2010.

Groos, Ulrike, Barbara Hess, and Ursula Wevers (eds.). *Ready to Shoot. Fernsehgalerie Gerry Schum. Videogalerie Schum*. Catalogue of the eponymous exhibition, Kunsthalle Dusseldorf, Dusseldorf, 14 December 2003-14 March 2004. Cologne: Snoeck Verlag, 2003.

Ippolito, Jon. "Accommodating the Unpredictable: The Variable Media Question-naire." In *Permanence Through Change. The Variable Media Approach*, edited by Alain Depocas, John Ippolito, and Caitlin Jones, 47-53. New York and Montreal: Guggenheim Museum/The Daniel Langlois Foundation for Arts, Science and Technology, 2003.

Keiller, Patrick. "Phantom Rides." *The Guardian*, 10 November 2007. Http://www.guardian.co.uk/books/2007/nov/10/2. Last access: 20 December 2011.

Kracauer, Siegfried. "Memory of a Paris Street." Trans. By Ross Benjamin. *Words Without Borders* (September 2009). Http://wordswithoutborders.org/article/memory-of-a-paris-street/. Last access: 20 December 2011.

Kuntzel, Thierry. *Title TK, Anarchive*. Nantes: Musée des Beaux Arts, 2006.

Kwon, Miwon. *One Place after Another. Site Specific Art and Locational Identity*. Cambridge, MA: MIT Press, 2002.

Lacy, Suzanne (ed.). *Mapping the Terrain. New Genre Public Art*. Seattle: Bay Press, 1995.

Laurenson, Pip. "Authenticity, Change and Loss in the Conservation of Time-based Media Installations." *Tate Papers. Tate's Online Research Journal* (Autumn 2006). Http://www.tate.org.uk/download/file/fid/7401. Last access: 23 July 2012.

—. "The Management of Display Equipment in Time-based Media Installations." In *Modern Art, New Museums. Contributions to the Bilbao Congress 13-17 September 2004*, edited by Ashok Roy and Perry Smith: 49-53. London: The International Institute for Conservation of Historic and Artistic Works, 2004.

Marin, Louis. *On Representation*. Stanford: Stanford University Press, 2001.

—. *Utopics. The Semiological Play of Textual Spaces*. Atlantic Highlands, NJ: Humanities Press, 1984.

McLuhan, Marshall, and Bruce R. Powers. *The Global Village. Transformation in the World Life and Media in the 21st Century*. New York: Oxford University Press, 1989.

McShine, Kynaston L. "Essay." In *Information*, edited by Kynaston L. McShine, 138–141. Catalogue of the eponymous exhibition, Museum of Modern Art, New York, 2 July-10 September 1970. New York: The Museum of Modern Art, 1970.

Neuhaus, Max. "Introduction." In *Max Neuhaus. Sound Works, Volume III. Place*, 5. Ostfildern: Cantz, 1994a.

—. "Conversation with Ulrich Look." In *Max Neuhaus. Sound Works, Volume I. Inscription*, 122-133. Ostfildern: Cantz, 1994b. [1990]

—. "Lecture at the University of Miami. Excerpts from Talk and Question Period." In *Max Neuhaus. Sound Works, Volume I. Inscription*, 71-79. Ostfildern: Cantz, 1994c. [1984]

—. "Lecture at the Siebu Museum, Tokyo. Talk and question period." In *Max Neuhaus. Sound Works, Volume I. Inscription*, 58-70. Ostfildern: Cantz, 1994d [1982].

—. *Max Neuhaus – Sound Installation*. Basel: Kunsthalle Basel, 1983.

Reiss, Julie H. *From Margin to the Center. The Spaces of Installation Art*. Cambridge, MA: MIT Press, 2001.

Schubiger, Irene (ed.). *Schweizer Videokunst der 1970er und 1980er Jahre. Eine Rekonstruktion*. Zurich: JRP Ringier, 2009.

Stern, Daniel. *The Interpersonal World of the Infant: A View from Psychoanalysis and Developmental Psychology*. New York: Basic Books, 1985.

Tomkins, Calvin, "Onward and Upward with the Arts – HEAR." In *Max Neuhaus. Sound Works, Volume I. Inscription*, 9-17. Ostfildern: Cantz, 1994.

On Curating New Media Art

Sarah Cook

INTRODUCTION

The constant navel-gazing on the part of curators into the terminological black-hole that is 'contemporary curating' tends to produce more discussion about its undecidability and fluidity, rather than precipitating any serious theoretical crisis or professional rupture (Charlesworth, 2007: 93).

An untested observation about the existing scholarship of curatorial practice suggests that the majority of articles about curating and the curatorial profession (considering those mostly published in the mainstream contemporary art press but also those found in the academic press) concerns the work of freelancers and what their large-scale temporary shows mean for the state of contemporary art (O'Neill, 2007). In other words, what is published generally focuses on "power people" in the art world – "über-curators" akin to the Harald Szeemans or Hans-Ulrich Obrists of the world – and "experimental" exhibitions such as Obrist's *Utopia Station* at the Venice Biennale in 2003. By contrast, discussions about curating *new media art* in particular have tended to focus on the changing role of the institutional curator and the issues brought up by the necessary tasks of a museum, from collection to exhibition to preservation. The first type of curating might generally be characterized by its equation of curating to DJ-ing or editorializing, and celebrated for its innovative and opinionated ways of showing work to the public (*The New York Times* memorably described one freelancer-curated show as being "on the nebulous topic of nonplaces" (Armin, 2010)). Institutionally based curating tends, on the other hand, to exemplify the mandates and characteristics of the institution in which it takes place – the shows look like their host museum, reflecting

its values and speaking to its identified audiences (such as, for example, the well-considered reinstallations of the permanent collection at Tate Modern in London).

The new-media-curating mailing list, which I coedit in my work with the online resource for curators of media art, CRUMB, has wondered aloud about this, populated as the list is, with commentators who are both institutionally based and freelance.[1] Is there a difference between institutional and freelance curating when it comes to new media art? Is the scholarship around the exhibition of new media art more prevalent in the field of museology than it is in curatorial studies? Or is it that the field of curatorial studies is more resistant to addressing the challenges to exhibition practice that new media art throws up?

In our book *Rethinking Curating. Art After New Media* (Graham and Cook, 2010) we deliberately addressed this latter point, and considered how the practice of curating new media art suggests new ways to curate art, considering exhibitions which were museum-based as well as ones which were extra-institutional (or even self-institutionalized). We also sought to foster debate around curatorial models beyond the traditional group show or exhibition. Yet, although we feel we made a contribution to the discussion, a distinction still remains between how the curating of new media art has been described mostly with reference to institutional issues, while the practice of curating contemporary art has been theorized predominantly with reference to extra-institutional practice and, in its way, has largely ignored media art.

Does this matter? What is important is that in the scholarship surrounding the field of media art (of which this book is a part) much attention has been given to significant recurring institutional issues which urgently need to be addressed if we are to overcome the historic gap between new media art and contemporary art: why do museums not collect new media art? Why do museums rarely show new media art? What are the difficulties associated with exhibiting new media art in museums in terms of marketing, education, or audience development? One can add to that list of practical questions other more theoretical ones, which have also repeatedly been discussed on the CRUMB mailing list: What words do we use to describe media art? Is "new media art" still a category worth maintaining? What other terminology can we use to describe the range of art practice we now encounter in this age after new media?

In *Rethinking Curating* we suggest considering the behaviors, or significant characteristics of the exhibition, of the work, alongside (and sometimes instead of) its medium: Is the work time-based, or is it lens-based art, or interactive or participatory? These categories and taxonomies have been cause for much debate. While some argue that the discussion that inevitably results from this concern with categorization (loosely paraphrased as, "why is new

media art still not yet a part of Art?") is the beginning of the end, the categories themselves do serve a purpose in pointing out the leading edges of the field.[2]

If we take as a given my untested assumption that curatorial scholarship (of contemporary art) revolves around the freelancer and the one-off event, and that museology (of new media art) is based on institutional practices and collections, we have the beginnings of the vexed path we have to follow to find answers to the question of how to curate art after new media. In museums, new acquisitions to the collection have to be categorized and usually vetted by committees of specialized interest (contemporary, modern, photography, drawing, Mexican, European, Canadian, Indian, etc.). New media art exhibitions, by contrast, have often been deeply temporary affairs in interstitial spaces – online as much as in real space, often in relation to residencies or festivals (one need only think of the myriad of festivals which have brought emerging art forms like new media to the public's attention such as Transmediale in Berlin or Wunderbar, the festival for participatory performance art practices in Newcastle, UK).[3] And, of course, on the rare occasions when new media art is collected, it poses the greatest challenges to existing museological categories (see chapter 8.3).

In scholarship, which seeks to find commonalities across a diverse range of practice, too often this is glossed over in search of one "way" to curate, the so-called silver bullet. But that demands unhelpful generalizations. Like all socio-political subjects, it is nearly impossible to speak of art exhibitions, art history, or the curatorial without either close readings of the art works involved, or the conditions of art's institutional setting. Yet, two problems seem recurrent, or perhaps inescapable, when looking back over a decade or more of curating media art: first, that art's temporary exhibition is predominantly a "drive-by event" viewed by curators undertaking some kind of mad "novelty hustle" (what we might call the temporal question) and second, that those exhibitions, and the curators who curate them, are continually trying to escape the tyranny of the overarching theme (what we might call the subjective question). In looking at both of these questions, could the practicalities of the commissioning process be part of the answer?

THE DRIVE-BY EVENT / THE NOVELTY HUSTLE / THE TEMPORAL QUESTION

While we were working on the exhibition here in Berlin, Maurizio [Cattelan] said that curating a biennial is like pointing a gun at your head and smiling at the same time, and waiting for someone else to come and pull the trigger... [...] We need to think how biennials can become more flexible structures and understand what they can offer to artists that galleries

and museums can't. By looking for new venues for the exhibition in order to connect the Biennial to a different idea of space, we are trying to say that when you reconsider the contents you have to reconsider the format too. It would be good to leave something functioning after the exhibition, but we're not equipped for that yet. After all, a biennial is still a one-night stand. (Massimiliano Gioni in Robecchi, 2005).

Curators of contemporary art are fundamentally concerned with the new, and with that concern comes a pressure to create exhibitions and events that demonstrate this newness. Work rarely enters the museum straight from the studio – it is shown somewhere else first. These temporal events and exhibitions (unless staged by the museum seeking to collect the work, for the sole purpose of documenting it and allowing their trustees to see it in situ) are often, though not always, in off-site, non-museum events, curated by adjunct curators, freelancers, or curators on contract (for example, the Glasgow International, an annual three-week-long city-wide visual arts event, has a full-time year-round festival producer but a "seconded" or short-term contracted curator).

Audiences at these events are also themselves engaged in a kind of "drive-by" viewing, in the words of Michelle Kasprzak (Cook, 2012), or what curator Barbara London memorably described as "the novelty hustle" (Cook, 2010: 64) – trying to see as much work as possible, and see it first, to bring it back to their institution. This is the same whether you are a curator visiting documenta or the Dutch Electronic Arts Festival (DEAF). Often these events are so large, or so short-run, that it is difficult if not impossible to give works the attention they deserve. There is a widely acknowledged fatigue with this, but few solutions have been suggested. In the words of one newspaper journalist at documenta,

> The quantity of work depending on the projected, moving image requires an inordinate degree of audience commitment and stamina [...] It cannot be given full attention in this context, unless one moves to Kassel for a week. I could spend six-and-a-bit hours watching walrus hunts and ice-cutting in the Arctic, but not on multiple monitors ranged along a busy corridor (Searle, 2002).

New media art, including web-based art, has long been exhibited in short-term exhibitions, often in a ghetto of their own making of recurrent dedicated festivals, such as ISEA (which changes city each iteration) or PixelAche (originally in Helsinki but now spread out across Finland).[4] This has been as much a consideration of funding opportunities as led by the internationally-networked qualities of the art itself, as artist and curator Olia Lialina has pointed out,

On-line galleries only store facts and demonstrate that a phenomenon exists. They neither create a space, nor really serve it. The same applies to festivals and competitions. Even if they are intelligently organised they are not events in net life. Mostly they are [...] the easiest and trendiest way to save money given to media events. Now that everybody knows the Internet is our paradise on earth, the long-awaited world without borders, visas, flights or hotels, it is the best way to make your event international (Lialina, 1998).

A longer look back, to say 1960 through 2000 would show that the new media arts, particularly networked, electronic works including net art, have been subject to many "ways" of exhibition – from their initial inclusion in museum-based exhibitions in the 1970s (such as *Software* and *Information*[5]) to their addition to exciting and global newly-founded festivals in the 1980s (such as the World Wide Video Festival in Amsterdam or Ars Electronica in Linz), to the creation of explicit online platforms for its presentation, such as servers and lists in the 1990s (The Thing, Rhizome) and then again their inclusion in museum exhibitions in the 2000s (such as *010101* or the Whitney Biennial[6]) (Cook, 2004). Given that new media art has changed forms, and continues to, across this time period, it is difficult to generalize the ways in which it has been shown (as fads for mobile technology projects are outstripped by apps, or by screen-based data visualizations, or participatory performances...[7]).

It is in fact only from the year 2000 onwards, with the unrelenting rise of contemporary art biennials and festivals the world over, that the festival has become the most widely accepted, or default, mode for new media art's distribution. This may not even be a new media or digital arts specific festival, such as, for instance, the one-night-only, dusk-til-dawn "Nuit Blanche" manifestation in Minneapolis, Northern Spark, which is rife with digitally-inflected public art projects such as David Rueter's project of wifi-transmitting and -receiving synchronized flashing bike lights (*The Kuramoto Model / 1000 fireflies*) which were given out to a thousand of the city's many cyclists. New media art's "festivalization" remains a key characteristic of its exhibition, just as the widespread adoption of technology suggests that the more social and temporary nature of arts festivals is the default mode for an encounter with networked culture.

One example, which I can report on first hand, is the Abandon Normal Devices Festival (AND), which has taken place in the Northwest of England, swapping locations between Liverpool, Manchester, and across Lancashire and Cumbria each year. In the 2011 AND Festival in Liverpool I curated, with the collaboration of Jean Gagnon, a small group exhibition which was on view only for the five days of the festival – an extended weekend. The exhibition,

Q.E.D., sought to bring together work which appeared to be the result or documentation of some kind of experimental process on the part of the artist (see Fig. 10.1 in color section). This artistic output, read as evidence, suggested how artists engage in scientific forms of hypothesis and enactment. The exhibition was curated not only for the context of the festival (which had a theme about belief structures) but also for the audience attending the biennial three-day conference on media art histories.[8] More than a few curators commented to me that the exhibition did not look like a new media art show, nor did it look like a festival exhibition. I can only assume this is because for this particular constellation of audience members I deliberately combined works of an historical nature (such as Norman White and Laura Kikauka's documentation in drawings, schematics, photography, and video of *Them Fuckin' Robots*, 1988) and new commissions (Alexandra Daisy Ginsberg and Sascha Pohflepp's project to model the world through an installation which investigated live and in real-time the weather forecast, or Scott Roger's two-part glass object and virtual animation piece investigating fluid dynamics). Alongside this I included works which were recent but not widely known either in contemporary art or new media art circles (such as Joe Winter's geological-like whiteboard "paintings" and prints from his project *Xerox Astronomy*, 2008, or Michel de Broin's *Braking Matter*, 2006) or well-realized works which were the result of extended research investigations on the part of the artists (such as Ulrike Kubatta's hyperreal documentary performance work about the women's space program at NASA, or Axel Straschnoy's collaboration with researchers at Carnegie Mellon University to make art by robots for robots).[9]

The curatorial conceit, that I could show documentation resulting from a pseudo-scientific artistic practice, helped get around the usual tropes of a "new media art show" that it should be full of functioning prototypes or novel technological experiences facilitated by the artist present alongside. There were plenty of those kinds of works elsewhere in the festival – from John O'Shea's pig's bladder football project to Kurt Hentschläger's sensory-deprivation immersive installation *Zee* in the main galleries at FACT. The fact that the exhibition *Q.E.D.* was on view for a short time period, and attendant to a conference, meant the works could be "reference points" for a longer-lasting and bigger discussion rather than have to be fully developed theses in and of themselves.

It has been suggested that in contemporary art festivals, such as the Venice Biennial, it is often the case that the freelance curator gains credibility (and has their name in the largest type on the poster) but that the art is easily forgotten (or, as mentioned above, impossible to take in). By contrast, in new media art festivals, it has often been the case that the works are prototyped and open for participation with a minimum of mediation, with the presence of the artist

394 |

there enhancing or troubleshooting its presentation, and therefore is a manifestation of a less explicit form of curating (curating as project management or event-production). I would suggest that it is in the combination of older and new works in the same exhibition around a tightly defined curatorial concept, that it is possible to get around the "novelty hustle" and build shows which, regardless of their short-runs (5 days or 2 weeks) offer to a drive-by audience a more sustained meditation on art.

But with the tightly controlled curatorial concept comes our second prevalent problem in the curating of new media art...

THE TYRANNY OF THE THEME SHOW

Once taxonomies begin to settle in, the truly avant-garde begin to move on (Lichty, 2004).

The common danger in curating exhibitions for biennials and festivals is that curators feel they have to know about and comment on the whole world – current affairs, philosophy, politics, cultural studies, etc. – and not just art, in order to make their exhibitions timely and relevant. For example, the much discussed "platforms" of documenta 11, where the exhibition was considered just the final and not most important manifestation of the curatorial ideas at play, is evidence of a tactic adopted to deal with this increased workload (and increased demand on the international art fair/event that it be truly global in relevance). Yet that necessity – of tying art to debates taking place within a wider community than arts makers – fits quite well with new media, which is increasingly part of a larger cultural transformation.

So if new media, or technology itself, is no longer enough of a hook for an exhibition, then comes the need for a more general encompassing theme to collect works around. Yet then, is the tyranny of the theme just another way to get around the problem of "naming," so common with media art? Looking back to a debate on the new-media-curating discussion list in 2004 offers a series of thoughts still relevant today. A number of them are excerpted here:

> The taxonomies that new media art curators, academics, artists and critics are dealing with go much deeper than the structuring logic of a museum's collection or exhibition programming schedule, they permeate the entire culture industry such as ... grant awarding bodies, and more visibly they shape or determine the structures of art schools and graduate programs within research universities so that the definitions of new media art are made or shaped before the art is even produced. Secondly,

new media art as a category for collection, exhibition, archiving has been for the most part institutionally created. Unlike other 'avant gardes' or emerging media (photography, video, film), 'new media art' has been institutionally embraced within the same generation of its introduction, by embrace, I mean included in major biennials, have become a funding category [...], and now with the fact that you can earn an MFA in net. art, created its own dept. within the academy. So unlike earlier moments when definitions were usually connected to individual artists' practices, new media art has sort of, in my estimation, been reversed engineered so to speak (Sutton, 2004).

What I think has been interesting – and important – about net art in particular and 'new media' in general has been how much it has been self-defined and self-propelled. With the history of ISEA and Ars Electronica and numerous other festivals, I don't know what 'new media as a category for collecting, exhibition, archiving has been for the most part institutionally created' even means. Perhaps it is my U.S. set of blinkers, but I think it is the lack of acceptance that defines the institutional response to net art and new media art, not its reverse engineering. I think the initial problem was that so many important new media artists were being thrown into the 'visual arts' and 'media arts' pools for review and hardly ever getting funding. Creating new media categories – at least in the United States but arguably elsewhere – was an attempt to respond to work not create it or force it in a direction (Dietz, 2004).

[...] What [an earlier post not included here] denounces as a 'hierarchical system of selection, promotion, official recognition, award – something that once again cuts out the truly collective/anonymous/networked/feedbacked nature of creativity and production,' is – if you ask me – curatorial practice that 'has to' make choices, selections, and create public attention for artistic practices. to assume that this automatically and unavoidably 'cuts out the truly collective/anonymous/networked/feedbacked nature of creativity and production' seems a bit short-sighted, considering the effort that has been made, not only by transmediale, to include a variety of art and creative practices (Broeckmann, 2004).

I note now that the Arts Council in the UK removed all the categories of funding that they used to have, and now you have to define your own funding requirements. This of course does something similar to Ars Electronica's move [of abolishing prize categories] – it forces the artist to consider their own position in relation to everything else, not just in

relation to the small bubble that the funders/commissioners give them an opportunity to slip into. I would hope that this will make people look at art rather than at technology for antecedents and references, but who knows (Pope, 2004).

In 2005, just after this debate took place, Steve Dietz and I co-curated an exhibition called *The Art Formerly Known As New Media* at the Banff Centre in Canada.[10] We were drawing, for our checklist, on a long list of alumni to the then Banff New Media Institute – artists who had participated in residencies, workshops, summits, and conferences on a range of themes pertinent to the new media field over the previous decade (from 1995). These themes ranged from data visualization to immersion, from artificial intelligence, to what constitutes identity online. It occurred to us that a retrospective view of the history of new media art had to be very deliberate in its move away from the media and technology part of its definition. After all, all technologies were once new. What seemed more important was selecting works where the artists continued to interrogate these larger, more resonant themes within their work. For instance, we included Catherine Richard's work *Shroud/Chrysalis II* (2005), an installation including a woven copper blanket and a low glass table in a white room, in which visitors to the exhibition are invited to lie down and be wrapped up, to temporarily insulate them from the surrounding electromagnetic spectrum. Faraday cages were once new media; what remains pertinent today is the problem of living our lives continually "plugged in."

The Art Formerly Known As New Media may have been a way to move the theme of the show away from newness and technology towards other themes, such as embodiment or agency. In the years since this exhibition this tactic of the new media art group show clustered around a theme, continues to be prevalent, and has resulted in a kind of tyranny, and chase – which festival will work with which theme first? Once a theme, such as biotechnology or environmental response, has been claimed by a festival, and all the best work on that theme shown there, does that mean that other festivals and exhibitions cannot take it on?

Of course this is a silly way to think about curating. An exhibition at one museum about the ready-made will likely not stop another curator at another museum mount an exhibition about ready-mades.[11] Working in a field where there are three kinds of newness on the go at once – new technologies as both tool and medium, new methods of making art or processes, and new ideas to manifest in those works – does mean that one has to be curatorially creative and led by real ideas of interest to resist the urge to just pick one theme and try to make everything fit into it. In other words, being led by the content of the works themselves is going to make for a stronger exhibition experience than grouping

things together because they all *could* be understood under a larger umbrella theme, such as the environmental crisis to cite one. In contemporary art, media and methods are increasingly varied, and history has shown that most exhibitions which are solely medium-based tend towards the uninteresting.

THE ALLURE OF COMMISSIONING

Many exhibitions have taken place within and without museums, but have they made the situation of how to curate media art any clearer, if the characteristics and behaviors of the work (and the requirements of the audience in their engagement with that work) have also moved forward? Exhibition history is a growing field of study but still underdeveloped in the histories of media art. Yet as Paul O'Neill has written, given the changing media at play in art, and the different roles played by the artist, the audience, and the curator, there is no one solution for curators.

> In the new curatorial rhetoric the emphasis is on flexibility, temporality, mobility, interactivity, performativity and connectivity. This new found urgency to seek a common language is exemplified by the number of international curators who have treated them [exhibitions/biennials] as a collective activity, using them as a means to explore the processes of art production through temporary mediation systems rather than presenting art and its exhibition as a finished product (O'Neill, 2005: 7).

This concern to show work in progress, or the usually hidden process of making art, is familiar to curators of new media who have always had cause to do so, where audiences have often played a big role in bringing the artwork into existence or completed the experience of the work. Which brings us back to the question of categories and what exactly it is we are trying to curate, whether in a museum, festival or other context. Media art curator Jacob Lillemose has commented that,

> I often hear Danish museum directors ask for a list of categories because it would make them feel more comfortable with digital art; it frames digital art in accordance with the principles of non-digital art. However, I think they misunderstand the challenges and do themselves an unintentional disservice. Digital art demands new ways of institutional thinking about art works both in terms of curating and preservation; it's difficult, sure, but also a chance for the institution to develop (Lillemose in Graham, 2004).

The curating of work in progress means getting involved in the creation of the work "further up the idea stream," in the words of curator Scott Burnham (Cook, 2009). Which perhaps is why commissioning has become the common function of both the new media art curator and the extra-institutional freelance curator. A 2011 article in *Art Journal* pointed out that curators often talk of the "projects" they are working on, as that allows a myriad of outcomes, from exhibition to publication. A debate on the CRUMB list in 2010 addressed this aspect of the curatorial role, wondering if commissioning can help towards new curatorial models for new media art. Some excerpts follow.

> I have always found commissioning to be a very dialogical process. The conversation one starts with an artist (as a curator) can go on for a year or more before anything goes into production. Sometimes things fall into place quickly, but in my experience at least, this does not happen very often. Especially in relation to variable media... the production phase is also highly dialogical; as various logistics, contexts and ideas shift and develop throughout that process. Very little is rigidly defined by the artist or the curator at the outset. If there is anything I am likely to define (when playing the role of curator), it is context. Though even this is likely to be dynamic. Parameters can change or opportunities arise... (Dipple, 2010).

> Depending on your institutional setting you may, as a curator, have more or less so called 'power'. I find it hard to discuss power relations in the abstract. Power is always exercised in an institutional context. [...] But my attitude has always been to give freedom to the artist in the first place as they know more and are the specialist in terms of technology; but it also is giving them responsibility. The only aspect that always gets in the way is financial resources. But if you establish the financial framework right off the bat, rarely is it a major problem after (Gagnon, 2010).

> New media art certainly seems a natural for commissions since there is (or was) not such a large body of extant work to 'shop' for. And new media production is naturally technical, involved, and labor intensive. Sometimes the curator or gallery/museum tech staff know as much or more about different aspects of the technology as the artist (not always, but sometimes). This means that close collaboration is necessary, and it also results in the dynamic you mention, where the collaborative boundary between curator and artist is blurred. On the one hand, this appears to be a good thing; breaking down the old curatorial model where the artist is asked politely to drop off their work at the loading dock and disappear until opening night (to paraphrase Robert Storr) (Rinehart, 2010).

Establishing a framework for the art project with the artist in advance, getting involved in the different stages of the production of the work, and keeping discussion open about how the work is going to be exhibited, are all activities which take important time on the part of the curator And the more time taken in the curating of a project, the more collaborative with the artist it is, the less likely it is that the curating will be "sloppy" in the style of the all-out, huge, temporary theme show, where, often for reasons of space, time, budget, and marketing pressures, one-size-fits-all is the only method available.

IN CONCLUSION

The unofficial CRUMB motto is that once you have curated new media art you never curate art the same way again. Which is another way of restating the lessons above – that once you have collaborated with artists, including commissioning their work, you might be less keen on the curatorial model of practice which seems to only result in a big themed show seen by a drive-by audience. Other practical and theoretical problems with the way art is received will no doubt come to replace those two mentioned so far. For instance, a common complaint, written nearly a decade ago, is still the case today:

> Perhaps critics, print magazines and newspapers would consider writing/
> printing/commissioning more articles about 'one-person shows,' individual web sites or single 'projects,' rather than round-table discussions or those articles covering entire festivals, biennials, etc. (although there are great exceptions, the latter type of articles is the one most often ending with the 'So, is it art?' question, because you can't possibly develop a full, well-argued critical judgement of one art project when covering a whole festival) (Broegger, 2003).

This comment rightfully suggests that the curator's role also has to encompass the scholarship around media arts (its history, and its key works, understood in a monographic form) if we want to help evolve better ways to show the work.

What other lessons have we learned from curators dealing with new media arts in the field in the last ten years? First is that in the last decade the art has changed a lot and as such defining the roles and responsibilities of the curator remains a case-specific activity. Artworks made ten years ago have been almost completely forgotten (or, in the case of net-based art, left to molder online while software and operating systems are upgraded rendering their coding obsolete) while earlier histories (twenty or more years) of media art, including time-based and lens-based practices, are gradually being excavated,

and restaged and reshown. How do we keep the recent memory of art alive? Can freelance curators – those who are non-institutional, non-collecting, not-museum-based – help, through their practice, to extend the future relevance of recent media art? How can we take the best of a freelance curator's attitude to engage with new art forms and new themes, and mix that with the institutional curator's responsibilities to scholarship and preservation? Perhaps the time has come for curators to ensure that the considered exhibition, or the single art commission, extends beyond the "drive-by" "one-night-stand" of a festival or biennial, and speaks to ideas beyond the obvious and beyond the tyranny of the overarching theme.

NOTES

1 See http://www.crumbweb.org.
2 This is an ever-evolving area of inquiry; for its most recent significant entry see Quaranta (2010).
3 Transmediale, see http://www.transmediale.de. Wunderbar, see http://www.wunderbarfestival.co.uk. For a considered look at the place of new media art within the history of the Venice Biennale, see Franco (2012).
4 Recent iterations of the ISEA (the Inter-Society for Electronic Art) festival have been held in Istanbul and Albuquerque, see http://www.isea2012org. After ten years of programming, PixelAche has changed its director and its format and largely abandoned the festival model in favor of year-round, community-based programming related to new media culture, under the strand Pixelversity, see http://www.pixelache.ac.
5 *Software: Information Technology: Its New Meaning for Art* took place at the Jewish Museum in New York in 1970, curated by Jack Burnham; *Information* took place at the Museum of Modern Art also in 1970, curated by Kynaston McShine.
6 *010101: Art in Technological Times* took place at the San Francisco Museum of Modern Art in 2001 instigated by David Ross and curated across four departments of the museum; the 2000 edition of the Whitney Biennial attracted attention for its inclusion of net-based art practices, see Graham and Cook (2010).
7 On the former, see the discussions from the eyeo festival, held in 2012 in Minneapolis – http://www.eyeo.com. On the latter, see Benford and Giannachi (2011).
8 Rewire: The fourth international conference on the histories of media art, science, and technology was hosted by FACT at Liverpool John Moore's University, see http://www.mediaarthistory.org.
9 The exhibition *Q.E.D.* took place in Liverpool in 2011 and is documented online with the gallery guide available to download from http://archive-2011.andfestival.org.uk/event/qed.
10 *The Art Formerly Known As New Media*, Walter Phillips Gallery, Banff, Canada, 2005. See the catalogue for the exhibition available in Cook and Diamond (2011).
11 Obviously many museum exhibitions are based around collections which are distinct to the museum.

REFERENCES

Armin, Janine. "The Creative Landscape of Independent Curators." *The New York Times* 15 June 2010. Http://www.nytimes.com/2010/06/16/arts/16iht-rartfreelance.html?pagewanted=all. Last access: 25 July 2012.

Benford, Steve, and Gabriella Giannachi. *Performing Mixed Reality*. Cambridge, MA: MIT Press, 2011.

Broeckmann, Andreas. "heuristics / techno-culture." *New-Media-Curating Discussion List*, 8 September 2004 – http://www.jiscmail.ac.uk/lists/new-media-curating. html.

Broegger, Andreas. "criteria for judgements of quality?" *New-Media-Curating Discussion List*. 3 June 2003 – http:// www.jiscmail.ac.uk/lists/new-media-curating.html.

Charlesworth, J.J. "Curating Doubt." In *Issues in Curating Contemporary Art and Performance*, edited by Judith Rugg and Michele Sedgwick, 91-99. London: Intellect Books, 2007.

Cook, Sarah. Notes from an unpublished interview with Michelle Kasprzak, Rotterdam, May 2012.

—. "Multi-multi-media. An interview with Barbara London." In *A Brief History of Curating New Media Art*, edited by Sarah Cook, Beryl Graham, Verina Gfader, and Axel Lapp, 57-72. Berlin: The Green Box, 2010. Originally published online, 2001 – www.crumbweb.org.

—. Curatorial Master class with Scott Burnham. New York: Eyebeam Art and Technology Center, 2009 – http://www.eyebeam.org/events/.

—. *Balancing Content and Context. Towards a Third Way of Curating New Media Art*. Ph.D. diss., University of Sunderland, 2004.

—, and Sara Diamond (eds.) *Euphoria and Dystopia. The Banff New Media Institute Dialogues*. Toronto: Riverside Architectural Press and The Banff Centre Press, 2011.

Dietz, Steve. "reverse engineering?" *New-Media-Curating Discussion List*, 8 September 2004 – http://www.jiscmail.ac.uk/lists/new-media-curating.html.

Dipple, Kelli. "Re: Three questions about commissioning variable media." *New-Media Curating Discussion List*. 8 March 2010 – http://www.jiscmail.ac.uk/lists/new-media-curating.html.

Franco, Francesca. *Art and Technology at the Venice Biennale*. Ph.D. diss., Birkbeck College London, 2012.

Gagnon, Jean. "Re: Three questions about commissioning variable media." *New-Media-Curating Discussion* List. 3 March 2010 – http://www.jiscmail.ac.uk/lists/new-media-curating.html.

Graham, Beryl. "Taxonomies of Media Art. September Theme." *New-Media-Curating Discussion List*. 8 September 2004 – http:// www.jiscmail.ac.uk/lists/new-media-curating.html.

—, and Sarah Cook. *Rethinking Curating. Art after New Media*. Cambridge, MA: MIT Press, 2010.

Lialina, Olia. "cheap.art." *Rhizome*. 19 January 1998 – http://rhizome.org/discuss/view/28198/#c1026. Last access: 25 July 2012.

Lichty, Patrick. "Re: Definitions." *New-Media-Curating Discussion List*. 6 September 2004 – http:// www.jiscmail.ac.uk/lists/new-media-curating.html.

| 403

O'Neill, Paul. "The Curatorial Turn. From Practice to Discourse." In *Issues in Curating Contemporary Art and Performance*, edited by Judith Rugg and Michele Sedgwick, 13-28. London: Intellect Books, 2007.

—. "The Co-dependent Curator." *Art Monthly* 291 (November 2005): 7-10.

Pope, Ivan. "Re: taxonomies, definitions, archives, etc." *New-Media-Curating Discussion List*. 8 September 2004 – http:// www.jiscmail.ac.uk/lists/new-media-curating.html.

Quaranta, Domenico. *Media, New Media, Postmedia*. Milan: Postmediabooks, 2010.

Rinehart, Richard. "Re: Three questions about commissioning variable media." *New-Media-Curating Discussion List*. 3 March 2010 – http://www.jiscmail.ac.uk/lists/new-media-curating.html.

Robecchi, Michele. "An interview with Maurizio Cattelan and Massimiliano Gioni." *Contemporary* (special issue on Curators) 77 (2005) – http://www.contemporary-magazine.com/profile77_3.htm.

Searle, Adrian. "Being Here Now." *The Guardian*. 23 July 2002. Http://www.guardian.co.uk/culture/2002/jul/23/artsfeatures. Last access: 25 July 2012.

Sutton, Gloria. "taxonomies, definitions, archives, etc." *New-Media-Curating Discussion List*. 7 September 2004 – http://www.jiscmail.ac.uk/lists/new-media-curating.html.

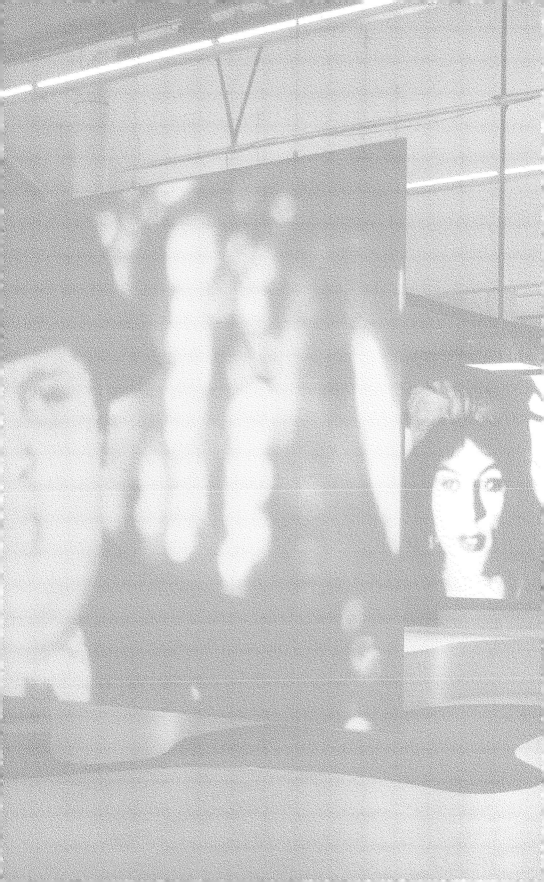

Epilogue

Julia Noordegraaf and Ariane Noël de Tilly

During the fall of 2007, the Stedelijk Museum CS in Amsterdam presented the exhibition *Andy Warhol. Other Voices, Other Rooms.*[1] Curated by Eva Meyer-Hermann, the exhibition put forward the great variety of media Warhol used in his career such as film, photography, video, sound, graphic design, painting, and printmaking. Divided in three main sections – *Cosmos*, *Filmscape*, and *TV-Scape* – the exhibition shed light on artworks within Warhol's oeuvre that were not yet widely known by the public: his films and videotapes. The section *Cosmos* was conceived as an inventory of all the media and themes Warhol had worked with. The artworks in that section – drawings, paintings, Polaroids, postcards, LP sleeves, and so on – were spread out on 28 different pillars. The section *TV-Scape* comprised the 42 television episodes that Andy Warhol made for New York TV companies and for MTV between 1979 and 1987, and a series of unknown video pieces dating from the 1960s and 1970s. Finally, the section *Filmscape* was subdivided in four spaces named *Screen Tests*, *Films*, *Silver Clouds*, and *Theatre*. A first room was dedicated to the presentation of the artist's *Screen Tests*, a series of short films the artist had made by asking his peers as well as strangers to pose, sitting as still as possible, until the three-minute reel used for the shooting ran out. In order to extend the duration of the *Screen Tests*, Warhol decided to project them at 16 frames per second rather than at 24 frames per second, and the films ended up being four minutes long each. The next room of the section *Filmscape* featured 19 films, all of which were projected simultaneously (see Fig. 11.1 in color section). On the back wall of that space, a large window the size of a projection screen opened up onto the room where the *Silver Clouds* – floating balloons of helium – were presented. Ultimately, when the visitors left that exhibition space, they could walk to the theater where eight other of Warhol's films were projected in a two-day cycle. These films had not been integrated in the *Filmscape* room of the exhibition

because the curator decided their dramatic structure required that they be shown from start to finish, rather than as a loop.

The setup of this exhibition positioned the films and television works as a logical extension of the themes and issues such as portraiture, celebrity, repetition, seriality, and the multiplication of images that Warhol explored in his better-known paintings, drawings, and sculptures. In that sense, the exhibition illustrates how media art has become more firmly situated within art history in recent years. Ironically, it may have been the renewed interest in film and video by visual artists from the 1990s that led to a rediscovery and revaluation of Warhol's time-based artworks, as well as those by other artists and experimental filmmakers in the 1960s and 1970s. Like many of the artists discussed in this book, Warhol used the *mediums* of film and video in ways that challenge the conventions and cultural impact of the *media* related to them (cinema and television, respectively), thus provoking new ways of viewing and interacting with these media. For example, his films lack the clear structure of mainstream narrative films, instead simply observing the members of the group of people that hung around his studio. The *Screen Tests*, with their almost non-moving subjects and slowed-down projection speed, expose film's paradoxical relation to time (capturing reality in still photographs that, because of the movement of the filmstrip in the projector at 24 frames a second, create the illusion of movement), thus puncturing the suspension of disbelief that characterizes traditional cinematic spectatorship. Yet while the works refer thematically in many ways to the ontology of film, in order to be projected, they had to be transferred to non-film carriers and another projection system.[2] Both in its overview of the way Warhol employed time-based media in his artistic production and its design and technical setup, the exhibition *Andy Warhol. Other Voices, Other Rooms* epitomizes many of the issues discussed in this book and thus serves as a suitable anchor for its conclusion.

MIGRATION AS AN EXHIBITION STRATEGY

For the making of his films, Andy Warhol had used 16mm-film reels, and in the case of his videotapes, 1-inch reel-to-reel and ½-inch reel-to-reel. Considering the ephemerality of these carriers, and also to facilitate their looped presentation, in the exhibition *Andy Warhol. Other Voices, Other Rooms*, the films were transferred to high definition video files (HDD) and the videotapes were migrated to digital video files (DVD). Various texts in this book discuss the advantages and disadvantages of such migrations. One of the reasons to support presenting the films on a digitized format is that it enabled them to be shown continuously, and also, simultaneously – thus allowing a comparison between the

films. Considering that film projectors make more noise than video projectors, the simultaneous projection of 19 films was only possible with the use of video projectors.[3] However, if a step is skipped during the migration process, there are consequences for the aesthetic appearance of a work. In this specific case, the video images projected had not been *de-interlaced*.

The feature of interlaced images is specific to the video format. Both analogue and digital video images are built up from horizontal lines. Every $1/25^{th}$ of a second, a complete image is written on the screen starting at the upper left-hand corner up to the lower right-hand corner. This is done in two steps. First the uneven lines are drawn: from line 1 to 599. This is called the upper field. Second, the lower field, consisting of the even lines 2 to 600, is generated. There is thus a $1/50^{th}$ of a second time lag between the two layers, but this time lag is invisible to the human eye. This manner of generating images is called "interlacing."[4]

When a film needs to be transferred to video format, a digital scan of the work provides the best image quality. In the specific case of the films shown in *Andy Warhol. Other Voices, Other Rooms*, the films had been previously transferred to an analogue video format. In order to avoid the highly expensive costs of digitizing the original films, the digitization was based on earlier analogue video transfers. However, when an analogue video is transferred to a digital format, the digital formats record the two fields described above simultaneously. The consequence of this is that the time lag between the upper and lower field become visible. This resulting visual distortion can be removed through the process of *de-interlacing*, a method involving the removal of one of the fields and the duplication of the other to substitute for the field removed.[5] Since this method of de-interlacing was not applied in the digitization of the analogue video transfers of Warhol's films, the lines remained visible, especially to those who are more sensitive to the effects of the digitization of analogue videos on the quality of the image. This case demonstrates the consequences of obsolete technologies and migration strategies discussed throughout this book.

FILM AND TV: SWITCHING PLACES

The exhibition *Andy Warhol. Other Voices, Other Rooms* stood out from other monographic exhibitions on the work of Warhol held in the last decade because of its focus on lesser-known works by the artist – his films and videotapes – but also because of the manner in which the artworks were presented. For instance, the choice of presenting 19 films simultaneously in the same space was audacious, but also technically challenging. It created, as this sec-

tion of the exhibition was called, a *Filmscape*. In a way, this setup appeared to transform the entire space into one installation, almost a work of art in itself. However, in the exhibition catalogue, curator Eva Meyer-Hermann argued: "This presentation is neither pure documentation nor work of art: it does not fully conform to any usual expectations yet it has something of everything" (Meyer-Hermann, 2007: 139).

Showing many of Warhol's films in proximity to one another had the advantage of making the films enter into dialogue with one another, but it also had a distracting effect: the attention of the visitors was fragmented and distributed over space and time. The fact that each projection screen was accompanied by a numeric clock displaying the remaining time of the screening, invited visitors to stay, move on, or return, thus further stimulating their *flânerie*-like spectatorship of the films. In this sense, the *Filmscape* was characterized by the distracted, fragmented viewing position that is usually associated with watching television in a private home (see Caldwell, 1995). In contrast, the television works shown in the *TV-Scape* had to be viewed and listened to in isolation, seated on a star-shaped stool in front of one of the monitors with a set of headphones for the sound, positioning the visitor in the fixed viewing position normally associated with the cinema theater (see Fig. 11.2 in color section).[6] The choice of presentation in this exhibition was very Warholesque in that the artist himself experimented widely with the presentation of his films in the 1960s. For instance, the expanded cinema production *Exploring Plastic Inevitable* was presented in several locations between 1966 and 1967 and was a complex project in which Warhol's films were only one of the elements. This production included, among other things, film projections, slide projections, strobe lights, and sets by the Velvet Underground and Nico (Fig. 1.3).[7] The presentation format chosen at the Stedelijk Museum CS demonstrates that there is not one perfect manner of exhibiting Warhol's films, but several, and some of them are more experimental than others.

TIME TRAVELING

Warhol was fundamentally concerned with the "now" of his time; thematically as well as formally, his works are very much about the present. In that sense the exhibition *Andy Warhol: Other Voices, Other Rooms* raised the wider question of how to exhibit works that refer to a past present. The exhibition gave the films a new presence, by transferring them to a contemporary, digital video format and by showing them in the kind of screen-scape so characteristic for contemporary urban screen culture (see Verhoeff, 2012). The digital clocks beside each of the films, counting down to their ending, emphasized

410 |

the visitors' situatedness in the here and now. The *TV-Scape*, with its isolated, fixed viewing and listening position, invited a concentrated experience of the television work that it did not have when originally broadcast, removing it from the flow and liveness of television and inscribing it in the history of Warhol's oeuvre and in wider art and media history. The complex relation of this exhibition to time is nicely illustrated by the work *Time Capsule 61*, exhibited in the *Cosmos* section: a cardboard box in which Warhol put all the knick-knacks and memorabilia that he found relevant at the time. He knew that in due time people would open these boxes and would try to discover a seemingly logical order to its contents (Hofmans, 2007). In that sense, the upside-down *Time Capsule 61* in the exhibition is a nice metaphor for the fact that preserving and exhibiting media art always entails interpretation, choices, and the acceptance of a certain degree of change.

Seen from an archaeological perspective, the coexistence of various mediums, formats, and exhibition techniques and styles is not something to be avoided, but a way to make the past experiential in the present. In that sense, preservationists and curators of media art facing obsolete technologies have a certain freedom in determining preservation and exhibition strategies, ranging from the repair or replacement of contemporary technologies to more radical reconstructions. As pointed out throughout this book, such an approach requires that the preservationist and curator respect the artwork's logic, distinguishing between the work's core – those elements considered crucial to its identity – and its appearance, artistic concept, and historical context – elements which might be susceptible to change over time. Additionally, it requires extensive and multilayered modes of documentation, so that future preservationists and curators can make new, well-informed decisions about the appearance and functionality of a work. And the special nature of media art, situated between art, media, and popular culture, also requires a type of archiving that documents not only the technologies used, but also the cultural practices related to them.

Andy Warhol, besides having been a highly influential 20th-century artist, can retrospectively also serve as a model for such a preservationist/curator. In the creation and exhibition of his film installation *Outer and Inner Space* (1965) Warhol combined these roles in interesting ways. *Outer and Inner Space* is a portrait of Edie Sedgwick, filmed while watching a prerecorded videotape of herself playing on a monitor next to her. Since in the video recording Sedgwick faces left, the film appears to show Edie having a conversation with herself. Thematically the work reflects on the relation between film and video, with the making of the video inviting the making of the film, rather than the other way around. At the same time, and ironically, the fact that Warhol recorded the video registration on film ensured its survival – the original Norelco vide-

otapes can no longer be played back (Angell, 2002). The work also refers to many other core themes in Warhol's work related to celebrity, media attention, and the multiplication of images – themes still relevant to our present-day media-saturated world. Finally, Warhol experimented with the exhibition of this work, alternating between cinema theater screenings and gallery projections, either with a single screen or with a double one – the latter turning Edie's double portrait into a quadruple one (as in the Stedelijk Museum CS exhibition). In that sense, Warhol serves as a model for any preservationist or curator ready to take up the challenges posed by preserving and exhibiting media art.

NOTES

1 *Andy Warhol: Other Voices, Other Rooms*, 12 October 2007-14 January 2008. Amsterdam: Stedelijk Museum CS. In the years that followed, the exhibition traveled to other venues such as the Moderna Museet Stockholm, the Hayward Gallery in London, and the Wexner Center for the Arts in Columbus, Ohio.

2 Similarly, the TV works, recorded on videotape for broadcasting purposes, were shown in this exhibition as DVDs on television monitors.

3 Electrostatic speakers by the Finnish firm Panphonics were also used to focus the sound in a specific place in space. For details on this sound system, see the Panphonics website: http://www.panphonics.com/solutions/museums-exhibitions-directional-audio-solution. Last access 5 July 2012.

4 The authors would like to thank Gert Hoogeveen, Head of Audiovisuals at the Stedelijk Museum, Amsterdam, for his time and for generously answering their technical questions.

5 The consequence of this method is a reduction by half of the image information, causing a considerable blurring of the images, but there are ways to compensate for this.

6 For a detailed analysis of the way this exhibition relates to cinematic spectatorship see Hesselberth (2012: 35-63).

7 Ronald Nameth's film *Andy Warhol's Exploding Plastic Inevitable* (1967), which documents some of the performances of this production, was screened in the introductory room at the Stedelijk Museum CS exhibition.

REFERENCES

Angell, Callie. "Doubling the Screen. Andy Warhol's *Outer and Inner Space.*" *Millennium Film Journal* 38 (2002): 19-33. Available online – http://www.mfj-online.org/journalPages/MFJ38/angell.html. Last access on 12 July 2012.

Caldwell, John. *Televisuality. Style, Crisis, and Authority in American Television.* New Brunswick, NJ: Rutgers University Press, 1995.

Hesselberth, Pepita. *Cinematic Chronotopes. Affective Encounters in Space-Time.* University of Amsterdam, Ph.D. diss., 2012.

Hofmans, Daniëlle. "Andy Warhol. Other Voices, Other Rooms." *De Witte Raaf* 22 (2007) 130: 11.

Meyer-Hermann, Eva. "Other Voices, Other Rooms. Filmscape," in *Andy Warhol. A Guide to 706 Items in 2 Hours 56 Minutes*, edited by Eva Meyer-Hermann, 134-139. Amsterdam/Stockholm/Rotterdam: Stedelijk Museum/Moderna Museet/NAi Publishers, 2007.

Verhoeff, Nanna. *Mobile Screens. The Visual Regime of Navigation.* Amsterdam: Amsterdam University Press, 2012.

LIST OF CONTRIBUTORS

CLAUDIA D'ALONZO is a Ph.D. student in Audiovisual Studies: Cinema, Music and Communication at the University of Udine.

ARIE ALTENA is archive editor at V2_, organizer of the Sonic Acts festival and author on new media, art, internet-culture, media-theory and literature.

ALESSANDRA BARBUTO is Head of the Collection, Conservation, Registrar Department at the MAXXI Art /MAXXI National Museum of 21st Century Arts, Rome.

LAURA BARRECA is Research Fellow at the University of Palermo. She holds a Ph.D. and a Post-doc in the Conservation and Documentation of New Media Art.

ELENA BISERNA holds a Ph.D. in Audiovisual Studies from the University of Udine and works as a researcher in the field of sound and contemporary art.

ALESSANDRO BORDINA is Postdoctoral Fellow in Methodologies and Techniques for Media Art Conservation, Restoration, Access, and Dissemination at the University of Udine.

RENATE BUSCHMANN is director of the IMAI – inter media art institute.

TERESA CASTRO is Associate Professor of Film Theory and Visual Studies at the Université Sorbonne nouvelle – Paris 3.

SARAH COOK is a curator and Reader at the University of Sunderland where she co-founded and co-edits CRUMB, the online resource for curators of new media art www.crumbweb.org.

ANNET DEKKER is an independent curator and Ph.D. researcher in Cultural Studies at Goldsmiths University, London.

PHILIPPE DUBOIS is Professor of the Theory of Visual Forms at the Université Sorbonne nouvelle – Paris 3.

JÜRGEN ENGE is Head of "Medienzentrum" at the University of Applied Sciences and Arts in Hildesheim, Germany.

TÉRÉSA FAUCON is Associate Professor of Film Theory and Aesthetics at the Université Sorbonne nouvelle – Paris 3.

VINZENZ HEDIGER is Professor of Film Studies in the Institute for Theater, Film, and Media Studies at the Goethe-Universität Frankfurt am Main.

STÉPHANIE-EMMANUELLE LOUIS is a Ph.D. candidate at the École des Hautes études en Sciences sociales and the Institut d'histoire du temps présent (IHTP-CNRS).

PIP LAURENSON is Head of Collection Care Research at Tate and holds a Ph.D. in the care and management of time-based media works of art from University College London.

BARBARA LE MAÎTRE is Associate Professor of Theory and Aesthetics of Static and Time-based Images at the Université Sorbonne nouvelle – Paris 3.

TABEA LURK is Professor of Digital Conservation at Bern University of the Arts, Switzerland.

DARIO MARCHIORI is Associate Professor of History of Film Forms at the Université Lyon 2 Lumière.

ARIANE NOËL DE TILLY is Postdoctoral Research Fellow in the Department of Art History, Visual Art and Theory at the University of British Columbia.

JULIA NOORDEGRAAF is Professor of Heritage and Digital Culture in the Faculty of Humanities at the University of Amsterdam.

IOLANDA RATTI holds an M.A. degree in Art History from the University of Milan and is Assistant Conservator in the Time-based Media Department at Tate Gallery, London.

COSETTA G. SABA is Associate Professor of Film Analysis and Audiovisual Practices in Media Art at the University of Udine.

MIRCO SANTI is Postdoctoral Fellow in the Restoration of Small Gauge Films and Obsolete Formats at the University of Udine and co-founder of Home Movies.

SENTA SIEWERT is Professor of Film Studies (*ad interim*) in the Media Studies Department at Ruhr-University Bochum.

WANDA STRAUVEN is Associate Professor of Film Studies in the Media Studies Department at the University of Amsterdam.

VIVIAN VAN SAAZE is Postdoctoral Researcher at the Faculty of Arts and Social Sciences at Maastricht University.

SIMONE VENTURINI is Assistant Professor and scientific coordinator of the La Camera Ottica Film and Video Restoration laboratory at the University of Udine.

CHRIS WAHL is a researcher at the University of Film and Television "Konrad Wolf" Potsdam-Babelsberg.

GABY WIJERS is Head of Collections, Preservation, and Related Research at the Netherlands Media Art Institute (NIMk) Amsterdam, the Netherlands.

INDEX

424